A STRANGE BUSINESS

A STRANGE BUSINESS

A REVOLUTION IN ART, CULTURE, AND COMMERCE IN 19TH CENTURY LONDON

JAMES HAMILTON

PEGASUS BOOKS
NEW YORK LONDON

A STRANGE BUSINESS

Pegasus Books LLC
80 Broad Street, 5th Floor
New York, NY 10004

First Pegasus Books hardcover edition September 2015

ISBN: 978-1-60598-870-2

10 9 8 7 6 5 4 3 2 1

Printed in the United States of America
Distributed by W. W. Norton & Company, Inc.

This book is for Kate

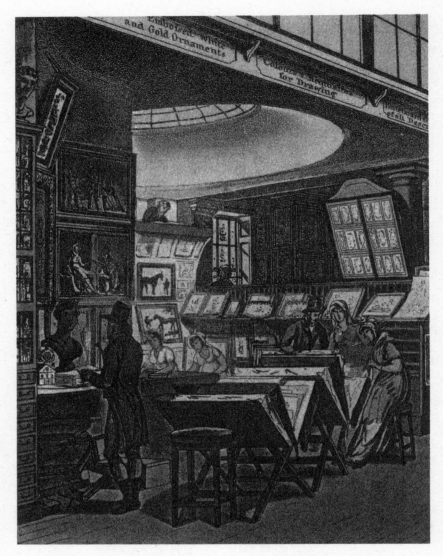

Rudolf Ackermann's premises, The Repository of Arts, in the Strand, London. Etching with aquatint by A. C. Pugin, published by Rudolf Ackermann, 1809. Detail. (*British Library / Robana via Getty Images*)

CONTENTS

'Painting is a strange business'
J. M. W. Turner

FOREWORD AND ACKNOWLEDGEMENTS

A Strange Business is the last in an evolving quartet of books that began with my *Turner: A Life* (1997), continued with *Faraday: The Life* (2002) and looked more widely at the social background of art and science in the nineteenth century in *London Lights: The Minds that Moved the City that Shook the World* (2007).

J. M. W. Turner, 'Mr Turner' as he has been known in our house for twenty years, is the thin red line that runs through all four books. He is an occasional presence in *Faraday: The Life*; he hovers about *London Lights*; and in *A Strange Business* he is a constant undercurrent, churning here, surfacing there. Beyond, around and reflected by Turner, the nineteenth is a rich and extraordinary century, a gleaming, oil-streaked, sun-drenched pool. The only way that seemed appropriate for me to approach it was with a running jump and something of a splash.

Those listed here all helped usefully and critically in bringing this book to fruition, and I thank them all warmly: Lucy Blaxland, Felicity Bryan, Julius Bryant, Claire Burnand, Neil Chambers, Robert Chenciner, James Collett-White, Nicholas Donaldson, Zach Downey, Tracey Earl, David K. Frasier, Colin Harris, Colin Harrison, Kurt G. F. Helfrich, Rosemary Hill, Jeannie Hobhouse, Frank James, Andrew Kernot, Stephen Lloyd, David McClay, John Maddicott, Martin Maw, James Miller, Sebastian Mitchell, Clare Mullett, John and Virginia Murray, Oswyn Murray, Mark Norman, Jan Piggott, Froukje Pitstra, Jonathan Reinarz, Gabrielle Rendell, Eric Shanes, Bruce and Maggie Tattersall, Jevon Thistlewood, Michele Topham, Matthew Turi, Nicholas Webb, Andrew Wilton, Joan Winterkorn, Lucy Wood, Susan Worrall and Vicky Worsfold. Staff of the Bodleian, the Royal

Institution, the British Library, the National Art Library, the National Gallery Archive, the University of Birmingham Cadbury Research Library, the Barclays Bank Archive, the London Metropolitan Archives and Coutts & Co. were active and prescient in their assistance. Likewise, my love and thanks go to my family, in particular my wife Kate Eustace who has once again put up with a lot, and advised sagely.

Permissions to quote from copyright material have been generously given by Bodleian Libraries, University of Oxford; Bourlet; British Library Board; Cadbury Research Library, University of Birmingham; Lilly Library, University of Indiana; National Art Library, Victoria and Albert Museum; National Gallery Archives, London; National Library of Scotland; RIBA Drawings & Archive Collection, British Architectural Library; Royal Institution of Great Britain; Wilson Library, University of North Carolina at Chapel Hill. If I have inadvertently quoted copyright material without proper acknowledgement, I apologise and invite copyright holders to contact me. I would like to thank the John R. Murray Charitable Trust for a generous grant towards illustration costs. At Atlantic Books Ben Dupré, Toby Mundy and James Nightingale have been sources of strength and confidence. I thank them all.

ILLUSTRATIONS

First section

Interior of the British Institution, 52 Pall Mall (hand-coloured etching and aquatint, published by Rudolf Ackermann, 1808) by A. C. Pugin, after Thomas Rowlandson. (*British Library / Robana via Getty Images*)

Interior of the National Gallery, when it was at 100 Pall Mall (watercolour, 1834) by Frederick Mackenzie. (© *Victoria and Albert Museum, London*)

The Festival of the Opening of the Vintage of Macon (oil on canvas, 1803) by J. M. W. Turner (*Sheffield Galleries and Museums Trust, UK / Photo © Museums Sheffield / The Bridgeman Art Library*)

Noli me Tangere (oil on canvas, c.1514) by Titian. (© The *National Gallery, London 2014*)

Waiting for the Times (oil on canvas, 1831) by Benjamin Robert Haydon. (*Private Collection / The Bridgeman Art Library*)

William Brande and Michael Faraday precipitating Prussian Blue (oil on panel, 1827), attributed to George Reinagle. (*Reproduced by permission of the Museum of the History of Science, University of Oxford, ref. 56477*)

Thomas Coutts (marble, 1827) by Sir Francis Chantrey, Coutts Bank, London. (*Photo: James Hamilton*)

The Chantrey Wall at the Ashmolean Museum, Oxford. (*Photo: James Hamilton*)

James Watt's workshop at Handsworth, Birmingham, as he left it at his death in 1819 by Jonathan Pratt (1889). (*Getty Images*)

Whalers (Boiling Blubber) Entangled in Flaw Ice, Endeavouring to Extricate Themselves (oil on canvas, 1845) by J. M. W. Turner. (© *Tate, London 2014*)

Isabella (oil on canvas, 1848–49) by John Everett Millais. (*Courtesy National Museums Liverpool*)

The Random Shot (oil on canvas, 1848) by Edwin Landseer. (© *Bury Art Museum, Greater Manchester, UK*)

The Random Shot (engraving, 1851) by Charles Lewis, after Edwin Landseer. (© *The Trustees of the British Museum. All rights reserved*)

Ackermann's premises, The Repository of Arts, in the Strand, London (hand-coloured etching with aquatint, published by Rudolf Ackermann, 1809) by A. C. Pugin. (*British Library / Robana via Getty Images*)

Interior of Benjamin Godfrey Windus' library and gallery at Tottenham (watercolour, 1835) by John Scarlett Davis. (© *The Trustees of the British Museum. All rights reserved*)

*Titianus redivivus [*Titian reborn*]; -or- the seven-wise-men consulting the new Venetian oracle, - a Scene in ye Academic Grove. No 1.* (engraving, 1797) by James Gillray. (© *The Trustees of the British Museum. All rights reserved*)

Exhibition Stare-Case (watercolour, *c.*1811) by Thomas Rowlandson. (© *The Trustees of the British Museum. All rights reserved*)

Second section

The Louvre, or the National Gallery of France. No. 100, Pall Mall, or the National Gallery of England (lithograph, *c.*1832), published by Joseph Hogarth. (© *The Trustees of the British Museum. All rights reserved*)

Ruins of Fonthill Abbey (lithograph, 1826) by William Westall, after John Buckler. (© *The Trustees of the British Museum. All rights reserved*)

Pages from Turner's 'Academy Auditing' sketchbook, *c.*1824 (© *Tate, London 2014*)

Entrance to the Adelphi Wharf (lithograph, 1821) by Théodore Géricault, printed by Charles Hullmandel. (© *Ashmolean Museum / Mary Evans*)

Paintings being delivered for selection to the Royal Academy, Trafalgar Square (wood engraving) from the *Illustrated London News*, 1866 (*Time & Life Pictures / Getty Images*)

Mr Fuseli's Painting Room at Somerset House (watercolour, c.1825) by an unknown artist (© *Victoria and Albert Museum, London*)

Portrait of J. M. W. Turner (stipple engraving, published in 1852) by Charles Turner. (© *Tate, London 2014*)

The Artist's Studio (sepia drawing, c.1808) by J. M. W. Turner. (© *Tate, London 2014*)

Richard Cosway RA (soft ground engraving, published 1811) by William Daniell, after George Dance. (*Yale Center for British Art, Paul Mellon Collection*)

'*Caleb curious – the Witty Wine Merchant': portrait of Caleb Whitefoord* (hand-coloured etching, 1792) by Isaac Cruikshank. (© *The Trustees of the British Museum. All rights reserved*)

Self Portrait (oil on paper, 1823) by William Etty. (*Yale Center for British Art, Friends of British Art Fund, and Paul Mellon Fund*)

Study of a Standing Nude (oil, 1820s/30s) by William Etty. (*Private Collection / Photo © The Maas Gallery, London / The Bridgeman Art Library*)

John Boydell, Engraver (engraving, 1772) by Valentine Green, after Josiah Boydell. (*Yale Center for British Art, Paul Mellon Collection*)

Rudolf Ackermann (oil on canvas, 1810–14), attributed to Francois Nicholas Mouchet. (© *National Portrait Gallery, London*)

William Seguier (oil on card, c.1805), attributed to John Jackson. (© *National Portrait Gallery, London*)

Sebastian Grandi (oil on panel, 1806) by John Opie. (© *Ashmolean Museum, University of Oxford*)

Sir John Julius Angerstein (mezzotint, c.1815), after Sir Thomas Lawrence. (*Getty Images*)

'*Maecenas, in pursuit of the Fine Arts: scene, Pall Mall; - a Frosty Morning': Thomas Leveson-Gower, 2nd Marquess of Stafford and 1st Duke of Sutherland* (hand-coloured etching, 1808) by James Gillray. (© *The Trustees of the British Museum. All rights reserved*)

Study for 'Patrons and Lovers of Art' (oil on canvas, 1826–1830) by Pieter
 Christoffel Wonder. (© *National Portrait Gallery, London*)
Joseph Gillott (engraving). (*Getty Images*)
Captain Francis Fowke (gilt bronze bust, 1866) by Thomas Woolner.
 (© *Victoria and Albert Museum, London*)
Steel-framed picture galleries in the South Kensington Museum, 1857.
 (*SSPL via Getty Images*)

INTRODUCTION:
A SHARP AND SHINING POINT

Standing on a table, the better to be seen by his audience, a burly man raises a sledge-hammer above his head and slams it down onto an anvil. Thomas Boys, the print dealer of Oxford Street, London, retiring in 1855 after forty-five years in the trade, had hired an executioner as party entertainment in his glittering gas-lit gallery to smash to pieces a dozen or more engraved printing plates of popular images by popular artists. Like magpies shot by a farmer, the shattered metal pieces were then nailed up for all to see. The object of the exercise, ran its *Times* advertisement, was to destroy the plates utterly, 'to give a sterling and lasting value to the existing copies, which by this means can never become common'. Thus proceeded an event in which art and business, reputation and value, came together in an attempt to keep these four boisterous creatures together and in trim. On the anvil, past practices in the business of art were shattered into pieces, and new systems wrought. This was a consequence of art's industrial revolution; it had left the quiet of the studio far behind and entered the furious market. It showed that art had a redoubled economic purpose, a sharply focused aggression, and was a significant factor in national and international trade.

This book explores how art in the nineteenth century was made and paid for, and how it evolved in the face of fluctuating money supply, the turns of fashion, and the new demands of a growing middle class, prominent among whom were the artists themselves. An endless subject such as this remains synoptic and laced with story and metaphor: it looks at networks, friendships and enmities, at debts, disasters and loyalties; and dances across a complex landscape in which art, literature, invention and

entrepreneurship are the hedges and ditches, villages and townships that separate and maintain a shifting population. Complex social and institutional structures evolved across the nation, embracing art and music, drama and science. New clubs and academies, societies and institutions articulated the lives and motivations of the ingenious, ambitious and quarrelsome people who inhabited them. Together, they created a potent mixture to hurry the rapid growth of culture in Britain.

The violent and noisy performance in the Oxford Street gallery, as theatrical as some of the images it destroyed, was heavily criticized in the press and justified at considerable length by Thomas Boys. It demonstrates the sophistication of the relationship between art and business in the mid-nineteenth century, and reflects a complex evolution, with explosive bursts of invention and activity that confuse the rational and rattle society. One series of explosions, centred in Britain in the nineteenth century, stimulated social, technological and political change which continues to influence and direct us today. Its reactants were human genius, money and influence, its crucibles the streets and institutions, its catalyst time, its control the market.

It is in details such as the Boys Destruction that we can see local rules at work. Consumed by curiosity, some art collectors gather to watch engraved plates being smashed. Elsewhere in the landscape of art, down in its undergrowth, a scientist and a printer meet to experiment with wax crayon, ink and a slab of limestone to forward the printmaking art of lithography; an engineer invents a machine that will copy a piece of sculpture; a new yellow pigment is precipitated by chemistry over a brazier of coal; a sculptor cuts inscriptions on tomb-slabs at the price of 100 letters to the pound; a passionate horticulturalist builds a great art collection with the help of gold bullion dug up on the Isle of Wight; and a Chancellor of the Exchequer argues passionately and publicly for a new home for the Royal Academy 'commensurate with the wealth and grandeur of the metropolis of this great and free country'. Activities of this kind, unremarkable individually, gather together to change the way we see, and intrude on understanding. A thought begets a risk, becomes an experiment, grows into an obsession, sparks an accident, begins a chain reaction, inspires a thought elsewhere,

many miles away. 'How splendid is the glow of that sunset', a newly rich manufacturer exclaims in an art gallery, 'I have never seen a sunset like that.' 'No, but don't you wish you had?' responds the artist, standing by. This exchange reflects the use of new pigments, discovered by accident, purified with water, dried, ground to powder, mixed with oil medium, squeezed into a tube, and bought by an artist.

Cultural events were both a cause for, and a product of, celebration. Where Boys celebrated a commercial advancement by having his engravers' plates smashed in public, an engraver of an earlier generation, William Woollett, celebrated the publication of a new engraving long laboured over by firing a cannon from his roof. So great was the joy in his house that he would line up his family outside his studio, and wife, children and servants all gave three cheers. The sheer relief at all the time, energy and financial danger, during which a family's welfare might hang by a thread, was overwhelming. Reproduction of images, whether those by old masters or living artists, topographers or travellers, had become big business, and as much a cause for advertisement and celebration as the launch of a new film or television series is today.

The multiplication of art had a wider, civic purpose, as John Pye, another leading engraver, made clear as early as 1845 in a voice that echoes down to our own time:

> [E]ngravings, and casts of statuary, cherished by the mass of the people, have been spreading the genius of great masters abroad. Their conceptions are no longer pent up in galleries, open to but a few; they meet us in our homes and are the household pleasures of millions. Works designed for emperors, popes and nobles, find their way, in no poor representations, into humble dwellings, and sometimes give a consciousness of kindred powers to the child of poverty.

While the leading figures of the world of art and literature are players here, so too are patrons, financiers, collectors and industrialists; lawyers, publishers, entrepreneurs and journalists; artists' suppliers, engravers, photographers and curators; hostesses, shopkeepers and brothel-keepers; quacks, charlatans and auctioneers. There is something magical about

these people, these living mysteries: Caleb Whitefoord, the respected chairman of a Committee of Polite Arts, who kept a bedroom full of erotica; Maria Callcott, pioneer traveller in India, Italy, Chile and Brazil, who survived earthquakes, revolution and bandits, wrote delicious histories, but became a sad old gossip, racked by tuberculosis, confined to her couch in Kensington; David Uwins, a pioneer homeopath who gave his services free to artists and their families; and J. M. W. Turner, well known to all his contemporaries, the ringmaster of magic, sensual, grumpy and human, who rode his imagination through the deserts and forests of early nineteenth-century understanding, and left it drenched in colour, sparkling with unexplained consequences. His paintings are isles of wonder; his sketchbooks a clutter of rudimentary and not wholly coherent maps; his art 'a strange business'.

Since the thirteenth century Britain had evolved freedoms, unique to itself. The eighteenth-century economist Adam Smith in *The Wealth of Nations* (1776) articulated the general effect on a nation of economic freedom at a local level:

> It is the highest impertinence and presumption . . . in kings and ministers, to pretend to watch over the economy of private people, and to restrain their expense . . . They are themselves always, and without any exception, the greatest spendthrifts in the Society. Let them look well after their own expense, and they may safely trust private people with theirs. If their own extravagance does not ruin the state, that of their subjects never will.

Adam Smith's careful, even pedantic, analysis of ways of spending lays out in the eighteenth century the conditions required for the business of art to flourish in the nineteenth, and to echo with justification and warning down into the twenty-first. Capitalism, as developed by Smith's 'private people', must have a sharp and shining point. A thriving art market, an essential component of a capitalist economy, provides just that.

1

CONDITIONS OF SUCCESS

The annual exhibition of the Royal Academy was in the early nineteenth century a barometer of activity in painting, sculpture and architecture in Britain. Two hundred years later, while there have been lapses and shifts in emphasis, it probably remains so. The Academy was also, with its near-neighbour and sometime rival the British Institution, a barometer of artistic talent and politicking, an art school, a cathedral of the nation's established church of art, and the place where the shared interests of artists and collectors could join together in mutual support and parade. Fine ideals; but behind the walls of paintings, beyond the plinthed busts and the modelled figure groups, social and economic competition involving patrons, artists and the priestly organizing councils of the Academy and the Institution was driven by the hydraulic forces of cash flow and money in the bank. This was expressed in a multitude of ways: the desire of a young family to lighten a parlour with a painting; the desire for a sculpture in a grand garden; or the attraction for many of a good print. As Jane Austen observed in *Persuasion*:

> He was standing by himself, at a printshop widow . . . in earnest contemplation of some print . . . 'Here I am, you see, staring at a picture. I can never get by this shop without stopping.'

The most powerful driver of contemplation and purchase was, however, the sheer necessity of decorating large walls in large houses with evidence of the owner's wealth, taste and intelligence. In this chapter we will try to touch the intangible: what it was, apart from talent, that artists required to succeed in their chosen business.

London lay in the centre of a pan-European web of art businesses: art dealers working with agents abroad and with ship-owners brought works of art, 'old masters' and antiquities, to London for sale. Artists brought their work from studios and back rooms for exhibition and sale. Auctioneers recycled paintings and sculpture from dispersed collections at home and abroad to be split up and sold to the highest bidder: prices rose for the work of one artist, prices fell for the work of another. Sculptors produced portrait busts, reliefs, memorials, mythological or other figure groups from studios that, for the more successful, were in effect sculpture factories. Engravers working in as good light as they could find in smoky London and elsewhere engraved on dully shining copper plate images that reproduced works of art, evoked landscape, or illustrated books and journals. These sold and spread worldwide. Auctioneers – principally James Christie, father and son, from their rooms in Pall Mall – sold paintings by the greatest artists of the previous three hundred years, along with countless copies, fakes and failures. The art trade came to London because everything else did, and because that was where the money was made, held, spent and enjoyed.

The old master trade was fast and fickle. For living artists, pressures were of a different kind. When Turner exhibited his early masterpiece *Festival upon the Opening of the Vintage of Macon* at the Academy in 1803, he asked 300 guineas for it – the equivalent of about £20,000 today. This was the same sum that in 1801 the 77-year-old George Stubbs, venerable painter of horses, had earned for his heroic horse portrait *Hambletonian, Rubbing Down* – and he had to go to court to squeeze the money out of an inconstant young patron, Sir Henry Vane-Tempest. As a comparison, this was about the same sum as the £330 that the collector and amateur dealer Arthur Champernowne of Dartington Hall, Devon, paid in 1802 for Titian's small masterpiece *Noli Me Tangere*. At the end of his career in the 1790s the first president of the Royal Academy, Sir Joshua Reynolds, grand and respected, charged 200 guineas for a full-length portrait; Reynolds's successor as president of the Academy, Benjamin West, on the other hand, had a contract running with George III that brought him 1,000 guineas a year. Gainsborough asked £1,000 for a Shakespearean subject, but that was probably because he did not want to do it (see page 151). Pricing therefore

was variable and inconsistent, but always some indicator of perceived worth at the time of transaction.

Turner, young, impetuous and bloody-minded, was well known around the Academy. He had been a diligent and attentive student in the Academy's Schools; he had exhibited there since 1790 when he was fifteen years old; and he had peppered the Academy's walls with new paintings ever since. Nevertheless, 300 guineas, near enough the price of a small Titian and a large Stubbs, is still an extraordinary sum to demand for a painting on the artist's first appearance as a Royal Academician. Being made an Academician meant being fully accepted as an equal, or at least as a rival, by a majority of the established painters, sculptors and architects of the day, so it is already clear that self-doubt was not one of Turner's problems. While *Opening of the Vintage of Macon* is a large painting, nearly 8 feet long, a third smaller than *Hambletonian*, the price demanded indicates that Turner was making a calculated move to benchmark his prices in the light of his own assessment of his worth.

Sir John Leicester, a landed baronet whose income came from the produce of farms and salt mines in Cheshire, and who had a penchant for buying British art, offered 250 guineas for the *Macon*. Turner refused the offer and held the painting back. The following year Leicester returned to the subject and offered the asking price, but Turner now demanded 400 guineas. He was trying aggressively to keep the painting out of Leicester's hands, and one or other of them broke off the deal. Senior Academician John Opie took Turner's side here: Joseph Farington reported that 'he did not see why Turner should not ask such prices as no other persons could paint such pictures'. That was not the end of the story, as another aristocrat, Lord Yarborough, who owned large swathes of both Lincolnshire and the Isle of Wight, moved in and bought the painting for the original asking price of 300 guineas. Within two years, Leicester had got over that loss by acquiring Turner's *Shipwreck* for 300 guineas.

This exchange raises many questions, principal among them being why was Turner playing such a dangerous game with rich and influential men who might believe they could destroy him with a glance? He was a Covent Garden barber's son – his father trimmed their wigs; they owned and

managed the lands that created the wealth that fed and fuelled the nation. Playing one off against the other was not the best way for a young artist to win friends, and clearly young Turner was not keeping to his place. On the other hand, Yarborough had helped to finance Turner's 1802 trip to Paris and the Alps, and may have expected preferential treatment when the products were displayed. Nevertheless, even he was not offered a reduction in the price. Turner's behaviour in respect of two powerful men bidding for his favour is a sure sign of artists' growing awareness of their economic power.

The nation was gearing up to face the first, grand, visual results of industrialization. Shouldering its way onto the skyline of London, the huge Albion Flour Mill with its steam-driven mill-wheels dominated the southern end of Blackfriars Bridge. Even after it was burnt out in 1791, probably by arson, its heavy form and black windows glowered across the river until its façade was cleaned up and used to front a line of private houses. The steam-engines of Matthew Boulton and James Watt that had powered the flour mill brought forests of chimney stacks to towns and cities, but also brought the benefit of decoration, colour and new manufacture to the nation, including bright coins, fine pottery, colourful cotton cloth. The ubiquitous churning steam-engine could by now be seen, heard and smelt in towns and villages around the country: it pumped water, winnowed crops, spun cotton and drove trip-hammers that shaped red-hot metal to make anything from steel girders to soldiers' belt buckles. The noise of the steam-engine in its evolving state echoed behind the wealthy men now coming to town with rough accents in their speech and the trace of oil on their hands.

Even as late as 1836 the engineer Isambard Kingdom Brunel was considered an exotic creature as he mingled in the drawing rooms of Kensington with the Callcott and Horsley families. Augustus and Maria Callcott, and Augustus's brother John Callcott and his wife Elizabeth, were painters, writers and musicians, earning their living through the practice of their arts. John and Elizabeth's daughter, another Elizabeth, married the composer William Horsley; of their children, John Callcott Horsley became a successful Royal Academician, Charles Horsley became a composer, and

Mary Horsley, elegant and aloof, was productively wooed by Brunel. Their Kensington home, near the Gravel Pits, was a social hothouse; their family a dynasty. Piano music floated through the fern pots; conversation might turn equally to pigments or Paganini. Brunel's friend and colleague William Gravatt found himself to be even more out of place than Isambard in these rooms: 'wild beast', the Horsleys called him, as he nervously spilled snuff on the carpet. When Brunels and Gravatts met Horsleys and Callcotts the steam hissed as two new unpredictable forces, with talent, ambition and wealth-generating power, collided. The artist's creative energy and the engineer's scalding steam had first to be defined, then harnessed, and only then, if necessary, understood. The Brunel–Horsley collision, and a generation earlier Turner's calculating action towards his patrons, are reflections of the long-drawn-out change from the eighteenth-century art of picturesque response to landscape and its ownership, to the nineteenth-century romantic engagement with personality, emotion and mass production. Curiously, it was the engineer Brunel who, through his love of clarity in art and of control in process, came in the 1840s to attempt to draw together the production of art through the profits of transport.

In 1791, when Turner was exhibiting at the Royal Academy for only the second time and showing two watercolours, 295 artists sent 672 works to the annual exhibition. Ten years later, the size of the exhibition had increased by about a quarter, with 404 artists sending in 1,037 works. Fifty more years on, in 1851, the year of Turner's death, the number of artists had doubled to over 800, while the number of works shows only a modest increase, restricted both by the dimensions of the Academy's new premises in Trafalgar Square and by the expanding scale of the paintings that some Academicians chose to exhibit. In 1847, for example, William Etty showed his monumental triptych *Joan of Arc*, 10 feet high by nearly 30 feet wide, 'set up at the top of the Great Room'.

Snowballing figures not only reflect the growth in the number of people competent enough to submit their paintings to the judgement of leading artists and the public, but are a consequence of many other interrelated changes. They reflect that these artists – along with their canvas, brush and paint suppliers; and the trades that clothed and shod them; and the gangs

that built the turnpikes; and the carriage-owners who transported them around the country to encounter new subjects; and the men and women who considered, even if only momentarily, that they might buy their works – were part of the revolutionary social movement that brought a fresh breath of activity, income, and the dim illusion of leisure to a growing proportion of the British population.

In the first two or three decades of the nineteenth century, the disposable income of Britain's wealthiest came from the digging out and sale of minerals, coal, iron, salt and clay from their land; from improvements in canals, roads, building construction, road transport, shipping and agricultural practices; and from a speeding-up of the circulation of knowledge, principally in printing and publishing. It had come also from the profits of slavery, both in the transport of slaves from West Africa and in the products of their labour, sugar and cotton in the West Indies. Coming back to his former home after thirty years in the country, the weaver Silas Marner, the eponymous protagonist in George Eliot's novel, seeks Lantern Yard, in the town where he grew up:

> 'Here it is . . . It's gone, child . . . Lantern Yard's gone. It must ha' been here . . . but they've made this new opening; and see that big factory! It's all gone – chapel and all.'

George Eliot transports us in her story from the opening years of the century to the 1830s, from the 'bent, tread-mill attitude of the weaver', to factory men and women 'streaming for their mid-day meal'.

Britain was now noisier, fuller, changed by the appliance of science and technology to invention and engineering. There was now brewing and clothing manufacture; banking, investment and insurance; international export in everything from egg cups to steam-engines; and import of sugar and cotton from the west and tea and spices from the east. This was where the money was made. Money was also lost in great quantities, or failed to materialize through dismal investment, lost harvest and bankruptcy, with the result, way down the line, that work would dry up. This happened to the talented and well-known engraver Valentine Green in the early 1800s. Entrepreneurial acts would fail through miscalculation and

over-enthusiasm, as in the case of the printmaker W. H. Pyne in 1815, who lost thousands of pounds on an undercapitalized printing project (see page 162). Large firms would go bust with catastrophic fallout, as in the case of the publishers Hurst and Robinson in the financial crash of 1826. Round and again, artists would not be paid, as the sculptor E. H. Baily experienced many times in the 1830s. Result: misery. To seek the sources of patronage that flowed out towards culture in Britain, it is most profitable to see where the money accumulated.

William Beckford was an exception to all rules: thus he is a good place to start. The only legitimate son of a sugar plantation owner and politician – he had six illegitimate half-brothers; his father was Lord Mayor of London – at the age of ten he inherited a million-pound fortune, 5,000 acres in Wiltshire and a string of Jamaican estates. The influential diarist and Royal Academician Joseph Farington reported in 1796 that Beckford's income was '£70,000 [per year], all of which he expends, and sometimes overdraws his agent'. The following year Farington recorded Beckford's income as £155,000, much of which he spent on building and furnishing his Gothic palace, Fonthill Abbey in Wiltshire. Daniel Defoe, the author of *Robinson Crusoe*, had analysed the economic classes in Britain in the early eighteenth century. He defined three upper classes: the great, who live profusely; the rich, who live very plentifully; and the middle sort, who live well. Beckford was most assuredly one of Defoe's 'great'. Others in that category included the landowner George Granville Leveson-Gower, Second Marquess of Stafford and First Duke of Sutherland; the collector Thomas Hope, whose inherited wealth came from his family's merchant bank in Amsterdam and London; the mysterious Russian-born insurance broker Sir John Julius Angerstein; the owner of Cheshire landscape and its salt mines, Sir John Leicester, Bart; Charles Anderson-Pelham, First Earl of Yarborough, Lincolnshire landowner and art patron; and Samuel Rogers, the banker and poet whose long life crossed many. Some of these, perhaps Leicester and Rogers, believing themselves to have been among the great, may only have been rich. It's complicated.

Many dozens, hundreds, of such families, more or less inventive and entrepreneurial, more or less wealthy, had long evolved within the

shires of Britain, social and economic steam-engines many of them, each holding sway over local areas, each rolling influence and connection as far as it might reasonably reach. Debrett's *New Peerage* and Burke's *Peerage, Baronetage and Knightage*, first published in 1769 and 1826 respectively, reflect the depth and endurance of landed families. That both publications are still going into their fourth and third century indicates yet further the depth and endurance of their featured subjects.

Leveson-Gower had inherited the entire fortune of his uncle, the coal owner and canal entrepreneur Francis Egerton, Third Duke of Bridgewater. This comprised the income of the Bridgewater Canal and estates – around £30,000 a year (roughly £1.5 million today). He went further and married Elizabeth, Duchess of Sutherland, who herself owned over a million acres of Scotland. As if that were not enough, from his father, the First Marquess of Stafford, Leveson-Gower inherited estates in Staffordshire, Shropshire and Yorkshire. All these marriages and connections demonstrate why he had so much of the British Isles – Bridgewater, Sutherland, Stafford – tacked onto his names. 'Abominably rich', he was described; and 'a leviathan of wealth'. George Leveson-Gower, the First Duke of Sutherland as he became, was the greatest landowner in the country, with a gross annual income of £200,000 (£10 million). His living standard, as Farington observed, 'exceeded everything in this country. No-one could vie with it.' The sculptor Francis Chantrey dreamed of carving a colossal figure of the duke on a rocky outcrop on Sutherland's Staffordshire estate, but while the duke could reasonably have paid for it, the prospect defied even Chantrey's great spirit.

These men and their families had their grand houses in London and even grander palaces in the country. Some, such as Leveson-Gower, Leicester and Yarborough, entered Parliament or the House of Lords; others, such as John Byng, Fifth Viscount Torrington of Southill, Bedfordshire, spent their money unwisely and clung to their wreckage or fled it. Yet others developed an area of study and made it their own: Samuel Rogers was a distinguished poet; Sir John Leicester made himself an authority on birds and fish, as well as becoming 'the greatest patron of our national schools of painting that our island ever possessed', according to an obituary in the

Gentleman's Magazine. He bought paintings with an eye for quality, and in 1823 he offered unsuccessfully to sell his collection to the nation.

Thomas Hope also lived for art. He had no need to earn his living, but instead travelled widely in Europe meeting artists and collecting their work. Hope's dominant interest was in spotting artists whose stars were rising: the sculptors John Flaxman, Francis Chantrey and Bertel Thorwaldsen; the painters John Martin, Benjamin Robert Haydon and Thomas Daniell. Chantrey, then a young man fresh from Sheffield, carved decoration on Hope's furniture. Hope bought a London house in Duchess Street, designed by Robert Adam, and there, in rooms of exquisite taste and gas-lit grandeur, he displayed his collections to friends and other guests who had acquired tickets for the purpose. Leveson-Gower had been, in 1806, the first aristocratic collector to open the purpose-built gallery in his house to the public, but with mixed results. He was assailed by 'the ignorance, vulgarity and something worse' in some sections of his visitors; and 'frivolity, affectation and insolence' in others. The pleasure, availability and experience of art, though owned by others, was among the excitements and comparative freedoms of being in London.

By the opening years of the nineteenth century, art and literature that would come to be called 'Romantic' was beginning to develop a market in London and the main provincial towns of Britain. The hours that Samuel Taylor Coleridge invested sitting in his lime-tree bower, or William Wordsworth spent walking the fells of Cumberland to find inspiration for *Lyrical Ballads*, sooner or later began to be relived in the metropolis. The pace and determination of Wordsworth's steps, as evoked in his published poems, added directly to the pace of visitors' steps along to the Royal Academy exhibitions where new paintings by Turner, Martin and Wilkie were on show, alongside portrait busts by Nollekens, Flaxman and Chantrey. Coleridge's reflections on nature, 'her largeness and her overflow', led also to his readers making their way to the Royal Institution lecture theatre. There they heard Humphry Davy and later Michael Faraday expounding and explaining scientific principles. While *Lyrical Ballads* sold in only modest quantities, its first publication in 1798 was in itself the prelude to the developing hum of contented browsing by customers among the

thousands of volumes in John Hatchard's bookshop in Piccadilly, and the Lackingtons' Temple of the Muses bookshop in Finsbury Square.

How was it that the intense and personal thoughts of a pair of English poets, or Turner's response to the landscapes he travelled through, or the young Faraday's back-room experiments with electrical batteries came only ten or fifteen years later, while these men were of an age to appreciate the fruition of their work, to result in bookshop purchases and a lively market in paintings and engravings for domestic decoration? What were the conditions of success for an artist, scientist or poet in the nineteenth century?

Turner's father kept a busy barber's shop in Maiden Lane, 200 yards from the Covent Garden piazza. His clientele included lawyers and theatrical people from Drury Lane, merchants from Long Acre, artists and musicians from the surrounding streets, and yet more artists, scientists and antiquaries from Somerset House nearby. There was no real shortage of money in the Turner family. Counting up from James Boswell, who paid around £6 per year to have his hair dressed every day, and Charlotte Burney who reported that ninepence (9d) for a hairdressing was '3d too dear', and further still the London woollen draper William Mawhood who recorded 'hair combed; cost 6d' in 1778, and multiplying those up by a figure that suggests an average of about twenty customers a day, the elder William Turner might have earned £300 a year. This represents perhaps £20,000 in the early twenty-first century. Turner the barber was not a poor man, and he had the foresight and vicarious ambition to display his son's early watercolours in his shop with a three-shilling price tag. This was perhaps six times the price of a good haircut, and about right. Nevertheless, only ten years later Turner would be demanding for one painting what his father might have earned from cutting hair in a year.

The first condition of success for the young Turner, given energy, purpose and ability, was continual support from a busy father who had high ambitions for him. A further condition was the capture of luck and good fortune and the contacts these might bring. An early patron, when Turner was twenty-four, was the broker Sir John Julius Angerstein, who paid 40 guineas (£2,000) for a watercolour of Caernarvon Castle, perhaps

twice the asking price, when it was exhibited in 1799 at the Royal Academy. Why Angerstein was so inordinately generous we do not know, but it is an indication of the beguiling chemistry that the young Turner had about him that he could begin to entice such prices.

For Michael Faraday, conditions of success comprised a father substitute, the radically inclined bookbinder George Riebau of Marylebone, whose shop hummed with the intellectual élite of the day. Faraday was one of Riebau's many apprentices, and, through craft and diligence, he showed that he might have become a great bookbinder. But Riebau noticed other talents which distracted Faraday from binding books, and so gave him the time to pursue them by allowing him to visit steam-engines on the banks of the Thames and exhibitions at the Royal Academy and the British Institution. He also gave him the opportunity and perhaps some of the materials to build electrical machines in a room behind the bindery. Circumstances in Faraday's young life developed to the extent that one or two of Riebau's customers, particularly the painters John James Masquerier and Richard Cosway and the architect George Dance the Younger, took special notice of the apprentice; Cosway and Dance may also have invited him to their homes to see their art collections. Memory of the kindness of each one of these men stayed with Faraday, and nearly ten years later he wrote appreciatively that 'Mr Dance's kindness claims my gratitude, and I trust that my thanks, the only mark I can give, will be accepted.' A further assistance Dance gave to Faraday was to give him tickets to attend Humphry Davy's lectures at the Royal Institution in 1812. This led to the further development of Faraday's profound interest in the discoveries and teaching of science, his first meeting with Humphry Davy, and all that followed. Bookbinding's loss was science's gain.

Samuel Taylor Coleridge was the last of ten children of an uxorious elderly Devon clergyman and his middle-aged, put-upon wife. There were many children but not much money in those rural valleys, but nevertheless, as Coleridge expressed it in a proto-Oscar Wildean remark, 'my father was very fond of me, and I was my mother's darling – in consequence I was very miserable.' The sudden death of his father when the boy was nine changed Coleridge's life instantly. Within a year he had been parcelled off

to London to live with an uncle, a tobacconist in the City, with whom he dived into clubs and coffee-houses to pick up the ebb and flow of idle gossip and high-minded conversation. 'My Uncle was very proud of me, and used to carry me from Coffee-house to Coffee-house, and Tavern to Tavern, where I drank, and talked, and disputed, as if I had been a man ... I was most completely spoilt and pampered, both mind and body.' Coleridge's education continued at Christ's Hospital and Jesus College, Cambridge, followed briefly by the army, preaching, dreams of America, marriage, fatherhood and mounting debt. Energetic and provocative editorship of the periodical *The Watchman* gained Coleridge enemies as well as friends, some of whom contributed generously to his modest and unreliable income, as did a royalty in 1796 of 30 guineas for his first volume of poems with the unpromising title *Poems on Various Subjects*. Coleridge lived on the edge.

Coleridge and Wordsworth met in Bristol in 1795. The former was already a literary lion, well known, acclaimed, forthright, but not really to be trusted with money. Wordsworth, on the other hand, tall, lithe and weathered, had invested his youth and early manhood in walking many hundreds of miles in the Lake District, Wales and Somerset, and down into Burgundy and the Alps. While less worldly than Coleridge, Wordsworth had seen more of the world by walking through it. Like Coleridge, however, he had hardly a penny to his name. To publish *Lyrical Ballads*, the pair had to raise 30 guineas to pay the costs of Joseph Cottle, their publisher and friend. Reputation mattered, and Coleridge insisted on the two authors remaining anonymous: 'Wordsworth's name is nothing – to a large number of persons mine *stinks*.' By this time Coleridge was twenty-six, a surprisingly young age to have garnered a 'stinking' reputation, while Wordsworth was a more measured twenty-eight. Within two years, Cottle's edition had sold out, and the authors' copyright was bought for £80 by Thomas Longman. This was a modest but notable success.

Four young men – an artist, a scientist and two poets – started out in life with nothing to declare but their geniuses. Two had fathers or father substitutes behind them for early support, while the other two were cut adrift from family support in their early years. All were fuelled by internal

energy and varying strengths of mind and self-belief. While two of them, Turner and Faraday, may have had institutional hopes or ambitions, there was sparse institutional support to go round. Turner won a silver medal (but no prize money) from the Society of Arts in 1793. Faraday found employment from 1813 at the Royal Institution; for the rest of his life he received a modest salary, first as a general assistant, rising over the years to become director of the Royal Institution. Coleridge never received a salary, and with a wife and lover, children, and an inordinate desire to travel, lived on subventions from friends, publishers and patrons. Wordsworth likewise lived precariously on his writing, until 1813 when he was saved from imminent financial ruin by being given the £400-a-year appointment as distributor of postage stamps for Westmorland and Penrith. This post was found for him after a word from Samuel Rogers (one of the rich, who lived very plentifully) was dropped softly into the ear of the local patron, the Earl of Lonsdale (one of the great, who lived profusely). Being a poet in the mid-nineteenth century was no guarantee of making a living, but knowing the right people would certainly help.

The origins of Turner's early benefactor Sir John Julius Angerstein, who by 1800 had over forty years' experience in marine insurance, are mysterious and romantic. He came from Russia as a fifteen-year-old, bearing the surname of the doctor who had delivered him of his supposed mother, Anna, Empress of Russia. His father was said to be Andrew Poulett Thompson, a Russia merchant from London, whose company traded with St Petersburg and who evidently had close links with the Russian court. Whoever he was, and wherever he came from, Angerstein made large sums of money as an independent underwriter, as a modernizing member of Lloyd's, and as a deviser and founder of the national lottery of his day. Making his money in the City, he spent it in the West End, collecting old master paintings and entertaining friends from the literary and theatrical worlds at his home, 100 Pall Mall, in the heart of fashionable moneyed London. When he was in his late eighties, Angerstein narrowly avoided an ill-advised marriage, and a sudden net outrush of funds. As Joseph Farington reported it, Angerstein

(now 86 or 7) complained of want of domestic society & thought Mr
Coutts had judged well in securing this to himself by marrying the
actress, Miss Meilan [i.e. Harriet Mellon]. Sir John Colpoys, Gover[nor]
of Greenwich Hospital, had conversations with Mr A disswading him
from it. It has, however, broken off in consequence of the Lady requiring
a Carriage for herself & a separate bed.

Angerstein's greatest contribution to the development of culture was his
imposing art collection. This, along with his house, was bought by the
government after his death, and came to form the nucleus of the National
Gallery. Angerstein owned paintings by Raphael and Titian, Rubens and
Van Dyck, Rembrandt, Claude and Poussin – masterpieces that were and
remain the backbone of the national collection. He had paid 1,600 guineas
in 1803 for Rubens's *Rape of the Sabine Women*, and 5,000 guineas after a
London auction sale in 1807 for Rembrandt's *Woman Taken in Adultery*.
These were enormous sums, but money Angerstein could well afford. It
puts into context the 40 guineas that he pressed on the young Turner for
his watercolour *Caernarvon Castle*.

For Faraday, assistance came not in cash but in contacts. One of his
early contacts, Richard Cosway, was a Devon schoolmaster's son, a com-
parably modest background to Coleridge's, though he was a generation
older. Sent to London from the far west with only his trunk and his talent
to accompany him, Cosway, aged twelve or thirteen, had been attached
in 1754 to the drawing master William Shipley. Whether by chance or
intention, this was a fortunate choice, as Shipley was the founder and
driving force behind the new Society of Arts – full name: Society for the
Encouragement of Arts, Manufactures and Commerce, which was resident
then, and is resident still, in John Adam Street, parallel to the Strand.
When the talented Mr Shipley and the young genius Master Cosway came
together, they were both at the start of great projects – Shipley his Society,
and Cosway his career. Within weeks, the former had presented the latter
with the £5 first prize for drawing in the under-fourteens category, and
Cosway never looked back.

With a talent to amuse and entice as potent as Turner's ability to charm
money out of clients, Cosway developed a portfolio of willing sitters,

enraptured by the delicacy of the likenesses he wrought and the aromatic intimacies that his portraits hinted at. Cosway had passed through the Royal Academy Schools in their earliest years, and in 1771, still under thirty, was elected an Academician. Only Turner, in the next generation, came to such high recognition at so young an age. Even within the social conventions of the day, Cosway lived loosely; indeed, he and his wife themselves seem to have had a loose relationship, his wife Maria having had an affair in Paris in 1786 with the then American ambassador to France, Thomas Jefferson. Though he never went to Italy, unlike his wife who had been born there, Cosway admired Italian women. 'Italy for ever I say – if the Italian women fuck as well in Italy as they do here,' he wrote to his patron Charles Townley, 'you must be happy indeed – I am such a Zealot for them, that I be damned if I ever fuck an English woman again (if I can help it).'

By the first decade of the nineteenth century, Cosway had risen through careful application of his extraordinary talents as a draughtsman and his clever use of social networks to be one of the most sought-after miniaturists of his day. He was patronized by the Prince of Wales and by aristocrats including the Earl of Radnor and the Marquess of Blandford. These and many other patrons paid Cosway fully and generously, leaving him rich, successful, and heavily and apparently happily encumbered with his Italian-born wife. The Cosways rented from 1784 a sumptuous apartment in Schomberg House, Pall Mall, a late seventeenth-century mansion that by this time had been divided into three. Their middle portion, 81 Pall Mall, had previously been occupied by James Graham and his Temple of Health and Hymen, a high-class brothel filled with sparking electrical paraphernalia which masqueraded as a centre of sex therapy and electromedicine. Thomas Gainsborough was a neighbour at number 80 until his death in 1788, Christie's the auctioneers was nearby at number 125 until 1823, Angerstein was just up the road to the east at number 100, and there was royalty in St James's Palace down the road to the west.

Being compulsive collectors, the Cosways filled their apartment with fashionable furniture and furnishings, and a growing collection of old master paintings and drawings, some of course from Christie's, their neighbour. At one time they had an Egyptian mummy lurking about the place.

They were an odd couple, the demonstrative Italianate Maria and the petite Richard, only 5 feet tall, known as 'Miniature Macaroni' and 'Tiny Cosmetic'. Theirs was a private collection of quality and breadth, exotic and, in an era of artist-collectors, unrivalled by that of any British artist of the day. The Cosways had tone, and entertained: money flowed in and out, and sitters came and went, announced and ushered in by their elegantly attired black servant, Quobna Ottobah Cuguano. Cosway was, according to his wife, 'toujours riant, toujours gai'.[30]

By the time Faraday met Cosway, around 1806–7, the painter was in his mid-sixties. He was way past his prime, had sold or given away the bulk of his old master collection, and had moved north to Stratford Place, Oxford Street. His wife had to all intents and purposes left him, and was travelling Europe. Cosway gave Faraday a brief experience of the world beyond the bookbindery, a brush with glamour, and a hint of an alternative way of life. But as a leading player in the art world of his day, as a producer of art as well as a conduit for money, Cosway was central. He was a maker of fashion, who lived at the apogee of style, though it may be that after the departure of his wife he tended to let his standards of housekeeping slip. The critic William Hazlitt wrote of Stratford Place:

> What a fairy palace was his of specimens of art, antiquarianism and *virtù* jumbled all together in the richest disorder, dusty, shadowy, obscure with much left to the imagination. How different from the finical, polished, petty, perfect, modernised air of *Fonthill*!

Cosway was not such a suitable patron for young Faraday, the son of devout members of the Sandemanian church, a fundamental Christian sect. It may be for this reason that, apart from a polite mention in correspondence, Faraday does not refer to him again. Cosway's fellow artists tended to despise him; perhaps it was the inordinate success of the pint-sized miniaturist that got under their skins, or his flaming talent, or his amorous opportunities and victories. This of course also brought grudging admiration, as Sir Thomas Lawrence the portrait painter said to Joseph Farington when he compared Cosway to contemporary portrait painters:

What are [they] . . . when compar'd to the knowledge . . . of this little Being which we have been accustom'd never to think or speak of but with contempt?

Not content with raising high prices for his miniatures, Cosway went into business with reproductive engravers such as John Raphael Smith, Valentine Green and Francesco Bartolozzi. Together they published more than 160 prints after Cosway's work, in extensive editions which spread his popularity around Britain and Europe, exemplifying John Pye's observation that 'works designed for emperors, popes and nobles, find their way . . . into humble dwellings, and sometimes give a consciousness of kindred powers to the child of poverty'. While reproductive engraving was a highly volatile business, very susceptible to recession and financial crisis, it was nevertheless the only effective and economical means of broadcasting images and widening an artist's reputation. A risky way of making money though it was, in times of stability some engravers such as Bartolozzi made a very good living. Others, like Green, suffered in 1804 'a total want of employ in his profession [which has] reduced him at a very advanced age to great distress'.

A man who crossed the lives of most if not all of those discussed here was the banker and amateur poet Samuel Rogers. He seems already to have been around for ever even before our period started. Inheriting his father's fortune in 1793 by a lucky stroke, his elder brother's ill-advised marriage, Rogers was able to indulge himself with an income of £5,000 a year in the writing and self-publishing of his poetry, in travel and in entertaining. Invitations to Rogers's breakfast parties in the grand house he built for himself in St James's, overlooking Green Park, were highly prized, and it was there that poet met painter, aristocrat met actor, and novelist, publisher, politician and natural philosopher stood toe to toe, discussing issues of the day and looking at the pictures. This social round went on for years, even into a third generation which had other, different, pressures. A fortnight after she had visited the Great Exhibition in 1851, the diarist Isabella Mary Hervey went to see the by now 88-year-old Samuel Rogers, to 'have breakfast there and see his pictures'.

While being a wicked gossip, with a tongue as sharp as a knife, Rogers could be generous to an out-of-pocket writer such as Thomas Moore, conciliatory in patching up a quarrel between Moore and Byron, perceptive in offering the smiling young Sheffield lad Francis Chantrey the opportunity to decorate furniture for himself and Thomas Hope, and thoughtful when realizing that Wordsworth needed the financial certainty of an official post. Rogers was the bell-wether for the attitudes of the widely spread social group that encircled him, and prompted Moore to remark that:

> I always feel with him that the fear of <u>losing</u> his good opinion almost embitters the <u>possession</u> of it, and that though, in his society, one <u>walks upon roses</u>, it is with constant apprehension of the <u>thorns</u> that are among them.

Nevertheless, he could be difficult company. In a conversation at Farington's table, where Thomas Lawrence and the collector Richard Payne Knight were fellow guests, Rogers said little. 'He must have the lead', Farington remarked, 'or he is silent.'

There are some common routes in the journeys to fame and fortune outlined here: a rich man's one-to-one patronage from above (Angerstein and Turner; Rogers and Wordsworth); a rich man's munificence to many (Beckford to painters, stained-glass and furniture makers and craftsmen involved in creating Fonthill; Hope to furniture makers and upholsterers); determined advocacy from below (Turner, father and son; Coleridge and uncle; Cottle, for Coleridge and Wordsworth); family contacts from a great distance (Cosway and Shipley); apprenticeship and lucky encounter (Riebau, Faraday and Cosway); exotic benediction (Cosway and Faraday; Rogers and hangers-on). Most such routes are one-to-one, with little or no institutional involvement.

This was, however, the period in which the institutions rose in influence. The British Institution, founded in 1804 by aristocrats, collectors and moneyed men to boost the reputation of painting and sculpture, rapidly became a challenge to the Royal Academy. The British Institution was to the Royal Academy what in scientific endeavour the Royal Institution was to the Royal Society: in each case the former claimed for its purpose

the cultural improvement of the general public and the creation of an economy, while the latter remained principally a professional body. When Angerstein, Beckford, Leveson-Gower and Rogers were reaching the peaks of their influence in the first decade of the century, a new generation of entrepreneurs was beginning to look about itself and see where the money could be made, and where it could be spent for enjoyment and showy investment. There was also the shock of the new, as the politician John Cam Hobhouse recalled:

Dined at Lord Lovelace's . . . [His] eldest son is to be a sailor, [his] second a civil engineer – a new profession for a peer's son!

The backgrounds of the new rich were very different from those of the landed and moneyed gents who had the deep pockets that the patronage of artists requires. They included the horse-and-carriage dealer Robert Vernon; the Leeds cloth manufacturer's son, John Sheepshanks; the whaling entrepreneur son of a Somerset serge manufacturer, Elhanan Bicknell; the carriage manufacturer Benjamin Godfrey Windus; and the tile manufacturer from the Black Country, John Hornby Maw, a farmer's son.

These men did not come from rolling country acres, except where their forebears had been working them, but instead from more or less the same modest backgrounds from which sprang the natural artistic talent and genius that they would come to support. Their attitudes to their artists were, immediately, new. Their roots were in Defoe's 'middling kind'; the sort that William Beckford's father, the London alderman with slave-owning interests in Jamaica and reform interests in Britain, had described eloquently in the House of Commons in 1761:

the manufacturer, the yeoman, the merchant, the country gentleman, they who bear all the heat of the day . . . [They] are a good natured, well-intentioned and very sensible people who know better perhaps than any other nation under the sun whether they are well governed or not.

The particular quality of British life in the eighteenth and nineteenth centuries was that talent, whether for industry or art, was a passport.

In the dealings between art and money in the mid-century we witness a change in the values of social class and the intricate relationships between money and status as expounded by Fanny Burney and Jane Austen, a shift to the crueller, cutting worlds of Dickens, George Eliot and Mrs Gaskell. Articulate foreign visitors noticed the changing ways of life that natives of Britain might miss. The German historian Friedrich von Raumer, in London in 1835, went out to dinner in a grand London house:

> In the first place the furniture of that room was antique; hangings and furniture resplendent with silk and gold; the dinner service of silver, a silver hot plate under every plate, change of knives and silver forks with every dish, and of these dishes, as well as of the wines, a countless succession; servants in full livery, and all in white kid gloves . . . Several times, when all the plates were removed, I thought the business was at an end, but in a minute the table was full again. At length we came to the rinsing of the mouth; but instead of rising after this operation, it was only succeeded by new varieties of sweet dishes. Again the table was cleared, and a large silver basin was placed before one of the gentlemen. He poured a bottle of water into it, dipped in a corner of his napkin, and pushed the basin to me. It was filled with rose water, and was a new and very refreshing luxury to me. At length we arose; but the ladies only left the room, and passed their time in amusement or in ennui, while the gentlemen sat down again and did not rejoin the ladies for an hour. Cards were now introduced; but I made my escape, mindful of the coming day, and got home about midnight.

The French critic Hippolyte Taine drew a picture of the British from the viewpoint of a guest in a large house forty years later. The sense of display and detail that Raumer noted in the 1830s concerned rooms that were public: the drawing room and the dining room. By the 1870s, however, it had flowed like a tide upstairs and into the guest bedrooms, out of general sight:

> In my bedroom . . . there are two dressing-tables, each having two drawers, the first is provided with a swing looking-glass, the second is furnished with one large jug, one small one, a medium one for hot water, two porcelain basins, a dish for tooth-brushes, two soap-dishes, a water-bottle with its tumbler . . . The servant comes four times a day into the

room; in the morning to draw the blinds and the curtains . . . at mid-day and at seven in the evening, to bring water and the rest . . . at night to shut the window, arrange the bed, get the bath ready, renew the linen; all this with silence, gravity, and respect. Pardon these trifling details; but they must be handled in order to figure to oneself the wants of an Englishman in the direction of his luxury; what he expends on being waited on and comfort is enormous, and one may laughingly say that he spends a fifth of his life in his tub.

The nation's fluctuating financial state of health was a permanent background presence. After the end of the wars with France in 1815 money supply suffered intermittent constrictions, about one every ten years, which manifested themselves variously and painfully as bank crashes, share-price collapses, private misery, public uncertainty and social unrest, against a deceptively camouflaged background of advances in technology, improvements in urban living and expanding world influence. Big splashes in one part of the ocean reduce to a wave that washes away a cottage on a distant shore. One respectable London family, the Venns, who had for generations produced parsons for the Anglican church one after the other like eggs from a hen, is an example of the struggling middle class of the immediate post-Waterloo years. They tripped off to Margate for fun, they deplored slavery, they were good to their maid; but anxiety will out: 'What shall we do', 28-year-old unmarried Emilia Venn wrote in 1825, 'now that they are reducing the interest from 5 per cent.' A few days later the family was pulling itself together:

Had a long discussion with [brother] Henry about our affairs after breakfast . . . Became more fully acquainted with the state of our income, & Henry's characteristic liberality & generosity towards us.

The shock, when it came, left the Venns flapping and clucking and unable to see straight:

12 Dec 1825 Mr Batten [Emilia's brother-in-law] went into the city, & came back with the news of the banks failing everywhere & of such a panic as has not been known for years.

13 Dec Mr Cunningham came & brought the news that Sir Peet Paul & Henry Thornton's bank had stopped payment. Mr Batten dined at Sir Rob. Ingles & had a letter in the evening telling him of the failure of their bank.

23 Jan 1826 Nothing talked about but the Drury's & their debts.

1 Feb News brought to us early in the morning that the Drury's were gone! . . . Half the tradesmen round have been ruined by them.

The 1825 crash was heralded in two letters from a perceptive young London architect, Thomas Donaldson, to Robert Finch, a retired parson living in Rome. In the first, written in April 1824, Donaldson saw nothing but riches in London:

> We are going very well in England . . . and so rich that the great Capitalists know not how to employ their money. Project after Project, Bubble after Bubble rises, has its day and then sinks to nothing. They have already begun upon London Bridge, which is to consist of 5 elliptic Arches . . . They are driving piles. Scientific men profiting by the excess of money in the market are devising schemes which tend at the same time to public utility and individual profit and by this means we have some very useful projects in contemplation.

But within a year Donaldson realized that something else was coming:

> The people in England seem completely mad with schemes for the formation of large associations of capitalists in schemes of every description. The famous South Sea Bubble of former days is acted over and over again. Speculators are continually failing and involving hundreds of others yet still the floating unemployed capital is so great as to make the money'd men undertake any speculation in the hopes of realising some interest for their capital. We have 2 steam washing companies – a bread company – a fish company – a milk company. In fact all the necessaries of life are now furnished by companies at reduced prices and they say goods of the best quality.

The shudder from the 1825 crash had its intimate repercussions on the early life of one of the great commentators on his time. Charles Dickens's

father lost his job as a journalist when the *British Press* went bust in 1826, so the fifteen-year-old boy was thrown out of the only school he had known when John Dickens could no longer pay the fees. Too much, then too little money around caused intricate chains of bad investments to snap: these ups and downs are in the nature of a developing economy, in which losers and winners are the hedges and ditches, the light and shadow of the landscape. Many tiny tragedies followed in the wake, for example, of the scam of majestic proportions dreamed up by the Scotsman Gregor McGregor. After an adventurous career fighting in the Peninsula War and in South America, McGregor invented in 1820 a small state in South America, 'Poyais', somewhere on the coast of Venezuela. Coming to England, he sold investment bonds, deeds to land, and official positions with a civil service that did not exist, of a nation that never was, in a landscape populated only by mosquitoes, mangoes and monkeys. Thousands of people were taken in, millions of pounds were invested in this pretending Utopia. As this house of cards fell apart, and fever-ridden, furious victims crawled back home, banks and companies came to pieces and livelihoods were ruined. McGregor, having escaped across the Channel, tried it on again in France, failed again, and skipped back over the Atlantic to Caracas, where he died.

The journalist Alaric Watts wrote of the 1825–6 crash as 'the Great Panic, with which there has been nothing since, in the way of commercial distress, to compare'. Seventy or eighty country banks failed, as did six in London. Sir Walter Scott and his publishers, Constable in Edinburgh and Hurst and Robinson in London, went bankrupt and Scott had to sell his lucrative and formerly unassailable copyrights to pay part at least of his debts, tied up as they were in a complex web of business links with publishers and printers. At the other end of the income scale, William Woollett's widow Elizabeth, who had joined in the three cheers for the completed plates in the good old days, had transferred all her late husband's engraved plates to Hurst and Robinson in exchange for an annuity in 1819; when they collapsed, the Woolletts' surviving daughter was left in penury.

Charles Knight, proprietor of the educational *Penny Magazine*, widely read by all classes, described the dismay at the Publishers' Club when news of the crash came through, the panic 'passing over all our tribe like

the Simoom, bringing with it general feebleness, if not individual death'. Hearing that his bank in Windsor was about to close its doors to creditors because its own money was tied up in another failing bank in London, Knight acted as an emergency courier from London of a large amount of cash. 'Funds for the Windsor Bank!' he cried as his coachman changed horses at Hounslow. 'Funds for the Windsor Bank!' cried the turnpike man as the news spread and Knight's coach galloped on through the river mist. Arriving at last in Windsor, the coach clattered and clashed on the old bank yard 'amidst hurrahs of a multitude outside, to whom I had proclaimed my mission'. The bank was saved by Knight's timely and determined action.

Further crashes, in 1837 and 1838, came about when very large sums of money were poured into capital schemes in both Britain and the United States. Another in 1847 was fuelled by 'railway mania' – over-investment in the burgeoning railway system developed through private enterprise scarcely controlled. And so they went on, the inevitable results of a fluid supply of money meeting hope, miscalculation and criminal fraud. A young apprentice wood engraver, Edward Whymper, later a distinguished mountaineer, safely employed in cutting illustrations for books, coolly described the next crash of 1855:

> A London bank has failed (Strahan, Paul and Co) which has made moneyed men rather dull. They have debts to the amount of £750,000 and next to nothing to pay it with. How they have managed it, nobody knows, for the last partner brought in to the business £180,000. They have made away with securities that were placed with them to keep (that is, stole them) and one clergyman lost all his means (£22,000).

This crash found expression in Dickens's novel *Little Dorrit*, published as a monthly serial between December 1855 and June 1857. In real time Dickens evokes the growth and climax of the swindle carried on by 'the Man of the Age', Mr Merdle, 'the richest man in London'. When Merdle's Bank collapses and the company's fraud is exposed, Merdle kills himself.

> The late Mr Merdle's complaint had been simply Forgery and Robbery ... he – the shining wonder, the new constellation to be followed by

wise men bearing gifts . . . was simply the greatest Forger and the greatest Thief that ever cheated the gallows.

Merdle's suicide demonstrates the danger and insecurity inherent in the new money that paid the artist that painted the picture that furnished the house that Jack built. Merdle killed himself with a pretty tortoise-shell-handled penknife borrowed for the purpose from Fanny Sparkler. Fanny was the newly married daughter of William Dorrit, former long-term resident of the Marshalsea debtors' prison, whose fortune had been swindled from him, then belatedly returned. Thus the circle turns: in life rather than fiction the penknife might have been lent to Merdle by Emilia Venn.

PATRON OLD STYLE:
'BUSINESS IS OFTEN FRIENDSHIP'S END'

The patronage of art in the nineteenth century was expensive and exhilarating, dangerous and disappointing in various and mixed measure for all involved. 'Business is often friendship's end', wrote the politician and brewer Samuel Whitbread in 1806 in an encomium on Henry Holland, the architect he employed to remodel and enlarge Southill, in Bedfordshire, the house his father had bought from the bankrupt Viscount Torrington. For Whitbread, however, architectural business with the efficient, well-organized Holland led happily and surprisingly to deep friendship, which closed only with death.

The social revolution consequent upon the revolutions of the steam-engine burst upon art patronage and the business of art in the first half of the nineteenth century. The Callcott/Horsley/Brunel interface in the 1830s was merely a continuation of the process whereby art and architecture played their part in local economies that were the warp in the national tapestry: not disposable decoration but an essential structural part in the system that allowed wealth to display itself and confidence to follow. The naturalist Sir Joseph Banks expressed this early on: 'the Arts will always flourish in Proportion to the Patronage given by the Rich.'

Whitbread used modern methods to keep his business in production and profit: Boulton and Watt steam-engines to pump the water and grind the malt; iron girders to enlarge his warehouse; and management methods that ensured efficient use of labour. The art he commissioned came as a direct result of the success of his business, and was its signal.

Nevertheless, there were always the personal difficulties. Choosing unreliable or headstrong artists and allowing misunderstandings to get out of

hand were mistakes that presented dangers; so too did over-involvement and association with an individual artist, thus risking a distorted relationship. Additional irritations for a wealthy collector were obsequious middle-men who had to be dealt with patiently and courteously, 'persons of worship', as John Opie called them dismissively. Choosing the wrong kind of artist in defiance of prevailing taste was a further danger, while taking poor advice added yet more risk. One of Reynolds's sitters, Sir Walter Blackett, could only watch as year by year his portrait sank away through the use of ill-chosen materials (see page 188). He wrote with dismay:

> Painting of old was surely well designed
> To keep the features of the dead in mind,
> But this great rascal has reversed the plan,
> And made his pictures die before the man.

While the dangers of patronage were real, its pleasures might include the growth of life-long friendship between patron and artist, as with the Yorkshire landowner Walter Fawkes and Turner, and all too briefly between Whitbread and Holland. They might encompass the stimulating decoration of a fine house, as for Sir John Leicester in both Mayfair and his Cheshire mansion at Tabley; they might breathe new life into an old family house, as Henry, Third Marquess of Lansdowne found when he inherited the *tabula rasa* of a sale-ravaged Bowood, Wiltshire, in 1809; and further, they might allow access to and enjoyment of an unfamiliar social milieu, as in the case of Lord Egremont with his artist friends at Petworth. A charming letter from Lord Egremont to Francis Chantrey reflects the friendship that always preceded Egremont's patronage:

> I shall be happy if Mrs Chantrey & you will let me have the pleasure of your company here. Turner is here catching fish by the Hundreds & there is plenty of pheasants for you.

Patronage of artists should always bring the satisfaction of seeing a reflection of one's wealth on one's walls – a pleasure shared by so many patrons across the nation, from Sir George Beaumont in Leicestershire and London to the

energetic pen manufacturer Joseph Gillott of Birmingham in the following generation, the coach-builder Benjamin Godfrey Windus of Tottenham and the pharmaceutical supplier John Hornby Maw.

Whitbread's Southill, Fawkes's Farnley and Beaumont's Coleorton are modest houses compared to vast piles such as Althorp, Blenheim, Bowood, Broughton, Castle Howard, Chatsworth, Fonthill, Holkham, Ickworth, Kedleston, Longleat, Stowe, Woburn, Wrest . . . the list moves at length from one end of the alphabet to the other. For these, the collecting of paintings was a necessity, not a luxury, for how else are such wall acreages to be covered if not by distemper (boring), frescoes (expensive) or tapestries (very expensive indeed)? A picture collection with focus, purpose and direction, driven by intelligence, was much more satisfying to procure, particularly when it ventured beyond the bounds of family portraiture, or moved further than such special-interest subjects as sporting paintings, naval subjects and paintings of livestock.

There is a distinct divide between the taste, attitude and activity of collectors from the generation of Egremont, Fawkes and Whitbread, and those of Windus, Maw, Gillott and many others including Bicknell, Sheepshanks and Vernon. Walter Fawkes derived his income largely from his 15,000 acres north of Leeds, while his expenditure went out on his grand Wharfedale house, Farnley Hall, his London mansion in Grosvenor Place, his collection of paintings mostly by Turner, and his financial support for hungry Whiggite causes such as anti-slavery and political reform and for his own successful but brief election to Parliament in 1806. 'I have been a Whig, a Great big Whig all my life,' he wrote to the political diarist Thomas Creevey in 1806, 'ever since I was a reasonable being, in defiance of advice, or persecution, of hostility of every kind, I have stuck to my text.' Artist and patron discovered one another early in Turner's career. By 1808 Fawkes had bought Turner's *The 'Victory' Returning from Trafalgar, in Three Positions*, and was building up a peerless collection of the artist's watercolours, including scenes in the Alps made during or soon after Turner's 1802 journey. As time went on, he was to buy fifty more watercolours painted on and around the Rhine in 1817.

This was a business relationship which became a friendship, and a friendship which went on to develop into Turner becoming one of the

family. Eventually Fawkes was to own five of Turner's oil paintings, more than one hundred watercolours and, in albums variously, a set of bird drawings now in Leeds Art Gallery and, extraordinarily, a detailed pageant of English history, the *Fairfaxiana*, illustrated from Fawkes's ancestral history and his family's evolving political viewpoint. Fawkes drew from Turner art and direction that might otherwise never have occurred to him: there is the benefit of patronage – it can take even the greatest artists further than they might otherwise have dreamed.

Given Fawkes's increasingly imperilled financial state in the early 1820s, due to falling income and over-expenditure, and Turner's characteristic generosity towards people who were special to him, it is likely that some of these works were never actually paid for. Fawkes organized a public exhibition of his watercolour collection in the months before Turner went to Italy in 1819, an event that was the source of great pleasure and pride to Turner, and which prefigured in its popularity the national passion for the artist in the late twentieth and early twenty-first centuries. Inviting the architectural draughtsman John Buckler to Farnley to make some drawings of the house, Fawkes added:

> you must stay a <u>few days</u> with me, as I <u>must</u> have a few of your beautiful & masterly sketches – and I can shew you such a collection of <u>Turner's drawings</u> – all such a treat to any man who knows any thing about the matter.

Fawkes wrote feelingly to Turner in 1819, in an open letter that was printed and read by many, of the 'delight I have experienced, during the greater part of my life, from the exercise of your talent and the pleasure of your society'. So close indeed were they that Turner was one of the very few people Fawkes wanted to see during his final illness in 1825. Thus a generous patron became in return the focus of the generosity of the artist, a creative and enduring relationship that has all the hallmarks of the purest virtue. This echoed down the generations, as Walter's son Hawkesworth became Turner's friend, his prop in old age, an executor, and the enthusiastic if not entirely successful catalyst for a new way of reproducing Turner's works photographically (see page 229).

Samuel Whitbread, educated at Eton, Cambridge and Oxford, had been groomed within the strict orthodoxy of the late eighteenth century to succeed his father, the elder Samuel Whitbread, as a landowner and brewer of great wealth. In this, and in his Whiggish convictions, young Samuel had much more in common with Walter Fawkes than he had with his Tory father: while he and Fawkes may have known each other as collectors, they were colleagues in the 1806–7 parliament and spoke together in the House of Commons. The Whitbread family's riches came in abundance from their brewery in Chiswell Street, City of London, the largest brewery in England, which the elder Samuel had founded in 1749. Wherever Whitbread's ale flowed, more wealth rolled into London and Bedfordshire on its froth. Some of Whitbread's beer may have made it to France, where it challenged the primacy of wine. Samuel Rogers recalled that he had seen at a dinner party in Paris, given by a French nobleman, 'a black bottle of English porter set on the table as a great rarity, and drunk out of small glasses'.

Samuel Whitbread the elder had nursed his brewery's annual production over nearly half a century from 18,000 barrels of porter in its first year to 200,000 in 1796, the year of his death. A serious, god-fearing, level-headed businessman from a low-church Anglican family, this Samuel Whitbread saw early opportunities for bringing modern technology to bear on the ancient art of brewing. But his confidence in modern technology ran hand in hand with his deep-rooted religious belief: as he watched the beer slowly bubble and froth in its vats, he would, in the brewery's early days, read the Bible and the Book of Common Prayer. In 1785 Whitbread installed one of the first Boulton and Watt steam-engines in London to grind the malt and to pump the water from a deep natural well. He also began the process of building and extending the brewery complex: he bought up neighbouring properties and used new iron construction to build a warehouse with an unsupported roof that spanned 65 feet and could hold 5,700 barrels. This was production on the grand scale required to keep the population of London watered and nourished in a period when the only readily available drinking water came from the sewage-polluted Thames. The elder Samuel's assistant Joseph Delafield wrote of the brewery that it had become 'the

wonder of everybody, by which means our pride is become very trouble-some, being almost daily resorted to by visitors'.

The skilled and loyal team of managers and brewers that the elder Samuel Whitbread had assembled at Chiswell Street was perhaps the most useful treasure that he left to his son. As a measure of their worth, and of his appre-ciation, the elder Samuel commissioned portraits of the most senior among them by Romney and Gainsborough, while to paint himself he took the risk of his image deteriorating and engaged Sir Joshua Reynolds. The por-traits are all at Southill. It was the capable staff on whom Whitbread could rely to keep the brewery running while he served his country yet further as Member of Parliament in the Tory cause for Bedford. His humanity and good sense nevertheless took him away from the party line, to fight political corruption and to become an early anti-slavery campaigner. The younger Samuel relied on his brewers even more heavily than his father had, as he too turned his eye to politics, embracing the Whigs.

The emotional distance between Reynolds's portrait of the elder Whitbread and Gainsborough's of the younger speaks volumes for the difference in outlook and ambition between them. The former portrait, commissioned in 1786 and painted, unusually, on a large sheet of copper, is bulky and red-faced, and looks out sternly with an inkwell and docu-ment to hand. The latter is lithe, revealing a flickering good humour, and presenting a taut, curved pose that portends a spring into action; this was commissioned by the son in 1788. So close are the portraits in time that they are uniquely clear in their portrayal of generational change in ambition and attitude. Throughout the latter years of the father's life, the chasm between their characters and ambition yawned wider and wider. In the elder Samuel's seventieth year, when at the 1790 general election he unexpectedly faced a contest for his long-held parliamentary seat, young Samuel ruthlessly pushed him aside and won the constituency for the Whigs. Reflecting on the event, the elder man felt he had 'lost by too much kindness', and experienced a 'storm to my soul . . . my son is not kind nor respectful'.

The Whitbreads are a classic case, like the Leeds cloth manufacturer Joseph Sheepshanks and his son John, of the father making the money

through industry, and the son spending it on art. There was indeed some doubt between the Whitbreads whether the son would want to inherit the brewery. The thoughtful and reflective elder Samuel offered his 21-year-old son a way out:

> You express yourself handsomely and feelingly on the subject of trade. But pray don't make a burden of it to hurt your spirits, for it is a matter that you and myself can part with. And you would have two reasons to give; one that it would take too much of your time from other employment in life that you are from education more inclined to yourself. The second is that you have as much affluence as would make a reasonable man happy.

Young, radical, Whiggish politics had put an unquiet pulse into the Whitbread brew to the extent that Samuel the elder thought it was all over, and in 1796 drew up an agreement to sell the brewery for £300,000. However, he died before it could be signed, and the deal was off. Like it or not, Samuel the younger inherited Chiswell Street, beer barrels, shire horses, employee portraits, goodwill and all.

The younger Samuel found brewing to be 'a tolerably easy source of income without making too many demands on my time'. Daily demands of business he passed on to his faithful staff. He could never inhabit the mantle of the stout brewer that *au fond* his father had been, but became instead a compassionate and liberal landed gentleman with friends of a profoundly different kind to the Tory-leaning county landlords with whom his father had mixed. The elder Samuel observed of his son, as he sat opposite him across the chamber of a stormy House of Commons, where, eventually, he secured a seat, that he was 'very very very much with Fox and co.'. Younger Samuel's circle centred on the 'Devonshire House Set' – Georgiana, Duchess of Devonshire, Charles James Fox, Richard Brinsley Sheridan and Charles Grey, Sam's brother-in-law, the suave young politician who in 1830 would become the nation's reforming prime minister, the First Earl Grey.

Politics apart, what occupied young Samuel Whitbread's time was his setting out of plans to form a collection of British art, and remodelling the

house and estate of Southill Park near Biggleswade. This his father had bought in 1795 for £85,500 from the ruin of the Fourth Viscount Torrington. The elder Samuel Whitbread cast a long shadow over his son, not only by buying Southill the year before he died, but also by giving young Samuel the framework, foundation and setting for his collecting ambitions. The landscape designer Capability Brown, left unpaid by Torrington's employment, had to be wooed back to remodel the Southill landscape, while Brown's son-in-law Henry Holland was engaged to develop a vision for the house. Holland, an architect with Whiggish allegiance, was already famous from London to Bedfordshire, having designed Carlton House for the Prince of Wales, and having worked at Althorp for Lord Spencer and at Woburn Abbey for the Fifth Duke of Bedford. Pulling down walls, remodelling rooms and throwing out wings, the entire *grand projet* had cost over £54,000 by the time work was finished in 1802.

While rebuilding a great house was an ambition of a kind shared by many of his generation and class, in his ambition to make a collection of determinedly British art in Bedfordshire Whitbread was one of the collector-pioneers across the country in the early years of the nineteenth century. With others such as Walter Fawkes in Yorkshire, Sir George Beaumont in Leicestershire, the Third Marquess of Lansdowne in Wiltshire and Sir John Leicester in Cheshire, he shared a determination to see British art given the status it deserved on the walls of the wealthy. Only a fortnight after his father's death Samuel Whitbread let it be known that he proposed 'to make a collection of the works of English Artists'. This came to the ear of Joseph Farington, who added that Whitbread's 'father lately dead is said to have left him a million of property'. Telling Farington was tantamount to telling the world, and it was clear to Farington that this was no sudden decision. Samuel had already bought Romney's colossal and troubling canvas *Blind Milton Dictating to his Daughters* for Southill, and had had a grand frame made for it to mark the occasion and to celebrate its acquisition. By the time of his death in 1815, Whitbread had acquired nearly eighty paintings by British artists, fifty or more of them directly from the artists themselves, and nineteen pieces of lead statuary from the posthumous workshop sale of the sculptor John Cheere.

However, unlike Leicester, who bought controversial artists includ-
ing John Martin, Turner and James Ward to decorate his 'British Gallery'
in Mayfair and his country house in Cheshire, and Fawkes whose col-
lection in London and Yorkshire was overwhelmingly directed towards
Turner, Whitbread kept carefully within the conservative waters of taste
by commissioning portraits from John Hoppner, John Opie and James
Northcote, and subject paintings by George Garrard, Sawrey Gilpin and
S. W. Reynolds. While Gainsborough in his day was an artist of advanced
and uncompromising authority, he was in the final year of his life when his
portrait of Samuel was commissioned. However, while the choice of artists
that Samuel Whitbread the younger patronized broke no new ground, the
manner and extent of his generosity to his artist friends was remarkable.
The engraver S. W. Reynolds came under Whitbread's wing in 1801 when
he was 'nearly bankrupt in hope' and unable to maintain his engraving
commitments. Within a year Reynolds's bills were being sent to Southill
for Whitbread to settle, and the artist himself was being manfully encour-
aged by his patron to pull himself together and take up a new career
in landscape gardening and architecture. Setting this less-than-organized
Reynolds (not of course to be confused with the busy but dead-by-now
Sir Joshua) to work in the country, Whitbread parcelled him out to Sir
George Beaumont to carry out landscape design and building alterations
at Coleorton, and to other grand estates, including Woburn and Colworth
in Bedfordshire and Ashburnham in Sussex. At Southill Reynolds oversaw
changes to the landscaping of the park, and the installation there at focal
points of the John Cheere lead figure groups.

Whitbread was godfather and protector to his artists, commissioning
and collecting with his heart rather than his head. This tends to set him
apart from most patrons, who, like Leicester and Beaumont, paid out
large sums, but nevertheless took little interest in their artists' subsequent
welfare. None of Whitbread's artists would make advanced artistic state-
ments; instead his patronage was a close expression of his political instincts
and aspirations. Thus, it was the subject of Romney's *Milton*, the radical
poet and voice of liberty, as much as its status as a work of art, that directed
Whitbread's intention to buy it. Further, in acquiring John Opie's portrait

of the artist's second wife, Whitbread was not just adding a handsome woman to his walls, but buying a fine portrait of the courageous leading anti-slavery campaigner Amelia Opie; and in commissioning at length the sculptor and painter George Garrard, Whitbread, as his father before him, was displaying his pride in agricultural improvement on his Bedfordshire estates and in the inexorable growth through good management of the brewery. Garrard was a regular visitor to Southill, for which he painted views of the house under reconstruction, to add to the oil portraits of trees and lively canvases of industry which he had painted for the elder Whitbread. 'Garrard is a very ingenious little fellow,' young Samuel wrote kindly in 1811, 'who has been patronized by me and my father for more than five and twenty years.'

The most interesting aspect of Garrard's work at Southill is the dozen or more white plaster models of cattle displayed in various life-like attitudes in rank after rank of glass cases. These are the result of a mid-career change of course in which Garrard became a sculptor and a highly competent maker of plaster models of animals, singly and in groups, in active, static or anatomical arrangements. The new secretary to the Board of Agriculture, Arthur Young, whose travels in England, Ireland and France had brought him to an intimate knowledge of the state of agricultural economy, encouraged Garrard in his work and in the scientific accuracy of his models. Agricultural improvement was gathering pace through scientific research and land management to such an extent that Garrard sensed a lucrative opportunity, a new interest and market in images of farm animals. He published his aquatints *A Description of the Different Varieties of Oxen Common in the British Isles* in 1800, and opened an agricultural museum at his home and studio in George Street, London. There, according to the art dealer Rudolph Ackermann, he 'formed a collection of models that have raised him in this department to a competition with the greatest statuaries of Greece'. That is somewhat exaggerated, a salesman speaking, and a view which was balanced by the direct and argumentative sculptor Joseph Nollekens RA, who described Garrard dismissively but with some accuracy as a 'jack-of-all-trades'. Garrard spread his talents thinly; he also moved into the carving of portrait busts in which, with some help from the

easy-going Whitbread, he found commissions to make busts of Whitbread himself, Sir Joseph Banks, Arthur Young, Charles James Fox, the Earl of Egremont and Henry Holland. Across these years he made nearly ninety busts, a whole menagerie of farm and exotic animals, church monuments and architectural sculpture. Garrard's was a busy studio from around 1800 until his death, so it is likely that his ultimate fall into poverty came through inadequate studio management, a real danger for many sculptors (see chapter 5). The point about Garrard and Whitbread is that the business of art, when seen in the perspective of the time, does not always reflect the course of art history as perceived 200 years later.

Garrard's bust of Henry Holland, commissioned by Whitbread soon after the architect's death in 1806, carries touching lines written by the patron himself, expressing mixed delight and regret at the ending of a long partnership during the remodelling of Southill:

> Business is often friendship's end:
> From business once there rose a friend;
> Holland! That friend I found in thee:
> Thy loss I feel, whene'er I see
> The labours of thy polished mind;
> Thy loss I feel whene'er I find
> The comforts of this happy place;
> Thy loss I feel whene'er I trace,
> In house, in garden, or in ground
> The scene of every social round,
> Farewell! In life I honour'd thee;
> In death thy name respected be!

Whitbread's central purpose was politics, however, not art, and it was this blurred focus that would draw him to commission artists of the modest standing of Garrard, whose art had its own appealing political angle. Whitbread was himself the rallying point of extreme Whig opinion that saw Napoleon as a hero figure, and the champion of anti-royalist liberty. Against popular opinion Whitbread campaigned for a peace deal to be struck with the French emperor in the early 1810s, and became a vehement opponent of the war with America in 1814.

Whitbread's point of view in the House of Commons was characteristically contrary, and little supported. His friend Richard Brinsley Sheridan, the playwright, theatrical impresario and extraordinarily active Whig MP of no fixed abode, drew Whitbread into his own private cause when in 1809 a calamitous fire destroyed the Drury Lane Theatre. Sheridan, the theatre's unpredictable manager and chief shareholder, walked a fine line between financial success and disaster, while usually putting on a good show. In 1809 the theatre was only about fifteen years old, having been designed (by Henry Holland) to the most modern specifications. These included a large water tank in the attic, to be released in the event of fire, and other splendid precautions such as iron columns and an iron safety curtain. Nevertheless, when the theatre burnt down, none of the much-trumpeted fire precautions could save it. Sitting in a chop-house across the road from the theatre, Sheridan watched the blaze with a glass of wine in his hand, musing: 'a man can surely be allowed to take a glass of wine before his own fireside'. On the day of the fire the theatre owed nearly £44,000 in unpaid dividends to its subscribers. The perks given to these 'New Renters', as they were called, included free admission to any performance, and two shillings and sixpence in rent payable to each from every performance. As a consequence, up to 475 people were admitted free each night, cutting significantly into nightly income of the 3,600-seat theatre, and this income was already heavily mortgaged. To balance the books, takings had to reach £330 a performance, but at the end they were languishing at an average of around £70. In the weeks after the fire, Samuel Whitbread was expected to sort all this out.

With characteristic energy Whitbread eventually raised enough capital through the sale of £100 shares in the new building, inviting architects to submit designs and overseeing the construction up to the opening night, 10 October 1812. The appointed architect, Benjamin Dean Wyatt, was a member of the ubiquitous and proliferating Wyatt family of architects, the son of James Wyatt who was Beckford's architect at Fonthill. The cartoonist Charles Williams followed the saga of money-raising and rebuilding, expressing the removal of Sheridan as 'Rubbish of Old Drury' and evoking the role played by the profits of the brewery in the process. Whitbread

was seen publicly through these prints as the hero of the hour, depicted as fresh-faced and energetic, even though by now he was already heavily built, overweight and unwell. In one cartoon he wheels Sheridan away; in another he is chaired in triumph onto the building site, waving a foaming mug of ale and saying: 'We . . . shall now have a Theatre as much like a Brewhouse as one Barrel is like another, which is certainly the most elegant of all buildings & what publican is there that thinks the same?' Soon after the opening season began, George Cruikshank depicted the theatre's stage alive with activity, with the central figure of Whitbread stirring a huge brewing vat with papers inscribed 'Expectations', 'Subscriptions' and 'Promises'.

Despite the frenzy of the fund-raising, rebuilding and opening, the theatre's finances remained complex and arcane. The burden of finance affected all involved in the theatre, as Joseph Farington noticed in 1814: '[Edmund] Kean . . . was puffed up beyond his claim, probably to fill the Drury Lane Theatre, which was reduced almost to bankruptcy.' Whitbread's anxieties were not restricted to his responsibilities for the theatre's rebirth, but circled also around his unpopular political position. After spending the evening of 5 July 1815 in apparently intense discussions with lawyers about money, Whitbread fretted, tossed and turned in his bed, and the following morning killed himself by slitting his throat with a razor. His Whig supporter Lord Holland (not to be confused with the late architect Henry Holland) said of him afterwards:

> It is no slight homage to his character that at a moment when the grief of everybody seemed to be engrossed by some loss in the battle of Waterloo, his death should have made so deep and so general an impression.

Whitbread spread himself very thin over his multifarious interests and responsibilities – politics, the brewery, Drury Lane Theatre, landscaping his grounds at Southill, charities in Bedford – to the extent that his collecting activities failed to show the courage of his early convictions. He was not a man for the new art. While John Constable had by 1815 barely emerged out of Suffolk and would not come to disturb the art scene for five more years at least, Turner was already exhibiting challenging paintings at the

Royal Academy, as was John Martin at the British Institution and Augustus Wall Callcott at the Academy. The artists that Whitbread came up with were limited to Gainsborough, now dead, the down-at-heel engraver S. W. Reynolds, Sawrey Gilpin the elderly painter of horse flesh, and the multi-tasking cow-man George Garrard. The world was too much with Whitbread for him to become serious and effective as a patron of art.

Sir George Beaumont, ten years Whitbread's senior, was diametrically opposed to Whitbread in his interests and approach as a patron. Where Whitbread followed his heart and had his purse open to others, Beaumont was dogmatic and certainly dictatorial in his tastes. Loved and loathed in equal measure, he was described by the topographical painter Thomas Hearne as 'a supreme Dictator on works of art'. More recently the economic historian Gerald Reitlinger described him as 'a sort of permanent public school prefect'. Beaumont knew very clearly which living artists he liked, and while his income was comparatively modest – the nosey Farington estimated it at £8,000 per year – he spent it extremely wisely in buying not only his British artists, but more particularly the finest available old masters: Claude, Poussin, Rembrandt, Rubens, and the spectacular Taddei Tondo by Michelangelo, which he bequeathed to the Royal Academy. These more than matched acquisitions of old masters made by infinitely richer contemporaries such as Sir John Angerstein, William Beckford and Samuel Rogers. By political cunning, public spirit and moral blackmail towards the end of his life, Beaumont devised that, even though he bequeathed them to the British Museum, his paintings would eventually contribute to the founding collection of the National Gallery.

However, rather than keeping his views to himself and quietly buying old masterpieces incognito, Beaumont took the noisier route of telling the world of connoisseurs which of the younger artists they should support: his protégés included Thomas Girtin, David Wilkie, Benjamin Robert Haydon, John Constable and John Gibson. He encouraged James Ward RA, more in word than deed, by assuring him that were he to paint his huge canvas *Gordale Scar* (1812–14) he would build a dining room in his new house at Coleorton large enough to accommodate it on an end wall; if he had done so, the wall would have had to have been at least 14 or 15

feet from floor to ceiling. The artists Beaumont loathed included above all Turner, whose high colouring even in the 1810s he felt to be a pernicious influence on the progress of art and apt to sap the moral fibre of younger artists such as Callcott.

Not limiting himself to painters and sculptors, Beaumont encouraged and befriended writers including Wordsworth, Coleridge and Southey. Nevertheless, while his general perspective was backwards, and he installed a monument at Coleorton to Sir Joshua Reynolds flanked with Coade stone busts of Raphael and Michelangelo, he showed more than a spark of forward thinking by commissioning Constable to paint the scene of its setting. Beaumont did a bit of painting himself and considered himself to have notable talent. Others found it best to agree with him, to the extent that Wordsworth was so struck by Beaumont's gloomy and old-fashioned *Peele Castle in a Storm* that he composed fifteen Elegiac Stanzas in praise of the work that brought back his own vivid memories of Peele Castle in what is now Cumbria. Its over-enthusiastic response suggests, however, that this might just have been flattery:

Oh 'tis a passionate Work! – yet wise and well;
Well chosen is the spirit that is here;
That Hulk which labours in the deadly swell,
This rueful sky, this pageantry of fear!

And this huge Castle, standing here sublime,
I love to see the look with which it braves,
Cased in the unfeeling armour of old time,
The light'ning, the fierce wind, and trampling waves.

Beaumont was the connoisseur's connoisseur – perceptive, opinionated, astute and sharp-tongued, never short of a caustic put-down, but never short either of the odd fifty pounds to give to an artist whose work in his view deserved support. His nervous energy even got the better of the manically active painter Haydon: after an exhausting few days in Beaumont's company at Coleorton in 1809, Haydon could only lie back and close his eyes in the coach as it trundled home to London, thinking, 'they did nothing, morning, noon or night, but think of painting, talk of painting,

dream of painting and wake to paint again'. Only an amateur could be so utterly obsessed. Beaumont was a magnet of critical anecdote and tittle-tattle, and went about his business in a manner which caused as much amusement as it did displeasure. Callcott had a story about him and his wife:

> Sir George and Lady Beaumont are the greatest Lion hunters of the day. Every season produces its wonder, and every fresh wonder exceeds all the wonders that have preceded it. Their mode of puffing the powers of these wonders however is not always calculated to unlock their hearers with a conviction of the propriety of their judgement any more than the ten thousand wonders which they have exposed to the world and which are now forgotten.

The inability to maintain friendship successfully was a quality that Beaumont shared with Haydon. The latter became convinced in 1811 that Beaumont had reserved his *Macbeth* for £500. Beaumont recollected the matter differently, but offered Haydon compensation of £100 anyway. At this time Haydon was £616.10s in debt, so £100 meant little to him, with the result that he sent Beaumont a series of abusive letters for his pains. Their relationship hit rock bottom, and despite his acid words, one can only have a sneaking sympathy for Haydon over Beaumont:

> It is over three years since I first became acquainted with Sir George Beaumont. I was at first flattered by his affability, his smiles, his flattery, his notice expressed & uttered with all the warmth of sincerity and regard ... Sir G. Beaumont is a man who wishes to have the reputation of bringing forth Genius without much expense, if a young man promises any thing he immediately procures a slight sketch for a trifle; if this youth succeeds he has something to shew, to prove he first employed him, he first had acuteness to discover his talents – if on the contrary he fails, the sketch passes into oblivion, he denies all knowledge or recollection of him, and every thing relating to him is forgotten ... Sir George never comes to Town, but he brings Doubt, Irresolution & Misery in his train.

When Sir John Leicester inherited Tabley House, it was hung with his father's collection of eighteenth-century English paintings, including

works by Wilson, Reynolds and Barrett. Buying also a London house, 24 Hill Street, Mayfair, he built his own private gallery in 1806 to display the collection of paintings by living British artists that he was himself gradually beginning to assemble. We have read how he missed acquiring Turner's *Opening of the Vintage of Macon*, but he soon acquired that artist's dramatic and terrifying *Shipwreck* to command centre stage in the new gallery. Leicester's 'British Gallery' celebrated national achievement in painting, and was one of a clutch of rich men's art galleries, including those of Thomas Hope, Lord Grosvenor and the Marquess of Stafford, that were open for restricted periods for restricted classes of people to visit. Leicester, however, was the first to display British art exclusively and, from 1818, to open it to the public. As a former Grand Tourist, travelling in and around Italy in 1785 and 1786, Leicester had developed his tastes in opposition to those of his contemporaries. He had no desire to fill his houses with gold-framed saints or prophets, gods or goddesses. Instead, as a poetic eulogy in the *Literary Gazette* put it in 1819:

> . . . Leicester
> Should feel that he when Britons all would roam
> In search of graphic treasures far from home
> That he was foremost with a patriot's heart
> To shew they need not roam in search of art.

He did not, however, please everybody, as one visitor to Hill Street complained:

> The only thing we can say of <u>this Gentleman</u> is, that he possesses a fine house in the country, and a Picture Gallery which has been collected with more <u>liberality</u> than distinction.

Sir John Leicester burnished the self-esteem of native artists and contributed greatly to the regard in which they were held by the world. He had extensive correspondences with 'his' artists, many of whom had the warm conviction that Leicester was their friend. The dealer and critic William Carey, who advised Leicester on his acquisitions, described Leicester's

'unclouded temper, his gaiety of spirit, his accomplishments . . . [which] rendered him an object of distinguished note in the high circles of fashion'. Leicester invited artists to stay at Tabley and clearly looked after them well. Callcott looked forward to a visit with anticipation, hoping to accept an invitation to Tabley 'unless he is to be fattened like prize cattle, as [Henry] Thomson [RA] had been'.

Leicester owned nine Turners, and John Martin's *Destruction of Herculaneum and Pompeii*, paintings by James Ward including a terrifyingly dramatic *Fall of Phaeton*, and works by Reynolds, Lawrence, Northcote, Fuseli and Benjamin West. A place in his gallery was a rich accolade, with artists jockeying for position to be included. Ward recalled grimly how 'the Owen, Callcott and Thompson [*sic*] squad . . . for so many years took so much pain to keep me from the patronage of Sir John'. The dealer and publisher John Britton acknowledged Leicester's primacy when offering the collector the opportunity to buy Thomas Gainsborough's *The Cottage Door*. 'I really wish to see it in your British Gallery: I am confident it will form a leading feature in it': as indeed it did. He offered a commission to Benjamin Robert Haydon, but Haydon turned it down because he was too busy. Nevertheless the artist was bold enough to touch Sir John for a loan a few weeks later: 'I well know the utter impropriety of asking a man of your rank to lend me money . . . but if you should be disposed to assist me . . .' Just as there was nobody like Haydon, nor, for British art, was there anywhere else at the time like Sir John Leicester's 'British Gallery'.

Leicester is one of the forgotten heroes of nineteenth-century British art. Before he died in 1827, he offered his collection at a reasonable price to the then prime minister, Lord Liverpool, as the foundation of a national gallery of British art. He was turned down. However, he successfully sought other outlets for his generosity, presenting a large canvas by James Northcote, *The Alpine Traveller*, to the Royal Irish Institution:

> It has often I confess given me pain to think my feeble efforts to promote the arts in this Country has never elicited even the slightest [. . . ?] from the Academy, but in Ireland how differently is it felt – Viz by the unanimous Vote of thanks & immediately electing me an honourable member of their Society.

There was an ulterior motive to this gift: the painting was of Leicester's former mistress, passed over when the collector married another woman.

While Leicester's entire collection would have been an asset to the nation, it would also have been a highly controversial, precedent-setting and unique purchase. It was one thing for the nation to buy Angerstein's old master paintings during these years, all great artists, almost all safely dead; but to buy works in such bulk by living artists was quite another. The government could with circumspection commission portraits and statues to its heroes, and paintings of epic events; but to buy nine Turners, three Wards, a Martin and a bevy of works of merit, not genius, would show the government to be giving those artists in particular high official sanction, a step with unforeseeable consequences. In the event, Leicester's finances had been so weakened by his expenditure on art and on his support for his local militia during the recent wars that his collection was sent by his heirs for auction after his death. Turner himself bought back his *Country Blacksmith disputing upon the Price of Iron* (1807) and *Sun Rising through Vapour* (1807), and both works eventually came to the nation through the Turner Bequest, as, by other routes, did five of Leicester's other Turners.

A man who had at best perhaps ten times as much money to spend each year as Beaumont and Leicester put together was William Beckford. On inheriting from his father, Beckford began a complex and probably unfortunate life, with too much, too soon, too readily; but he made his own judgements. Beckford's rich mix of talents as a writer, connoisseur, collector and party giver, his ambitions and his weaknesses, were fuelled by excess, and by a licence to indulge. Wealth can create outcasts, but Beckford, who lacked only the ability to control events, successfully managed to turn himself into an outcast. As a young married man with a child, he was shunned by the society of which he was a natural leader for suspected sodomy with one of the most beautiful boys, so it was said, in the land. So Beckford, wife and daughter found the need to travel thrust upon them, and off they went to Switzerland. The unfortunate event with the beautiful boy, with its allegations of horsewhipping and 'some posture or other – strange story', blighted Beckford's life and reputation, and he never recovered from it. Over thirty years later the incident hung around

him like the albatross around the neck of Coleridge's Ancient Mariner. The Irish poet and songwriter Thomas Moore, who also had a difficult reputation, steered clear of Beckford, even after the latter had sung high praise for Moore's exotic narrative poem *Lalla Rookh*:

> Beckford wishes me to go to Fonthill with R[ogers] – is anxious that I should look over his Travels (which were printed some years ago, but afterwards suppressed by him) and prepare them for the Press – Rogers supposes he would give me something magnificent for it – a thousand pounds perhaps – but if he were to give me a hundred times that sum I would not have my name coupled with his – to be Beckford's <u>Sub.</u> – not very desirable.

Beckford's riches and his particular tastes fired him to write his Gothic novel *Vathek*, published in 1786, and to continue his voracious collecting and building plans. Beckford's was real collecting: paintings by Raphael, Mantegna, Claude, Poussin, Rembrandt, Velázquez; tapestries, furniture and objets d'art; Cardinal Mazarin's Japanese lacquer coffer; Greek and Roman sculpture; medieval enamels; books by the cart-load – enough stuff to fill the cavernous, massy and monstrous Fonthill Abbey that he was constructing on his inherited Wiltshire acres. Following the vaulting designs of the architect James Wyatt, strongly influenced and encouraged by Beckford's own ideas, this came to replace the elder Beckford's Fonthill Splendens, itself one of the most magnificent mansions in the land, which the younger Beckford tore down. Citizen Kane, in Orson Welles's 1941 film, for all his mythical US newspaper wealth, was a mere child collecting matchboxes by comparison with the real-life Beckford.

Beckford sought grandeur, and he got what he sought. Wyatt proposed to create a first-floor living storey at Fonthill 60 feet from the ground, reached by a staircase so wide and graded that Beckford 'might drive a coach and four [up it] and turn in the hall'. But Beckford knew neither prudence nor control, and on and on the objects came as Fonthill Abbey grew bloated and stupendous, devouring its acres and touching the clouds with its spire. It was perishing cold in winter: 'There were 60 fires always kept busy, except in the hottest weather', fuelled by 'perfum'd coal that

produced the brightest flame'. The envy of the nation, he shivered where he should have shone, haunted by the evaporation of his money. When Samuel Rogers visited, Beckford

> led him thro' numberless apartments all fitted up most splendidly, one with minerals, including precious stones; another the finest pictures; another Italian bronzes, china &c &c., till they came to a Gallery that surpassed all the rest from the richness and variety of its ornaments. It seemed clos'd by a crimson drapery held by a bronze statue, but on Mr B's stamping and saying 'Open!' the statue flew back and the Gallery was seen extending 350 feet long.

Fonthill tended to send Beckford's guests into silly trances. The wife of the sycophantic print publisher John Britton was one such:

> This spot alone shall be my heaven of Heavens: I will worship it . . . All around me seems like the work of enchantment, and I can only gaze, and gaze, and wonder how the mind of man should have projected so gigantic a structure, and still more, how the mind of man could have so far, almost, outstretched itself, as to have organised and arranged each and every individual part in such true and perfect order & harmony.

Built on inadequate foundations, however, its central tower, made of wood and a sticky cement of Wyatt's own invention, fell down in May 1800 and had to be quickly recreated in time for the planned triumphal visit the following December by *the ménage à trois of* Sir William Hamilton, his wife Emma and Horatio Nelson. Work lumbered on, with poor communication between architect and client; the construction was over schedule and over budget. The sugar market collapsed; Beckford's Jamaican estates were mortgaged (as, by now, was Fonthill); his solicitors bled him dry; and in 1813 Wyatt was killed in a coach accident. That more or less spelled an end to Beckford's dream. He sold up in 1823 and withdrew to Bath. Fonthill had been a bottomless pit which daunted, then defeated, even Beckford. In 1825, for the second and last time, its central tower fell down, taking part of the surrounding building with it: thus, posterity – which in reality would

have meant English Heritage – was saved the impossible task of keeping Fonthill going.

Beckford spent most extravagantly on the work of dead artists, but while he also commissioned the living, he had a poor reputation for settling his bills with artists and suppliers, being both tight-fisted and generous by unpredictable turns. Nevertheless, Farington heard that Beckford 'is disposed to encourage the English arts', and that 'he is to lay out £60,000 in purchasing Modern art'. He commissioned Turner in 1798 to paint watercolours of the abbey showing the building from distant points dominating the landscape, and bought for 150 guineas the artist's turbulent *Fifth Plague of Egypt* (1800). Even in his years of retreat to his tower in Bath he continued to buy from artists who lived and breathed, in 1827 acquiring Francis Danby's *Opening of the Sixth Seal*, 'as mad a picture as ever was painted', in Gerald Reitlinger's view. However, over the decades of Fonthill's long-drawn-out construction Beckford also provided income for furniture makers, stonemasons, carpenters, plumbers, decorators, drapers, potters, weavers and all the manifold building trade skills. His expenditure on Fonthill, however interrupted his payments might have been, created plenty of employment for the workshops and artisans of London and the south and west of England until it all fell down. Then it became a quarry providing building materials locally.

In the business of art in the first half of the nineteenth century, when the landscape of patronage was dominated by the land-owning classes, artists were left to decide their own tactics for breaking into the hearts and wallets of the rich. Haydon banged his nose repeatedly as one door after another slammed in his face; Turner kept tight control of what he exhibited, and when and where he did so, thus by controlling the supply making patrons hungry. He would sell his work and his services, but he was until the last decade of his life effectively his own agent. Before he attracted the interest of Thomas Griffith, the collector and dealer who encouraged him to create a series of watercolour masterpieces and took him commercially into the modern world, Turner contrived not always successfully to keep himself aloof from the mechanics of the market, while endeavouring to sell his work both to the highest bidder and to the highest in the land. He

hoped indeed for a royal purchaser, and appears to have had a puppy-like affection for royalty, wanting its patronage though in almost every case failing to land it when close to success. Luck, with royalty, was never on his side. George IV was a reluctant and non-committal patron to him; when the young Victoria bought Landseer after Landseer, and made a fuss of Callcott and Westmacott by knighting them at the beginning of her reign, Turner felt the cold unfocused gaze of royal blindness as if he were absent from the room. John Constable described the chasm between artist and patron with a breathtaking directness that was all his own:

> It is a bad thing to refuse the 'Great'. They are always angered – and their reasoning powers being generally blinded by their rank, they have no other idea of a refusal than that it is telling them to kiss your bottom.

PATRON NEW STYLE:
'THE DELICATE LIPS OF A HORSE'

A Boston sugar merchant, Isaac Schofield, on business in London in 1840, found himself stuck in a traffic jam extending down the Strand and Fleet Street, 'amongst carts, omnibuses, phaetons, livery coaches &c &c.'. The coachman who took Schofield slowly through the crush, 'making his calculations to an inch and threatening me momentarily with instant annihilation', was as much a beneficiary of the new rich, turbulent economy as were the entrepreneurs who created it. This chapter will look at the new entrepreneurial generation coming to London, making money there and elsewhere, and spending their fraction on art. While there are a multitude of possible approaches to this subject – through the collecting practices of bankers, of younger-generation aristocrats, of property developers, of technologists – the common thread here, if only for the sake of breaking new ground like the railway navvies, will be transport.

The London Schofield arrived in was very different to the London of Leicester or Fawkes. Principally, it now had a highway running from its edge to its heart: John Nash the architect had designed and masterminded the construction of Regent Street in the 1810s, cutting through medieval streets and flattening communities, offering smoother traffic flow and new commercial opportunity. Destruction of inner cities by road construction and the insertion of shopping malls, as experienced in the late twentieth century, is nothing new. Regent Street, an initiative of the Crown not the City, tore into London, echoing urban developments in Paris and Berlin. The railway stations, when they came, settled at London's edge, in the villages of Paddington and St Pancras, and at Euston Square. This was not out of courtesy or respect for the capital, but because of immemorially tangled

property rights. As Schofield experienced only too vividly, London's road infrastructure developed through pressure from the economic growth that he himself participated in. The fortunes of the coach-building industry profited from the resulting demand at the same time as they helped to create it. Schofield observed:

> Occasionally the road [Strand and Fleet Street] was so completely blocked up that we were obliged to stand still for a moment or two. If I looked out of the window to see what the matter was, my cheeks would be saluted by the delicate lips of a horse, and when you consider that the dray horses here are as large as Elephants you may judge that it is not pleasant to be <u>kissed</u> by them . . . It is truly wonderful to see the skill of driving and the infrequency of accident.

Among the immediate beneficiaries of the demand for improved road transport were Benjamin Windus, Robert Vernon, Isambard Kingdom Brunel and Joseph Gillott. They built the vehicles that filled the roads; supplied the horses that pulled the vehicles; designed the bridges that carried the traffic; manufactured the pens that wrote the orders to supply the horses to pull the vehicles to fill the roads, to cross the bridges, and so on. From his father, the owner of a coach-building company in Bishopsgate, Benjamin Godfrey Windus had inherited in 1832 a 'unique and elegant cottage residence', or as John Ruskin called it, a 'cheerful little villa' in Tottenham. One of his first actions on moving in was to add a library to the side of the house, where he shelved his books and displayed his growing collection of pictures. Windus commissioned in 1835 a watercolour from John Scarlett Davis to celebrate the delights of his picture room: ranged around in gold frames, and painted in clear detail, are some of the hundreds of contemporary watercolours that Windus had collected, including works by Turner, William Cattermole, J. F. Lewis and David Roberts. On the left-hand side of Scarlett Davis's watercolour is a generous pile of leather-bound, gold-tooled albums, some of large (folio) size, lying horizontally, with other smaller quarto volumes tucked into the bookshelves. The two children depicted, Windus's own, were perhaps a too perfect youthful audience, attentive, engrossed and well behaved; but nevertheless

a clear suggestion that here was the object of all this creative and considered investment, the coming generation, their education and enlightenment.

Benjamin's uncle, Thomas Windus, a character as cerebral as Benjamin himself and a particularly active partner in the family coach-building company, lived nearby in Gothic Hall, Hackney. There he accommodated his museum of antiquities in a new wing which may have been the inspiration for Benjamin's library; certainly, museum extension building seemed to be a family practice. The two Windus collections were fruits of the labour of three generations of coach-builders whose company supplied some of the better carriages that were sold and rented out, perhaps to Robert Vernon, and jammed the streets of the capital. The name 'coach-builder' is still used by manufacturers of buses and railway carriages, the vocabulary remaining static as the technology moves on. Britain, a small connectable island with a benign climate and geography, was a nation of inland travellers, by coach, carriage, barge, omnibus and rail. As a consequence, the industry of coach-building, harness-making, upholstery, painting and polishing prospered to maintain the healthy momentum of supply and demand for comfortable travel to suit every pocket and engage every shire. Additional crumbs of profit were left over for investment by entrepreneurs in art. The Winduses were particularly successful and respected in their business, being the company engaged to keep the Lord Mayor of London's coach in good repair and to maintain its appearance with fresh crimson velvet for public display. The family provided four Winduses as Master of the Worshipful Guild of Coachmakers from 1794 to 1826, when Benjamin had that honour.

Benjamin Windus's inheritance was not solely derived from his paternal grandfather's coach-building business, however. His mother's father, Benjamin Godfrey, had built up a fortune making and selling Godfrey's Cordial, a mixture of opium, treacle, brandy, caraway and spices, prescribed for fretful babies (and their mothers). Known colloquially as 'Mother's Friend', Godfrey's Cordial was one of a number of patent variations marketed all over the country. Having sold his grandfather's cordial business, finding it as distasteful as the medicine he manufactured, Benjamin Windus managed to live his collecting life on the proceeds of both cordial

and carriages, and from his directorship of Globe Insurance. Windus was
buying watercolours when he was still a young man: he lent his Turner
watercolour *Margate* to an exhibition organized by the engraver and pub-
lisher George Cooke in 1823, and thereafter, in particular since he built his
library, he was generous and welcoming in allowing visitors to see the col-
lection, by ticket, on Tuesdays. In this he followed the practice of collectors
of the previous generation including Stafford, Hope and Leicester. Ruskin
was an early and regular visitor:

> I believe the really first sight [of a Turner watercolour] must have been
> the bewildering one of the great collection at Mr. Windus's . . . bewilder-
> ment repeating itself every time I entered the house, and at last expand-
> ing and losing itself in the general knowledge to which it led.

Immersing himself in Windus's collection was one of the prompts that
encouraged Ruskin to embark on writing *Modern Painters* in the late
1830s. Scarlett Davis's watercolour shows the collection at its height, when
Windus owned more than 160 Turners and dozens of works by other
contemporary watercolour painters. Davis confided to a friend about the
complexity of the task that Windus had put before him:

> I am now engaged on a very difficult subject, the interior of the Library
> of Mr Windus, who has filled it with about fifty Turners . . . there are
> parts of some of them wonderful, and by G–d all other drawings look
> heavy and vulgar, even Callcott and Stanfield and even the immortal
> Alfred Vickers, J. D. Harding and J. B. Pyne.

Turner had himself seen Davis's drawing and spoke 'in the highest terms'
of it. The majority of the Turners that Windus bought were works that
had been through the engraving process, having been commissioned by
engravers including the Cooke brothers and Charles Heath specifically to
be published as engraved illustrations. The originals had fulfilled their first
purpose, and so entered the market. Walter Fawkes had amassed his col-
lection of watercolours during the first two decades of the century, before
Turner had become such a juicy target for the expression of publishers'

commercial instincts, and on the strength of his own uninfluenced eye. Windus's collection, on the other hand, was the direct product of the new commercial direction for art, a collecting attitude which had a contained reassurance in the presence of a buoyant art market, and further added value in the circulating presence of hosts of engravings after the originals. While he bought in quantity and with some rapidity, Windus was a man of his time and had a dealer's instinct, knowing what to buy and when to sell. So in the 1850s he had little hesitation in trading his watercolour collection more or less entirely to buy important Pre-Raphaelite paintings, including Holman Hunt's *The Scapegoat* and Millais' *Vale of Rest*.

Benjamin Windus is one classic example of a manufacturing business-man who relaxed with his paintings. Another is the Birmingham pen-nib manufacturer Joseph Gillott, who does not appear to have been the relax-ing kind; a third is Elhanan Bicknell, whale-oil merchant of Herne Hill; a fourth is William Gibbs of Tyntesfield near Bristol, a bulk importer of guano from South America; a fifth is John Hornby Maw, the son of a druggist and pill-maker of Cripplegate. Entering his father's trade in the early 1820s, Maw ran it so successfully by diversifying into the lucrative field of surgical instrument and prosthetics manufacturing that he had taken full control of the company by the end of the decade. Maw had 'the very brightest of blue eyes . . . and an enormous capacity for and love of hard work for its own sake, inventive genius and wonderful powers of acquiring general information'. Maw's energy, fuelled by the money he made, enabled him to buy a modest estate near Roydon, Essex, fill it with artists, clients, friends and relations, throw parties, organize country trips, arrange art exhibitions in his house, and live a life of comfortable fulfil-ment. Like Windus, he collected watercolours, many bought from artists who became friends, such as John Varley, David Cox, John Sell Cotman, William Henry Hunt, J. D. Harding, Samuel Prout and Turner, and from friends who became artists as a result of the many trips Maw took into the country with Cox and Hunt as tutors. Cotman, indeed, also supplied Maw with paints, from his informal colour manufactory, Cotman & Co., established at his house in Hunter Street, Brunswick Square, in London. Cotman had a friendly correspondence with Maw in the 1830s, when he

was a well-known if not too financially successful artist who had moved to London from his native Norwich.

> I have duly entered your order for Dabs of all colors, an article I have long wished to speculate in, from their know[n] quality of exhibiting if well executed the essential spirit of the Raw Material. Not that I mean to build a Gin Palace, nor one quite of air, therefore I think the price for such dabs as I shall send you will be two guineas each, Half a dozen of which shall be sent to you forthwith as a sample.

The correspondence between artists and Maw demonstrates the close business and personal friendships that he and his family enjoyed. Having made his fortune, Maw retired aged thirty-seven and moved to Hastings, where he directed his energies to improving his own skill as a watercolour painter under the eyes of Cotman, Cox and Hunt. The latter was assiduous in providing a service to Maw and his other clients, chasing payment, offering to remake a favourite subject, giving attention to his pupils. 'I shall feel greatly obliged,' Hunt told Maw,

> if you will let me know if you are in the same mind that you was at the Exhibition Room when something was said about my making you a similar drawing to the one of the Boy tickling the Girl. If so I am going to the same spot and would make something as near like it as possible. The drawing you purchased of mine at the Exhibition . . . I shall feel greatly obliged if you will let me have the amount as soon as convenient.

Samuel Prout also had drawings to sell, and told Maw that 'I have finished several small drawings which I mean to exhibit . . . I will endeavour to obtain your opinion of them at the first opportunity.' Cotman declined with regret an invitation to one of Maw's many parties, referring as he did so to the astrological obsession of their mutual friend John Varley (see page 82):

> I am sorry to say I am too ill to be with you & your delightful party this evening. You know well my disappointment! If John Varley was by my side I would send you a luminous reason for this. As it is, I know no more than the Man in the Moon whether it's Jupiter, Mars, Leo or Saturn that

are active in the ascendant against my poor Taurus . . . Why the next time he serves me so why I will ring his nose for him in the very face of his Horns.

Fed up perhaps with the constant attention of artists needing something from him, and tiring of retirement, Maw found a new interest in the manufacture of ceramic tiles. He bought in 1850 the stock and patents belonging to the pioneering ceramicists Herbert Minton of Stoke-on-Trent and Walter Chamberlain of Worcester, and reinvigorated the companies to produce the intricate and inventive encaustic tiles that decorate churches, public buildings, hotels and homes all over Britain. John Betjeman, among many, was touched as a young man by the terracotta and buff tiles of the kind that were produced through the entrepreneurship of Maw at his Jackfield Tile Works. In his poem 'St Saviour's, Aberdeen Park' Betjeman speaks of 'solid Italianate houses for the solid commercial mind', and recalls his parents and the church where 'over these same encaustics they and their parents trod'. This interest in decorative pattern led Maw naturally to enquire about mosaics, and to open a correspondence with the painter Charles West Cope, who had himself designed mosaics. Cope responded:

[I will do] anything in my power to assist you in your experiments in mosaic decoration & I should be glad to see this branch of art take root in the country . . . giving employment to many persons it would be a great means for retrieving our public buildings & private dwellings of their present colourless & sombre dullness.

Transport was the key to the development of art patronage in nineteenth-century Britain. Its pace of change continued inexorably, providing the networks that Maw needed to distribute his tiles and the income that both he and Windus required to create their collections. The carriage-building industry, of which Windus was a leading figure, depended on the transport industry in all its manifestations to buy its production of vehicles, while the transport industry, before, during and after the coming of the railways, required good roads to run on. The dealer Thomas Griffith, who sold paintings to both Maw and Benjamin Windus, was a member of the

wide-reaching circle of artists and collectors in which conversazioni were regular events and difficult road journeys were undertaken to maintain contact and to keep the circles in motion. Cotman had one particularly bad journey, when returning from a visit to Maw in Guildford. He spilled out his experience for therapy:

> I left your house at ½ past 2 o'clock AM & by mistake got upon the outside (no inside place) of a Van, a coach looking affair as far as a dark night wd allow me to see it, but soon, very soon found out my mistake to my severe cost. The Mail in about ¾ of an Hour passed us like a blazing meteor – and the Rocket in about 10 minutes after that did the same at the same rapidity – and by this I had taken my place. Well my dear Sir – a cold & wet ride of no less than Six hours. Six long, long hours brought me into Blackfriars Street, to my great, great joy, I being almost dead I could be said to feel anything but cold & wretchedness – and that night to a sick bed, of a violent & dangerous inflammation of the bowels from which I am but just recovered.

So the circles rotated, one within the other. Cotman urged Maw to encourage Griffith to call on Cotman: 'at all events I have invited that gentleman for Tuesday though I own it to be a great piece of presumption in me to do so & so I said in my Note to him.'

Successful businessmen, who had made their fortunes in trade or manufacture on the back of scientific discovery and technical improvement during the first years of Victoria's reign, were among those who filled their villas in Ealing and Hackney, Blackheath and Roydon, Herne Hill and Tottenham, Birmingham, Bristol and Hastings, with glowing collections of watercolours. What was it about large, bluff, secure men like Fawkes in his generation, and Windus, Maw, Gillott and Gibbs in theirs, that drew them to the fragile art of watercolour? All would know to their cost that daylight fades watercolour, robs it of its life, turns blue to grey, green to brown, and steals away with red. They would not put up with that kind of behaviour in their business dealings; they might indeed bankrupt a rival who threatened the value of their investments, the colour of their reputation. Watercolour collections need nurturing, protecting, keeping like mushrooms in the dark. They are fleeting in their effect and delicate in transmission, and like

a book can really only be read by one person at a time. An oil painting will dominate a room and can overwhelm all present; a watercolour, on the other hand, has to be approached with care and humility, the meeting sometimes akin to a séance. Artists knew this only too well, and it was this difference that many had sought to diminish by exhibiting watercolours that aped oil paintings in their size, subject and treatment. Indeed, an entire exhibiting circuit grew up on the back of it, and fade-resistant paint manufacture developed to counter it. Nevertheless, the attraction of riches to watercolour may be that watercolour touches the quiet, feminine side of the alpha male of business, and suggests that he does have a care.

Collectors have widely varying impulse, taste and purpose: Windus the coach-builder, volatile enough in his collecting to sell up his water-colours entirely to buy Pre-Raphaelite oils; Maw the surgical instrument maker, then tile manufacturer. These are two prominent figures in art collecting in the mid-nineteenth century, both of the meritocratic genera-tion, emerging from traditional but reindustrialized trades. Another was Elhanan Bicknell, whose income derived from highly prized spermaceti oil, used in cosmetics and candles and found only above the eyes of sperm whales. One large whale, hunted in the North or South Atlantic, might produce four tons of oil, enough to soften the cheeks of a million women, or to light up London for a weekend. Bicknell's income derived from his company which managed whaling fleets and the purchase and sale of their cargo, while his expenditure went on his succession of four wives, on his five (or more) children, on his houses in London and Herne Hill, and on his passion for collecting British painting and sculpture. Among his artists were Clarkson Stanfield, David Roberts, Augustus Wall Callcott and E. H. Baily. Turner, who was one of Bicknell's friends and confidants, made one of his few business errors when in the mid-1840s he produced a series of four uncharacteristic paintings on the theme of the South Atlantic whaling fleet, in the apparent hope that Bicknell might buy them. Bicknell seems to have bought only one, which he soon got rid of, while the other three remained with the artist.

Yet another major collector, one whose collection has come down to us more or less intact, was Robert Vernon, a horse-and-carriage dealer in

London who had inherited from his father his successful business selling
and renting equine transport. Royalty, aristocracy, the army, business and
trade formed a client base of such affluence that the father was able to
collect seventeenth-century Dutch paintings, and the son capped that with
one of the most important collections of contemporary British painting
of the period, including works by Gainsborough, Turner, Constable and
Landseer. He made money so efficiently and effectively, principally out of
supplying horses to the army, that in 1832 he bought the lease of 50 Pall Mall,
the grand London street in which Gainsborough, Cosway and Angerstein
had lived, where Christie's had been, and where the British Institution
still drew the crowds. Vernon was an enthusiastic and perceptive collec-
tor, displaying his paintings both at his country house, Ardington, south
of Oxford, and in Pall Mall, with the rapid effect that Vernon's collection
tended to echo the popularity and purpose of Angerstein's collection, by
then reborn as the infant National Gallery at number 100. Next door to
Vernon in Pall Mall lived Samuel Carter Hall, the proprietor of the journal
Art-Union, which published a through-the-keyhole article on his collection
in its first issue in 1839:

> Every room in his mansion is filled with [pictures] . . . there is no gaudy
> drapery or gilded furniture to attract the eye and distract the attention
> . . . Even the brass rods that hang the pictures are painted over.

The aim of *Art-Union* was, inter alia, to bring engraved reproductions
of works of art to a wide public. Prints were distributed by lottery to
subscribers, who were kept abreast of art-world news and gossip through
editorials and chit-chat. In sum, the journal was a vital tool in maintaining
the circulation of information and money in the art trade. Every volume
had engravings and lithographs bound into it, each 11½ by 8½ inches,
printed on heavy paper, and inscribed 'Published exclusively in the Art
Union Journal'. These the subscribers could cut out and frame. Vernon and
Hall made a business partnership with a lucrative deal in which *Art-Union*
reproduced and distributed Vernon's paintings by engraving, thus increas-
ing public knowledge and raising the value of Vernon's collection. This
was a reverse of the system in which Turner's watercolours were engraved

on completion and then sold off to collectors. Among the backers of *Art-Union* were the engraver John Landseer, Edwin Landseer's father, and the print publishers Hodgson and Graves. This early form of co-operation set the tone for a range of business developments in the arts, the intention of which was not only to broadcast works of art more widely, but to make large sums of money. Samuel Rogers caustically and characteristically objected:

> The Art Union is a perfect curse: it buys and engraves very inferior pictures, and consequently encourages mediocrity of talent; it makes younger men, who have no genius, abandon the desk and counter, and set up for painters.

Angerstein's collection was removed from 100 Pall Mall to the new National Gallery in Trafalgar Square in advance of its opening in 1838. Ten years later Vernon's collection embarked on a similar short journey along Pall Mall to Marlborough House, when it was accepted as a gift as the foundation of a national collection of British art. The bulk of it is now in Tate Britain.

The robust Birmingham pen manufacturer Joseph Gillott rose from a family background of cutlery-making in Sheffield to become the wealthiest and most successful maker and supplier of pen-nibs in the world. Gillott cleverly grasped the obvious – that written records for trade were essential and would only grow; that growth in education demanded writing; and that expansion of the opportunities in travel required at the very least that somebody write out a ticket for somebody else. The common factor here was the pen-nib, and Gillott joined the competition to make and improve pens and their nibs. No network of goose farms could possibly hope to produce enough quills to meet the exponential rise in demand for a reliable instrument to transfer ink to paper, so a small shaped piece of treated metal at the end of a fashioned stick was the answer. When Dickens's Mr Merdle killed himself with a penknife – that is, a knife designed to trim goose quills into pens – the 'Man of the Age' was employing old technology.

Gillott moved to Birmingham aged twenty-two in 1821. Beginning in the buckle-making trade, his grasp of miniature metalworking and his cutlery background gave him a rich understanding of the qualities of flat

metal. With the availability of thin sheet steel, he was able to develop means to stamp out nib forms, give them a simple lateral curve, and, crucially, split them lengthways to create a channel and a small reservoir for ink. This is not a complex industrial process; its simplicity allowed the pen-nib to evolve from primitive appendage to near-perfection in a few short stages. While a goose-quill pen might hold enough ink to write two or three words and make a blot, a steel pen, properly curved and cut, could hold enough for a complete sentence – and not blot.

By 1829 Gillott was advertising his pen-nibs and assorted calligraphi-ana, and had set up in Newhall Street, amidst a plethora of small trades in Birmingham's Jewellery Quarter. By the end of the 1830s he had expanded into his new factory, the Victoria Works on Newhall Hill. From there he turned out 490,361 gross of pen-nibs in 1842, a figure that nearly doubled the next year. One gross is 144 individual units, so his factory was making more than 70 million nibs in 1842, and more than 100 million the follow-ing year – that is, a quarter of a million pen-nibs a day. Gillott's pens sold across the nation, filling goods wagons on the railway lines now beginning to fan out from Birmingham, and barges on the canals. He was among the earliest entrepreneurs to travel on Brunel's steamship the *Great Britain* to New York, where he opened first an agency in Chambers Street and then a US manufacturing base in New Jersey. Gillott's profits were monumental – his personal income beyond the dreams of avarice, the tentacles of his trade drawn in long, thin pen-and-ink lines across the world's map.

Picture collecting could be, for Gillott, a hobby limited only by the reach of his taste. He did not, for example, buy Pre-Raphaelite paintings, not because he could not afford them, but because he did not like them. His house in Westbourne Road, in the Birmingham suburb of Edgbaston, had three picture galleries; other rooms also had pictures in them, of course, as did his town house in Newhall Street. His houses were filled by the schools Gillott liked best: Dutch seventeenth-century painting, eighteenth-century French and nineteenth-century British. In the latter category Gillott col-lected Callcott, Constable, Danby, Etty, Frith, Goodall, Hunt, Landseer, all the way through the alphabet to Turner, Varley and Ward. For a short time in 1866 he owned Constable's *Landscape: Noon*, better known as *The*

Hay Wain (1821), before selling it on to Henry Vaughan. He tried unsuccessfully to persuade Landseer to paint exclusively for him by giving him £5,000 over and above his usual earnings; he bought from Etty and carried on a long and familiar, even intimate, correspondence with him from 1843 until Etty's death six years later. The Turners Gillott owned included *View of the Temple of Jupiter Panellenius* (1816), *Calais Sands* (1830) and *Schloss Rosenau* (1841). 'Turner's a rum chap,' Etty remarked to Gillott, 'but a kind heart at bottom.'

For Gillott, collecting shaded very sharply towards dealing. His enjoyment of art was not only in the thrill of making a successful purchase; what he also enjoyed was buying and selling, sometimes quite quickly. *The Hay Wain* he sold again within weeks, sharing the relatively modest profit of £273 with his adviser William Cox. Buying dozens of nudes from Etty in 1847, he rapidly sold many of them on, and he owned some of his Turners for a remarkably short time. Not wholly satisfied with the bland market in pen-nibs, Gillott got his kicks in the art world. Inevitably, Gillott had intensive trade activities with dealers, including established companies such as Agnew's, Ernest Gambart and Henry Graves, and chancers such as Serjeant Ralph Thomas, a lawyer who inhabited the fringe of the art-dealing world. Thomas, 'a most voracious collector of every sort of object from pictures to warming pans', knew John Martin well enough to write extensive notes on his life, patronized the young John Everett Millais with irritating small payments, and came to write the first comprehensive catalogue of Whistler's etchings. Gillott bought property including, from Gambart in 1862, the lease on 62 Avenue Road, St John's Wood, and in 1867 the jewel in the crown of the art world of the past seventy or eighty years, the former Boydell's Gallery in Pall Mall, when the British Institution was dissolved by its directors on the termination of the lease.

We can reasonably reflect on the idea that it was the taste for extensive collections of paintings in the nineteenth century that generated the need for art galleries in large ground-hungry houses and consequent suburban development. Architecture followed art: houses may not have needed paintings to function; but paintings needed houses. Gillott was so prominent as a collector that he attracted the attention of Gustav Waagen, the

director of the Berlin Museum, on his fact-finding tours of England in the 1850s. Visiting Manchester, Liverpool and Birmingham, Waagen remarked that 'the good star which had presided, with few exceptions, over my various excursions in England, was more especially in the ascendant during my visit to Birmingham'. Waagen had first been to England in 1835, and on his 1850s visits he could see how collecting by the new industrialist generation would compare with the practices of the aristocracy (see chapter 10).

The railways were, in the 1840s, a catalyst for a rapid change of step and of perspective for both patrons and artists. The movement around the country of cooking pots and calico, papers and pen-nibs, may have been made swifter and more regular by rail; but so too, by rail, were artists and their patrons able to get together faster, carry on their businesses, and get on with the next thing. Haydon bumped uncomfortably back to London in a horse-drawn stage-coach in 1809 after some days paying court to Beaumont in Leicestershire; thirty-four years later, in 1843, the portrait painter John Lucas could nip up to Tamworth on the steam train to call on the then prime minister and see his portrait gallery at Drayton Manor. Finding time from domestic and world affairs, Sir Robert Peel told Lucas how to get there: 'trains from Euston Square . . . bring you to Tamworth 2 miles only . . . in five or six hours. The eleven o'clock is the best.' Patterns were changing. The year 1843 was the moment when Turner conceived his painting *Rain, Steam, and Speed – the Great Western Railway* (exhibited 1844) in which a steam train flies at an unconscionable speed across Brunel's railway bridge, and eats up the miles to Bristol.

William Gibbs, of Tyntesfield, whose imported South American guano provided raw material for both explosives and fertilizer, invested his time and money generously in Brunel's Great Western Railway. Gibbs clearly saw the commercial and social value of a railway line connecting London with the west of England, and the further benefits of Brunel's giant leap of imagination in linking Bristol with New York by the *Great Britain* steamship. For Tyntesfield, the neo-Gothic house he built out of guano profits, Gibbs collected paintings by Clarkson Stanfield, Callcott, John Phillip, and many other artists in oil and watercolour. The year after William Gibbs' death, his son Anthony, heir to the fortune, bought Turner's grand

visionary landscape celebrating Greek history, myth and independence, *The Temple of Jupiter Panellenius Restored* (1816), the pair to Gillott's *View of the Temple of Jupiter Panellenius*. This hung at Tyntesfield until 1982, when it was sold to America. Thus these two hymns to Greek independence were owned out of the profits of independent free trade: one from pens, the other from bird droppings.

Gillott may be seen as the kind of collector who enjoyed the process of collecting as much as he enjoyed the collection itself. Gibbs bought relatively calmly, seeing his paintings as but one part of an integrated whole with architecture, furniture and fittings. Maw, on the other hand, relished the multiple engagements that collecting brought him: his own amateur painting, tuition from his artist friends and gossipy friendships in which he experienced the rough and tumble of the artistic temperament – with an easy exit via the salerooms always available if required. Gillott and Maw in particular clung to their amateur status while trying to run with the professionals. Windus, though happy to get out of one particular stock, watercolour, when oil painting seemed to be more satisfactory, had a more straightforward approach to collecting, a simple one-to-one act of buying, enjoying, sharing and then selling. He was one kind of transport entrepreneur who used his business income to fuel his collecting habits; others, however, notably Joseph Baxendale and Isambard Kingdom Brunel, were developing businesses elsewhere in the transport network and making profits that kept the wheels of the art market turning. Joseph Baxendale was the director of the cartage company Pickfords; Brunel was the man who built the ship that took Gillott to America, and whose genius made possible transport initiatives and their infrastructures on land and sea. These confident, opinionated and powerful men together personify the changes that had taken place in patronage in Britain. Samuel Carter Hall writing in 1847 in the *Art-Union* observed:

Amongst our wealthy manufacturers there exists an appreciation of the artist and patronage not dissimilar to that which was once the pride of the citizens of Florence, Genoa and Venice ... Nor is this patronage indiscriminate.

Elizabeth Eastlake, the writer and critic, was a particularly well-connected woman who noticed the social and financial trend by which art patronage had begun to move down the social scale, to the enrichment of British art. Eastlake's connections lay deep in the literary world: she wrote for the publisher John Murray and was a regular guest at his Albemarle Street conversazioni, while her husband, Sir Charles Eastlake, had been both the president of the Royal Academy and the director of the National Gallery since 1854. The generation of landed patrons was being followed 'by a wealthy and intelligent class, chiefly enriched by commerce and trade', as Lady Eastlake put it. The painter Thomas Uwins expressed this trend more directly:

> The old nobility and land proprietors are gone out. Their place is supplied by railroad speculators, iron mine men, and grinders from Sheffield etc., Liverpool and Manchester merchants and traders.

As a consequence, the pocket book that an artist might carry, 'while it exhibited lowlier names, show[ed] henceforth higher prices'. Lady Eastlake went on to propose an explanation, which is as sweeping as it is patronizing:

> For one sign of the good sense of the *nouveau riche* consisted in a consciousness of his ignorance upon matters of connoisseurship. This led him to seek an article fresh from the painter's loom, in preference to any hazardous attempts at the discrimination of older fabrics.

Pickfords, still in the early twenty-first century a thriving transport company, was already a prominent name in the industry in the 1840s and 1850s. In 1858, when he was forty-six years old, Charles Dickens travelled to his childhood home of Rochester to see how it had got on since he was a lad. He remembered the playing fields, but they had been swallowed up by the railway station; he remembered the horse-drawn coach that had carried him off to London, Timpson's *Blue-Eyed Maid*, but that had now been replaced by a locomotive 'called severely No. 97, spitting ashes and hot water over the blighted ground'. And he remembered Timpson's small town coach-office, 'with an oval transparency in the window, which looked beautiful by night, representing one of Timpson's coaches in the act of

passing a milestone on the London road with great velocity, completely full inside and out, and all the passengers dressed in the first style of fashion, and enjoying themselves tremendously'. In Dickens's heart-felt regret at the changes in things, Rochester becomes 'Dullborough', Timpson's he notes is now Pickford's, 'one great establishment with a pair of big gates', and the illustrated window has vanished. 'He is not Napoleon Bonaparte', Dickens observed of Pickford, referring to Napoleon's looting of works of art from conquered nations. 'When he took down the transparent stage-coach he ought to have given the town a transparent van. With gloomy conviction that Pickford is wholly utilitarian and unimaginative, I proceeded on my way.'

While with one hand a Windus might welcome visitors to his collection, with another a transport entrepreneur like Pickford might dispose (according to Dickens) of a familiar public picture. While Dickens set pugnaciously upon 'Mr Pickford', the man who should have been in his sights was Joseph Baxendale. The Pickford family had long since sold out their company to Baxendale, a surgeon's son from Lancaster, whose intuition and energy detected a synergy between road, canal and rail, and who saw how by using the three modes of transport in harmony he could create a flourishing business and keep commerce moving around the country. Further, he could make a fortune. His father had exhorted him to 'make yourself a perfect master of Book-keeping . . . The advantage you will ultimately receive from it, there is no appreciating.' Baxendale not only heeded his father's advice, but gave advice to his staff, in the form of notices pinned up in Pickfords offices and warehouses around the country. These he called his 'Run and Read Sermons': 'Method is the hinge of business, and there is no method without punctuality'; 'Nothing without labour'; and 'He who spends all he gets is on the way to beggary'. Sam Smiles devoted some pages to Pickfords in his popular book *Thrift* (1875), using Baxendale, whom he referred to as the Benjamin Franklin of business, as a paragon of business practice and entrepreneurial energy. He tells how Baxendale would travel between towns looking out for Pickfords vans, and double back on them to check if they were delayed, or if the driver was drunk in charge, or failing to carry a loaded blunderbuss against highwaymen. With

his canal boat, named *Joseph* after himself, he carried out similar inspection routines on his water transport. Baxendale's employees never knew where he might pop up, and with this prick of uncertainty always in the backs of their minds, Pickford drivers ensured the company's success and longevity. Baxendale died a rich man, with a personal estate of £700,000, passing Pickfords securely, as far as he could tell, on to his three elder sons. One of these came to give to the nation an extraordinary and unique collection of portrait drawings of over a hundred leading contemporary cultural figures (see chapter 11).

The man whose name is never far from the surface whenever mid-nineteenth-century transport is discussed is Isambard Kingdom Brunel. As the creative and executive energy behind the Thames Tunnel, the Clifton Suspension Bridge, Saltash Bridge, the Great Western Railway with its embankments and tunnels, and the steamships *Great Britain* and *Great Eastern*, Brunel possessed all the courage, invention and bloody-mindedness that was required in the development of Britain's transport infrastructure. As a patron of art, however, he is less well known, despite the fact that he brought unfamiliar industrial production techniques to the commissioning of art.

Brunel had an engaging habit of noting down his own assessment of his life so far, and how he should improve or progress his career. He was short in stature and this troubled him – he was 5 feet 4 inches tall, about the height of Turner and Faraday, Napoleon and King Louis-Philippe of France. Reflecting on this in 1827, he wrote some frank self-analysis:

> My self-conceit and love of glory or rather approbation vie with each other which shall govern me. The latter is so strong that even on a dark night riding home when I pass some unknown person who perhaps does not even look at me I catch myself trying to look big on my little pony . . . My self-conceit renders me domineering, intolerant nay even quarrelsome with those who do not flatter me in this case.

Brunel thrived on flattery and the cheers of the crowd, and sought to be lionized. His self-esteem was unmatched, and he knew that to be accepted into society he had to marry well. Engineers in the early nineteenth century,

before engineering became organized as a profession, were considered to be horny-handed, grubby workmen, with little or no intellectual pretension, who could not be taken into a drawing room. 'Shall I make a good husband?' he asked himself:

> Am doubtful. My ambition, or whatever it may be called (it is not the mere wish to be rich) is rather extensive, but still – I am not afraid I shall be unhappy if I do not reach the rank of Hero and Commander-in-Chief of His Majesty's Forces in the steam (or Gaz) boat department … Build a splendid manufactory for Gaz engines, a yard for building the boats – and at last be rich, have a house built of which I have even made the drawings. <u>Be the first Engineer and example for all future ones.</u>

Eventually he found, courted and in 1836 married Mary Horsley, the daughter of the organist and composer William Horsley of Kensington, and part of Kensington society that so richly included Mary's great-uncle Augustus Wall Callcott RA, his wife Maria Callcott, and Mary's brother the painter John Callcott Horsley RA, an associate of the Pre-Raphaelites. The latter was known as 'Clothes Horsley', on account of the extraordinary and detailed costumes he made his models wear. Isambard, introduced to the Horsleys by a Brunel family friend, met Mary in the family music room over a grand piano that had been, or would be, played by other Horsley friends, giants in the musical world, including Brahms, Chopin, Joachim, Mendelssohn, Bellini and the violinist Paganini. The Callcotts and Horsleys were starry and self-regarding, a family of talent, social connection and aplomb that wove its spell around Isambard Kingdom Brunel. His own background of mud, oil and engineering was the antithesis of the Horsley–Callcott world, and Brunel was desperately attracted to this other ethereal magic.

Mary Horsley, though beautiful, had none of her family's artistic talents and was aloof, haughty and unemotional. In marrying her, Brunel was associating himself publicly with the conventional art world of the metropolis. He was also procuring for himself a 'trophy wife', one who enjoyed the nickname 'Duchess of Kensington'. Isambard and Mary Brunel went

to live in Duke Street, St James's, where he set up an office at number 18. One wonders why he bothered to marry, if not only for dynastic purposes. Totally engaged as he was by his engineering projects, Isambard was rarely at home, and Mary held salons alone: 'my profession is after all my only fit wife', Isambard had once written.

Living above the shop, as the Brunels did in the first few years of their marriage, they expanded by acquiring in 1848 the neighbouring house, number 17, as Isambard's engineering business prospered and their family grew. At Duke Street Brunel employed a staff of up to forty men – engineers, draughtsmen, clerks and pupils, among the latter Joseph Baxendale's nephew – with a constant ebb and flow of personnel as men were hired, fired or failed to cope with Brunel's demanding management technique. 'Your duty', 'our angry discussion', 'opinions differing very much from my own' – these are phrases which crop up like tin-tacks in Brunel's correspondence with his staff. But while fiery and challenging discussions went on in the office, upstairs Brunel established his new credentials as a collector and lover of art by commissioning a Shakespeare collection for his dining room with twenty-four paintings of scenes from Shakespeare by some of the leading painters of history and literature of the day, including his in-laws Augustus Wall Callcott and John Horsley, Edwin Landseer, David Roberts and Joseph Noel Paton. This was a reworking on a domestic scale of the disastrous Shakespeare Gallery project inaugurated at the end of the previous century by John Boydell (see chapter 6). In an act highly revealing of his characteristic expectation and need for command, Brunel invited these and seven other distinguished artists to a series of meetings so that he could describe his grand plan to them. Brunel knew what he wanted: he gave the orders and expected artists, like boilermen, to come up with a product that worked, on time and to budget. Astonishingly, the artists did as they were told.

The first meeting over dinner on 18 December 1847 saw Brunel outlining his vision for his Shakespeare Room. His goal was to make

the rendering . . . of one of our most National of English Poets of <u>past times</u> the occasion or means of obtaining a collection of the best examples

of the first English Artists of the <u>present</u> time and I should wish to make the more apparent object – the illustrations of the Poet – subservient in each case to the second object.

In a letter to Landseer, encouraging his participation in the scheme, Brunel added: 'If I am so fortunate to induce the several <u>promising</u> contributors to this collection to enter warmly into this view, the collection will become one of National interest.' The contributors were instructed to meet Brunel a month later to discuss the way they would approach their proposed subjects, while at the third meeting Brunel looked over the artists' sketches so that he could find and secure 'harmony' among the participants and launch the paintings 'with a prospect of tolerably short voyages'. It was perfectly clear who was in charge. Brunel took the role of a chairman of the board and made it plain that success would depend on the painters' commitment to the patron's aims. Emulating Whitbread, Leicester, Fawkes, Beaumont, Gillott, Windus and Maw rolled together, Brunel desired to create in Duke Street a collection of British art of 'National interest'. But more than any of these other patrons, Brunel kept tight artistic control.

Decorating and furnishing Duke Street provided Brunel with one of his rare opportunities to relax and take his mind off engineering. He was currently working on the design and construction of the Great Western Railway line from London to Bristol, on railways in Devon and Cornwall, Wales and Ireland, on Saltash Bridge, on Plymouth Dock and on a number of other initiatives, so he had no time to spare for artists failing to stick to agreements. Artists were to Brunel just another branch of the industrial supply chain. Horsley told Brunel's son in 1870 that the engineer

passed, I believe, the pleasantest of leisure moments in decorating that house, and well do I remember our visits in search of rare furniture, china, bronzes &c, with which he filled it, till it became one of the most remarkable and attractive houses in London . . . In buying pictures [he] evinced a taste often found in men of refined mind and feeling – viz., a repugnance to works, however excellent in themselves, where violent action was represented. He preferred pictures where the subject partook more of the suggestive than the positive, and where considerable scope

was left in which the imagination of the spectator might disport itself. This feeling was displayed in a great love of landscape art, and in the keenest appreciation of the beauties of nature.

Brunel's ambition for his Shakespeare scheme echoed his many collector predecessors who had an eye to their cultural legacy: Sir John Leicester, Sir John Julius Angerstein, Sir George Beaumont, Robert Vernon – all had looked beyond the immediate task to the national interest when considering the growth of their art collections. In the event, Brunel's Shakespeare Room fell apart after his death, just as Boydell's Shakespeare Gallery had, and was dismantled and the paintings sold. For nineteenth-century speculators Shakespeare was not an auspicious pairing with painting. The burden of the Bard's language and legacy was so great that art orchestrated from many sources could rarely find the genius to balance it, certainly not in quantity. Nevertheless, as John Horsley recalled:

> This room, hung with pictures, with its richly carved fireplace, doorways, and ceiling, its silken hangings and Venetian mirrors, lighted up on one of the many festive gatherings frequent in that hospitable house, formed a scene which none will forget who had the privilege of taking part in it.

While Brunel's legacy as an engineer remains with us still, his legacy as a collector has blown away in the winds of chance and circumstance. A collection as solid, apparently, as Sir John Leicester's evaporated in the salerooms to pay debts; Gillott's collection was sold, as were Bicknell's, Maw's and the Windus collection. Those that remain largely intact – Angerstein, Beaumont, Stafford, Vernon, Sheepshanks, and many others – do so because of a combination of factors: a willing nation or city to accept them, generous collectors to offer them, well-rooted families to retain them, robust institutions to house and look after them, and an educated populace eager to enjoy them. We have moved from the Britain that George Eliot identified; a Britain where the 'tread-mill attitude of the weaver' had changed to one where 'factory men and women stream for their mid-day meal'. As John Pye observed in the late 1840s:

It must be borne in mind that [in the mid to late eighteenth century] sources of rational pleasure and mental improvement, such as in the nineteenth century are afforded to the million by the British Museum, National Gallery, Royal Institution, exhibitions of various kinds, and scientific institutions in all parts of the town, were then only within the reach of the few whose wealth enabled them to travel, or otherwise to make great sacrifices to obtain them.

Times had changed; art was coming into general reach.

PAINTER:
'PAINTING IS A STRANGE BUSINESS'

The mid-nineteenth-century art world ebbed and flowed with deep and loving friendships, legal and social conflict, high worldly success, miserable failure, riches and poverty. Turner found commercial and artistic success when he was barely old enough to shave; Haydon had 'a genius for failure'; Landseer, an angel with the paintbrush, was an unstable paranoiac with a drug dependency. This chapter looks at painters, against a complex back-cloth of the lives of unpredictable individuals: their instances of failure; their manifest opportunities for hope and generosity; and the shudder of the juggernaut success and its effect upon them.

The architect and draughtsman Joseph Gandy ARA was a firecracker whose temperament upset the public face of the Academy. He painted visionary architectural fantasies, creating on large sheets of paper alarming and congested urban landscapes that devour the acres, all planning night-mares that could never be adequately contained in brick and stone. A few of them did escape into reality, and one survives intact: Doric House, on Sion Hill in Bath. Constable believed that Gandy had been 'hunted down . . . most cruelly and unfairly' in his attempt to find due recognition for his visionary architectural conceits. He had worked for John Soane, a man of equally splenetic temperament, and it may be that they found themselves to be kindred souls in their furies. But Soane, as a successful architect, could harness chance and trouble to his own purposes, a talent that Gandy always failed to grasp: 'I never have any idle moment . . . to spare from work to keep my family alive, or being destroyed in a sea of trouble', he wrote. With his wife and ultimately nine children, Gandy moved from address to address in Soho in perpetual flight from the consequences of

financial imprudence. Soane, not a naturally generous man, paid up when Gandy was in trouble: he gave Mrs Gandy £100 when her husband was carried off to the Fleet Prison for debt in 1816. 'Mrs Gandy called to say her husband had surrendered and they were all starving', Soane noted in his diary. After being imprisoned for debt a second time in 1830, the Royal Academy listened sympathetically to his plea for help by allowing him a pension due to his 'total want of professional employment'. Constable was one of the few who supported Gandy when he applied to become an Academician:

> Another melancholy letter of poor Gandy's was read [to RA Council]. It was very strangely worded – much like a person in distraction. He mentioned his having dreadfull symptoms of a discharge of blood from his mouth – sometimes in quantities and always a constant spitting of it – this will I fear dispense you & me of fulfilling our proper attention ... [Westmacott] said he was a 'bad-mannered' man – & was <u>rude</u> to any <u>gentleman</u> or <u>nobleman</u>, who <u>found fault</u> with his designs – & 'that he would not alter his drawings' &c. This has much enhanced Gandy <u>with me</u>!!

Benjamin Robert Haydon, however, was a uniquely difficult artist. Peppery, vain, debt-ridden, self-destructive and casting himself perennially in the role of victim, he nevertheless combined a flair for figure drawing with a particular talent for creating complex and arresting compositions in his historical narrative paintings. Coming to maturity as an artist just as the fashion for historical painting, the 'Grand Manner', was on the wane, he failed, or perhaps refused, to recognize that to make a decent living in the 1820s and 1830s he might have been better off choosing landscape or domestic subjects, genre or portraits. But no: he wanted to draw younger artists into the web of history painting, even as its purpose and audience was ebbing away. John Singleton Copley's *Death of the Earl of Chatham* (1779–81), a painting of contemporary secular history raised to the condition and scale of a Baroque altarpiece, had been exhibited and engraved in the 1780s, and sold by lottery with acclaim for 2,000 guineas in 1806; thirty years later Haydon found it difficult even to give his history paintings

away. The fact that his paintings were not so accomplished as Copley's would not have registered with Haydon.

Haydon's rigour as an artist, while destructive in the long run, was what attracted the engraver John Landseer to him in 1814 as a tutor for his sons, one of whom was one day to be the distinguished artist Edwin Landseer. Some years earlier Haydon had taught Charles Eastlake, an artist destined for the worldly and artistic success that Haydon craved. Eastlake, as a knight of the realm, president of the Royal Academy and director of the National Gallery, would become the sort of stuffed shirt that Haydon instinctively both wooed and loathed. 'Eastlake and his Brother spent the evening', Haydon wrote in his diary in 1809:

> Young Eastlake has determined on being a painter, which he should never [have] thought of, he says, had he not seen my Picture [*Dentatus*]. I hope he may be eminent. If before I die I can but see the Art generally improved and all in the right road, I shall die happy.

Haydon characteristically saw himself as the centre of interest: the words most used in his diary must be 'I' or 'my'. He was determined to found a dynasty, to be art's Abraham: 'My great object is to form a School', he proclaimed,

> deeply impregnated with my principles of Art, deeply grounded in all the means, to put the clue into the hands of a certain number of young men of genius that they may go on by themselves . . . so that we may raise old England's head to honour & glory & greatness in Art.

Haydon's charges for teaching were modest: he drew up an agreement with the parents of one pupil to give him three years' tuition for 200 guineas. He never gave up his determination to keep alive the subject of the Grand Manner of painting into the next generation. To an audience at the London Mechanics' Institute he proclaimed in January 1836:

> If there be any noble-minded boy who hears me, who is resolved to devote himself to keep alive the historical feeling . . . from utter decay; let me tell him his bed will not be a bed of roses, and his habitation as often

a prison as a palace; but if he be of the true blood . . . neither calumny nor want, difficulty nor danger, will ever turn him aside from the great object of his being.

Landscape painting Haydon scorned. During an interview in 1835 with the prime minister, Lord Melbourne, to discuss a commission to decorate the chamber of the House of Lords with paintings depicting Good and Bad Government, Melbourne teased him:

'Suppose we employ Callcott?'
'Callcott! My God, a <u>Landscape Painter</u>! Come, my Lord, this is too bad'.

Haydon loved the grand gesture. Temporarily in funds in 1814 when he sold his *Judgement of Solomon* for 700 guineas, he was able to pay off his baker, tailor, coal merchant and wine merchant at a stroke. However, he also owed money to the radical poet Leigh Hunt, who happened, at this moment of Haydon's good fortune, to be in Surrey County Gaol for debt. Leigh Hunt refused Haydon's offer of money, but enquired after *Judgement of Solomon*. In a trice Haydon had the 140-square-foot painting rolled up and sent to the prison for two days 'to relieve the tedium of confinement'. Then he had it sent to Cold Bath Fields Prison, where the radical orator John Hunt was being held, to cheer him up. He held open house at his studio from time to time, one visitor being Turner who, probably in 1823, made a pencil study of Haydon's enormous *Raising of Lazarus*, with colour notes, indicating that it was done in front of the painting.

When he painted genre scenes, such as the topical *Punch, or May Day* (1829) or *Waiting for the Times* (1831), Haydon did so with verve and an oblique sense of drama and narrative pace. In *Waiting for the Times* bloody-mindedness and impatience meet: one man is taking too long to read a *Times* report of the vote on the Reform Bill, and he knows it. We cannot see him, but we can tell a great deal about his attitude from the way he sets his legs. The other is waiting, his patience rapidly evaporating, his knuckles clenched over his umbrella handle. Nearly a quarter of the surface of the painting is taken up by a broadsheet newspaper, only very

slightly crumpled, as if this were a mid-twentieth-century collage, while one of the two active protagonists is visible only from the knees down. A charming still life of port or sherry decanters stands on one table, another table is set for dinner, and through the window is a street view straight out of northern Renaissance art. But this is also Manet *avant la lettre*; a quiet Parisian Belle Époque restaurant translated to 1830s London. Manet, northern Renaissance, twentieth-century abstraction, and a scene that has a touch of Harold Pinter about it: with all these cross-currents to express, and painterly ideas well ahead of their time, it is no wonder that Haydon found the world to be confusing and dysfunctional.

To the world, however, it was Haydon who was dysfunctional. Cocky and overconfident when things were going well for him, and cast-down, miserable and vindictive when his troubles beset him, he could spin like a weather-vane. He would take issue with fellow artists not only in personal letters, but in letters to the editor of *The Times* for all to read. Here he is in May 1835:

> Sir, Will you permit me to ask Sir Martin Shee [president of the Royal Academy] why he places all his figures on tip-toe? This is a question of perspective, can lead to no controversy, and can be settled by a mathematical demonstration in one minute, and will be very interesting to artists. I mean nothing offensive in the world.

And he could annoy his potential subjects by his persistence. Writing again and again to the Duke of Wellington for the loan of his blue frock coat, his trousers, his boots and spurs, sword and sash, glove and cocked hat as props for a painting of the hero of Waterloo surveying the battlefield at dusk, the duke responded with a profound hope that there would be 'some cessation of note writing about Pictures'.

A redeeming feature in Haydon, which prevented him from strangling those he saw as his oppressors, was his firm religious faith and non-violent nature. 'Let me not die in debt' was one of his regular prayers, and he probably would not have done so had he not at last succeeded in killing himself in 1846. At that time winds of change were already beginning to blow in a fashion for the modern-life subjects that members of the Pre-Raphaelite

Brotherhood (founded 1848) would soon come to paint, and his *Waiting for the Times* would most certainly not have been out of place among them, or out of its time.

A method Haydon adopted to avoid low-level, short-term debt was to go to the pawn shop. This was time-wasting and debilitating. Following his first lecture on the art of painting at the London Mechanics' Institute in September 1835, he pawned his £10 suit, receiving £2.15s for it; then his spectacles for five shillings; then his tea urn for ten shillings. 'Harrass, threats, harrass' was how Haydon succinctly described the problems that beset him. Haydon was no unknown. His status in the world of art was assured, and it would have been a very different place without him. Nevertheless, so insecure and volatile was his profession that one evening he might be lecturing to hundreds in an important London institute and receiving thunderous applause, and the next morning be served with a court order to repay a £50 debt. After Landseer's generous and accommodating patron the Sixth Duke of Bedford had sent Haydon a fiver to get his suit out of pawn for a lecture, the prime minister's messenger brought him £70 'to relieve . . . present difficulties. You must not think me hard if I say . . . that I cannot do this again.'

Haydon's justification for his disordered way of life was his determined, hopelessly unrealistic and impossible sense of purpose, which was undoubtedly the root of his problem. In a prayer that rolls all his demands on the Almighty into one, he made in 1814 'one request more'. It was not to be the last, of course:

> spare my life till I have reformed the taste of my Country, till great works are felt, ordered, & erected, till the Arts of England are on a level with her Philosophy, her heroism & her poetry, and her greatness is complete.

Haydon's long-suffering wife Mary had all this to put up with in running their home in Lisson Grove. With their nine children, five of whom died in infancy, Haydon was as uxorially prolific as Gandy. When they married in 1821, Haydon described Mary as having 'the simplicity of a child, the passion of an Italian Woman, joined to the wholesome tenderness & fidelity of an English one'. She also had the fortitude necessary to cope with a

demanding and unpredictable husband, modelling for him, attending his lectures, joining him on a cold, wet and miserable Channel crossing to visit the battlefield of Waterloo, and putting up with his long-running infatuation with the author Lady Caroline Norton. Benjamin and Mary had been on the brink of disaster together many times, none more so than in June 1834 when, after the failure of the exhibition of his painting *The Reform Banquet*, they faced 'executions, poverty, misery, insult and wretchedness . . . Mary packing up her little favourite things – expecting ruin at creeping pace.' Some of their children's clothes, and Mary's favourite gown bought for £40, were pawned by her husband for £4. In the hours before he killed himself, overwhelmed by his obsession with money, he wrote to Mary:

> God bless thee, dearest love. Pardon this last pang, many thou hast suffered from me; God bless thee in dear widowhood. I hope Sir Robert Peel will consider I have earned a pension for thee.

Haydon failed spectacularly. That there are few engravings after his work suggests that he was impossible to deal with and was a no-go area for most engravers. Nevertheless he saw himself as a great artist, the sole guardian of the Grand Manner:

> The art is becoming a beastly vulgarity. The solitary grandeur of History painting is gone. There was something grand, something poetical, something touching, something inspiring, something heroic, something mysterious, something awful, in pacing your quiet Painting room after midnight, with a great work lifted up on a gigantic easel, glimmering by the trembling light of a solitary candle, 'when the whole world seemed adverse to desert' [Wordsworth]. There was something truly poetical to be devoting yourself to what the Vulgar dared not touch, holding converse with the great Spirit, your heart swelling, your Imagination teeming, your being rising.

The watercolour painter John Varley was, like Haydon, never a member of the Royal Academy, although he did exhibit there early in his career. He was told by his discouraging father that 'limning or drawing is a bad trade', but persevered nevertheless; he found tuition in landscape sketching

and portrait drawing as a young man in London, and dedicated himself to improving his art. Only three years younger than Turner, his and Turner's early careers have marked similarities. Both took themselves off to the high ground around London to draw – Turner to Hampstead, Varley to Stoke Newington and Tottenham; both found experience in travelling farther afield on bold sketching tours in search of the picturesque – Turner to Bristol, Varley to Peterborough; both ventured into the mountains of Wales and brought back vivid evocations of the wild landscapes that thrilled visitors to the Royal Academy. Both Turner and Varley studied and drew from watercolours and engravings in the collection of the physician of the insane, Thomas Monro; both took pupils to help themselves pay their way.

However, while Turner's practice was to analyse rules of art and to rework and rewrite them, Varley tended to follow an accepted practice and stick to it. Indeed, he formulated 'accepted practice' himself, publishing in 1816 a guide to technique – his own – for other artists to follow. Varley's *Treatise on the Principles of Landscape Design* is a clear introduction to painting an accomplished watercolour, but the difficulty that it brought its author was that it also became his cage. Varley's watercolours lack the variety, impulse and aggression of Turner, and his inability or unwillingness to wrestle with the difficult and bulky art of oil painting further limited his interest to the market.

John Varley was a charming, generous, loving man. He fostered the art of generations of pupils, including William Henry Hunt, and Elizabeth Turner, the daughter of Dawson Turner, a friend and confidant of his unrelated namesake J. M. W. Turner. Dawson Turner ran a successful bank in Yarmouth, Norfolk, and was himself a generous host, prolific correspondent and distinguished amateur botanist. Elizabeth Turner described Varley's charm and effectiveness as a teacher, while inadvertently evoking the in-built limitations of his art:

It is not enough to tell you that we have been delighted with this most singular man: I must try to describe his character a little, it is so rare and extraordinary . . . Not only has he, with most unwearied diligence,

sought to show us every way of copying his drawings, he has also tried to make us compose, and explained to us all those principles of composition, which after many years of hard fagging, he discovered himself.

Varley, a gentle giant who 'could never learn how to use his strength', had a bizarre side to his character that puzzled many who knew him, and turned others away. He was a convinced astrologer, one who would quiz acquaintances mercilessly for the time, date and place of their birth so he could assess their horoscopes. He himself made it clear that he had been born at the Old Blue Post Tavern, Hackney, on 17 August 1778, 18 degrees 56 minutes, Sagittarius ascending – William Blake inscribed this detail on his idealized portrait of Varley in the National Portrait Gallery. With astrology as his obsession, Varley attempted to link facial features with star signs, publishing his *Treatise on Zodiacal Physiognomy* in 1828.

While he was popular as an exhibiting watercolourist during the 1810s and 1820s when the art was passing through a particularly active phase, this buoyant period could not last. Varley had been one of the founders of the Water-Colour Society in London in 1804, a group which immediately touched the heart and pocket of a new audience for small-scale, modestly priced, domestic pictures. This was not quite the heights of the Royal Academy, but it held an accessible and interesting annual exhibition which attracted a paying audience (one shilling entry) and spawned rival groups eager to cash in on the trend. Varley showed forty-two watercolours in the 1805 exhibition – out of a total of 275 – and in that and surrounding years sold his work successfully. Each exhibition might earn him £150–£200, his prices being modest, at around £5 a picture. Varley would churn his watercolours out – they were known in the Society as 'Varley's Hot Rolls'.

But Varley had other difficulties: he was married to an unpredictable, spendthrift wife, Esther Gisborne, who despised him. She nevertheless somehow bore him eight children, but Varley's own inability to control his finances took him and his family into hard times, leading to his bankruptcy and imprisonment for debt in 1820, and further threats and near-imprisonments in his later years. His fellow artists had some feeling of

affection and care for Varley, Constable among others buying his drawings and listening to this engaging Ancient Mariner who seemed to live in a world of his own:

> I have bought a little drawing of John Varley, the conjuror – who is now a beggar – but a 'fat & sturdy' one. He told me how to do landscape & was so kind as to point out all my defects. The price of the little drawing was a guinea & a half – but a guinea only to an <u>artist</u>. However, I insisted on his taking the larger sum – as he had clearly proved to me I was no artist!!

Living artists had to look after themselves and each other in the first half of the nineteenth century, and pick up friendly and sympathetic assistance where they could, both in prize money and in charity through the Royal Academy, the British Institution, the Society of Arts and artists' benevolent insurance schemes. When a painter failed, such as Joseph Gandy, Benjamin Robert Haydon or John Varley, he failed alone, with a weeping family pleading the artists' benevolent funds for relief; when a sculptor failed, however – Charles Rossi or E. H. Baily, for example – he failed for dozens, bringing not only misery on his family, but dissolution on his studio and unemployment on his assistants. Successful artists, from Gainsborough and Reynolds to Martin and Turner, had their own means of displaying their work outside the annual public exhibitions, either in their own galleries, in their homes or through engraved reproduction. Other opportunities included word of mouth and proud display by a patron. The work of sculptors such as Flaxman and Chantrey was readily seen in popular public settings, principally St Paul's Cathedral. They had an economy of a different nature to that of painters, operating on an industrial scale, creating products such as portrait busts or church monuments that demanded the existence of a purchaser. Thus the prospect of payment and the financial status of the client were generally clear for the sculptor before the work was conceived (see chapter 5).

The Royal Academy was not always a friendly place for artists to be. Haydon suffered there; Constable had suspicions that feelings among Academicians were stacked against Gandy when he stood year after year

for election. Constable himself had long suffered disdain and rejection there. It was thought that the keeper of the Academy, Henry Thomson RA, had spiked Gandy's chances; that Gandy 'was one of the victims of Thompson's [*sic*] caprices'. Thomson was only very briefly keeper, between 1825 and 1827 – a highly influential post that had responsibility not only for the Academy's property and its growing collection of 'Diploma works', but also for the management of the Schools. Animosity within the Academy could be poisonous. Thomson was widely loathed: Thomas Lawrence wrote vehemently that 'for <u>envious hatred</u>, and low, busy, toiling, <u>crafty</u> mischief, there has existed in the Academy no Iago like that man'. John Soane was also well known to be spiteful and unpleasant; James Northcote was 'a vain man, of a contracted mind . . . not over good-natured'. John Martin hated the Royal Academy. Turner detested Constable, and indeed it seems to have been mutual: Francis Chantrey, distinguished Academician, wrote in 1826 to Constable, by now a highly esteemed Associate, about their colleague, the widely revered Turner. Marked 'Private', with a double underlining, Chantrey's letter to Constable says pithily:

> I wish particularly to know by return of post if you entertain the opinion
> or that you ever said 'Turner's pictures are only fit to be spit upon.'
> Very truly yours, F. Chantrey.

Haydon put many of his fellow artists in a state of apoplectic rage, and cruelly attacked the Academy: 'He stabbed his mother! He stabbed his mother', Turner muttered on hearing the news of Haydon's suicide. 'Mother', here, in Turner's emotional and unfettered response, was the Academy, where Haydon had studied but to which he was never admitted as an Associate. Such are the energies released when people of temperament and genius meet within a limited and fluctuating market, and try with mixed success to club together to support themselves and each other, and express their ambitions. However, one does sometimes wonder why any self-respecting person would want to join such a rabble. Discord spread over to the British Institution. At its private view in 1818 James Ward observed that 'only Callcott & Jackson there of the RA. Haydon shunned by them. Am blamed by them for speaking to him but find the comfort of

forgiving injuries above such considerations.' Constable had a punch-up at
the Institution with Thomas Phillips in 1828:

> Mr Phillips likewise caught me by the other ear, and kicked & cuffed
> me most severely – I have not yet recovered. I have heard so much of
> the higher walks of art, that I am quite sick. I had my own opinions
> even on that – but I was desired to hold my tongue and not 'argue the
> point'.

The Academy was nevertheless a society in which a sick or destitute member
artist, or his widow and family, would find benevolent support through the
Academy's charitable funds. Failing or sick artists who were not Associates
or Academicians could, on paying premiums, have recourse to the Artists'
Annuity Fund, later titled the Artists' Benevolent Fund – also known as the
Artists' Joint Stock Fund and the Artists' Fund of Provident Care. This was
a private insurance scheme, set up in 1810 and later subject to mergers and
rivalries, which paid benefits to members in distress, or to their dependents
after their deaths. The Benevolent Fund's birth was a matter of controversy,
the Royal Academy being seen to have drowned out existing benevolent
schemes of the past century for artists and diverted charitable funds exclu-
sively to its own members. John Pye, untiring campaigner for artists, put
the case for the independent funds with clarity:

> At the beginning of the present century, almost every class of British
> subject enjoyed the advantage of a fund for the protection of the super-
> annuated of their number; such for example the musical funds, the
> theatrical funds, and the like. [There was] no fund for the <u>community</u> of
> British artists.

The Academy, Pye added, 'protected against the evils of pauperism its own
members only'. He went on to say that those countless artists who were
not elected to the Academy, 'the great body of British artists', were suffer-
ing as a consequence, appearing to be 'the singularly unfortunate children
of neglect and improvidence'. By 1844 the Artists' Benevolent Fund had
established itself fully and was, according to Pye, protecting 'upwards of
300 artists'.

The Fund was supported by contributing artists, by dealers in art such as Rudolf Ackermann and Dominic Colnaghi, and by patrons including the king, the Duke of Sutherland, the Duke of Bedford, Sir John Swinburne and Sir John Julius Angerstein. Samuel Whitbread was another active contributor: he spoke energetically at the Fund's 1814 annual dinner, and demonstrated how political opponents such as he himself and the Tory MP Charles Long, who was chairing the dinner, nevertheless had 'but one mind' when drawn together by art. In a speech which 'produced an electrical effect on the meeting . . . their applause was unbounded', Whitbread also praised the Duke of Wellington, who was a hero in artists' eyes for having recovered the paintings plundered from Spain and Portugal by Napoleon during the Peninsula War.

Early minutes of the Fund, initially under the chairmanship of the aged landscape painter Anthony Devis, show that its president was drawn from each branch of the arts in rotation (i.e. painting, sculpture, architecture, engraving), and that four years' membership, with regular payment of premiums, should secure claims made by a deceased artist's family.[170] Premiums were on a sliding scale: £2.2s.5d for entry at age twenty, £9.10s for entry at age fifty. The Fund amended and polished its rules as the years progressed, so that in 1817 we read that an artist would have to be ill for a full month, but could then receive relief at £6 per month, and that after a year on sickness benefit, provided he had been a member for five years, he would become superannuated on an annual pension of £60, or on death £40 a year for dependents. This is a reasonably generous payment of an early form of social security, the profession of artist looking after its own. While the early membership appears to have been dominated by engravers, as a result of the Academy not admitting them, it gradually took members from all branches of art, including Francis Chantrey (1810), the watercolour painters John Glover and Anthony Vandyke Copley Fielding (1817), and 'senior' oil painters Henry Howard RA, Richard Ramsay Reinagle ARA, John Martin (all 1822), and Edwin Landseer (1824). Martin served energetically as the Fund's secretary in the 1830s and 1840s. The Fund had its own private medical arm, the physician and pioneer homeopath David Uwins, brother of the painter Thomas Uwins RA, whose 'offer [to the

Fund] to attend members and their families gratuitously during any sickness they may endure . . . is most gratefully accepted'.

The Fund's account books show that its money was well managed, turnover being £625 in 1810, rising to £2,688 seven years later. Among the artists' widows and families who were relieved by the Fund were Anne Legé, widow of the sculptor Francis Legé who died in 1837, and John Varley's widow who received a pension after her husband's death in 1843. This was not the difficult and spendthrift Esther – she had died in 1824 – but Varley's second wife, the gentler Delvalle Lowry. Francis Legé, who we will meet again in chapter 5, was a loyal assistant to Francis Chantrey, serving him for twenty-two years. While Chantrey had himself been a subscriber to the Fund since 1810, there seems to be no record of contributions from Legé. Thus, it looks as if Chantrey's benefit was passed on to Anne Legé, as Chantrey's own accumulated riches put him and his wife far beyond the need for charity. Over the years 1816 to 1844 the Fund expended £8,150 on widows' pensions alone.

Fund supporters had a rollicking good time at the annual dinners, usually held at the Freemasons' Tavern in Great Queen Street, near Covent Garden. Such was the social level of art in London at this period that the then Chancellor of the Exchequer, Frederick Robinson, took the chair at the seventeenth annual dinner in 1826 and presided over toasts and speeches, songs and laughter, as the evening progressed into the small hours. When a toast was raised to the king, the Chancellor, probably slightly drunk by now, reported that the monarch 'possessed a heart open as day to melting charity' towards art and artists. The glee 'Hail Star of Brunswick' was sung in the king's honour as his annual contribution of 100 guineas was reported to thunderous cheers. Robinson took the opportunity to lobby for better exhibition space for the Royal Academy, then still at Somerset House in 'apartments . . . which were inadequate for the display of those works which the public showed so much anxiety to behold'. The Chancellor made the point that he trusted that 'at no distant day a building would be erected worthy of the Arts, and commensurate with the wealth and grandeur of the metropolis of this great and free country'. The building that Robinson was so publicly lobbying for came about ten years later

when the new National Gallery, part-occupied by the Royal Academy, was completed in Trafalgar Square. At the Fund's annual dinner in 1836, the chairman on that occasion, Lord Ashburton, continued to press the economic value of the arts by reminding the audience that 'four fifths of the manufactures of the country were partially dependant on the arts'. The painter Richard Reinagle pointed out that the Academy had spent £150,000 in prizes to artists and on maintaining prize-winners in Italy: 'the whole of this money had been obtained by the exhibitions, without a shilling aid from the government.' All of this has an early twenty-first century feel about it. There is also a modern feel about the fact that one charity, established to give money to artists facing poverty, should be in bitter dispute with another, the Artists' General Benevolent Institution, with its very similar title to the Artists' Benevolent Fund, both of which ostensibly pursued the same aims.

John Pye, in his long and justificatory account of the Fund's progress, had no hesitation in accusing the Royal Academy of hijacking the administration and exhibiting of art, and rolling into this grand heist the responsibility for running benevolent funds for artists. This was all very well for Academicians and Associates, but it left the widows of artists excluded from the Academy – and this meant all engravers – out in the cold. Turner maintained a close and personal interest in the workings of the Artists' General Benevolent Institution, and was also the Royal Academy's auditor from 1824 to 1839, and again for five years from 1841. Assiduous in his attention to detail, he made sketchbook notes listing pensions paid out and donations received, from Christmas 1818 to 1823. In the pages following the copious Academy figures there are thirty-six pages of erotic drawings, a subject which he evidently took up with a sigh of relief after all those sums.

A careful and attentive steward of a charitable cause for artists, Turner was also careful with his own money. His sketchbooks carry many details of financial transactions, concerning sales not only of paintings and prints, but also opaque details of his own investments. During the 1810s he bought Bank of England consols (consolidated 3 per cent annuities), presumably with the income from sales of his pictures, totalling almost £1,500. His holdings came and went: in 1814, he made a loss on the sale of £50 of

reduced 3 per cent annuities at the rate of 68¼ per cent, receiving just £34.2s.6d, less the commission to his stockbroker, William Marsh, of 1s.3d. Receipts for these transactions he tucked away in the pocket of the sketchbook. Generous though he was to the Academy with his affection and his time, Turner nevertheless had his moments of meanness. In 1839, at the Christie's auction of the painter John Jackson's effects, he bought for £2.10s a palette said to have belonged to Hogarth, and tried to decide if he should give it or sell it to the Academy. Constable soon got wind of this, lacing his retort to C. R. Leslie with a touch of malice:

> He has got poor Eastlake 'in secret' to enquire if the Academy paid for the silver plate and glass case, in which is the palette of Sir Joshua. I told him no, all the attendant expenses was borne by me – £5 or £6 for the plate, the case 3.3.0 – he will be greatly annoyed by being obliged to take my folly as a precedent.

An artist at the extreme opposite to Gandy, Haydon or Varley on the scale of social and professional success is Augustus Wall Callcott, the painter whose name once caused Haydon momentary anguish with the prime minister. Personable and polite, Callcott slipped upwards through the levels of the Royal Academy Schools in the late 1790s, with evident talent and without attracting envy from fellow students or disapproval from his teachers.

Henry Thomson, later so reviled, told Farington that Callcott was 'a modest, well behaved young man'. The talented son of a Kensington builder, Callcott used the trade connections that his father had developed with Lord Holland to gain regular access to the tradesmen's entrance of Holland House, to find experience in picture repair and copying, and to make tentative social and business contact with this influential Whig family. He was the ideal of the young artist who benefited, as Pye had noticed, from the liberality of collectors who allowed access to their collections to the young and interested.

Callcott came to specialize in landscape, and developed a manner of brightly lit painting that Turner was pioneering and which caused such upset to the taste of Sir George Beaumont. This refreshing new luminous

manner drew Beaumont to bracket Turner and Callcott together and to dismiss them both as 'white painters', a stigma that temporarily at least stopped Callcott in his tracks and kept him aloof from the Academy in 1813 and 1814. While Callcott's technique was slow and his prices modest, he did gradually find himself in the mainstream as a painter by being bought early in his career by knighted collectors including Sir John Leicester, Sir Richard Payne Knight and Sir Thomas Lister Parker, and later on by John Sheepshanks and Robert Vernon. For good or ill, Callcott was a bargain: he charged Leicester just 150 guineas in 1807 for his 9-foot-long canvas *Market Day*, twice the size and half the price that Leicester had paid Turner for *The Shipwreck* the year before.

Callcott was careful and orthodox in his choice of subjects, delicate with his patrons, and cautious in the way he planned his life. He married late; he was forty-eight when in 1827 at last he took a wife. But his choice of wife, a woman of strong opinion and rich experience of life, art and travel, surprised many. Maria Graham, the widow of a naval officer, was a member of a small and exclusive group of women writers, and of an even more exclusive group of women artists. She was already a published author, lionized and admired in London, Edinburgh and Rome, where in 1819 she had sat for her portrait by Sir Thomas Lawrence. In Rome she mixed with British visitors, including Francis Chantrey, Thomas Moore, Turner, Lawrence and the man of the future, Charles Eastlake. She also met Sir Humphry Davy, who 'talked to me a great deal about colours when we met in Rome'.

'The intrepid Mrs Graham', as Lady Holland called her, met and married Augustus Wall Callcott within a year of her return home after four subsequent years in Chile and Brazil. Callcott was by now at the centre of the intellectual, artistic and musical circles of Kensington, the vibrant artistic hub west of London that would, in time, seduce Brunel. He was rising as an authoritative figure in the Royal Academy: Constable said of him gnomically: 'in painting he is a correct, sound – and just – bigot'. For Callcott, the marriage to Maria had all the appearance of an excellent career move, while to Lady Holland, who thought she had Augustus's best interests at heart, it was 'a bad prospect'. From childhood, Maria had suffered from intermittent tuberculosis. After her marriage

to Augustus the illness worsened gradually, and by the early 1830s she was more or less confined to her rooms. However, with long friendships running deep into London's literary and artistic society, she could twitch on her threads and draw people including Rev. Sydney Smith, Samuel Rogers and Edwin Landseer to her salons, where, as Richard and Samuel Redgrave put it:

> Lady Callcott mostly supported the conversation. She was somewhat imperious in her state chamber; the painter being more of a silent listener, until some incident of travel, some question of art, roused him up to earnest interest or wise remark.

Maria was a shadow of the young woman who in December 1812 had come to London as a new, celebrated author; in November 1840, she described herself miserably as 'a dying woman shut up in my bedroom never more to leave it!' From this diminished perspective, Maria Callcott became angrier and angrier. The Callcotts had a curious marriage: she a strong personality, he quiet and reserved, slow-performing, deliberate and reliable. From her sofa, she was far from the dangers of the Tivoli hills, where she had braved gangs of bandits lying in wait for travellers; the noisy Piazza di Spagna in Rome, where Lawrence had painted her romantic portrait; or the harbour of Valparaiso, where in 1822 she buried her first husband and went aboard the *Rising Star*, the first steamship to enter the Pacific. She was instead reduced to making cutting remarks about her visitors, among them Harriet, the daughter of Samuel Rogers: 'Miss Rogers . . . is growing large and coarse.' Augustus tried hard to cheer her up. He invited young painters to bring the works they were about to send to the Academy, and 'to range them before the sick lady . . . that she might have a sight at least of some portion of the coming exhibition'.

One of the many friends who visited her was Edwin Landseer. He had in 1840 suffered a nervous breakdown which threw a shadow over the rest of his life. This admired artist, charming and prodigious, had become watchful, terrified and beset by demons, fantasies and paranoia through dabbling in the occult and attempting to cope with his fame and demands from patrons. While Landseer rallied and continued to paint, producing

some of his greatest works, drink and drugs got the better of him. Maria
Callcott expressed her concerns:

> Edwin himself thrown back – again we have to lament over talents mis-
> applied, and curse 'ill weaved ambition' and so kind and generous a heart
> too! Jesse [Edwin's sister and housekeeper, Jessica] with all her gentleness
> and talent is always like an incubus. Why? I can't tell unless it be the total
> want of tact & practice of conversing.

Maria's concerns about Landseer were shared by many in the world of art.
In her direct voice, made the more resonant by the close echoes in her
closed world, she touched on Landseer's breakdown. Landseer had been
a child prodigy with an ambitious and energetic father who recognized
the boy's genius, which he was determined to foster. In an age of increas-
ing specialization in art, Edwin's unmatched talent for drawing animal
subjects, guided by the irascible and unreliable Benjamin Robert Haydon,
directed him to study cows in the fields around Marylebone, lions in the
Zoological Gardens, and dogs and horses everywhere.

By 1840, at the age of thirty-eight, Landseer had reached a pinnacle in
both his art and its reception. His aristocratic patrons included the Dukes
of Bedford and Devonshire and the Marquess of Abercorn; among his
meritocratic patrons were former prime minister the Duke of Wellington,
current prime minister Lord Melbourne and the author whose writing
characterized the age, Sir Walter Scott. Among businessmen he counted as
his collectors the horse dealer Robert Vernon; John Sheepshanks, the Leeds
cloth manufacturer's son; the ship-builder William Wells; and John Gillott,
the Birmingham pen-nib manufacturer. Landseer crossed every boundary
among the rich, finding collectors of his work in money old and new. He
had many admirers among prominent fellow artists and writers, including
the sculptors Francis Chantrey and John Gibson, his own early mentor
Benjamin Robert Haydon, J. M. W. Turner, Charles Dickens, and hard-
to-please Royal Academicians who nevertheless elected him to the high
status of Academician in 1831. He became quite a character in Academy
circles. Constable spotted him with William Wells, in a hansom cab trot-
ting spiritedly along the Strand, soon after the 1829 Academy exhibition

had opened. Constable, who was making the same journey in an omnibus, made a quick sketch of the moment in a letter to his friend the painter C. R. Leslie, 'all waving our catalogues in the air'.

But vanity got him in the end. Constable remarked in an aside to Leslie that he had invited Landseer and a fellow Academician, George Newton, to meet Leslie at the Academy,

> neither of whom came – or sent any message – and as I class them both with the nobility (they having adopted their habits), I sat up 'till twelve to receive them.

Harriet Martineau pointed out waspishly when she met Landseer in 1834:

> There was Landseer, a friendly and agreeable companion, but holding his cheerfulness at the mercy of great folks' graciousness to him. To see him enter a room, curled and cravatted, and glancing round in anxiety about his reputation, could not but make a woman wonder where among her own sex she could find a more palpable vanity.

When Landseer caught the eye of Princess Victoria, who invited him to paint her pet dogs Hector and Dash, she described him in her diary as 'an unassuming, pleasing and very young-looking man, with fair hair'. Thereafter it was Edwin Landseer who was engaged to immortalize one royal dog after another, as well as a menagerie of royal stags, hinds, parrots and princes. Thus, his debilitating nervous breakdown shocked his many friends and admirers, and those who aspired to own his paintings.

For an artist active in London in the late 1830s and 1840s, royal patronage was the apogee. The nation had a new beautiful young queen, light-hearted, competent at painting in watercolours, and such a relief from that long sequence of Hanoverian kings. The rich mixture of royal, aristocratic, trade and peer patronage of the sort enjoyed by Edwin Landseer was at this period unique. Landseer was everybody's. Talent, like virtue, might be its own reward, yet unlike virtue it always pay handsomely in addition. In Landseer's case, however, it went further than that: not only did he have the patronage of the queen, the dukes, most especially the Duke of

Bedford, and the others above mentioned, but he also enjoyed that duke's warm and understanding friendship, as well as the close loving comfort over nearly fifteen years of the duchess, the duke's second wife, Georgina. This friendship produced a daughter, Rachel.

One of the triggers of Landseer's collapse was that the Duchess of Bedford refused, once she had been widowed in 1839, to marry him. The duchess was 'highly vulgar and capricious', in Thomas Moore's view, and the focus of much gossip. She was fond of practical jokes, 'to a degree not very becoming of a Duchess in the nineteenth century'. Moore had observed her some years before she and Landseer met:

> I remember hearing various tricks she played upon a poor artist who visited Woburn, to make drawings from the Duke's pictures – among others she had a goose put into his bed, & had given it brandy to make it a more skittish and troublesome bed-fellow – but it only made the poor goose sick, & the poor artist, who was a humane man, took care of it & nursed it all night.

Landseer may not himself have suffered such indignities at Woburn, but the mental difficulties he encountered after the Duchess rejected him were further rooted in an excess of success, an inability to enable supply to meet demand, and perhaps uncertain contact with reality in life, even though he could vividly describe it in paint.

Among Landseer's initial attractions to some of his patrons was the fact that his prices, like Callcott's, were low in relation to those of his peers, and failed increasingly to reflect his standing. Landseer would charge for a thoroughbred what Vernon might just accept for a winded carthorse. Giving away his drawings as if they were toffees for children, Landseer was criticized by fellow artists for risking damage to the structure of the art market. His friend the painter Frederick Goodall chided him: 'you must have given away hundreds of pounds, Landseer.' Francis Chantrey took him to task when in 1836 he painted a portrait of the sculptor's dog, Mustard. 'Now on the score of Money,' Chantrey wrote:

> a delicate question to a high-spirited young Dandy who can live on Air
> – I have to request that you will do yourself and your profession justice

without one word about friendship, delicacy or Stuff. <u>This I insist upon, and with this you must comply or I no longer remain</u> Yours sincerely, F. Chantrey.

Mark this, Mister Landseer!

Chantrey generously persisted when Landseer came up with an insufficient figure:

> I always expected that the proper and remunerating price would at least have been two hundred guineas – you say one hundred and fifty. The question between us stands thus – either I must feel endebted to you 50 Gns or you will feel under the obligation to me for the like sum . . . I remain your debtor for the sum above named which I shall seek an early opportunity of discharging.

However, it is clear from the account that Landseer opened at Gosling's Bank in January 1827 that he was not quite as vague and unbusinesslike as Chantrey seems to suggest. With an initial deposit of £250 Landseer shows that he was really quite organized in his financial affairs and kept a careful eye on money matters. Remarkably, the entries over the following forty-three years until his death have survived in the archive of Barclays Bank, now held in a low-rise glass and steel building on an industrial estate outside Manchester, behind a branch of Tesco. It is a curious place to discover that in July 1827 Landseer's lover the Duchess of Bedford paid the artist £50, and two months later her husband paid him 50 guineas (£52.10s). This puts some flesh on the bones of the letter to Landseer in which the Duke of Bedford insisted that the price he asked for his portrait of the Duchess 'is quite ridiculous', and that as a consequence he would pay £50 into Landseer's account at Gosling's. This was certainly a generous gesture from a kindly, cuckolded old duke. Bedford evidently paid 50 guineas rather than pounds, but overlooking that fact, for the portrait of the duchess Landseer received a total of over £100 from husband and wife. A further entry in December 1827 shows Landseer earning £180 from the Duke of Northumberland for *Highlanders Returning from Deerstalking*. These are significant, but not huge, sums for a 25-year-old artist at a

breakthrough point in his career, but not comparable with Turner, who at about the same age in 1804 had earned 300 guineas for *The Festival upon the Opening of the Vintage of Macon*.

Over the first eight years of the bank account, Landseer's income went up from £582 in 1827, to £832 in 1830, and to £1,158 in 1835. This is not by any measure a spectacular rise, nor a particularly stupendous income. But while he may have been confused about the value of his work, out of a combination of good nature, modesty and initial surprise, Landseer earned enough to be the 'high spirited Dandy' of Chantrey's observation. He did not 'live on Air'. His income from the sale of copyrights of his paintings to engravers became, with the help of others, organized and systematic, and by this means he became the centre of a prosperous business, which further enriched a network of dealers and craftsmen. As a direct result of the spectacular growth in interest in his work by engravers and dealers in the 1840s, Landseer's income rose dramatically. His growing wealth came both from the commissions from patrons, and from the market-ability, through reproduction, of his art. In 1840 we see payments into his Gosling's account of £105 (100 guineas) each from the print dealers George Moon, and Hodgson and Graves, with 300 guineas coming from Hodgson and Graves the following year. While this may not have been Landseer's only bank account, it does give clear evidence for the steep rise in interest in him, not only from print dealers, but from patrons also. In 1840, the year of his reported mental breakdown, and 1841, he received payments from the Marquess of Abercorn, the Duke of Beaufort, John Marshall, John Sheepshanks, Sir Henry Wheatley and others totalling £1,436, and cash payments of £662. Adding income from investments of £577, the Gosling's account shows that across these two years he earned £3,201, perhaps £160,000 in today's money. Financial success seemed inviolable: in 1846 Landseer earned £6,850 from four paintings alone – £2,400 for the sale of the paintings themselves, one being *Stag at Bay*, and £4,450 in total for their copyrights. The *Art-Union* doubted that this was a wise invest-ment, but it is nevertheless an important example of price inflation and bravura in the market: 'It is, we imagine, utterly impossible that the sale of the engravings can be such as to return so prodigious an outlay.'

For Landseer's pocket, mental collapse was a prelude to ample cash flow. Year on year, Landseer got richer and richer. His investments tell their own story as they grew. In 1830 a £500 investment in consols yielded £26; by 1847 with year-by-year income the capital had grown to £14,200, bringing him £224.0.5d interest at 3½ per cent. By October 1850 the value had increased again to £24,200, and by 1868 to £50,000 with further share-holdings in English and Indian Railway and Russian and Anglo-Dutch Bonds of a few thousand pounds each. Over thirty-eight years, £500 had become £50,000, in the steadiest of investment portfolios. Payments in the Gosling's accounts identifiable as from engravers and print dealers, principally Graves and Co., totalled over £17,500.

Landseer's nervous breakdown, whatever that may mean medically, was a severe blow to the artist and his friends; it became the catalyst to a change of manner, mood, expression and priorities in his art. The problem was, flatly, that many people had many thousands of pounds riding on Landseer, and their anxiety was that this milch cow might cease to produce the goods. Landseer wrote of his 'self-torture' to his friend Count d'Orsay. This was not wholly ironic:

> My unfinished works haunt me – visions of noble Dukes in <u>armour</u> give me nightly scowls and poking . . . Until I am safely <u>delivered</u>, fits of agitation will continue their attacks.

Landseer's breakdown, however, led to the beginning of a more rigorous way of doing things in his business as an artist. The guardian angel who stepped out of the shadows at the right time was Jacob Bell, a failed artist who had turned successfully to business when he followed his father into pharmacy. He became a pioneer in the mass marketing of pharmaceuticals and the founder of the Pharmaceutical Society. Bell and Landseer had known each other since the 1820s when Bell dragged Landseer away from the gambling tables and got him to see sense. For Landseer's illness, Bell prescribed European travel and 'blue pills' – that is, the popular preparation 'calomel', or mercurous chloride; for his art, meanwhile, he recommended and delivered a means of greater efficiency, an organized way of running his studio and a certain crispness with dealers and engravers.

Bell firmly increased Landseer's prices, and was the pivotal figure in many
negotiations, drawing together artist, engraver and publisher:

> Boys has just been here and consented to give our price for the copyright
> of the Royal Mother and Brats . . . Moon has called on me to pay 200 gns
> for Breeze . . . If Graves consents to what he originally seemed anxious
> to give, I shall close: it is my policy to be quite independent and not to
> appear at all anxious to dispose of the copyrights.

When Landseer won prizes at foreign exhibitions, it was Bell who took
care of the money. A teasing letter from his good friend Charles Dickens,
writing from Paris in January 1856, assured 'My Lanny' that the prize
money which came with the Grande Médaille d'Honneur which Landseer
had won at the 1855 Paris Esposition Universelle was safely in Bell's hands.
To Dickens, Landseer was 'my Lanny'; Clarkson Stanfield 'my Stanny'.

Standing on the sidelines of the business arrangements and painting
his pictures, Landseer could only shout and stamp when things failed to
go his way. His correspondence is full of anger and frustration which the
artist may partly have brought on himself through pressure of work and
unexpected distractions. In 1844 he is strongly warned by an intermediary
of the potential consequences of crossing Robert Vernon:

> I have just heard from my friend Mr Vernon, that the picture painted
> for him, by you, upon which I had the pleasure of seeing you about two
> years ago, has not yet been added to his collection . . . I assure you I am
> exceedingly disappointed and distressed . . . first, because I learn the
> non delivery of the Picture has been a source of great annoyance to Mr
> Vernon . . . I can observe by Mr Vernon's conversation with me that he
> considers himself both ill treated and neglected by you in this matter;
> and I really believe it will vex you to hear this, as much as it has done
> me.

The demands of engravers to have paintings in their workshops for
extended lengths of time gave further twists of frustration to Landseer.
The collector Martin Blackmore, a supporter and steward of the Artists'
Benevolent Fund, wrote to Charles Lewis, who was engraving Landseer's

Collie Dogs, a painting that Blackmore owned. The agreed time for the work had been two years, and Blackmore felt he had released the painting for long enough already. When Lewis asked for it again, Blackmore was terse in his response:

> My room is now arranged & I do not mean to let the picture go away again unless my friend Sir Edwin Landseer sends me a letter requesting me to let it go to the engravers for a short time. You will learn from me perhaps that it is quite proper that engravers should keep something like a consideration for owners of pictures & not treat them as if they had no right or title to their own property. You may spare yourself any more applications for only to Sir E. L. will I listen, and for him I will do anything.

Lewis seemed to be fated to annoy Landseer's patrons, a rash talent. He angered the artist when he retained one of the Duchess of Bedford's paintings for longer than was tactful. However, Landseer's other issues with the duchess may have coloured his response to Lewis:

> I have been expecting to see you, or to hear something of the condition of the various works you have in progress (from me). My object in writing was, is to say the Duchess (dow[ager]) of Bedford is impatient to have the Pictures of the Equestrian sons home <u>immediately</u>. Pray let me know when they can be returned to C[amden] Hill as I must give a positive answer to her Grace without delay.

'Painting is a strange business,' Turner reflected towards the end of his life. He had the talent not only to paint but the sense to invest his money and to diversify by having income from investment and from engraving, as well as from sales of his paintings, to rely on. Supported from his youth by his enthusiastic small-businessman father, Turner rapidly became a success from a business point of view and never looked back. However, where Landseer succeeded with his royal patrons and hit the jackpot, Turner consistently failed again and again. He did, briefly, have a royal patron in 1819. A press report in the *Literary Gazette*, announcing Turner's arrival in Rome that year, clearly states that this was the case:

Mr Turner, the English painter, has arrived here. It is said that he is as
great in landscape painting as Sir Thomas Lawrence in portrait ... Mr
Turner is to paint the most striking views of Rome, for his royal highness
the Prince Regent.

This may have been the motivation for the sixty or seventy studies of the
city and environs which Turner drew in magnificent potential detail, but
left largely incomplete. Only seven subjects were completed and engraved,
but this was long after faint talk of the Prince Regent's interest seems to
have faded. Those seven went off to Walter Fawkes, probably as a gift.

Another brush with royalty came for Turner two or three years later in
August 1822, when he travelled by sea up the east coast of England from
London to Leith to cover, as a journalist might, the official visit to Scotland
of the new king, George IV, his putative patron as Prince Regent in 1819.
This was to be the first visit to Scotland by a reigning monarch for 115 years,
since the 1707 Act of Union. Turner drew busily in and around Leith and
Edinburgh, catching the most important moments of the visit, and came
subsequently to make five paintings on mahogany panels as the beginnings
of a cycle representing the royal progress. The prime purpose of the paint-
ings may have been commercial, to create images which would fix the ico-
nography of the visit and be engraved for wide circulation: hence perhaps
the use of mahogany, strong enough to withstand the rough treatment the
paintings would risk during their years in the engraver's workshop. In the
event, this was a second commission with royal connections that failed for
Turner, and once again everything turned to ashes.

The commission that he did at last obtain from George IV through the
intercession of Sir Thomas Lawrence was to paint *The Battle of Trafalgar*
(1822–4). This smacks of a diplomatic offer: Turner had his pride and
could only watch perplexed as lesser artists like George Jones or Sir Martin
Archer Shee got the royal nod to produce paintings for the monarch. *The
Battle of Trafalgar* overwhelmed the Ante-Room in St James's Palace, where
it hung for only five years before being taken off to the Royal Hospital
at Greenwich. It has been in Greenwich ever since, moving across to the
National Maritime Museum when that was opened in 1937.

Turner knew by now where he stood with British royalty: nowhere; or if anywhere, only in Greenwich. The French were, however, different. In 1844 the King of the French, Louis-Philippe, came to England on a royal progress, a state visit to Queen Victoria. Louis-Philippe was the first French monarch to visit Britain since the fourteenth century, so this was a huge step forward in improving Britain's long and bellicose relations with the French. It was thirty years since Napoleon had been vanquished, and it seemed now as if the unstable post-war years were coming to an end. Turner and Louis-Philippe had known each other since the first decade of the 1800s, when the then Duke of Orléans lived in exile in Twickenham. They were only two years apart in age, had extensive experience of travel in common, and had already exchanged gifts: a set of engraved *Picturesque Views in England and Wales* from painter to prince; a diamond-encrusted snuffbox from prince to painter. Interestingly, at about 5 foot 3 inches tall, they were roughly the same height, so could with some equality look eye to eye. As in 1822 in Leith when waiting for George IV, Turner was on the quayside in Portsmouth when Louis-Philippe arrived. He made many quick pencil sketchbook studies and, perhaps some days later, a group of seven or eight pen-and-ink and watercolour drawings, including an eloquent image of the king stepping out of his ship to walk down the gangplank. From these studies derived a pair of atmospheric canvases of the scene in Portsmouth harbour with high aerial perspective, and a further pair which two years later Turner altered and turned into a whaling subject, and exhibited them as such.

We do not know if Turner and Louis-Philippe met in 1844, but in the autumn of 1845, when the artist was travelling along the Channel coast in northern France, he visited the town of Eu, where the king had a château. There they met, and together these old acquaintances 'passed the pleasantest of evenings in chat'. But if there was ever a commission in the offing from the French king, before or after this final meeting, it also turned to ashes, and the watercolour studies and the two aerial canvases sank into the piles of the artist's studio. The latter were, years later, wrongly assumed to be Venice subjects. The other two canvases, I suggest, Turner thoughtfully reconfigured: to one he added the head of a whale and a ship's flag;

to the other a touch of flame and a gang with a large saw. In both he put a certain chilliness into the air. Thus he converted two fine canvases of a royal arrival in the shallows of Portsmouth harbour into rather unconvincing evocations of partying and working in the depths of the South Atlantic. To each he gave a ludicrous Tristram Shandyish title: *Hurrah! for the Whaler Erebus! another Fish!* and *Whalers (boiling Blubber) entangled in Flaw Ice, endeavouring to extricate themselves.* For Turner, the Louis-Philippe paintings began with a bang, but, like the *King's Visit to Edinburgh* series twenty years earlier, ended in disappointment. Whatever it was that prompted Turner to make these four paintings – misinterpretation of a kind remark of the king? a misunderstanding of the king's taste and requirements? self-delusion? – it soon evaporated, and Turner was left with the four paintings. Endeavouring to extricate himself, like his whalers entangled in 'flaw ice', he altered two and exhibited them as a pair at the Royal Academy. Nobody bought them: Turner had misjudged the market. Despite his unparalleled success, Turner could also fail.

5

SCULPTOR:
CREATING INTELLIGENT LIFE

Sculpture in Britain in the eighteenth century was the liveliest and most vibrant of art forms, carrying the nation's reputation for creativity and artistic invention in a way that painting never did. As a consequence, the nineteenth century had as firm a foundation for the continuation of a national school of sculpture as could be desired, and, further, a fresh supply of military victories to be commemorated, new heroes to honour, new dead to be praised, and – as time went on – a burgeoning industrial economy to pay for it.

As early as the 1730s, four supremely talented sculptors from the continent had set up shop and settled in London: the elder John van Nost from Malines, who generated a dynasty of sculptors, Michael Rysbrack and Peter Scheemakers from Antwerp, and Louis-François Roubiliac from Lyons via Paris. All were attracted by the growth in the building of grand houses, the demand for church monuments throughout the country, religious toleration as a national characteristic, and relatively easy communication within a small island. They created a platform of talent and opportunity at home for younger native sculptors, including Henry and John Cheere, Joseph Wilton, Joseph Nollekens and Thomas Banks. While the latter three spent some years in Italy, all grew in skill and stature in the presence of piquant influence from continental sculptors in London. Their businesses thrived in response to opportunity and familiarity, and fluctuated as rivalry compromised individual market share.

Sculpture-making was expensive, heavy-going and hungry of space; in both the eighteenth and the nineteenth centuries it was not an occupation for the faint-hearted, nor for those afraid of high overhead costs.

The younger generation that looked in awe at new work by the cheerful Rysbrack in Westminster Abbey, Blenheim and Bristol, and by the witty and cultivated Roubiliac in Westminster Abbey, Cambridge and Windsor, knew that they were succeeding a race of giants. These capable men had employed small armies of assistants and studio apprentices, required plenty of space for the delivery of materials and the despatch of completed works, and needed plenty of room indoors and out to build up a clay modello, raise a plaster cast and carve a marble block. Sculpture was an industry; the 'studios' at Hyde Park Corner, Westminster and Millbank became factories. They required lifting gear, rollers, wedges, hammers and crowbars, foundries and furnaces, and fresh air to disperse noxious fumes. Scheemakers, the maker of giant monuments at his works on Millbank, at under 5 feet tall was himself no giant; but given equipment and assistants, what he needed was agility, not height. The sculptor's workshop was to a painter's studio what a slaughterhouse is to a chicken run: noisier, bigger, busier, bloodier.

Studio apprentices would grow into sculptors themselves, and it was in Roubiliac's studio that young John Flaxman encountered the art that would become his own. He followed in the footsteps of his father, the elder John Flaxman, an artisan sculptor who had also worked with Roubiliac and Scheemakers. Joseph Nollekens was trained across seven years with Scheemakers at his works in Vine Street, Piccadilly, and Rysbrack employed assistants including Gaspar van der Hagen, and many others whose names are yet unknown, in his studio in Vere Street, off Oxford Street. Sir Henry Cheere and his brother John Cheere, the latter known as the 'man at Hyde Park Corner', ran two separate and equally successful statuary businesses, Henry specializing in stone in his workshop conveniently near Westminster Abbey, John in lead and plaster. Henry employed assistants including William Collins and Robert Taylor, later a successful architect. After John's death, one of the leading buyers of his work was Samuel Whitbread, of Southill, Bedfordshire.

Sculpture also ran in families – the Nosts, who rapidly dropped their Flemish 'van', the Cheeres, the Flaxmans, the Gahagans, the Westmacotts: Sir Richard Westmacott RA was taught by his sculptor father Richard

Westmacott the elder; John van Nost's cousin, John Nost II and his son, John Nost III, carried on the family trade; Peter Scheemakers and his brother Henry, also a sculptor, were the sons of the elder Peeter Scheemakers, sculptor of Antwerp; Lawrence Gahagan had four sons, three of whom became sculptors. The demanding dynastic threads would tend to ensure that the high cost of premises, materials and equipment would pass down the generations. It is thus not so surprising that monumental sculpture, the art that most powerfully and permanently commemorates dynasties, tended to run in dynasties of its own.

Joseph Nollekens – long-lived, highly productive and successful but something of a misanthrope – travelled to Italy as a young man after serving seven years as apprentice to Peter Scheemakers. He had won a string of prizes at the Society of Arts which launched him on his journey to Rome where he lived and worked from 1762 to 1770. There he perfected his skills in the workshop of the sculptor, faker and dealer Bartolommeo Cavaceppi, and started a business of his own in the vibrant area of workshops around the Spanish Steps. In Rome he laid the foundations for his popularity and large fortune by making sculpture for British Grand Tourists, many of whom continued to be patrons when he returned to London. Nollekens naturally sought out 'the works of Michelangelo and other great men', as his biographer J. T. Smith put it, and gained experience in dealing in antiquities. Like Cavaceppi, he restored and even faked some when the market lured him that way. Setting up in Mortimer Street, Marylebone, soon after his return to London, Nollekens became the most successful monumental and bust sculptor of his generation, a productive successor to Rysbrack, Roubiliac and Scheemakers, and a characterful forerunner who set a high standard for Flaxman, Chantrey and Westmacott.

The trade in sculpture was satirized on the London stage by the actor-manager Samuel Foote, who performed in his own play *Taste*. This is a scene in an auction room:

Puff: Upon my honour, 'tis a very fine bust; but where is de nose?

Novice [i.e. amateur collector]: The nose? What care I for the nose? Where is de nose? Why, sir, if it had a nose, I would not give sixpence for

it. How the devil should we distinguish the works of the ancients, if they were perfect? The nose, indeed! Why, I don't suppose, now, but, barring the nose, Roubiliac could cut as good a head every whit.

The most expensive item that monumental sculptors had to buy was the stone they would carve. While limestones or alabasters would come from relatively local sources, the material that their clients overwhelmingly insisted upon was marble. There is no marble in the British Isles – so-called Derbyshire and Kilkenny marbles are in fact very hard limestones which will take a high polish. The most convenient place to find marble of a quality adequate for sculpture was Italy, specifically the marble quarries at Carrara on the Mediterranean coast north of Pisa. Marble merchants in London with direct connections to Carrara included Giuseppe Fabbricotti at Thames Bank, Egisippo Norchi in King William Street, Strand, and Francis and White at Vauxhall. John Flaxman's suppliers included Cock and Crowder, McDaniell, and Wallinger and Turner of Millbank. This was big business in every way. J. T. Smith reported that:

> So immense are the blocks now imported into England for works of sculpture, that at this moment [1828] Mr Chantrey has one weighing many tons for which he paid about £600.

'Patience on a monument, smiling at grief', as Viola described Olivia in *Twelfth Night*, would have been carved in white, shining Carrara marble; so indeed would the 'piece many years in doing and now newly performed by that rare Italian master Julio Romano', as the Third Gentleman breathlessly imagines in *The Winter's Tale*.

Flaxman revealed something of the centrality of marble to the sculpture trade by describing the complexities of working rival materials, and their shortcomings:

> Granite and Basaltes are not to be classed together for the manner of working, as Basaltes is much softer than granite and may be worked with the same tools as are used for the same operation on other Marbles; Granite is worked with steel points, and matting tools case-hardened,

the surface so worked is then ground to a smooth surface with sand and water and lastly polished first with Emery then with Putty. It is very possible that a tool with a leaden end might be used with Granite powder, or that of Porphyry or any other hard stones to assist in smoothing the surface or giving a polish, because friction will insinuate the particles of hard stone into the surface of the leaden tool which by this means becomes a surface of hard, sharp particles, capable of grinding the granite. For this reason seal engravers use leaden pointed tools with oil of Brick and Diamond powder to cut gems and precious stones, and this is the only way in which I see the possibility of using lead to advantage for this purpose.

The high cost of the material was such that the sensible sculptor would cut a rectangular block as carefully and as economically as he could: waste cost money. Chantrey's statue of George III, commissioned in 1811, was 'cut out of a single block of beautiful Italian marble, with the exception of one of the arms, and cost 1,200 guineas before the chisel of the sculptor had touched it'. Flaxman paid sums of up to £400 (£20,000 in twenty-first-century prices) to his marble suppliers in the first decade of the century. He seems to have discussed his business costs with Farington:

Though [Flaxman] received £4,000 for the monument to Captain Montague, his expenses were so great for marble and good workmanship that he did not derive more than £700 for his own use from it, which was a very moderate payment for his time.

Nollekens reportedly 'cunningly economized' on cutting a marble block by removing the corners carefully to preserve the shape of a future bust and contriving 'to drill out a lump from between the legs large enough for the head, which he put on the shoulders of the block'. This was no more than good sense, although the anecdote in Smith's unsympathetic biography was written to display something of Nollekens's alleged meanness rather than his sensible domestic economy. The marble which Nollekens cut so carefully was intended for a statue of William Pitt, a work which, according to Smith, earned the sculptor more than £15,000. This money came through Nollekens's marketing of versions and reproductions of the image

of the controversial politician – as clever a way of going about things as the politician himself. The sculptor was paid 4,000 guineas by Trinity College, Cambridge, for the statue and pedestal itself (installed in the Senate House in 1812); earned 120 guineas for each of the seventy-four busts he is said to have carved from the same design; and a further 6 guineas each for more than 600 plaster casts of the bust. While some of these figures may be optimistic and partial, there is no doubt that Nollekens knew how to keep his business costs low and his sales income high.

To run such a successful practice, from which across thirty years he turned out over 140 church monuments, forty statues, and busts of 300 or more individuals, Nollekens will have needed a ready supply of assistants, with good managers and reliable sources for his materials. Marble had to come in as well as go out, so it would not have been so unusual in Marylebone for passers-by to see rough grey cuboids being taken to the workshop and curvaceous polished white figures coming out of it on the back of a wagon. The patterns, casts and models that Nollekens needed to work from caught Smith's eye around the studio, which was

> principally covered with heads, arms, legs, hands and feet, moulded from some of the most celebrated specimens abroad, together with a few casts of bas reliefs of figures, and here and there a piece of foliage from the Vatican; all of which were hung up without the least reference whatever to each other.

While we know about Nollekens's terrifying housekeeper, Mary Fairy, who scolded both the artist and his wife, and was 'indeed frequently rude to his visitors', only two of Nollekens's studio assistants are known: Lucius Gahagan and Lewis Goblet. Gahagan was himself a sculptor's son, a member of the dynasty of London sculptors founded by his father Lawrence. Smith tells us that Nollekens paid Gahagan and Goblet only £24 for making the busts which he sold on for five times that sum; but that surely is how business works. The assistant is trained and paid for his labour, while the owner pays the overheads and takes both the risks and the profits. Lucius Gahagan moved on from Nollekens's employment and had set up business in Bath by about 1820. Lewis Goblet stayed on until

Nollekens died in 1823, and while he exhibited at the Academy under his own name (including in 1816 a bust of Nollekens himself), he remained within the orbit of Nollekens's practice, helping to care for him in his final illness, 'at all times ready, night and day, to render him every assistance in his power'. Goblet was loyal and attentive to his master, qualities that led to Nollekens bequeathing to this young man all his tools and the materials left in his yard. Much of this information comes from Smith's biography, a book as vilified for its tone as Walter Thornbury's biography of Turner (1862) was disdained thirty years later. But this is less than fair to both authors. While Smith and Thornbury identified colourful and enticing soap-opera story-lines, many have the ring of truth, and readers just have to take care.

The way that cash for sculpture and marble architectural fittings flowed in the first years of the nineteenth century is revealed in the many account books used by John Flaxman, who had his studio at 7 Buckingham Street, between Portland Place and Fitzroy Square. A box containing twenty-nine of his account books is in the British Library, the largest no more than 7 inches by 5 and about fifty pages long, all of a size which could be carried in the pouch of a sculptor's apron. Some are leather- or vellum-bound, others marbled; many carry the year of their use on their covers, from 1789. The books, which include five which show sums paid into and drawn from Messrs Herries, Farquhar Bank, reveal the clarity with which Flaxman ran his business, a habit which developed in his years in Italy, where all daily expenses, down to coffee and breakfast, as well as model fees, rasping and battering tools, pencils and so much else, are carefully noted down. In Rome we see he had to pay £1 for 'mending Sr Canova's Carr[iage]' and giving it a new axle – perhaps the weight of marble had snapped it. Back in England, running his own workshop, Flaxman made weekly payments to recurring names, including known sculptors Gahagan and Gott. In 1805, for instance, these names recur: Bone, Bridges, Broadrick, Burge, Butterfield, Dowling, Farrell, Hinchliff, Howard, Langley, Laycock, Lovat, McKandlish, Paris, Perkins, Thomas. They are all paid in January 1805, and most are still on the payroll the following December. Their weekly wage ranges from around £1 a week to odd sums of about £3 or £4, presumably

denoting both their value to Flaxman and the hours worked in a particular week. Many of these names are still appearing in the accounts in the 1820s, clear evidence of their loyalty and of the good sense of Flaxman as an employer.

The most detailed book contains the accounts of commissions undertaken by Flaxman between 1795 and 1808, for statuary from busts to monuments, as well as architectural fittings such as fireplaces, pediments and friezes. Each entry is cancelled by a vertical pen line, made presumably when the job was fully paid for. Lucrative commissions came from the Lords of the Treasury, through the Committee of Taste set up in 1802 under Pitt's Treasury minister Charles Long to commission monuments to victory and kingship. From them Flaxman received in May 1803 a commission to produce a monument to Admiral Howe, the victor of the Battle of Ushant in 1794, in which the French fleet was destroyed on the 'Glorious First of June'. He was paid £2,100 on account of £6,300 (6,000 guineas), the first of three equal instalments for the monument to be erected in St Paul's Cathedral 'without further expence'. Eighteen months later, as Flaxman admitted to a friend, 'Lord Howe hitherto is but an Embryo miracle of Art, and my smaller fry are scarce worth mentioning.' The second payment for Howe was made six years after the first in April 1809, and the final settlement on installation in December 1811. Thus, the work was completed, paid for and installed across a period of just over eight years.

A typical way of arranging public commissions was by open or invited competition. Flaxman would have none of this, however. Writing to the poet William Hayley, a friend to many artists, Flaxman explained why this was 'not the best way of proceeding in my opinion':

> As I have no great confidence in the judges who will determine on the merit of the works I shall have nothing to do with it, especially as I am more anxious to perform what I undertake in the best manner, than greedy of new employment.

Hayley evidently urged Flaxman to do more in the way of public monuments, but the sculptor was adamant about not entering competitions:

It will become me better to exert myself in finishing creditably the laborious works I am already engaged in, than to seek out others by competition which I was always averse to. I don't covet riches, but I should like to do whatever I engage in well.

Confident in Flaxman's abilities, the Lords of the Treasury then commissioned him in December 1807 to make a monument to Lord Nelson, also for 6,000 guineas, again to be paid in three equal instalments. The monument was installed in St Paul's Cathedral in April 1818, after an eleven-year process of creation. So, during the years 1807 to 1811, Howe and Nelson stood together in Flaxman's studio in various states of completion. Ann Flaxman, the sculptor's wife, wrote a lively account of work in progress in a letter of 1810 to their friend the Rev. William Gunn, vicar of Smallborough, Norfolk. Touching first on the home life of the Flaxmans, Ann makes some charming revelations when writing to thank the Gunns for the gift of a 'very fine Turkey' and of a hare 'which stares me in the face truly':

I send you a peep, and but a peep, into Flaxman's Studies. First then Lord Howe is nearly compleated, and will decorate St Paul's Cathedral towards midsummer. Lord Nelson is advancing slowly, and for the same cathedral, as also a fine, simple Statue of Sir Jo. Reynolds. Pitt's Statue for Glasgow is on the Eve of its journey northward. Lord Cornwallis for India and Mr Webber for the same place will set off next year. A pretty little gothic thing with two female figures for Salisbury. An interesting figure mourning the loss of 2 young men who died in their country's cause for Leeds, and a few others fill up the muster roll. He has refused to make any competition model for General Moore being already so overstock'd. He has been much thrown back by modelling a long frieze for the facade of Covent Garden Theatre. The mighty master of the Stage rought [*sic*] his genius to it[s] highest pitch and he [Flaxman] has succeeded accordingly. I must say I think if Shakespeare's self could look down his spirit would be pleased and he would cry content, as also to a most beautiful (<u>tho not fantastic</u>) statue of Comedy . . . Evenings are spent in making designs from the Shield of Achilles for a Royal salver and our odd moments are engaged in making out sketches from Nature.

Ann Flaxman goes on to disclose yet more burdens of work for her busy
husband to bear:

> The naughty Academy have elected him their Professor of Sculpture,
> indeed they made their <u>Professorship</u> on his account. So now he will
> have to teach the Boys, and this I fear will be a new and very unexpected
> impediment to his next summer's recreations.

During the five years from January 1808 to December 1811 Flaxman had at
least sixteen works on the go. Some of these are echoed in Ann Flaxman's
account: from a modest tablet and trophy to Admiral Millbanke and
reliefs for churches in Penang and Madras, to the grand statue of Sir
Joshua Reynolds commissioned for St Paul's Cathedral in September 1808.
Efficient transport systems allowed Flaxman's practice to serve both the
nation and the empire.

The average length of time for the execution of a large commission
was two or three years, but Flaxman could turn one around quickly if
he had to, particularly if he was being paid well: for his monument to
the Baring family he received 750 guineas, plus transport and installa-
tion costs; it was completed in just over a year. The accounts for the
Baring monument includes £2.3s for 'Wagon to Warwick Lane', which
gives an idea of how the monument might have made its onward
journey. Warwick Lane runs south from Newgate Street, past St Paul's
Cathedral to Puddle Dock. From there the work would be shipped on
the river, either downstream to be taken around the Kent and Sussex
coast to Southampton and then on by wagon, north to Micheldever in
Hampshire, or upstream to Reading, where it would be unloaded and
carted south. There were no other routes. Other costs that Flaxman
faced – ones that were common to monumental sculptors of his kind –
included the supply of packing cases (£40.16s.3d for the Barings, so these
must have been very substantial cases); plugs and cramps (iron or copper
fixing rods) to attach the marbles high on the chancel wall; rails (where
required) to protect them; polishing for the final touches, and travelling
and accommodation expenses that Flaxman or his assistants might incur
to install the work themselves.

The studio was a sculpture factory, with Flaxman in charge of the production and activity. Letters to clients reveal his concern for detail and his willingness to revise initial ideas. To John Hawkins, concerning a revision for a tablet in a Cambridge college, he wrote:

I have made another design, with the Chalice and Paten (as before) united by a small sprig of vine on each side, an ear of corn grouped with each to a garland of olive the emblem of peace as well as every liberal attainment and beneficial pursuit, to enclose the inscription, instead of the flowers.

Then, on acceptance by the client, he rapidly puts in his bill. 'I have made the small model . . . and am proceeding with the Marble, I shall therefore be obliged . . . for Fifty pounds, one third of the price in advance usually paid in Monumental works.' Flaxman priced another monumental work in a letter to Rev. William Gunn, who was considering the possibility of raising a monument to Nelson in Norwich: a statue 9 feet high, on an 11-foot-high pedestal with steps. This would cost, the sculptor estimated, £4,000,

with proper decorations, affixing and other etceteras of expence . . . You will perceive that such a work must differ in its price according to whether it is a group, or single statue; accompanied by Trophies or not, a decorated marble pedestal, or plain stone pedestal being its support. I would willingly send more particular and minute information, but to do this it is absolutely necessary I should see the places proposed to receive it, attending to, and weighing, many relative circumstances on the spot.

The monument was never made.

Day by day, Flaxman was an active presence, producing drawings to discuss with clients and making small clay models from these designs. The clays would be enlarged into marble or an interim plaster by his assistants, of whom there were fifteen or sixteen at any one time. Among them, in addition to the mason staff listed above, were some who would go further in sculpture: Lucius Gahagan and Joseph Gott already mentioned; Thomas Hayley, William Hayley's son, a promising sculptor who

died aged only twenty in 1800; James Smith; Flaxman's brother-in-law
Thomas Denman; John Ely Hinchliff; E. H. Baily – all became sculptors
of greater or lesser distinction in their own right. The assistants roughed
the composition out in marble, after Flaxman had made his amendments
to the plasters, and gradually carved the work to completion. The sculp-
tor Charles Rossi observed to Joseph Farington, perhaps over-critically,
that Flaxman's strength lay not in the carving, but in the designing and
modelling of his works.

Rossi's observation may explain the chilliness of Flaxman's finished
sculpture, an air of detachment that suggests that the artist's interest has
long since moved on to the next project. Flaxman's marble figures could
be locked up in a cold church, standing around with their torches and
togas like so many undead, and always feel at home. While there are a
small number of commissioned busts in his *oeuvre*, the capture of like-
ness and the transmission of personality were not his intention; his works
began, and remained, funerary. With the armies of the dead increasing in
number month by month, Flaxman could with good reason tell Farington
in 1808 that he had 'work in hand that would employ him near seven
years'.

Having a multitude of white figures carved in the round or in
relief, Flaxman's studio must have resembled the entrance to purgatory.
Nevertheless, it was a good turnover. Money paid to him in 1810 and 1811
alone totalled £6,797 – that is about £3,400 per year, or about £150,000
in early twenty-first-century terms, to run his studio. Relatively speaking,
it was a considerable thriving business. But Flaxman mused to William
Gunn on the perishability of monuments, in a manner that prefigures
Humphry Davy's thoughts on the mutability of civilization in *Consolations
in Travel* (1830):

> As piety or patriotism raise the golden or bronze statues, avarice will melt
> them and convert them into money, not caring that *opus superat mate-
> riam*. Necessity and barbarism will take stones from the finest palace arch
> or pillar to build a cot or a hovel, so that argument against any species of
> monument because it was not imperishable, would rather be arguments
> against raising any monument at all.

From the coming giant of monumental sculpture, Francis Chantrey, at least four ledgers remain which list his business transactions. One, in the Royal Academy, contains the bulk of Chantrey's records. When Flaxman was in his mid-fifties in 1809, Chantrey, aged twenty-eight, was beginning his professional career with a very precocious order for four colossal plaster busts, at 10 guineas each, of Admirals Howe, St Vincent, Duncan and Nelson for the Naval Hospital at Greenwich. Over the next five years, approximately the same period that we have examined with the well-established Flaxman, Chantrey began to build his career as the most able and inventive maker of marble and plaster busts, in which likeness and personality are vividly captured. No greater distance in terms of presentation, style and subject matter could there be than that between Flaxman of Buckingham Street and Chantrey of Eccleston Street, Pimlico. Where Flaxman produced monuments for dead gentry, soldiers and government officials, Chantrey created intelligent life in marble for the burgeoning professions. In the early 1810s Chantrey enlivened the name and memory of the Sheffield doctor John Browne, the radical politician Sir Francis Burdett, the surgeon Henry Cline, the agriculturalist Thomas Johnes of Hafod, and the mathematician John Playfair. These were the coming men, and so was Francis Chantrey. Where the generation of Rysbrack and Roubiliac created an iconography for a national identity with their sculpture, Flaxman and Chantrey in their generation expressed national purpose.

Chantrey's practice reached its first peak of complexity in 1811, when the City of London commissioned him to make the colossal statue of George III, mentioned above, for the Guildhall. This demanded that he efficiently and economically manage his studio, and employ a team of skilled and apprentice assistants. It was the year in which the Flaxman factory was engaged on, or had just completed, their Howe, Nelson, Pitt and Reynolds, and when the City aldermen had also commissioned James Smith, a former assistant of Flaxman, to make a monumental figure of Nelson, and another sculptor, James Bubb, to produce a huge figure of Pitt. This was a busy time for the colossus trade, a measure of the political imperative that the London Council's Tory loyalty to the Crown at this crucial stage of the wars with France should be visibly demonstrated. As

a measure of the relative celebrity of Flaxman and Chantrey at this time, the younger man's total fee, £2,100, was one third of Flaxman's fee for his Howe and Nelson statues.

Chantrey's studio workforce had to expand to take on so important and labour-intensive a commission as the king's statue, as well as the other commissions that were gradually accruing. Ten assistants are named in one of his ledgers, annotated by his secretary Allan Cunningham, a Scottish poet who had come to London from the Lowlands in 1810 in search of literary fame. Having known Robert Burns and James Hogg in Scotland, and being a talented poet and balladeer in his own right, Cunningham's ambitions appeared to be compromised when he was employed as a sculptor's assistant first by James Bubb, and then, in 1814, by Chantrey. Cunningham's literary career was already developing, with work on the journal *The Day* as a parliamentary reporter and with William Jerdan on the *Literary Gazette*. Nevertheless, he put this to one side, perhaps temporarily at first, to become Chantrey's assistant, trusted studio foreman and secretary. Cunningham continued to write important works, including a life of Burns, and to publish fervent songs of an exiled Scottish character under the pseudonym 'Hidallan'. Nevertheless, he remained in London in the security of Chantrey's studio for the rest of the sculptor's life. In his last decade, Cunningham wrote a life of David Wilkie. His literary and managerial talents were noticed at a high social level: the Sixth Duke of Devonshire described Cunningham as 'foreman, sculptor, poet' when he was working for Chantrey at Chatsworth in 1822.

Cunningham's career reflects something of the conflicts of interest in the artistic world of the early nineteenth century, and the economic pressures to take the safer option. He married his Scottish sweetheart Jean Walker in London in 1811, and the pair settled down in Pimlico in the shadow of the sculpture works to raise a large, happy family. As Cunningham's family grew and his children played with the marble chippings around the works, so Chantrey's own studio family expanded. He and his wife Mary Anne had no children of their own, but they did increasingly have a family of assistants coming and going, including David Dunbar, William Elliott, James Heffernan, Francis Legé and Frederick William Smith. Nothing is

known of Elliott, but the others all went on to become sculptors in their own right, being more or less successful in breaking away from the master's orbit. Of the three that stayed on with Chantrey, James Heffernan was an Irishman who had followed the classic course of coming to London, finding work in sculptors' studios, first with Rossi and then, in about 1810, with Chantrey, studying at the Royal Academy Schools, and travelling to Rome. On his return he went back to Pimlico and worked there for the rest of Chantrey's life. Heffernan became indispensable and, exhibiting at the Academy under his own name, was rebuked in the press for 'wasting the summer of his life, like so many other talented men in this town, to increase the already overgrown reputation of another'. He appears to have been dissuaded by Chantrey from embarking on a career of his own, perhaps because he was so useful around the studio. After Chantrey's death it was revealed, maybe with some accuracy, that he carved 'almost every one of Chantrey's busts literally from the first to the last'. Heffernan 'saw and caught and translated Chantrey into another material'. Reportedly very good-natured, amusing and good-humoured, Heffernan was 'marred by diffidence, a want of reliance on himself, and broken health'.

Another of Chantrey's early assistants, Frederick William Smith, was a local boy, born in Pimlico. He too went to the Royal Academy Schools, but failed to win a Rome scholarship. He turned, inevitably, to the security of the Pimlico workshop and became Chantrey's right-hand man. He too exhibited busts at the Academy under his own name, his subjects including people near to him, Allan Cunningham and Francis Chantrey himself. Smith received high praise from John Flaxman, but in a later account of the studio's work it was made clear by Peter Cunningham, Allan's son, that his 'ambition was limited by the necessities of the week'. In other words, he was trapped in the orbit. He died young. A feeling and sympathetic obituary remarked that Smith 'was certainly the first of our second class of sculptors; nay, some of his works have the right to stand in the first rank'.

A third long-term assistant was Francis Legé, a Prussian immigrant who had worked as a sculptor's assistant in Liverpool, alongside John Gibson. He came to Chantrey in 1815 fully formed, having shown a colossal figure of *Satan* in Edinburgh the previous year, and having evident talent and

ambition. But although he showed sculpture at the Academy under his own name, Legé stuck with Chantrey and faded into the anonymity of studio life. One, however, got away. David Dunbar was the son of a Dumfries stonemason, who had trained him. He travelled to Rome in 1805 and came back to London, where Chantrey took him on. He had clear talent, exhibiting a model for a statue of Robert Burns at the Academy in 1815. But by 1822 Dunbar had escaped Chantrey's gravitational pull and had moved north to Carlisle, where he became a major force in sculpture in the north-west of England. He co-founded Carlisle Academy of Fine Art and built his own influential career, becoming, indeed, the Chantrey of the North. He made busts of important northern figures including the heroine Grace Darling, the peer Lord Lonsdale and the novelist Mrs Gaskell, and through exhibitions and lectures he introduced the work of Canova and Thorvaldsen to the north of England.

Rather than have the young men idle when work in the studio slackened off, Chantrey (or Cunningham) sent them out into London to clean up city statues in advance of the victory celebrations over Napoleon. While the statue of the king was in progress, Chantrey received in 1812 a commission of similar importance for a 7-foot-high seated figure of Robert Blair, Solicitor-General for Scotland, for the Faculty of Advocates of Edinburgh. At £4,000, this was nearly double Chantrey's fee for George III and was becoming comparable to the amount that Flaxman could expect. It was patent recognition that Chantrey had become an established sculptor already at the age of thirty-one.

Chantrey's father was a tenant farmer and carpenter from Norton, near Sheffield, who presumably encouraged the boy in his first apprenticeship to a Sheffield decorative carver and print dealer from 1797 to 1804. He was noticed at this early age by the ubiquitous William Carey, then contributing paragraphs to the *Sheffield Iris*, and buoyed by Carey's published support, he was able to travel to London, where through trade contacts he found work carving details in furniture for the collectors Thomas Hope and Samuel Rogers. He clearly had charm and youthful brightness, for he was noticed also by Sarah D'Oyley, née Sloane, the grand-daughter of the collector and philanthropist Sir Hans Sloane, one of the founders of

the British Museum. When in London, Chantrey lived in Sarah D'Oyley's house, as a guest of her butler and housekeeper. He came very sensibly to marry the butler's daughter, his cousin Mary Anne Wale, and sensibly also must have charmed old Mrs D'Oyley. One thing leading to another, Mrs D'Oyley helpfully provided a large sum of money, 'said to be about £10,000', to set the couple up. With this money Chantrey bought his house and studio in Pimlico. This extreme generosity, proto-Dickensian as a rags-to-riches tale where natural genius is revealed and nurtured, became a source of gossip, Farington being one of the perpetrators. But what is also clear is Chantrey's talent at attracting business:

> Chantrey . . . during his progress in *Sculpture Study* was much assisted in pecuniary matters by Mrs D'Oyley of Sloane St, a Lady now aged abt. 90 . . . He has great employment and visits everywhere. He has 100 or 120 guineas for a Marble Bust. His inclination is not much to Classical reading but he is vigilant in obtaining a great variety of useful information.

But it was also the sitters who pressed for immortality by Chantrey's hand. Augustus Callcott relayed a story about Chantrey visiting the elderly banker Thomas Coutts, perhaps not with the primary intention of winning a commission. They chatted amiably, when suddenly turning to Chantrey Mrs Coutts said:

> 'don't you think Tommy would make a fine bust. He is the very image of Julius Caesar if you see him without his wig on.' As she said this she snatched it from his head and he was exposed in all his baldness.

This was Mrs Coutts's manner: she was the former actress Harriet Mellon, well accomplished at the significant and memorable dramatic gesture. Chantrey did in the event make an image of Thomas Coutts, but a posthumous seated figure, not a bust, which now sits smiling benignly on customers on the first floor of his bank in the Strand. His wig is firmly in place.

Francis Chantrey liked grandeur in sculpture. His full-length figures have a nobility that expresses the gravity of public life in early

nineteenth-century Britain and also carries its weight. The human scale was not really enough for Chantrey, however, and there were times when he mused on the super-colossal. His biographer, the painter George Jones, reflected on these ambitions:

> [Chantrey] thought a fine representation of man the most imposing of objects, and his desire to impress the world with its importance led him to wish to imitate [the Greek philosopher] Democrates, who offered to cut Mount Athos into a statue of Alexander. Chantrey wished to convert a projecting rock in Derbyshire into a human figure; he also gave a design for a colossal statue of the Duke of Sutherland, to be built up in a rough manner on an eminence near Trentham [Staffordshire].

Chantrey's studio output was by any comparison prodigious. He and his assistants were turning out sculpture on an industrial scale, with Chantrey as the managing director. While we might reasonably expect the hand of the master to be evident, romantically, in the cutting of the figures, the faces, the gestures, the light in their eyes, his personal contribution would effectively have been limited to composition and finish. The labour would be contributed by others: according to Chantrey's ledgers, Legé spent 142 days and seven-and-a-half hours, across five months, working on *The Sleeping Children* for Lichfield Cathedral in 1817.

Chantrey's genius was to take a modern route and make drawings of sitters by way of an optical drawing instrument, the *camera lucida*, invented and patented by Cornelius Varley, brother of the wayward John. He sat his subjects down on a chair in front of this instrument, made conversation with them, made them smile and laugh and animate, and made rigorous studies of them, full-face and profile with marks for shading and pointing. In many full-face drawings he marked a determined centre line which reveals that Chantrey understood that the human face was asymmetrical. The next stage in the process was for Chantrey to make a clay model, on a supporting armature, which would be worked persistently and with deliberation to capture the personality of the sitter and to develop a characteristic pose: James Watt's wide brow and firm, decisive mouth; William Wordsworth's diffident avoidance of the viewer's gaze; John

Rennie's tousled hair suggestive of a man of action; Walter Scott's quicksilver shift of the head. All these seem from a distance of nearly 200 years to be the projected character of the individual; it is what the sitter showed to Chantrey. Where Renaissance saints have their attributes – St Peter his key, St Catherine her wheel – Chantrey's men, and his few women, bear the marks of the sculptor's own expression of their character and profession in the set and temper of the face. There is the art.

The clays, long destroyed by the process, held the touch of Chantrey's soft fingers. From the clays a mould was taken to make the plaster. When dried, cooled and released from its mother-shape, this was rasped and filed, smoothed and rubbed, undoubtedly by Chantrey himself, before, in the case of busts, being placed within the pointing-machine system to have its dimensions transferred to the marble block. Initially roughed out, the block would be cut back to resemble, touch by touch, the dimensions of the plaster and to reveal Chantrey's conception of the subject. The rough cutting was studio work; the later smoothing of the cheek or the lighting of the eye was Chantrey's.

Francis Chantrey became an Associate of the Royal Academy in 1816 aged thirty-four, and only two years later was elevated to Royal Academician. For his diploma piece, the obligatory example of work given to the Academy by an elected Academician, Chantrey offered his bust of the Academy president, Sir Benjamin West. This particular choice of subject will have done him no harm among the Academy grandees. That same year he was elected a Fellow of the Royal Society, a group, strictly speaking, for scientists (or natural philosophers, as they were then known), but greatly influenced in their activities by their hospitality to artists, moneyed men, and dilettanti whose presence as Fellows came briefly to shift the Society's centre of gravity. The Royal Society, which shared the Strand-frontage rooms of Somerset House with the Royal Academy and the Society of Antiquaries, praised Chantrey on welcoming him to their number as 'highly distinguished as an artist and well-versed in various branches of human knowledge'. Becoming a Fellow of the Royal Society enhanced Chantrey's standing as a portrait sculptor, and Royal Society fellows became a staple of his subject matter. Chantrey was the consummate networker.

Across this period, sculpture came particularly to the fore in the deal-ings of the Royal Academy. In 1818 there were five sculptor Academicians, with one, E. H. Baily, on the rise as an Associate. Those sculptors who had made the grade were a lively lobbying group, buoyed up by the strength of the market for their art, a benefit in financial terms and public knowledge that painting could not hope to match. Nevertheless, this is a very small number, considering that there were thirty-eight painter RAs and ARAs in 1818. It indicates perhaps that sculptors' studios had a stranglehold on training and production, and created a strong economic disincentive for young, undercapitalized sculptors to break away and set up on their own. Thus, there was no real hope of Frederick Smith or Francis Legé ever becoming ARAs, nor yet David Dunbar in faraway Carlisle.

The foundation of the Academy's sculpture interest lay in its large and ubiquitous collection of plaster casts, seen by all, crowding rooms and cor-ridors with their blanched pallor, and already the subject of ten thousand student drawings. The collection was being added to *ad hoc* by enthusiastic purchases and gifts: Council minutes record, for example, that Flaxman purchased 'a cast in plaister from the Venus of the Capitol, for fifteen guineas'. A report commissioned in 1810 by the president and Council found that the Academy owned more than 250 large casts and dozens of smaller pieces:

> 70 statues, 122 busts, 50 bassi-relievi & 12 large fragments, besides 105 pieces from the Trajan Column, 2 marbles from the frieze of the Parthenon, 5 ornamental fragments in marble, 19 architectural casts & a variety of small figures, hands, feet etc.

But the filthy air of London and the smoke from the candles and lamps in the Academy, as well as the necessity of painting and repainting the plasters, had dulled their surfaces and killed their lines, making them by 1814 'unintelligible to the student'. Pedestals had been damaged, making them unsafe, and over the years they had been shuffled about the Academy, losing all sense of order in the process. As an initiative following the end of the Napoleonic Wars and the new availability of casts of antique sculpture from collections in France and Italy, the Academy made concerted efforts

to procure new casts to replace some of the old ones. At home, casts of the Elgin Marbles, which came to London in 1808, were a new desire; to acquire casts of sculpture on the continent, however, the Academy needed support from the top. After a wordy and loyal approach from the president and Council, the Prince Regent presented the Academy with the superb collection of plaster casts from Paris, Venice, Rome, Florence and Naples which he himself had been given by grateful European states, now freed from Napoleon's grip. With a wave of the royal hand they were transported to London on navy ships, bringing forth an effusive response reflecting the gratitude of the Academy:

> Your Royal Highness's liberality has renovated the School of Design of the Royal Academy, & provided it with a better stock of appropriate examples than it has hitherto ever possessed . . . Beneficial effects . . . will soon be apparent in the improvement of the students [providing] a new stimulus [to] promote the true principles of Taste; &, with Your Royal Highness's powerful support, to give to the Arts that effective Energy which is so generally characteristic of this Country, & renders it pre-eminent among the Nations of Europe.

Plaster casts, now that a new, crisp, pin-sharp set had arrived, were once again the gold standard for the coming generation of sculptors.

Taking two years of Francis Chantrey's output, 1820 and 1821, as a sample, we can see how his studio business unfurled. By comparison, Flaxman's output ten years earlier had been modest. Work in progress – that is, ordered before January 1820 and not yet completed – comprised three monumental statues, General Gillespie, Francis Horner and George Washington; twenty-five church monuments, both free-standing and to be mounted on a wall; seventeen wall-mounted church reliefs; and twenty busts, many of which were in multiples, so the number of busts waiting patiently on shelves and pedestals in the studio may have been in the thirties or forties. This was when the year 1820 began. The orders that came in over the following two years comprised five statues, seated and standing; sixteen monuments; fifteen reliefs; and sixteen new subjects for busts: statues of Robert Dundas for the Parliament House in Edinburgh, William Hey for

Leeds Infirmary, Cyril Jackson for Christ Church, Oxford, James Watt for Handsworth Church, Birmingham, and Joseph Banks for the British Museum. William Wordsworth, Walter Scott, the Duke of Wellington and William Blizard came to the studio in the flesh and left in the marble. With such activity it is little wonder that Chantrey fantasized about carving a living rock in Derbyshire or mounting a colossus on a hill in Staffordshire.

While only a small number of Chantrey's assistants are known by name, production at this level, as with Flaxman, called for a small army of specialists in the fashioning of rough blocks, architectural carving, decorative design, polishing, plaster-casting, heavy-weight lifting and tool-making. Another vital speciality was lettering, as all or most of the monuments bore inscriptions, some running into elaborate texts of 400 words or more. The order for one monument, to Richard Bateman installed in All Saints' Church, Derby (now Derby Cathedral), shows that 845 letters cost £8.9s.0d – that is, 100 letters to the pound, Chantrey's standard charge for inscriptions.

Chantrey himself was charming, entertaining and generous. His hospitality was on a lordly scale, and of a cerebral nature. Indeed, so it should be, bearing in mind the social and intellectual level of the men and women whose patronage he courted and whose likenesses he caught.

> With the members [of the RA] Chantrey's intercourse was frequent: his means and liberality enabled him to establish hospitable association. Sundays he generally passed at home, members of the Royal Academy and other intimate friends dined with him . . . [I]t was common occurrence to meet men distinguished by science and literature; and perhaps no hospitality short of Lord Essex's, Lord Spencer's and Lord Holland's could compare with Chantrey's. In the evening, the specimens of . . . minerals and fossils were examined and the instructive allurements of the microscope filled every moment with gratification.

However, Chantrey was direct in business, and like all tradesmen he had his share of abandoned orders, a broken supply chain, or bad payments. He took his share of sharp practice, too: a Bristol patron, William Elwyn, proposed a complex agreement over payment for a monument to his wife, with extra for this and changes to that. Then there was a bit of apparent

fast dealing by Elwyn over the fees due to Bristol Cathedral, so Chantrey did not really know whether he was coming or going. His rueful note in the ledger reads:

> Mr Elwin is a sharp clever man, he managed to make me pay Church fees after I had <u>completed</u> the monument to the <u>full</u> value of 300 guineas.

Of the fifty-eight commissions placed with Chantrey in 1820 and 1821, six were ultimately abandoned, including a (presumably) colossal figure of *Satan* for Lord Egremont's sculpture gallery at Petworth, 'Poetical Figures' for both the Duke of Devonshire and Lord Dartmouth, and a 'Figure or Groupe' for Lord Yarborough. Ideal figures and imaginative groups were not Chantrey's forte, however; these were more Flaxman's line, and although he did make friezes, such as subjects from the *Iliad* and the *Odyssey* for the Duke of Bedford, Chantrey's purpose was the commemoration of man in the life, whether the subject was living or dead. It is difficult to determine accurately how much money Chantrey turned over in his business, but the total of payments made or committed to him over the two years 1820 and 1821 approached £13,500 a year – the equivalent of an annual income of about £675,000 today. As a rule of thumb, a standard bust would cost the sitter 120 guineas and a modest monument perhaps £500 to £700. The completed works would leave the studio by wagon, with much heaving and groaning, some making their journey by road, but most using the canal system or the river where possible. The Bateman monument was carted to Paddington (charge: 11 shillings), where it would have been put on the Grand Union Canal and taken by barge to Derby.

As in any large-scale sculptural practice, the comings and goings of materials and products at Chantrey's workshop could not be carried out invisibly. The removal of sculpture from Pimlico must have been something of a public event, particularly if the departing work was a large statue long in the making. The arrival of a massive mineral specimen in Pimlico caused a sensation:

I am now deeply engaged in improving my own collection [of minerals], having during last week purchased and paid for <u>one Specimen</u>, which weighed eighteen tons, and which was brought to my house by eighteen horses, under the management of fourteen drivers, and accompanied by upwards of one hundred independent electors of Westminster.

The study of mineralogy, of fossils, and of the geology of the materials he carved was high among Chantrey's private interests. To this end he studied and compared his collection of geological samples with his friends, one of whom, the geologist Henry de la Beche, sent him a list of exact figures of the comparative weights of stone samples per foot cube, from chalk to granite.

There are many contributory factors to the wide spread of funerary monuments across early nineteenth-century Britain, and their increasing export to India and the West Indies: the rapid growth in the number of churches, the hangover of medieval attitudes to death, the social influence of the church, the nation's readiness to go to war, the social obligation to believe in Christian resurrection, the primitive state of medicine, and thus the inability of the wealthy to buy more effective treatment. The natural consequence of the wealthy buying commissions for their sons in the army and navy was the timely appearance of church monuments when they were killed. Away from the heat of battle, sickness and death would also make their way, late or soon, through all classes: certainly those who lived in the clean air and space of the country had health advantages over those in the cities, but the air in Birmingham, Manchester, Bristol and London was as filthy and debilitating for those with money as it was for those without; and cholera and tuberculosis cut through society as cruelly and certainly as a railway cuts through landscape. Chantrey's worldly success was the direct result of a natural fear in society, fuelled by religion as well as by literature. What Chantrey sold was reassurance. In the twenty-first century, insurance companies sell 'assessment of risk' through the suggestion of fear of what might happen, although they market this as 'peace of mind'. Two hundred years earlier that task was also performed by sculptors, with the local parson acting as insurer's agent and cheerleader: the nineteenth-century insurance policy was written in marble, at 100 letters to the pound.

The market for sculpture was driven by belief in an idea rather than desire for ownership, and was therefore disproportionate to the market-led pattern of industrial growth and efficiency seen in the factories and the fields. Nobody would contemplate selling for profit a church monument in which they had invested hundreds of pounds: here, the patron is the end-user. This also provides the reason why Nollekens could set up his own successful business after training with Scheemakers, and David Dunbar could break away from Francis Chantrey and find plenty of work from a new base in Carlisle: death was as certain and peace of mind as cherished in the north of England as it was in the south. Funerary sculptors' markets were aided by England's unique canal and river system, at the peak of utility in the 1820s and 1830s. To move a 10-ton monument from London to the Midlands, for example, meant a short wagon journey along hard city roads to the Paddington or Pimlico canal basins, followed by a frictionless passage as far as you liked. While wagon costs do appear in Flaxman's and Chantrey's accounts, inland barge and shipping costs do not, as they were paid at the other end.

Busts and, less commonly, statues carried the funerary tradition into the world of the living. The features of the Duke of Wellington, Walter Scott, George IV and James Watt are so familiar now because Chantrey created the icon. Reproduced down the decades, they have burned into the national memory: the Duke of Wellington's nose, James Watt's mouth, the jowls of George IV, all hang on a marble peg. In 1827, only seven years into the reign of George IV, 'The King's Thirteenth Bust' was ordered from Chantrey, and there were many more to come. The sculptor's ledger records in 1835 'James Watt's Fifth Statue [Greenock]', and in the year of his death in 1841 Chantrey was already working on his 'Third Bust of Queen Victoria'. The business of art in the nineteenth century was as much to promote the status quo as it was to delight, to challenge and to change. Chantrey maintained a tight quality control over his output. He noticed that a bust of the Duke of Wellington, commissioned in 1826, had flaws in the marble. Allan Cunningham noted in the ledger: 'This bust when executed had some spots on the neck and bosom which induced Mr Chantrey to lay it aside: it was afterwards sold in 1835 to A. Maclellan of Glasgow for one hundred guineas.'

Chantrey was overwhelmingly a sculptor in marble; he came to bronze late. Bronze production on any commercial scale required a foundry, sources of extreme heat, men with skills that were not required in marble-carving, heavy lifting gear, particular tools, and a working knowledge of industrial-scale chemistry. The last of these he could readily glean from his Royal Society friends. Bronze production also required a ready source of metals, but for the right subject, such as the king or Wellington, this was not a problem as the army had captured French cannon to spare.

Chantrey embarked on large-scale bronze sculpture in 1822 when commissioned by a committee headed by Lord Egremont to make a figure of George IV to stand in the Royal Crescent in Brighton. While it was in progress, a variant was commissioned by an Edinburgh committee led by Lord Meadowbank. Unfamiliarity with the medium and process on a large scale caused Chantrey initially to miscalculate his prices and to charge an inadequate figure, 3,000 guineas, for the Brighton statue. This he recouped in Edinburgh by doubling the price. To cast these works Chantrey installed a furnace at Pimlico in 1827, 14 feet long by 12 feet wide by 12 feet high, designed and overseen by the Lambeth engineer Henry Maudslay. Chantrey was extremely proud of his furnace, holding parties around it and dare-devil competitions to see which of his friends, including Charles Babbage, David Brewster and Thomas Lawrence, could bear the heat. David Brewster managed 320 degrees Fahrenheit for two minutes.

From 1828, when the Edinburgh statue was still under way, Chantrey's business in bronze remained at a high-status level. He continued in marble for his everyday work, in bronze for the spectacular: an equestrian statue of Sir Thomas Munro, Governor of Madras, which took ten years to complete; William Pitt for Hanover Square, London, which took six years, and a version for Edinburgh which took a further two; James Watt for George Street, Glasgow (six years); an equestrian of George IV for Trafalgar Square (nine years); and an equestrian Duke of Wellington for the Mansion House, City of London (commissioned 1837; incomplete at Chantrey's death). Thus from 1828 to 1831 there were six monumental bronzes in various stages of completion under way and in various bits and pieces in

Chantrey's foundry: two of George IV, two of Pitt, one of Munro and one of Watt. Interestingly, the George IV for Edinburgh and the William Pitt for London were cast in the same year, 1831, as were Munro for Madras and George IV for Trafalgar Square in 1838. This at the very least suggests that Chantrey was looking for economies of scale, and perhaps the retention of trained staff for a particular purpose, by managing a more logical flow of work. The toll the bronzes took on Chantrey's working pattern and on his rapidly advancing years was considerable. With only a degree of humour he wrote to his friend Charles Turner of the Munro equestrian:

It is done!!! & well done!!! Had it lasted a few days longer it would have done for me! I hope to meet man and horse at East India Dock today.

The general pattern for commissioning large public sculpture for outdoor locations was to raise public enthusiasm through the work of an organizing committee, and then funds from subscription. The statues of George IV in Brighton and Edinburgh were part-funded in this way. The campaign for the Duke of Wellington statue for the City of London was run like a military campaign by a group led by four of Wellington's former generals, Beresford, Combermere, Hardinge and Hill, who intended it to be sited near London Bridge. The many subscribers included Sir Thomas Baring (20 guineas), Sir Marc and Isambard Kingdom Brunel (£10 each), Lord Egremont (£20), John Murray (1 guinea), Sir John Rennie (10 guineas), John James Ruskin, the father of the critic John Ruskin (10 guineas), and Sir Robert Peel (20 guineas). At the dinner given by the Lord Mayor to celebrate the progress of the Wellington statue, Chantrey sat next to the journalist William Jerdan, who became excited when the Duke, 'about half-a-dozen chairs [away]', gave him a nod of recognition, 'a very rare compliment', as Jerdan acknowledged. This gave Chantrey the opportunity to digress to Jerdan on the

singular configuration of the Duke's ear, which he, as an artist, modelling his head, had naturally observed; it was almost flat, and destitute of the shell-like involutions which are the usual attributes of the organ.

So the Duke of Wellington had a curious ear, as well as a splendid nose.

Chantrey's fame and fortune rested in great part on James Watt, and not only through his well-distributed busts of the engineer. Watt, offering a further dimension of influence on civilization beyond the invention and development of the mere steam-engine, followed his unbridled ingenuity to the invention of a machine for copying sculpture – equipment which would also be able to scale a sculpture up or down, or indeed to copy or scale any suitable object and carve it from a stone or plaster block. The human benefits of this, in comparison with those of the steam-engine, might be small, but they are by no means negligible. Image bore authority and transmitted purpose. As Michael Faraday showed with his contemporary explorations of improvements in two-dimensional image reproduction through steel-plate engraving, lithography and photography, the end consequence of reproduction was better education for all. Watt's sculpture-copying machine, developed in his retirement and now in the Science Museum, London, looks like a small guillotine, with a high rectangular framework at one end, a central 'bench' supporting the locating and drilling machinery, and a fly-wheel at the far end to transmit the pedal power to the drill. Picking up the dimensions of the sculpture to be copied – this is clamped under the 'guillotine' – is a pointer that measures variation in depth, transferring these to the raw block by means of a ball-headed drill which grinds down to the level of the tip of the nose or the curve of the cheek. Thus infinite changes in gradient can be echoed from original to copy, amidst clouds of plaster or marble dust, and much clanking and clattering as the operator works the pedals. Detail, particularly in small objects, was initially poor. This was an ingenious and extraordinary piece of machinery, but how practical it was outside the potting shed is debatable. The simplest way of copying sculpture mechanically, rather than by taking casts, was not with Watt's rattling contraption, but with a static pointing machine. As used by Chantrey, this measured sample depths, for example between the bust's nose and the back of the head, and transferred them by means of rigid connecting bars to the new block, the copyist cutting the material back to the depth indicated.

Francis Chantrey ended his life a rich man, famed and lauded, his works spread out across the British Isles and washing up onto the shores of empire. His widow gave his collection of studio plasters to the University of Oxford, to be housed in C. R. Cockerell's new building for the Ashmolean Museum, where many of them are now dramatically displayed row upon row up a staircase wall – Oxford's ancestor gods. Mary Anne Chantrey also passed on the Chantrey Bequest, a capital sum bequeathed to the Royal Academy to buy works of art for the nation. It continues to do so. Nollekens before him made money hand over fist, but his frugality set him apart as something of a figure of fun, and he died in 1823 worth £200,000 (then) and owning 'several London houses'. Flaxman worked to the end, and although he left only a modest sum, he remained buoyant, inspired and productive. His accumulated collection of plaster casts and working models, valued with 'stock in trade of unworked marble' for legacy duty by James Christie at £469, was presented in 1847 by Maria Denman, his sister-in-law, to University College, London, where they are handsomely displayed to this day. His posthumous sale of books and engravings raised £300.18s.11d.

It is apparent that Nollekens, Flaxman and Chantrey handled their business affairs supremely well. They knew how to delegate and oversee, and inspired the loyalty of their staff by giving them interesting and challenging occupation. They also gave their assistants the training they needed to enter the mid-nineteenth century with their eyes open and the extra skills they required to manage the additional pressures of improved mechanization and mass production. Other early nineteenth-century sculptors were not so clever. Charles Rossi had all the opportunities of his contemporaries – training in London with the Italian sculptor Giovanni Battista Locatelli, attending the Royal Academy Schools, winning the three-year travelling scholarship to Rome, exhibiting to some acclaim at the Academy – but despite receiving more commissions from the Committee of Taste for monuments in St Paul's Cathedral than Flaxman, Banks or Westmacott, and becoming sculptor to the Prince of Wales, later George IV, and to William IV, he 'bequeathed to his family nothing but his fame', and died the recipient of a charitable Royal Academy pension. His most widely seen works – passed by millions, noticed by many – are the caryatid figures,

copied from the Erechtheum in Athens, outside St Pancras Church on Marylebone Road, London. Rossi's difficulties seem to have stemmed from his practice of being less than generous in payment to his assistants, and thus getting inferior work from them: 'rather <u>Mason's work</u> than that of a Sculptor', as Flaxman described one of his monuments in St Paul's to Farington. The diarist noticed also that 'Rossi . . . by employing ordinary men at low wages, got much money by it, but had greatly suffered in reputation.' He also had sixteen children by two wives and became the landlord to Benjamin Robert Haydon, two factors neither of which would have been easy financial burdens to carry.

A similar orthodox career pattern was followed by Richard Westmacott, who may have trained in the studio of his sculptor father Richard Westmacott the elder, and by Edward Hodges Baily. Coming to London from Bristol where his father had carved decoration for ships in the late 1700s, Baily trained at the Royal Academy and spent seven years working with Flaxman. He exhibited in his own right at the Academy and was immediately acclaimed as a powerful young force in sculpture. He diversified, as did Flaxman, by designing elaborate silver and gold tableware and trophies during a period of national elation and celebration after the Napoleonic Wars when such commissions were relatively plentiful. From a workshop off Tottenham Court Road, Baily worked for John Nash on the figures for the newly extended Buckingham House and produced the figure decoration on Marble Arch, as well as Britannia and Victory, possibly rejects from the Marble Arch, for the façade of the National Gallery. His highest achievement, in two senses, is the figure of Nelson on top of his column in Trafalgar Square. Everything seemed to be going right for Baily, except that delayed payments for work on Buckingham House sent him into bankruptcy in 1831, and further delayed payments bankrupted him again in 1838. Two further bankruptcies suggest that perhaps personal extravagance had a part to play in the difficulties of 'this eminent sculptor, whose productions do immortal honour to himself and his country'. However, Baily's personal circumstances – a wife and six children and an 'affection of the liver' – were in themselves heavy burdens, and contributory to the £5,000 debt he had in 1838. The court ordered the sale of Baily's

'models' – that is, his studio plasters and other sequestered works, which raised £150, from which Baily was allowed £10.

The first half of the nineteenth century was a golden age for sculpture in Britain. The following generation did not find the climate quite so invigorating. When Thomas Woolner attempted to become an Associate of the Royal Academy, he suffered the chill of competition, as he described to his influential friend, the writer Frederick Stephens:

> I am glad [Solomon] Hart [the painter] gushed about my works for he may vote for me if I want to get into the Academy . . . What do you think? Of course I should not get a single sculptor vote, no sculptor ever votes for another sculptor. My chance would be wholly with the painters, and as you know many of that ilk you might take soundings for me and see what my chance might be when you are talking [to] any of them from time to time.

Woolner was going to work extremely hard to get into the Academy, as Stephens no doubt gathered. He had managed in 1866 to land a commission for a statue of Gladstone for Oxford, and listed the painters William Creswick, Daniel Maclise and Richard Redgrave as supporters for his Royal Academy campaign. Also:

> I think Westmacott well disposed, and with a good energetic hint from some one I should not be surprized if he turned towards my claims favourably. I will write and ask him to come and look at Gladstone . . . I shall have to work vigorously among the painters to overcome the virulent opposition of the sculptors, who all hate me like poison, tho' I never had a personal quarrel or quarrel of any kind with one of them in my life; but they cannot stand any one having a reputation for a higher kind of work than they have themselves.

Woolner had a combative temperament, volatile and impulsive. He was eventually elected ARA, but not until 1871. Thinking he could not succeed as a sculptor in England, he emigrated with his new wife and child to Australia in 1852 – the family is the subject of Ford Madox Brown's painting *The Last of England* – but came back a year later. Woolner was not a contented man. He pointed out to Stephens:

Several sculptors, myself among them, have been underpaid for our statues. They first gave the sculptors £1200, then the price was reduced to £1000, then to £800: and this for 7 ft figures; the consequence being a heavy loss to the sculptor. In my own case in order to be able to do it at all I had to spread the work over 5 years.

What could be done to get these several sculptors justice; so that if they should not receive the original sum of £1200 (a small sum really for the work) they ought to have made up to them £200 each to make it up to the middle sum.

Think this over as a public duty like a good fellow and see if you can help to do a bit of sculptural justice. A few such government commissions would lodge in gaol or bankruptcy court.

One of Woolner's commissions, to be sited in Parliament Square in 1876, was for a figure of Lord Palmerston. Woolner wrote to Stephens when the piece was still in the making to ask him to mention the way he was treating Palmerston's clothes, in particular that he was dispensing with the subject's stick-up shirt collar. Such details attracted controversy. There is no reason why a sculptor should be slavish: sculpture, he added, 'is the art of compromise'.

DEALER:
'I HAVE PICKED UP
A FEW LITTLE THINGS'

Since collecting began, there have been people who would move between the artist and the collector to obtain the best possible price for the object, and a pretty good wedge for themselves. The go-between is an ancient species, early evolved to perfection, like the horseshoe crab. In the seventeenth century William Petty acted as agent for the Earl of Arundel, buying sculpture for him abroad; in the mid-eighteenth Thomas Jenkins intriguingly slipped thousands of pounds' worth of treasures in and out of Rome for clients in Britain, Russia and elsewhere. There were countless dealers, many of them artists, trading in Jenkins's shadow. Later in the century, and into the nineteenth, Michael Bryan sold old master paintings from his galleries in Pall Mall and Savile Row; Noel Desenfans bought for the king of Poland; John Smith made frames and a fortune selling paintings of high value in Piccadilly and Mayfair; and William Buchanan developed a buoyant and prodigious business importing old master paintings to Britain.

Other enterprising individuals, such as Samuel Woodburn in St Martin's Lane, grew into companies through insider knowledge and opportunity. Smith acted for William Beckford, who had many agents including Henry Tresham and William Clark on the lookout for him from London to Amsterdam to Rome. Across the range and ambitions of collectors, Sir John Leicester relied on William Carey, Sir George Colebrooke on Caleb Whitefoord, and in the first decade of the nineteenth century the Scottish artist James Irvine bought extensively in Italy for clients who were both dealers and collectors. Later, in the 1820s and 1830s, another Scottish artist in Italy, Andrew Wilson, bought and sent home old master paintings which were to form the basis of the collection of the National Gallery of Scotland.

Once, and once only so far as we know, Lord Egremont depended – when he bought a piece of antique statuary in Rome – on Turner. Artist as dealer, dealer as artist, collector as dealer, it was a chaotic process, a cut-throat survival of the fittest in quest of rich prizes. Picture-buying opportunities emerged from social and political chaos in Europe, and from the inability of the formerly rich and powerful to hold on to portable property of value. Touching on the opportunities thrown up by the turbulence of the Napoleonic Wars, Buchanan remarked 'in troubled waters we catch the most fish'.

Dealers and their commercial activities are fundamental to the development of the history of art. Knowledge of who owns what in any one period, how a work passed from owner to owner, and where and by whom it might have been seen is critical to a clear drafting of art history in the same way that the properties of two reactive chemicals is required knowledge before they are put into the same bottle. Had the paintings of Claude and Poussin been somehow invisible to young British artists in the late eighteenth century, the history of British art would have been very different. Claude's and Poussin's paintings, and their imitations and fakes, came in bulk to Britain through the activities of Grand Tourists, agents and art dealers. It is the market, display and exhibition systems that these people created that gradually enabled a wide public to see art from the continent, and for a rich culture to develop out of it through the insight and energy of a new generation of artists.

Britain's private art collections had grown rich since the seventeenth century on imports of art from Europe, whether of works bought in the auction rooms, or direct from artists and dealers abroad, or as bargain spoils of war or revolution. Works were bought and resold; attributed and re-attributed: nothing new there. Some of the finest 'bargain spoils' came from the collection built up by Charles I, auctioned off after the king's death during the Commonwealth (1649–60) and eventually bought back in part by British collectors after revolution had scorched Europe. By the early nineteenth century, the walls of the great houses of England and Scotland were well lined with sumptuous gold-framed canvases by Raphael and Veronese, Poussin and Claude, Rembrandt and Rubens, spoils both of

revolution and violence, and of the comparatively peaceful art market of the Grand Tour. Of course works by such faked and invented artists as 'Og of Bassan', 'Watersouchy of Amsterdam' and 'Blunderbussiana of Venice', as enthusiastically created by the housekeeper at Fonthill, were up there too, in their legions, and that is the point. Wealth and opportunity in England drew the art market to London and, driven by fashion and rarity value, it took the predictable route in embracing the art of Europe at the expense of native artists living or dead, and at the high risk of admitting fakes. Many collectors felt the force of the satires of Samuel Foote:

> Why, now, there's your 'Susannah'; it could not have produced you above twenty [pounds] at most: and, by the addition of your lumber-room dirt, and the salutary application of the 'spaltham pot, it became a Guido, worth a hundred and thirty pounds . . . Praise be to Folly and Fashion, there are, in this town, dupes enough to gratify the avarice of all.

By the first decades of the nineteenth century two or three generations of Grand Tourists – men and women of means accompanied by their valets, coachmen, hairdressers and tutors, and the occasional comfortable cow to produce reminders of home – had crossed the Alps or sailed the Bay of Genoa to experience the potent mix of ruin and renaissance that only Italy could adequately supply. The Society of Dilettanti – young men who gathered together for wine, conversation, song and a good time – shared a common experience of the Grand Tour and a determination to publish volumes recording classical remains and history: '*Esto praeclara; esto perpetua*' ['Let it be noble; let it endure forever'], they proclaimed together when they toasted themselves at the end of their meetings. Travelling in hope and enthusiasm, many brought home debt, others syphilis, while yet others, less indebted or diseased, ensured that by judicious purchase their great houses would be admired by their peers and treasured by their descendants. The influx by the cart-load of art and antiquities buoyed the art market, encouraged the businesses of engravers and stimulated fakers, while at the same time it both encouraged and dismayed native and British artists. Joseph Wright remarked grimly to his sister, by letter from Rome in 1775, on the general hike in living costs

he was experiencing: 'the Tour of Italy is now become so fashionable and the English Cavaliers so profuse with their money that the Artists suffer for their prodigality.'

Products of the Grand Tour also, of course, impressed country-house visitors, as the housekeeper at Fonthill instinctively knew when proudly ad-libbing about the splendour of Beckford's collection of paintings by Og, Watersouchy and Blunderbussiana. When the poet Thomas Moore stayed at Lord Methuen's great house at Corsham near Bath, he expressed his wonder at the treasures he saw around him. At first Moore 'had only the time to look at the two fine Claudes', but a few days later he was able to take a closer look at the collection, finding:

> a fine head of the Salvator Mundi by Carlo Dolci; Rubens and his Mistress hunting, a fine picture; Rubens and his three wives, which showed (Mrs M[ethuen] said) he had more taste in his wives than in his mistresses. Always makes himself so handsome, though he was by no means so, and was very carrotty-headed.

Paris rivalled London as the European centre for the display of art when, from 1796, Napoleon's armies looted the ducal, princely and ecclesiastical collections of the European nations and states that they had conquered. The spoils of war that were carried back to Paris in carts in their thousands included much that today is seen as the great masterpieces of ancient, Renaissance and post-Renaissance European art, to say nothing of irreplaceable archives and much scientific equipment and specimens. To pick just one work, the complex, delicate and compelling Roman marble sculpture of Laocoon and his sons entwined by sea-serpents was stolen from the Vatican, carried to Livorno in horse-, ox- and buffalo-drawn carts, and shipped to Marseilles. Among so much else, Raphael's *Transfiguration* was also taken from the Vatican, Van Eyck's *Adoration of the Lamb* from Ghent, Michelangelo's *Madonna and Child* from Bruges, and on and on – eighty-six carts were needed to carry the loot taken from Bologna alone. Europe was, effectively, stripped. It is a blot on the reputation of some British artists that they regretted the eventual repatriation of the treasures. Thomas Lawrence was heard to remark:

Every artist must lament the breaking up of a collection in a place so centrical to Europe where everything was laid open to the public with a degree of liberality unknown elsewhere.

However, for the few years that the treasures were on show in the Louvre – renamed by the emperor 'Musée Napoléon' – Paris was the place to go to see art. During the short-lived Peace of Amiens (1802–3), Britons flocked across the Channel, smug only in the knowledge that their nation had not been ransacked. When the war was over and the allies occupied Paris, Antonio Canova was one of the leaders in negotiating the repatriation of the works, and for his pains was abused and threatened with death for daring to disperse the 'collection'. Napoleon was no art dealer, but he was an astoundingly successful museum supremo. What he and his officers created in the Louvre was a temporary art exhibition of a richness and majesty that has never been seen before or since. Napoleon's director of the Louvre, Dominique Vivant-Denon, reported to his committee in 1804: 'One hundred cases have been opened: not one accident, not one fracture has diminished our happiness in acquiring these rare treasures.' The problem was that it had all been stolen.

While Napoleon stole his exhibits, historical figures of microbial size by comparison, such as John Boydell and Robert Bowyer, bought artists' copyrights. Until they closed in 1804 and 1806 respectively, Boydell's Shakespeare Gallery and Robert Bowyer's Historic Gallery were lively outlets for new paintings which followed specific themes; other even shorter-lived themed enterprises included Thomas Macklin's Poet's Gallery and Henry Fuseli's Milton Gallery. They and entrepreneurial successors such as Josiah Wedgwood, Rudolf Ackermann and Paolo Colnaghi picked up and reformed the market for painting, prints, pottery and decorative objects, while frame-making – always a measure of the health of the picture-dealing trade – developed into a lucrative craft industry drawing together carpentry, carving, plasterwork, polishing and gilding. All of these were (and remain) transferable skills of value throughout the building and manufacturing economy. The mechanization of printing and of paper, ceramic and metalwork production through the steam-engine transformed

trade in ornamental goods that were beautiful, decorative and useful. This rate of evolution in volume and scale would only come to be challenged effectively at the end of the century by the Arts and Crafts movement.

An art dealer might prefer to specialize in either the living or the dead. Dealing in old master paintings had its danger areas: provenance, authenticity, condition, ownership – all presented areas of potential doubt which would affect price. Michael Bryan made a fortune buying paintings in Holland, France and Italy and selling them to collectors in England and Scotland. The acquisition of the greatest of all European private collections, assembled in the eighteenth century by the Duke of Orléans and sold in the aftermath of the French Revolution, was a classic piece of clever dealing. Handled by Bryan, the collection was sold on in 1798 to a syndicate comprising the Duke of Bridgewater, the Marquess of Stafford George Leveson-Gower, and the Earl of Carlisle, the owner of Castle Howard. The price was £43,000, though the collection was later valued at £72,000. Retaining ninety-four pictures including works by Titian, Veronese, Poussin, Rembrandt, Rubens and Tintoretto, which they shared out between them, the trio of noblemen disposed of the rest for a total of 41,000 guineas. Thus were the foundations of three magnificent old master collections established for peanuts, while many of the other paintings came to find homes elsewhere in England and Scotland.

The travels of one painting, Titian's *Noli Me Tangere* ('Do not touch me'), illuminates one thread of the story of how paintings ebbed and flowed from Europe, to London, to the far counties of Britain and back to London again. Painted in Venice around 1514, this modestly sized and easily portable painting of Christ and Mary Magdalene was owned by the Muselli family in Verona, and had been taken to France before the seventeenth century, where it eventually joined the Orléans collection. Coming to London and sold by Michael Bryan to the Marquess of Stafford, it was sold on in 1802 for £330 to Arthur Champernowne of Dartington Hall, Devon. Champernowne was a speculator and dealer in pictures, as well as a collector, operating as a *marchand amateur* in that grey area of the trade where it is rarely clear who is the final buyer. *Noli Me Tangere* may have been at Dartington Hall in 1809 when Joseph Farington visited, though

Farington's observation that Champernowne's paintings were 'poor and hung without order' perhaps suggests otherwise. When Champernowne's collection came itself to be sold in 1820, the Titian was bought by Samuel Rogers for 315 guineas. He in due course bequeathed it to the National Gallery. Like a migrating bird tagged by an ornithologist, *Noli Me Tangere* can be followed from Venice to Verona, to Paris, to London, possibly down to Devon, and back to London again. London, then, provided the nest and shelter for this and so many other colourful birds as they travelled the world.

Writing home from Italy, James Irvine offered an insight into the luck and thrill of dealing:

> That I purchase for others I keep a secret here to prevent the dealers raising the prices upon me as they probably would did they know I bought for some amateur . . . I was so fortunate as [to] procure a capital allegorical picture of Rubens from a branch of the Doria family, on the back of which was found on taking off the lining on its arrival in England, the initials of King Charles 1st . . . This has been sold to Lord Gower for £3000 . . . At the same time I sent over three other Rubens's from another collection . . . [one] bought by Mr Champernowne for £800 . . . [another] to Sir George Beaumont for £1500.

William Buchanan, hard to please, urged Irvine to try yet harder:

> I have been pretty well able to judge of the English taste of late – that I find lies more in the Landscapes of Claude, the Poussins, Titian, Rubens, and Salvator Rosa, than in Historical Compositions . . . Subjects of Saints etc. etc. are not thought of here at all, it is lively and pleasing Compositions are altogether the rage or the great and grand in Landscape principally. Could a few Landscapes of Titian be procured these would command attention.

As John Pye put it, 'scarcely was a country overrun by the French than Englishmen skilled in the arts were at hand with their guineas'. The money Michael Bryan made from art dealing, and the knowledge and experience he accrued, enabled him to retire in the 1810s to write his *Biographical and*

Critical Dictionary of Painters and Engravers (1813–16), a work that remained a pioneering source of information well into the twentieth century. John Smith, in his turn, wrote a nine-volume *Catalogue Raisonné of the Works of the Most Eminent Dutch, Flemish and French Painters* (1829–42). In England the early art historians – those with easy access to their sources – were art dealers.

The successes of Bryan, Irvine and Buchanan can be set against the commercial disaster that befell Noel Desenfans, a French-born art dealer who bought at the top of the market and sold works on from his private address near Portland Place. He was disliked by his fellow dealers, being considered an amateur in the trade. However, he was honest enough to admit to having been duped at times:

> Many pictures have been made to acquire the appearance of age, even to a complete deception: and I remember, at the commencement of my collecting . . . having purchased some . . . Whatever uncertainty I might have been in as to their originality, I had not the least doubt as to their antiquity. I sent for a picture cleaner, who made use of spirits of wine, and, in a moment, that which he worked upon was totally ruined . . . which made the cleaner say, those pictures had been in the *Westminster oven*. He then informed me that there was . . . in Westminster a manufactory where several persons were employed making copies, which, after having been soiled with dirt and varnish, were thrown into an oven built for the purpose, and moderately warmed, where, in the course of an hour or two, they became cracked, and acquired the appearance of age . . . I will venture to assert that many of our superficial collectors have been caught, as I have been, with this snare, and have preferred to the best modern productions those of the Westminster oven.

Desenfans was embraced as an agent by the Polish royal family, who in 1790 engaged him to create a founding collection of European painting for a proposed Polish national gallery in Warsaw. However, King Stanislaw of Poland abdicated when his nation was overrun by Russia in 1795, and Desenfans was left with the pictures, a vanished client and a huge debt. While Desenfans survived this ordeal financially, he was left a broken, sick and derided figure – evidence that anticipated profits from art dealing

could rapidly be set at risk by sudden changes of fortune in politics, trade, economics or taste. Desenfans urged the British government to buy his paintings as the beginnings of a national collection, his being an early attempt to get such an organization founded, preceding Truchsess, Leicester, Beaumont and Angerstein. In the event, after auctioning nearly 200 works at a heavy loss, much of the collection was kept together and came to form the nucleus of the Dulwich Picture Gallery, where they remain.

A gallery that floated in and then floated out of the world of art in London was created by the optimistic Viennese Count Joseph Truchsess, who claimed to have been a victim of the Napoleonic Wars in Europe and had lost all his money. However, he had somehow retained about a thousand old master paintings, and with the help of Viennese bankers and associates he sailed these on barges up the Elbe and over the sea to England. When he opened his eight-room purpose-built gallery on the New Road (now Marylebone Road) opposite Portland Place in 1803, many were deeply impressed. None more so than William Blake, who told William Hayley, his friend and Flaxman's, 'I was again enlightened with the light I enjoyed in my youth, and which has for exactly twenty years been closed from me.' A young American traveller Benjamin Silliman, who would become a pioneering chemist, was equally impressed, dubbing Truchsess's collection 'one of the finest . . . in England'. Not all were taken in by this collection of works, however: it largely consisted of studio copies. Thomas Lawrence decided with some authority that there was 'scarcely an original picture of a great master among them'. Truchsess's overriding purpose was to persuade the British government to buy the whole lot as the basis of a national gallery, but like Desenfans before him, he failed.

The 'contemporary art' dealer, ubiquitous in the twentieth century, is a product of the mid and late nineteenth century, coming to the fore out of the previous generation of art patrons. Thus Lord Egremont, Sir George Beaumont, Sir John Leicester or Walter Fawkes might favour particular living artists for personal reasons, and buy their work direct and in quantity. Beaumont made his own decisions; Leicester heard advice from William Carey, though he generally took his own; Egremont and

Fawkes made friends with their artists. Of those artists who could not rely on regular patronage, Haydon bobbed just below the surface of financial stability, occasionally rising up like a happy trout, but more often half-drowned in debt and family responsibilities, making enemies, and in and out of the King's Bench Prison. Money rolled in for John Martin, who ran his own business, after success followed success in his practice as a painter of biblical and cataclysmic subjects and an engraver of the same. However, Martin spoilt it all for himself and his bankers when, during a personal crusade in the 1840s in which he must have felt he was the only crusader around, he spent all his money on developing and promoting a doomed and premature scheme to supply London constantly with fresh water from the Hertfordshire hills and to sweep away its sewage.

Caleb Whitefoord, a transitional and prototypical figure, for whom buying art for others was just one of many activities, channelled money to artists from multiple sources. In the 1760s this young Scot, who had rebelled against his father's wish that he become a minister of the Church of Scotland, emigrated to London and set up as a wine merchant. Success in that business gave him the opportunity to travel in Spain and Portugal and to taste the good life. On the suggestion of Benjamin Franklin, then in London, Whitefoord joined William Shipley's Society of Arts. Thereafter he became closely involved in the Society's management as the chairman of its Committee of Polite Arts, where he was responsible for handing out money and medals to aspiring artists and manufacturers. Through that position he came into contact with many of the coming genera-tion of artists who would drive the taste of the nation, and also with the patrons whose money would fund it: he ate turtle with Sir John Leicester, banked with Thomas Coutts, gossiped with James Christie, and put in a good word for Warren Hastings. The young artists who came into his ken included the hopeful David Wilkie and a hopeless George Wilson. The former he helped on his way with introductions when the aspiring young Scot came to London in 1805; Whitefoord was rewarded for his pains by being featured as a portrait in Wilkie's semi-autobiographical painting *Letter of Introduction* (1813). 'Give me leave to introduce to your notice & protection Mr David Wilkie', Whitefoord was asked:

[Wilkie is] a young artist who proposes to spend some time in London in the prosecution of those studies, and the improvement of those talents that have already brought him into some notice in this his Native Land & which I can not help believing will with proper culture raise him to eminence . . . I need not solicit your good offices in behalf of this young and unprotected adventurer because I well know the pleasure you have ever felt in befriending merit.

Balanced against such rising stars as Wilkie were those who failed to strike the right note with so busy and influential a figure as Whitefoord. George Wilson of St Martin's Lane reminded him:

About 2 years ago I presented to you as a small mark of my respect 2 drawings, representing a Boys & a Girls School, & did propose taking your advice on a little scheme I had laid out for the employment of my time in a manner congenial to my taste, & wishes . . . I have formed a desire to take up the Pencil, & to try if Painting . . . can procure me a little reputation & bread . . . If you should not think it too great a trouble to pay me a visit, I should be happy to see you . . . [p.s.] Upon enquiry I find Sir you left Town this day – this is rather unlucky as I had fixed my mind on you as my principle [*sic*] Arbiter & Adviser.

Whitefoord put up with such presumption, probably because he saw it as part of his role at the Society of Arts to handle approaching talent, whether promising or not. He also gave solace in 1801 to the once famous and sought-after engraver Valentine Green, now miserable, indebted and world-weary:

The casual visit Mrs Whitefoord and you have been so kind [as] to make to us in the New Road, since my retreat from thence, has so far antici-pated the communication of that occurrence to you by Letter, which I had intended. Doomed to be assailed by misfortune in every vulnerable part whilst I remained a visible and tangible object, I determined on a removal that should at least place me out of the reach of further attacks [from creditors]. It must strike with surprise those who remember the extent, the consequence, the rank, the opulence of the numerous circle to whom I had been for many years known, that I have been sick & in

prison, and they visited me not . . . after three years most ardent struggle
. . . I have . . . discharged upwards of 500£ debt, and am at last beat out
of the Ranks of Life, an Exile for an Eggshell, an Outcast for the value of
the Breakfast of an Alderman!

J. T. Smith, in his biography of Nollekens, poked fun at Whitefoord's
dandyish side:

> Whitefoord, who never ventured abroad but with a full determination to
> be noticed, dressed himself foppishly, particularly so in some instances.
> It is true he did not, upon trivial occasions, sport the strawberry embroi-
> dery of Cosway, yet he was considered extravagantly dashing in a spar-
> kling black button, which for many years he continued to display within
> a loop upon a rosette on his three-cornered hat, which he was sure to take
> off whenever he considered *bowing politically essential*. The wig worn by
> him for years when he was at the summit of his notoriety, had five curls
> on each side, and he was one of the last gentlemen who wore the true
> Garrick-cut [a wig with five curls on each side].

Whitefoord was a new kind of dealer and patron, one who occupied
neither position very clearly, but was nevertheless the prototype of the pub-
licly accountable arts administrator of the mid to late twentieth century.
He fought off criticism directed by artists at Noel Desenfans, who asked
him:

> Will you be so good as to submit the two Pamphlets & the Catalogue
> I now send, to the Society for the encouragement of arts & commerce?
> I beg the committee of the fine arts, will examine them & determine
> whether I had in view, the rise or the downfall of painting, & if their
> opinion is favourable to me, it will serve to make my peace with the
> artists.

As a dealer or an agent, Whitefoord was on the lookout for pictures
for friends, among them Sir George Colebrooke, Bart, a former banker,
MP and one-time director of the East India Company. Colebrooke was
clawing his way back to respectability in Bath, having overseen the finan-
cial collapse of the East India Company and having lost a fortune in bad

investments in minerals. Bankruptcy forced him into temporary exile in Boulogne. Clearly, Colebrooke had a rubber constitution, bouncing back into society with enthusiasm and vigour. 'As sales are coming to London,' he wrote to Whitefoord,

> it may happen that something will be presented that will tempt you for me, either a large upright picture, to hang on one side of the Door of Entrance of the Drawing Room . . . or a long oblong picture or pictures with a view of hanging smaller pictures underneath to fill up the vacancy. The space between Door & wall is eight feet five Inches . . . I am disposed to lay out a sum of between one & two hundred, either in one picture or more.

Whitefoord's personal resources were relatively modest; his importance was as an enabler and a fixer. The unlimited pockets of Beckford, Egremont, Whitbread, Gillott and Vernon, however – five patrons as different from each other as they were from Whitefoord – kept artists jumping to their tunes with the prospect of money. The artist–patron interface was roughly ground and insecure, and could easily come to a painful stop. While Haydon, Gandy, Baily and Rossi lived from hand to mouth, Martin, Turner, Northcote, Flaxman and Chantrey all coolly built up enough personal capital across their careers to maintain their independence, to finance (in Martin's case) their dreams, and to maintain too their desirability to their patrons. Although the charitable funds available to poorer artists could begin to ease poverty, it was nevertheless, and ruthlessly, feast for some and famine for many.

By the 1820s relationships between artist, dealer and patron were becoming systematized through precedent and contractual agreements. This had to be particularly clear when an engraver was involved in what was often a four-way deal linking artist, patron/owner, dealer and engraver. The system owes its early development to John Boydell, who found richer pickings by abandoning his own modest talent as an engraver in favour of marshalling the resources of others. Having himself trained under indentures with the engraver William Toms, he discovered new prospects by starting his own business as a dealer in artists' prints. He put

down further personal foundations in the London business and political world by becoming a councillor for the Cheapside ward. Boydell developed and increased the market in print-selling, finding new outlets by publishing prints of paintings which had won prizes under Whitefoord's aegis at the Society of Arts. Boydell was highly innovative in his business methods and entrepreneurial in the way he harnessed old and new engraving talent, such as the esteemed and reliable William Woollett and the initially buoyant Valentine Green. Boydell encouraged these engravers to produce images that he was convinced would sell – and, from the 1760s to 1790s, sell they did. Prints after paintings by Claude, Richard Wilson, Joseph Wright of Derby, Reynolds, West and Zoffany emerged from his shop and were sold as bound collections for subscribers and as individual prints to be framed and hung at home. It was Boydell's initiative and commercial courage that fostered the fashion for history painting that remained lucrative for decades. Sixty years later Turner looked back on the glory days, when he mused in a letter on the pros and cons of a potential engraving contract:

> Whether we can in the present day contend with such powerful antagonists as Wilson and Woollett would be at least tried by size, security against risk, and some remuneration for the time of painting . . . To succeed would perhaps form another epoch in the English school; and, if we fall, we fall by contending with giant strength.

Boydell expanded rapidly – too rapidly. From a large premises in Cheapside with a 70-foot-long upper showroom, which he rented from 1770 to 1789, he devised a new scheme whereby he would employ armies of engravers to make prints from paintings of Shakespearean subjects. These were to be published in volume form, with the texts of the plays, and also sold as individual prints or in sets. The scale of the project demanded a larger, more central gallery, and this Boydell – by now an alderman of the City of London – built at 52 Pall Mall to the designs of George Dance the Younger. His 'Shakespeare Gallery' opened in 1789. The financial demands that the Shakespeare Gallery made on him were enormous; so too were the demands of the artists. Boydell paid £500 to Reynolds in 1786 for *Macbeth*

and the Witches; he had Gainsborough walk away because he (Boydell) would not pay £1,000 for a Shakespeare subject; and Joseph Wright delivered a *Romeo and Juliet* that Boydell would not accept. On being turned down, Wright accused Boydell of creating a class system among his artists: he would pay Reynolds and West more than he might pay Northcote, and that would be more than he might offer Wright. 'Is not my picture as large as Mr West's?' Wright demanded of Boydell:

> Has it not equal, nay much more work in it? Is it not as highly finished? And has not the public spoken as well of it? Then why should you attempt to make any difference in our prices?

To which Boydell replied sharply:

> Had I ever presum'd to have classed the Historical painters of this country, perhaps Mr Wright's name would not have stood exactly where [he] has been pleased to place himself.

Boydell took on artists of far lesser talent than Reynolds and Wright: painters William Hamilton and Matthew Peters; engravers George and John Facius; his own nephew Josiah Boydell. Some of these were not up to the job, and Boydell saw the supply of engravers talented enough to take on the work dwindle. It became, in short, a disaster. With hindsight it is extraordinary that such a large capital investment should have been made to supply so particular and volatile a product, a prey to changes in fashion and fortune. Riding on the back of Garrick's Shakespeare revival of the mid-eighteenth century, Boydell's grand Shakespeare publishing scheme went the way of the five-curl Garrick-cut wig, as worn by the foppish Whitefoord but by nobody else.

When France invaded the Netherlands and the Rhine valley in 1792, the continental market that Boydell so relied upon shrank away and the debts piled up. Tipping on the edge of bankruptcy and feeling the tentacles of the debtors' prison reaching out to him, Boydell lobbied government to permit a lottery to raise the money required to pay off his bank loan and other debts and to get rid of the millstone of his Pall Mall

gallery. Conveniently, just as the lottery draw was about to take place in 1804, Boydell died, leaving the ruins of the business and his artists' odium to his nephew Josiah. When Green wrote ruefully about being 'an Outcast for the value of the Breakfast of an Alderman', he was referring specifically to John Boydell. Petitioning Parliament for permission to hold a lottery to dispose of the Shakespeare Gallery, Boydell claimed that he had spent more than £350,000 in promoting 'the commerce of the fine arts in this country'. The engraving plates had cost him in excess of £300,000, the paintings and drawings nearly £70,000, and the gallery itself over £30,000. By the day of his death all 22,000 lottery tickets had been sold at 3 guineas each. The lucky ticket was owned by William Tassie, the modeller of wax portraits and medals of Leicester Square, who auctioned everything off again the following year. Tassie sold the sixty years left on the lease of the gallery to the British Institution for £4,500 and went home very happy.

Caleb Whitefoord was asked in 1806 to assist with the lottery sale of John Singleton Copley's enormous, hagiographic painting *The Death of the Earl of Chatham*. It was premature to call it a 'death', as the Earl of Chatham, the former prime minister William Pitt the Elder, was only hit by a stroke in the House of Lords and lived on for a month. Nevertheless, this was the Enlightenment's secular answer to the Counter-Reformation depiction of martyrdoms of saints or deaths of popes. When he suffered his stroke in April 1778, Chatham was speaking passionately in favour of taking direct action to retain the American colonies and to prevent their independence from Britain: thus the painting depicted the death of a political ideal, as well as the death of an individual. Henry Hope, collector brother of Thomas Hope, asked Whitefoord a favour. He wanted to take part in the lottery but could not possibly cope with winning Copley's painting:

> By the inclosed from Mr Copley you will see that his plan for the sale of his picture has so far succeeded as to induce him to put up with 20 sub-scribers, & a most respectable list it is . . . [M]ay I request the favour of you to appear for & represent me, in concurring with what the majority may find proper to decide on, in regard to the mode of settling who shall have the Picture, taking care not to draw the prize for me with which I should be more embarrassed.

It was won eventually by Alexander Davison, a government contractor who had made vast sums of money supplying the army and furnishing barracks. The Scottish painter Andrew Wilson also valued Whitefoord's counsel on the matter of lottery:

> I wish to dispose of the Brazen Serpent by Rubens in the same manner as the Death of Lord Chatham by Copley was sold . . . For a work such as the Rubens I should hope that in good hands there would be little difficulty in obtaining 20 subscribers, for 100 guineas would be no great object to any nobleman or gentleman who had so great a chance of possessing such a Picture.

William Beckford had a lively time commissioning picture dealers and book-buying agents to bring him treasures of the quality of Rubens's *Brazen Serpent* from Europe to Fonthill. Henry Tresham, a member of the generation that had grown fat on the art trade surrounding the Grand Tour, was one of Beckford's regular dealers. Tresham, an Associate of the Royal Academy, was an uninspiring painter but a regular committee man of the kind that finds welcome distraction in trivial pursuits. He first sold his own paintings to Beckford, addressing him in the obsequious manner so characteristic of the eighteenth century:

> The pleasure you expressed last Year on seeing a Figure painted by me was highly Flattering, especially as your Approbation was confirmed by your purchasing the picture . . . I am ambitious of having the [pair of] pictures seen together in your possession, the price of this [*Ophelia*] as the former <u>sixty pounds</u> . . . I hope Sir that my proceeding will be interpreted as it really is – the Ambition of a Young Artist who is anxious to Merit the Approbation of Men whose Taste & Judgement Stamp a currency on Merit.

Within a few years, Tresham was buying old masters for Beckford out in the field, including works purporting to be by Guido Reni, Gaspard Poussin, Salvator Rosa, Raphael and Leonardo. In trying to attract Beckford's interest in buying the so-called 'Altieri Claudes' from the Orléans Collection, Tresham reveals something of the cut and thrust of the art business during a period of war and political turmoil:

I waited but for a sight of the <u>Clauds</u> and the hearing of the sentiment
of the person to whom they were consigned . . . [T]hey are in the posses-
sion of Mr Long a surgeon in Lincoln's Inn Fields, who has the power of
disposing of them . . . asking £7000 . . . I told him that I had the inten-
tion of bidding a very handsome price, but nothing like his demand . . .
the high prices [at] which the Orleans pictures have been sold encour-
aged Mr Long to advance in the demand . . . I waited on Mr Wyatt this
morning . . . he advised me to send you immediately . . . the pictures in
my opinion being invaluable; and the opportunity such as nothing but
the extraordinary revolution of things could have brought about.

Beckford secured the Claudes for £6,825. All this was against the back-
ground of Beckford's coming sale of the contents of his father's house,
Fonthill Splendens, soon to be demolished. Beckford himself described the
current state of affairs to another of his dealers:

Many of the pictures at Fonthill House will be disposed of about the
latter end of next August in the general sale which will take place of the
furniture & materials. The others will be removed to the gothic building
I have been employed several years in erecting. When properly arranged
I shall be happy in submitting them to your judicious inspection; but I
cannot fix the period, as some considerable time will be yet required to
perfect the edifice.

After he had left Fonthill to its imminent collapse, Beckford continued
to buy on the art market. The dealer William Clark told him in 1824 of a
recent bid for prints and drawings in Amsterdam, in terms of a campaign
characterized by seduction and derring-do:

I shall not come away empty-handed – the three magnificent volumes of
Vandyke's Heads with numerous proofs, and several extremely rare por-
traits, have fallen to my lot, for 1180 gns – about two hundred less than
I had intended to give . . . The young Canon offered me twenty pounds
for one portrait – no! no! no! no picking and plucking out the precious
tulips; they shall be planted in our garden in the state I receive them. I
have also bought the great and small Lands[cape] by Rubens, with some
proofs and variations, that you may have no regrets on that score. In my

rambles, by scrambling up perpendicular stair cases, and swinging by ropes into cellars, I have picked up a few little things.

Beckford's *grand projet* on the plains of Wiltshire attracted artists to draw and publishers to engrave view after view of his spiky Gothic madhouse. The entrepreneur and pioneer of topographical publishing John Britton, who believed himself to be thick with Beckford, chose the route of extreme sycophancy in his dealings over Fonthill. 'I have made arrangements to leave town for Fonthill on Friday & shall take two artists in <u>my suite</u>,' he told Beckford in 1822:

> These I expect & hope will make such drawings as will please <u>you</u>, & these I need not fear pleasing the first connoisseur in the country . . . I am anxious to profit by your advice respecting subjects for drawings – points of view &c. Your eye & mind must be familiar with every point & the most favourable times for taking them . . . it would be of infinite advantage to my projected work.

Britton was a middleman, an engraver of brilliance himself, but one who also gave employment to artists and published their collected and processed work. He was soon making his way still further into Beckford's favour:

> I cannot forget that you already complain of being nearly 'suffocated with the incense of adulation': & I should ever reproach myself were I to increase that incense, & thus augment the danger . . . The breezes[?] of authors & sycophants you have cause to suspect – for too many of them are heartless, selfish, dishonest. Of course I <u>flatter myself</u> that I am not one of this class: perhaps <u>you know</u> – by that unusual sagacity which you evince on many occasions, what I am and what I mean. I hope you <u>know</u> me then you will give me <u>full</u> credit in assuring you I am Most gratefully your obliged and humble servt. (& I wish I might presume to add <u>friend</u>), John Britton.

His wife poured yet more honey into Beckford's ear:

> You will, I fear, deem me presumptuous in daring to intrude upon you anything so truly insignificant as my thoughts, which have forced

themselves from me during my residence under your splendid and Princely Mansion. Permit me, Sir, to offer my most grateful thanks for this favor – above all price – which you have conferred in allowing me the enviable privilege of remaining as a part of your establishment for several days.

Sickly-sweet though they seem today, such encomiums were probably received so regularly by Beckford that they passed him by. Even after Fonthill had collapsed into a pile of rubble, Britton harped on about its glories to Beckford – perhaps not so tactful a course to take:

Having lately enjoyed a most delectable, familiar colloquy with you – listened to, and been gratified by your interesting, animated converse – having gone over former reminiscences – seen you – heard you – & sympathised with your witty, satirical-ironical discussion & profound eloquence, I cannot resist the impulse of thanking you, on paper: and to say that I saw Fonthill . . . in my 'mind's eye' as plainly & fully as ever vision appeared to mortal man.

Long after Beckford's dreams had been ruined, Britton pressed on in praise. When Brunel won the competition to design a suspension bridge over the Avon Gorge at Clifton, Britton mused to Beckford: 'What a grand thing may be made in Bridge at Clifton? Oh that a Beckford had the execution of such a work.' Just as well he did not – the Clifton Suspension Bridge might have fallen down as well. While dealing patiently over the years with Britton, Beckford had little to say to him, except to dismiss him as 'that highly ridiculous, highly impertinent Britton, the Cathedral fellow'.

While Britton irritated Beckford profoundly, he had an even more negative effect on the notoriously unpleasant John Soane. When writing a memoir of the architect in *Fisher's Portrait Gallery*, Britton found that Soane

suppressed many material facts . . . One of the vainest and most self-sufficient of men, he courted praise and adulation from every person and source, but dreaded, and was even maddened by anything like impartial and discriminating criticism . . . [the] memoir, though sufficiently

complimentary for any reasonable man, so displeased him, that he was never afterwards cordial, and scarcely courteous towards its writer.

Up to the day he died in 1857 Britton was showing and trading from his collection, undoubtedly still displaying the character traits noticed by the publisher Charles Knight – 'indefatigable, good-tempered, self-satisfied, pushing and puffing'. The architect A. W. N. Pugin, however, found a different, disgruntled side to Britton's character, indicative perhaps of the huge financial pressures that he bore:

> He seems Exactly the same man as ever only rather <u>thinner & shorter</u>, complains of want of encouragement, wishes he never had attached himself to Literary pursuits, and rings the sovereigns in his pockets with the exclamation of horrid bad times.

The American clergyman and collector the Rev. Elias Lyman Magoon visited England in 1854 and called on Britton, whose works Magoon had been buying from dealers in America. Writing in the third person, Magoon described a visit to the aged Britton, when he bought and carried off an edition of the *History and Antiquities of the Cathedral Church of Exeter*, interleaved with drawings and proofs from the publication's production:

> Just previous to his death, in his own home, many of the originals were bought and begged by a highly favoured American [Magoon]. One volume alone, with all the precious original pictures facing the engravings of the same cost the enthusiastic and generous antiquarian a hundred dollars. Other originals, in the same lots, cost over fourteen hundred dollars.

Magoon, a Baptist minister well known in the eastern United States, had a particular purpose in seeking out Britton, whose work was already spreading across the Atlantic. The engravings and the texts that accompanied them were so detailed and reliable that they became the source material for new churches and other buildings in the States.

Rudolf Ackermann, one of the early heroes of the art trade in Europe, was more personally detached and easier-going, and ran a more diversified

business than Britton. Unlike Britton, he was a man not given to vacant
flattery, but like Britton he found in Beckford's Fonthill a rich seam of
subjects for illustration. Magoon had come to England to buy; Ackermann
came from Germany to make and to sell. London, the city in which all
the trappings of Fonthill could be bought and sold, was the international
hub of the business of art. Ackermann was born in Leipzig, Saxony, the
son of a saddler. He came to London aged twenty-three, having served
apprenticeships both in his father's trade and, later, as a coach-builder in
Dresden, Basle and Paris. Trained in saddlery to work with leather and in
coach design to work with practically everything else – mechanical design,
metals, carpentry, fine furniture, upholstery, paint, enamel, glass, horses,
people – Ackermann had all the tools he needed to prosper in the luxury
trades. London in the 1790s was blossoming with the production of objects
of fine and decorative art, the building of new squares and terraces, and
the development of the demonstration and instrumentation of science.
Ackermann's rigorous and rare business sense, which created new oppor-
tunities for manufacture, commerce and employment, initially expressed
itself in the carriage trade. Long Acre, with Covent Garden nearby, where
he first settled, was the centre of coach-making in London: there Robert
Vernon and his father might have struck deals, and later the Winduses also.
Ackermann's flair for design and his talent for self-promotion soon won
him a contract to design and make a model for the ceremonial coach for
the Lord Chancellor of Ireland, Lord FitzGibbon; he was paid £200 for it.
From this he turned his skills to general purposes, helping an embryonic
London transport system to develop by designing the *Royal Sailor*, an
eight-wheeled omnibus built to carry passengers between Charing Cross
and Greenwich. Specializing in carriages as he did, Ackermann demon-
strated how he could turn round a complicated order at incredible speed by
designing and building the catafalque and coffin for Lord Nelson's funeral
in January 1806.

To promote his business as a coach designer, Ackermann worked
with the engraver Joseph C. Stadler on the publication of *Imitations of
Drawings of Fashionable Carriages* (1791), and then moved on to publish-
ing on his own account from his premises in Little Russell Street, Covent

Garden. This was the beginning of an extraordinary rise in production, prestige and influence for Ackermann, who by 1795 had bought the lease of part of 96 Strand where the Savoy Hotel now stands. Within three years that had become too small for his ventures, and he moved to 101 Strand – or as he put it, 'four doors nearer to Somerset House', the home of the Royal Academy. With a thirty-year lease on this building, Ackermann showed himself to be the obvious supplier of artistic goods, publications and materials essential to members of the Royal Academy, and more particularly to the Academy's thousands of visitors. He was particularly canny in moving close to Somerset House, creating at the eastern end of the Strand a commercial hub as a counterpoint to the scientific-instrument businesses developing on the other side of Temple Bar in and around Fleet Street. The instrument makers had grown in response to the presence nearby of the Royal Society in Crane Court, subsequently in Somerset House, and the equipment needs of its natural philosopher members. It was this newly engrossing centre of gravity that created a commercial force eastwards, away from royal and residential Pall Mall, where Boydell's Shakespeare Gallery was failing and where, in due course, the British Institution and the first National Gallery would open. The particular specializations in London's trade and display districts developed not by chance, but organically, by evolution and opportunity, as one entrepreneur, like Ackermann, built on another to gain strength, competition, camaraderie and market share. One pigeon will fly down to peck seed, then a dozen will follow.

The Royal Academy did not teach painting in its Schools, so as an answer to this Ackermann provided a service to the public that he had always, with profit, served. His drawing school was held in the 65-foot-long Great Room of his Strand building, where the Society of Virtuosi had once met and where William Shipley had recently held his own drawing school in conjunction with the Society of Arts. Ackermann was now developing an integrated commercial organism, combining a glittery shop on the ground floor with, above, a drawing school where eighty or more pupils could be taught by one master for the human figure, another for landscape, and a third for architecture. Stock for the shop

was manufactured on the premises – the waxed papers, jujube boxes, firescreens, transparencies, card racks, flowerstands, quills and crackers, all painted, folded and glued by the nimble fingers of a small army of émigrés from revolutionary France and, like Ackermann himself, from Germany. Ackermann had 'seldom less than fifty nobles, priests and ladies engaged upon ... ornamental work'; he knew how to orchestrate large forces, and knew too where to find his people. The artist W. H. Pyne wrote of Ackermann that he employed 'a multitude of ingenious and industrious persons, in the various branches of his great undertakings; a public benefit for which he is entitled to the esteem of the British people'. One among these, teaching watercolour painting from 1798, was the youthful John Sell Cotman, from Norwich.

Employing continental and local craft skills that were to transform and diversify the market in 'fancy' objects, Ackermann, crackerman, brought art and pretty things to (almost) every pocket, swiftly and in quantity. Diversifying yet further and seeing yet more lucrative and commercial opportunities, he entered an already crowded market to produce artists' materials and manuals in competition with Reeves, Roberson, Rowney, and Winsor and Newton. As a result, students in his drawing academy could use Ackermann paints, brushes and paper upstairs, choose Ackermann materials from the shelves downstairs, and study from Ackermann-published instruction books when they went home to practise and to paint. Nevertheless, he had commercial foresight enough to close his drawing school in 1806 when he needed the space to expand his retail business upstairs. *The Times* put it succinctly: 'Mr Ackermann ... has it more in his power to display and to publish to the world "The Fine Arts" than any other man in the kingdom.' Rudolf Ackermann was, as his contemporaries confirmed, generous and loyal, and a man who stood out in voice and bearing:

He retained a strongly marked German pronunciation of the English language, which was given additional flavour to the banters and jests uttered in his fine bass voice ... The friendships made by Mr Ackermann were so firm that they were unaffected by the great dissolver of amity – rivalship.

Ackermann made money in plenty: his accounts at Coutts showed an annual turnover of £30,000 in the 1810s. This was accrued not only through his shop, in which he also pioneered sales by mail order, but through additional opportunities such as the profits from his tea-room, and the one shilling entrance charge to his 'Gallery of Ancient and Modern Paintings and Drawings', otherwise known as Ackermann's Repository of Arts. Here he displayed and sold watercolours and engravings, in particular the prints in aquatint and, later, lithography that illustrated the many books and journals produced under his imprint. The most influential of these, *The Microcosm of London* (1808–10), was a collection in three volumes of illustrations of London architecture, landscape and life. Ackermann's success, which lasted well beyond the firm's 200th anniversary in 1983, was due to Rudolf and his immediate successors finding the pulse of nineteenth-century taste and satisfying the desires and aspirations for decoration and ornament in the homes of the rising middle classes.

Rudolf Ackermann had the Midas touch. He also understood, like many, the power and reach of reproduced illustration. He appreciated, too, the importance of a good title for a work of art, and asked Caleb Whitefoord for his advice:

> Mr Ackermann's best compliments to Mr Whifford [*sic*] & has taken the liberty of consulting Mr W about an appropriate name for the little print herewith send [*sic*], Mr W will remember there is a <u>Mother's Hope</u>, a <u>Father's Darling</u> also another cal'd <u>What's that Mother</u>, now any pretty but expressive name for this little print. A knows no body that is more likely to Baptise it than Mr Whitford & A will esteem [it] a particular favour to send him a few Ideas.

From the early nineteenth century to the twentieth the Ackermann name lived on through the appreciation of its products. As a young man apprenticed to a Marylebone bookbinder in 1813, Michael Faraday studied Ackermann's *Repository of Arts* weekly journal and made drawings from it. Nearly 200 years later, the writer Alan Bennett was reminded of Ackermann when he recalled the nineteenth-century mental hospital in which his aunt had been incarcerated: 'in any other circumstances one might take

pleasure in it as an example of the picturesque, in particular the vast Gothic hall which, with its few scattered figures, could be out of an Ackermann print.'

In 1825 Ackermann set up his eldest son, Rudolph, in business in a print shop in John Nash's newly completed Regent Street. This river of trade and promenade ran from the fashionable and expensive residential and shopping district of Oxford Street, Portland Place and Regent's Park, to the busier, more constrained urban spaces of Piccadilly, Soho and Charing Cross. Ackermann, father and son, now had a foot in both camps. Two years later, Rudolf the elder moved from 101 Strand back to his former address at number 96, where the architect J. B. Papworth, fresh from working for William Bullock at the Egyptian Hall in Piccadilly and Boodles' Club in St James's, had designed a new emporium for him on four floors. In the meantime the publishing side of the Ackermann business was growing. Beautiful, decorated books illustrated by the new process of lithography, and sumptuous books of coloured aquatints, including the popular *Dr Syntax* series, issued from its premises. One famous volume, with richly coloured pictures of the Royal Pavilion in Brighton, was published in 1826 in conjunction with the Pavilion's architect John Nash. Another, the three-volume *History of the Royal Residences* (1815–19), had such high production costs that it bankrupted W. H. Pyne, who had been so rash as to commission 100 aquatints before he had any chance of getting his money back. So insecure was the creative end of the fine-book market that Pyne, like Haydon, Gandy and Varley, became a regular in the debtors' prison. Ackermann, however, had no such failings. He introduced in 1822 the German tradition of 'gift-books', with the annual *Forget-Me-Not*, a small-format, highly decorated publication of poems and short, flowery illustrated articles. This sold around 20,000 copies a year.

Rudolf's second son, George, had tougher land to plough. He had studied drawing in his father's school and had learned the family trade at 101 Strand; but when the firm moved back to 96 Strand in 1827, he was sent by his father to Mexico City principally to sell Ackermann prints and books translated into Spanish and to make new publishing businesses work on the other side of the ocean. This western extremity of the Ackermann

empire had grown out of Rudolf's decision, in a rare moment of allowing his heart to rule his head, to invest in the emerging revolutionary movements of South and Central America after the collapse of Spanish influence following the Peninsula War. Rudolf had given money to Simón Bolívar's uprising against Spanish rule and began to issue Spanish-language books for export to the young nations. George was directed to make these initiatives work as businesses, overseeing shops also in Guatemala, Colombia, Argentina and Peru. His attention, however, became waylaid not only by the effects of falling in love with the sixteen-year-old daughter of the Dutch consul to Guatemala, but also by becoming fascinated by the flora of Central America. He came home in 1829 when his father fell ill with worry after the news of his plummeting South American investments and the piracy of his Spanish publications. In his luggage George carried home drawings and watercolours of exotic landscapes and botanical subjects, as well as unfamiliar plant specimens, some new to botany. The now ubiquitous red cactus orchid, *Epiphyllum ackermannii,* was one of the specimens that George brought home and gave to the Society of Apothecaries' garden at Chelsea, now the Chelsea Physic Garden.

Rudolph, George and their brothers took over the running of Ackermann & Co., as it became, after the *pater familias* finally retired in 1832. Diversifying and branching out as their father had done, the brothers took the company through cash-flow, liquidity and management crises, including a near bankruptcy in 1843, into new fashionable areas of print and object selling, to embrace railway prints and travel books, maps, games and photographs, and the continuing *Forget-Me-Nots.* They won royal appointment as Book and Printsellers to HM Queen Victoria and HRH Prince Albert, and in 1851 had a prominent display at the Great Exhibition. Their advertisement proclaimed that Ackermann's had 'the largest collection of exhibition prints and of London always on view: from 1s to 21s plain and coloured'. As publishers, Ackermann's were leaders in the field of selling multi-coloured lithographic images when rapid changes in mass-printmaking technology brought such intricate images to the market. Rudolf Ackermann and his successors were generalists, creating a market and leading the way. Inevitably they attracted competitors, principally

the Colnaghi family of art dealers, a development that demanded business decisions which led to the splitting apart of art dealing from the sale of pretty domestic objects. With high-value properties in the centre of London, the Ackermanns' businesses could not afford to stagnate.

A specialist art dealer of a new kind, one with a large fortune, low overheads and a modern approach, was Thomas Griffith. He was the only child of another Thomas Griffith, a successful auctioneer with a large practice in Blackman Street, Southwark, and houses in Dulwich and Rye. Thomas Griffith the younger, who was at first an art collector and only later a dealer, went up to Trinity College, Cambridge, the year after his father's death, graduating with an MA in 1824. Three years later he was admitted as a lawyer to the Inner Temple, but was not called to the bar. From his father, who had been grand enough in Southwark to be buried in the family vault beneath the vestry at St George's Church, Griffith had inherited the Southwark and Dulwich properties, together with family plate and books. This was a substantial London trade family, widely known through their auctioneering business and sufficiently moneyed to allow the younger Thomas to develop a life in collecting.

By 1823, aged twenty-eight, Griffith had built up enough of a collection to lend twelve watercolours to an exhibition at the Old Water-Colour Society. Six years later he seems to have bought thirteen watercolours by Turner from the exhibition organized in June 1829 by Charles Heath at the Egyptian Hall, Piccadilly, a clean sweep that astonished both Turner and Heath. The artist wrote to Heath at the time expressing some surprise at the size of the purchase and warning him against 'creating any feeling of uneasiness' in Griffith. This was the beginning of a business relationship between Turner and Griffith that lasted the rest of Turner's life, and one which became fruitful for both men, the cause of friendship, mutual understanding and profit. The particular role that Griffith adopted, working from his home in Norwood and, from 1845, from his gallery in Pall Mall, was not only as a collector and art dealer, but also as an agent who brought artists and patrons together.

Within a few years on the art-collecting circuit, Griffith had developed friendships with artists and collectors widely spread in England. The

painter Clarkson Stanfield, as much at home painting large theatrical back-drops as he was at making rapid studies of the erupting Vesuvius, received high praise from critics for his scene-painting for a production at the Drury Lane Theatre in January 1831. Stanfield told Griffith:

> The short time I had to cover the canvas (little better than two days) led me to fear that the hurried manner that the greater portion of the work was done in would prove its failure and it has been a source of gratification to me to find my friends and the public so favourably inclined to what was certainly an incomplete performance on the first night.

By 1835 Griffith was every artist's friend, receiving high praise from Edward Coleridge, a schoolmaster at Eton:

> I entirely approve of your gallant endeavours to rescue the really deserv-ing Artists from the tender mercies of the Dealers, and thus by quietly gagging those mercenary Harpies, who live by sucking the Brains of some, and poisoning the minds of others, to bring the 'Artists' into more immediate contact with their admirers, without any of the <u>disagreeables</u> generally attached to such meetings.

From Norwood and Pall Mall Griffith perfected the social side of art dealing. He was a smooth operator, close to patrons such as the novelist Frances Talbot, Countess of Morley, the collectors Benjamin Windus and Elhanan Bicknell, the socialite and artist Count d'Orsay, and the Ruskins. He was a friendly and staunch support for artists, and realistic to them about what he could achieve. When in 1842 Turner brought four magnificent new water-colours to him to sell, Griffith thought he could get 80 guineas each for them. 'Aren't they worth more?' Turner retorted. 'Yes, they are *worth* more,' Griffith replied, 'but I could not *get* more.' To Windus he gave Turner's watercolour *Tynemouth, Northumberland*. 'You lay me under great obliga-tions my friend,' Windus wrote to Griffith in 1844:

> But in accepting it believe me I shall truly value it & remember your kindness. I have written to Turner to ask him to meet you on Thursday,

I should like to see him again at Tottenham. I hope he will come & we
shall have a pleasant day.

The Countess of Morley, whom Griffith encouraged to paint, urged him
and his wife to come to Saltram House, near Plymouth, to be entertained
by her amateur 'corps dramatique':

> We have a very large Saloon in the House in which we had a very pretty
> little Theatre constructed & we acted three nights to an audience of
> about 150 of our country neighbours each night.

So impressed and engaged were they by Griffith's sales and support tech-
nique that a group of artists including Thomas Uwins, Henry Copley
Fielding and David Roberts clubbed together to buy him a silver-plate
tazza, a large flat dish on a single stem, with an inscription recognizing
his services to art and artists. David Roberts wrote to say how delighted
he was to be one of the number giving Griffith the testimonial of their
appreciation, 'knowing as I do, how much Art – as well as those who have
a love of it – are endebted to you for its promotion'. Uwins was even more
effusive:

> In my fondest dreams of happy days I never ventured to imagine such
> an arrangement between artist and patron as your zeal & kindness has so
> effectually realised.

The *Athenaeum* gave the event high praise, at the same time throwing light
on Griffith's detached approach:

> It is pleasant to find an amateur of pictures, whose fortune places him
> above the necessity of dealing, engaged in the delicate task of smooth-
> ing the difficulties which occasionally arise between painters and their
> patrons, and to see the artists manifesting their grateful sense of such
> liberal aid . . . To those purchasers of drawings who prefer negotiat-
> ing with a third person, who is by circumstances independent of both
> parties, it may be satisfactory to know that the artist fixes and receives the
> whole price paid for his productions.

Griffith is a rare example, perhaps unique at his level, of the altruistic collector-dealer. He is indeed a throwback to an earlier generation when collectors such as Walter Fawkes, Lord Egremont and Sir John Leicester might buy works in quantity and liberally allow access to them. But even they did not give much away: Griffith, by contrast, was a genuine and disinterested go-between, concerned that works should be in the right hands. To Turner he wrote:

> I have yielded to the pressing solicitations of Mr Windus and resigned your drawing of the Straits of Dover in his favour. He has paid me £50 for it, and as profit found no part of my purpose in this transaction, I enclose you a Cheque for the balance.

Dominic Colnaghi was a second-generation art dealer with family roots in Milan. His father Paolo Colnaghi had come, like his German contemporary Rudolf Ackermann, to England in the 1780s, after having first found work in Paris selling English prints in the Rue Saint-Honoré. There he was spotted as a coming man by Benjamin Franklin, who tried to persuade him to emigrate to America. As Franklin realized, the eve of the French Revolution was no time for a foreigner to run an art business in Paris, nor was Paris at that time a sensible place to design carriages for the aristocracy. Both he and Ackermann, by their own routes, came promptly to England.

With his Parisian business partner Anthony Torre, Colnaghi set up shop first off Pall Mall, and then, as Pall Mall prospered as a residential and business street, he moved to number 132. By 1788 Paolo Colnaghi, now anglicized to 'Paul' and having become a naturalized Englishman, was running the company, moving in 1799 to Cockspur Street, where Colnaghi's would remain for twenty-five years. Here, between Pall Mall and the Royal Mews, later Trafalgar Square, the company flourished, a particularly lucrative business line being the sale of engraved portraits of distinguished men and women. The rich contacts Colnaghi had developed with English printmakers when in France served him well in London. He was opportunistic, publishing an engraving of Hoppner's portrait of Nelson a fortnight after the Battle of Trafalgar, and showed entrepreneurial flair. Realizing the commercial value of Francis Wheatley's series

of paintings *The Cries of London*, representing sounds he would hear outside his shop every day, Colnaghi commissioned Luigi Schiavonetti to reproduce them in coloured mezzotint. Two of his most productive artists, Schiavonetti and Francesco Bartolozzi, were, like him, of Italian extraction – each, with the colourman Sebastian Grandi, the marble dealers Giuseppe Fabbricotti and Egisippo Norchi, the sculptor Giovanni Battista Locatelli and Paul Colnaghi himself, contributing a fertile Italian accent to the supply side of the art world of London.

Colnaghi was only ten minutes' walk away from Ackermann in the Strand. Customers who moved from one to the other would pass from the lilting Italian tones in Paul's shop, through the raucous cries and rattle of Charing Cross, past the roars of the lions at Exeter 'Change, to the sober German accents heard at Rudolf's emporium. London, as ever, was as colourful on the ear as on the eye. Like Ackermann, Colnaghi produced two sons to continue his name and trade: Dominic and Martin Colnaghi carried on the firm with relish and profit until 1824, when they quarrelled and Martin was bought out by father and elder brother. Dominic and *pater familias* Paul moved back to Pall Mall, and for some years the brothers bid against each other at auction with cunning and fury, until Martin faded into bankruptcy in 1843. There is a suggestion in one of his sketchbooks that Turner played Martin and Dominic off against each other at the height of their rivalry. In separate memoranda written on the same page, opposite ways up so that the first could be read only with difficulty by the writer of the other, Martin Colnaghi seems to offer one level of discount – presumably for prints – while Dominic offers another.

Paul and Dominic Colnaghi were at the forefront of art dealing in their day, championing John Constable's paintings, publishing David Lucas's mezzotints after his work, and supporting Constable in the diplomatic preliminaries required to show his *Hay Wain* at the 1824 Paris Salon. There it caused the kind of sensation that had greeted Géricault's *The Raft of the Medusa* when that huge painting was shown in London at the Egyptian Hall in 1820 (see page 286). *The Hay Wain* had failed to sell when first shown at the Royal Academy in 1821, after which Constable's friend and patron Archdeacon John Fisher advised:

Let your . . . Hay Cart go to Paris by all means . . . I would (I think) let it go at less than its price for the sake of the éclat it may give you. The stupid English public, which has no judgement of its own, will begin to think there is something in you if the French make your works national property.

In the event the French did not buy *The Hay Wain*, but the National Gallery had to wait until 1886 to acquire it.

The Colnaghis were always good friends to Constable; he responded with some dismay to the discord in the firm, remarking at the time:

I hear there is quite a bustle at Colnaghi's . . . They are all brisking up. Martin seems to be clearing the house of the old man & Dominic – but he is not quite liked himself – he is said to make love to all the ladies who look over prints there.

Constable was noticeably touchy, not the easiest character for art dealers to handle. He was burdened with financial insecurity and a growing family, worries Turner never had. In 1832 Constable sent a Lucas mezzotint to Lord Dover, who was a strong advocate for building a new National Gallery. When Dover sent by return a worn print of a painting in his own collection, Constable snorted to C. R. Leslie in response:

I find Lord Dover carries on no inconsiderable trade, with this private plate. This Colnaghi tells me. Colnaghi will not give more than a guinea for one – & that not in money . . . I do think that as his Lordship was too proud to receive a present from me, he should have sent me at least the equivalent, bearing the character of a gentleman – but Mr Burke said that he found the nobility 'weak & mean beyond the allowance to be made for such people!!'

Colnaghi's, like all art dealers, had to be constantly on the watch for pirate publishers who would steal subjects whose copyrights were owned by others, re-engrave them and pass them off as their own. The market for portraits and engravings after them was brisk and lucrative, and brought into particular public focus by the exhibition at the British Institution

in 1820 of *Portraits Representing Distinguished Persons in the History and Literature of the United Kingdom.* The exhibition's catalogue introduction asserted:

> We never read of the actions of any distinguished individual, without feeling a desire to see a resemblance of his person; we often imagine that we can trace the character of the man in the expression of his countenance; and we retain a more correct recollection of his actions, by keeping in our minds a lively impression of his general appearance.

Such public demand encouraged piracy. The High Court heard in 1834 that two portraits engraved for Colnaghi's – of the Lord Chancellor, Lord Eldon, and of the prime minister, Sir Robert Peel – had been pirated by William Darton. To much mirth in court, the judge remarked on what he took to be 'a most execrable likeness' of Peel. 'I suppose . . . that the defendant's print of Sir Robert Peel is now just brought out with a view to prevent the formation of a new administration?' To laughter, Colnaghi's counsel retorted: 'I am sure no one would like to have such ministers as those represented by the defendant's prints.' And they all rocked with laughter at the thought that their boss, Lord Chancellor Eldon, could be the subject of 'such a villainous production'.

By the 1830s and 1840s dealers were taking advantage of the huge profits to be made from the engraving of popular images and pricing the work of the artists they sold accordingly. Ernest Gambart, a Belgian art dealer with youthful experience of working in Paris, moved to England in 1840 to build a career selling prints. In doing so he was following the well-trodden path laid across the English Channel by entrepreneurial Europeans: where Ackermann and Colnaghi led, Gambart followed. When he arrived in London, a future of dealing in paintings was for Gambart still some way off: he had as yet no reputation, no secure premises and little capital. Prints, however, could be carried about, in rolls or portfolios, and taken from shop to shop. After two years of this kind of salesmanship, experiencing success, failure and a loose partnership with the Paris art dealers Goupil and Co., Gambart set up on his own, first in Pall Mall, and later in King Street, St James's. He was fully aware of the money to be made

in acquiring copyrights from artists whose paintings drew crowds in the Academy, and saw further the potential in buying and selling precious and covetable images in the new medium of photography: he bought in volume from Henry Fox Talbot's photograph-printing establishment in Reading. Among the artists whose work he sold and with whom he made lucrative copyright agreements for engraving were Landseer, David Roberts, Frederick Goodall and William Holman Hunt. What may have been Gambart's initial approach to Jacob Bell, as a route to Landseer, was described to Landseer by Count d'Orsay in a letter probably written in 1847:

> I saw Gambart today – he told me that he saw our friend Bell to whom he explained what he could do for you . . . Be sure that Gambart will show you on paper that by this present picture and the two other that you have in hand, that you will make £10,000 by the Engraving alone, in 3 years.

Landseer's correspondence reveals the level of detail and bile that emerges from complex negotiations between highly strung and intense individuals who were fellow spiders in the same financial web. This letter to Bell, probably written in 1848, carries a level of suspicion and mistrust that continued and characterized Landseer's business affairs with Gambart:

> Private. You know I am not very often mistaken as to character. (I don't want to boast). We have no <u>experience</u> in Gambart except his <u>presuming</u> upon one transaction as being the key to all I am ever to do or ever have done . . . Has any one any knowledge of his <u>real means</u>? I quite see his <u>merits</u> which he exerts for his <u>own benefit</u>. You will excuse my being so <u>plain</u> with the dispositions of a man you trust, but he does not give me the idea of a Gentleman (I don't mean a dandy). Take advantage of my doubts, but <u>don't</u> show me or my <u>opinions</u> up to him. And remember he does not care one D— for <u>Art</u>.

The dealer's role as a go-between had its price, and more than just as a commission fee or mark-up. As Landseer found, a dealer's attitude to the art he sold, and the artists he represented, created a constant dilemma to artist and buyer alike as prices rocketed and pressure to produce increased.

The commissioning and dealing in artists' prints that Gambart also found so lucrative had an additional insurance factor: it protected the boundary between the old master trade and the trade in paintings by living artists by adding variety to the market and increasing the range of art available through modestly priced engravings. The old master trade had become untrustworthy and risky for the generation of collectors who entered the market in the 1820s and 1830s and who could be duped by fakes. To them, a picture by a living artist had a short, traceable history, and could be openly discussed as a pleasure shared. How much more reassuring it was to have a bright Landseer dog hanging above the fireplace than a gloomy Roman saint shrouded in the Westminster oven's odour of sanctity.

COLOURMAN:
'THE DANGEROUS SYMPTOMS
HE LABOURS UNDER'

In the late eighteenth century artists bought their colours, just as they had for 200 years, in powder or lump form, dried and ground and contained in glass or pottery jars. Alternatively they might be supplied in screws of paper, like boiled sweets used to be, or as pastes to be squeezed out of bags made from pigs' bladders. This was a long tradition; pigs had been giving their bladders to art for centuries. Cennino Cennini, the early fifteenth-century painter and author of *Il Libro dell'Arte*, a manual for painters and craftsmen which was not published until the 1820s, recommended skins and bladders as the most convenient receptacles for dry or damp pigment. He also made it clear that the preparation of good colour was a slow, laborious, back-breaking and dangerous job. On grinding the highly toxic mercury-rich mineral cinnabar to make vermilion (red), he instructed the artist to put the cinnabar on a porphyry slab, 'grinding it with clean water as much as you can – if you were to grind it for twenty years, it would be but better and more perfect'. Orpiment (yellow) had further hazards and was no less time-consuming:

> It is the most difficult colour to grind of any used in our art; therefore when you are going to grind it . . . gently press it between the stones, mixing with it a little broken glass, because the powdered glass, by its roughness, assists in grinding the orpiment. When you have broken it to pieces, put clean water to it and grind it as much as you can, – and if you were to grind it for ten years, so much the better would it be. Beware of letting it touch your mouth, lest you should poison yourself.

Colour preparation, naturally messy and dangerous, involved the artist or assistants in complex preparation before the resulting colour could be

mixed with water or oil, and the painting begun. This essential activity made the workplace busy, allowing little space for the quiet reflection that in the mid-nineteenth century became the Romantic artist's dream. In the seventeenth and eighteenth centuries a large and continuous output of paintings could only be achieved with the help of support staff, servants, apprentices or assistants. Gradually, however, attitude, industry and economics caused this to be discarded, and in a romantic shift colourmen went off into business on their own in one direction, and frame- and stretcher-makers in another, while the artist was left alone with subject and canvas. 'Classic' might describe the ideal, ordered life of an artist such as Rubens or Reynolds, good at management and subtle in business; 'romantic' describes the chaotic lives of George Morland, Benjamin Robert Haydon and Joseph Gandy – talented, imaginative, but bedevilled by disorganization, debt and drink. Paintings such as the anonymous watercolour of Fuseli's workroom in the Royal Academy (c.1810) may reflect the organized ideal, but it was also an expression of a romantic dream. The dull reality of Morland's painting of himself and his servant, Gibbs, in the studio (c.1802), or Turner's remarkably similar *Artist's Studio* (c.1808), are probably nearer the truth. It is interesting to reflect that from the early twentieth century 'picture' has also meant a cinema film, a production achieved, like the production of a successful painter, only through the marshalling of large forces: huge cast, big business.

The painting of a picture came as the end product of a long and laborious craft process in which not only had the colours to be ground and combined, but also the associated carpentry, metalwork and fabric handling had to be carried out. For the painter, the wooden stretcher for the canvas had to be made, and the canvas stretched and nailed across it, prepared with a suitable size or ground to accept the paint. Artists shared suppliers with coach painters, house decorators, cloth dyers and printers, and pottery painters; canvas supply with ship-builders and riggers, haberdashers and upholsterers; stretcher- and frame-making with carpenters and plaster modellers. In a gradual refinement of their activity in the eighteenth century, painters moved away from the colour-makers' and grinders' premises and into studios of their own.

And just as well: colour-making remained a pretty sordid business, as Robert Campbell, the author of a mid-eighteenth-century treatise on the trades of London, made clear. Nothing much had changed since the days of Cennini:

> [The colourman] is, in some shape, the Apothecary to the painter . . . He grinds such as requires grinding, and adds that expense to the prime cost . . . A painter may go into his shop and be furnished with every article he uses, such as pencils, brushes, cloths ready for drawing on, and all manner of colours ready prepared . . . They employ labourers to grind their colours at the common price of ten or twelve shillings per week: so that I would not chuse to breed my son to this branch . . . There are some others employed in preparing colours, such as in making powder-blue, commonly called Prussian Blue, from that Mystery being invented in that Kingdom. It is made from bullocks' blood by the operation of fire. The work is chiefly carried out in the Borough of Southwark; is an odious stinking business, and by the secrets of the preparation being public, the profits are dwindled to a trifle . . . There are some who prepare that beautiful colour called Carmine, which is prepared by extracting the dye from scarlet rags. This is but in few hands, and no apprentices are bound to the mystery . . . There are works at Whitechapel, and some other of the suburbs, for making of White and Red Lead, with the rest of the preparations of that metal. But the work is performed by engines, horses and labourers, who are sure in a few years to become paralytic by the mercurial fumes of the lead; and seldom live a dozen years in the business. They take no apprentices.

Raising their discipline from a trade to an art and a profession, painters also removed themselves from the filthy business of producing the beautiful material from which they made their work. Turner's curious painting *An Artists' Colourman's Workshop* of around 1807 shows the old dispensation, before the introduction of more convenient ways of delivering colour. An aged colourman, the 'apothecary to the painter', as Campbell put it, is grinding red pigment, probably the poisonous vermilion, and is surrounded by bottles and jars of all sizes. His donkey rests beside the set of large grinding wheels which he daily pulls round for hours on end. The colourman is shown to be old and doddery,

probably prematurely aged through the vicious tyranny of his infernal profession.

An illustrated trade flyer of another mid-eighteenth-century colour-man, Joseph Emerton, who had his works near the Strand, reveals both ends of the colour-making process: to the right of the decorative engraving a horse drives a pigment-grinding machine, while on the left a portrait painter and his subject sit face to face with each other. Emerton, according to his advertisement, was fully diversified in the colour trade. He sold paint equally for house painters, to be applied 'by the help of a printed Direction which he gives with his Colours', and

> Water Colours and Varnish, with everything necessary for the New Japanning; and gives a printed Direction, for the doing of it to the Greatest Perfection, to those that buy Colours. Also Italian Powder for Cleaning Pictures, and fine Picture Varnish. He deals only for Ready Money.

In the margins of Emerton's advertisement are images of palettes, brushes and paint pots, and bladders hanging like the offal they once were.

Sebastian Grandi of Long Acre was a colourman who came from the generation that tried to overcome the apothecary label, while still using apothecary methods. In 1806, having asked Farington to support his application, Grandi won the silver medal of the Society of Arts and 20 guineas for his method of preparing panels for painters. His portrait, by John Opie, shows the medal tucked inside his coat. Despite the prize-worthiness of his approach, his technique was nevertheless another reason why painters wanted their materials to be made as far away from their studios as possible:

> Take the bones of sheep's trotters, break them grossly, and boil them in water until cleared from their grease, then put them into a crucible, calcine them [i.e. heat them up until they break down], and afterwards grind them to powder.

White was made by this method, while brown had a similar genesis, 'only calcining [the bones] in a crucible instead of an open fire'.

Success at exhibition and selling depended on artists having some special

ingredient in image, colour or technique that would lift them above the general mass of paintings on show. 'Colouring,' said Opie, 'is the sunshine of the art.' There was a brief flurry of excitement at the Academy in 1797 when the miniaturist Ann Provis, 'a very young lady, scarcely in her teens', persuaded some Academicians that she had inherited a colour recipe purporting to be one used by Titian and other sixteenth-century Venetian artists. The value of knowing this 'Venetian Secret', as it came to be called, caused some artists to pay Provis 10 guineas each for sight of the recipe. Their eagerness, notably in the case of the president Benjamin West, to know and to try the method smacks of desperation to find an answer to the problem of paintings fading and cracking that had bedevilled Reynolds and others for years. Nevertheless, as John Gage suggests, had the Academicians read sixteenth- and seventeenth-century treatises on painting, they could have pieced it together from there and saved themselves some money.

The 'Venetian Affair' was mercilessly lampooned by James Gillray in his engraving *Titianus Redivivus, – or – The Seven Wise Men Consulting the New Venetian Oracle* (1793). The seven – Rigaud, Smirke, Stothard, Hoppner, Westall, Opie and Farington – queue up for instruction, each with a question. Farington's is:

Will this secret make me paint like Claude?
Will it make a Dunce, a Colourist at Once?

A thousand other artists wave their palettes and clamour for the miracle. Sir Joshua rises from the dead with the words:

Black spirits & White, Blue spirits & Grey
Mingle, mingle, mingle! You that mingle may.

Martin Archer Shee, an ambitious portrait painter who would one day be president of the Royal Academy, continued the merciless criticism of those artists sucked into the affair. In his long and tedious poem *Elements of Art* (1809), which followed the canto form that Byron was to celebrate, but would be no rival to the author of *Childe Harold's Pilgrimage*, he (Shee) opined:

How many fondly waste the studious hour,
To seek in process what they want in power!
Their time in curious search of colours lose,
Which, when they find, they want the skill to use!
Till all in gums engross'd, macgilpts and oils
The painter sinks amidst the chemist's toils.

Shee enlarged on his lines in a footnote: 'The process-hunter is the alche-
mist of the palette . . . The Artist who has been once visited by the mania is
restored with great difficulty to the rational path of progress.'

The Venetian Affair, with its controversial public platform, was a
symptom of the relentless search by artists' colourmen to find pigments of
chemical compositions that would heighten the tone of paintings, not only
to create a brighter effect of nature, but also to stand out at public exhibi-
tions. Turner's *Opening of the Vintage of Macon* of 1803 attracted criticism
from Sir George Beaumont, who objected to the brightness of its tones and
announced that 'the subject was borrowed from Claude, but the colouring
forgotten'. In other words, as Beaumont had spotted, Turner's colouring
here was revolutionary, though the connoisseur could not quite give up his
allegiance to his own generation's way of judging modern art by the stand-
ards of an old master's palette. Likewise, a few years later, John Martin's
startling red and orange *Sadak in Search of the Waters of Oblivion* jumped
out from its green and brown neighbours in the 1812 Academy exhibition
and found a buyer, William Manning MP, a merchant of the West Indies.
New ways of making paint were offering new tones and colours to young
masters' palettes and generating new pictorial confidence. Seeking new
directions of their own, painters were naturally secretive about how they
made their effects. Augustus Callcott, cautiously ambitious, talented and
enquiring, noticed with frustration how his fellow artist William Owen
ARA would not talk freely about his methods:

Dined at Hoppners with Owen and [Henry] Thomson. Talking of colours
H said he was convinced Rubens and the Flemings had a yellow we know
nothing of. Owen gave us an account of a picture he had painted on a
wax ground. Whether it is that Owen is cautious of not talking but he

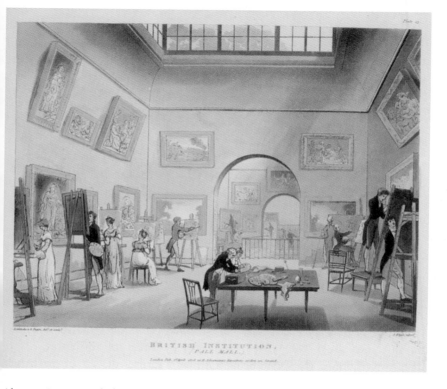

Above: *Interior of the British Institution, 52 Pall Mall* by A. C. Pugin, after Thomas Rowlandson (hand-coloured etching and aquatint, published by Rudolf Ackermann, 1808). Below: *Interior of the National Gallery, when it was at 100 Pall Mall* by Frederick Mackenzie (watercolour, 1834). The National Gallery and the British Institution were the two modern institutions in Pall Mall founded to bring art and its study to the public. Both encouraged copyists to work in their rooms.

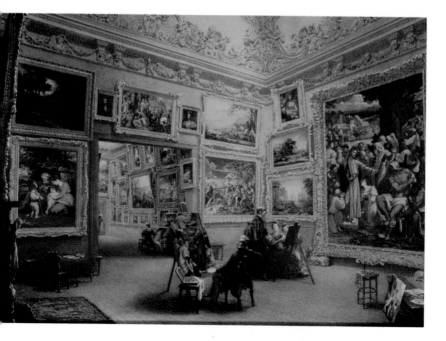

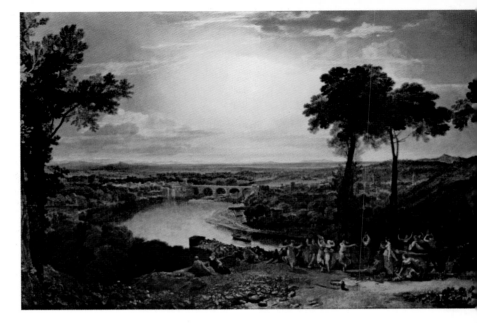

Above: *The Festival upon the Opening of the Vintage of Macon* by J. M. W. Turner (oil on canvas, 1803). Below: *Noli me Tangere* by Titian (oil on canvas, *c.*1514). These two paintings, the Titian being less than a quarter the size of the Turner, were sold for about the same price: £330 and 300 guineas respectively, in 1802 and 1804.

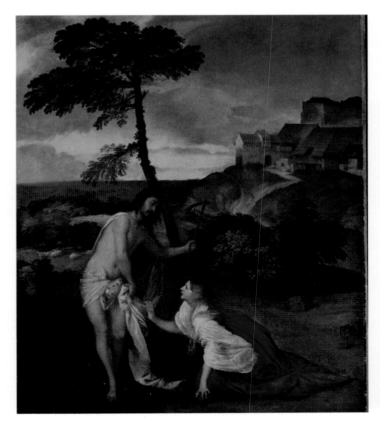

Above: *Waiting for the Times* by Benjamin Robert Haydon (oil on canvas, 1831).
Below: *William Brande and Michael Faraday precipitating Prussian Blue*, attributed
to George Reinagle (oil on panel, 1827). Haydon's painting reflects impatience, as
one man waits for another to finish reading the day's *Times* in a clubroom. Below,
two chemists, likely to be William Brande and his young assistant Michael Faraday,
patiently precipitate Prussian Blue, in a colourful experiment that brings immedi-
ate and satisfying results. Both paintings include remarkable still-life details.

Above left: *Thomas Coutts* by Sir Francis Chantrey (marble, 1827), Coutts Bank, London. Above right: The Chantrey Wall at the Ashmolean Museum, Oxford. Some of the original plaster preliminary models for Chantrey's many busts, presented to the University of Oxford by the artist's widow in 1842, were redisplayed here in 2009.

Below: *James Watt's workshop at Handsworth, Birmingham, as he left it at his death in 1819* by Jonathan Pratt (1889). Watt's sculpture-copying machine is seen centre background. His bust by Francis Chantrey is prominent at centre right. Watt's and Chantrey's workshop practices illustrate the increasing industrialization of sculpture production in the early and middle decades of the nineteenth century.

Above: *Whalers (Boiling Blubber) Entangled in Flaw Ice, Endeavouring to Extricate Themselves* by J. M. W. Turner (oil on canvas, 1846). Composed initially as a painting of the arrival of King Louis-Philippe in Portsmouth Harbour in 1844, Turner rapidly reconfigured it as a south Atlantic scene in an unsuccessful attempt to attract a buyer interested in whaling subjects.

Below: *Isabella* by John Everett Millais (oil on canvas, 1848–49). Against her family's wish, Isabella falls in love with the apprentice Lorenzo. When Isabella's furious brothers kill Lorenzo, she cuts off his head and buries it in a pot of basil which she waters with her tears. The story derives from Boccaccio, retold in a poem by Keats.

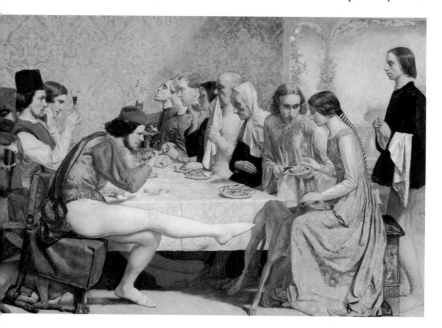

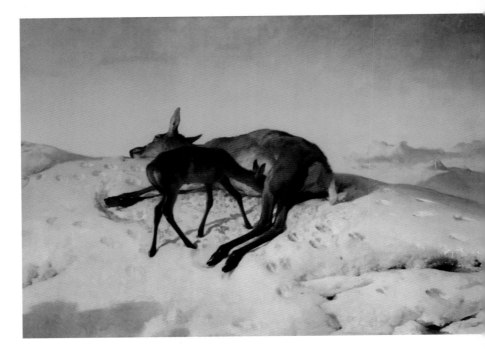

Above: *The Random Shot* by Edwin Landseer (oil on canvas, 1848). Below: *The Random Shot* by Charles Lewis, after Edwin Landseer (engraving, 1851). This engraving of Landseer's celebrated painting was the subject of a persistent commercial argument between artist, engraver, and the dealers Ernest Gambart and Henry Graves.

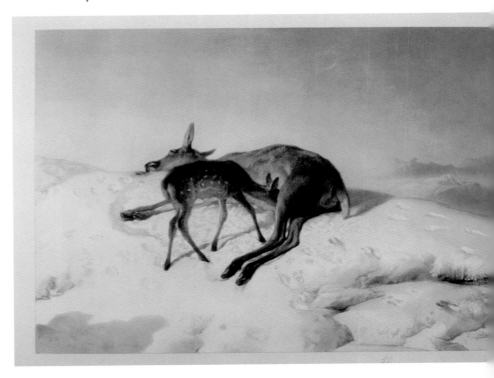

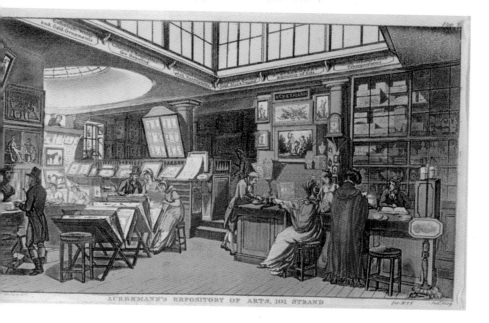

Above: *Ackermann's premises, The Repository of Arts, in the Strand, London* (hand-coloured etching and aquatint by A. C. Pugin, published by Rudolf Ackermann, 1809). Ackermann's shop was busy, successful and fashionable, supplying prints and drawings, decorative objects, books and artists' materials. Below: *Interior of Benjamin Godfrey Windus' library and gallery at Tottenham* by John Scarlett Davis (watercolour, 1835). Collectors such as Windus contributed richly to the business of art in the nineteenth century, and helped to maintain the buoyancy of the art market's many levels.

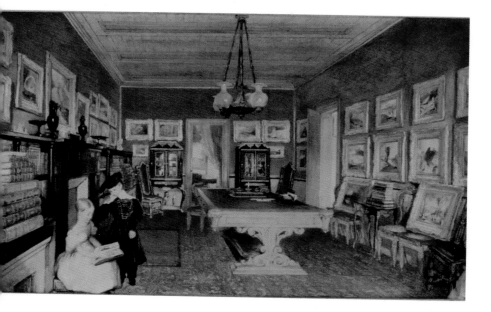

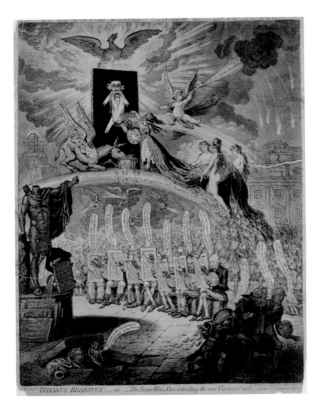

Titianus redivivus [Titian reborn]; -or- *the seven-wise-men consulting the new Venetian oracle, - a Scene in ye Academic Grove. No 1* by James Gillray (engraving, 1797). A lampoon mocking senior Royal Academicians who were duped into buying a dubious recipe for Venetian colour.

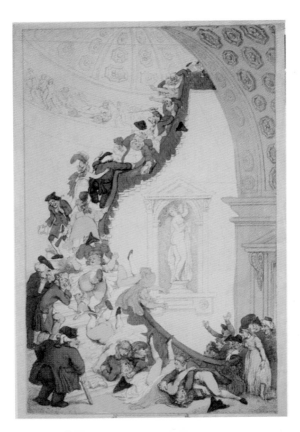

Exhibition Staircase by Thomas Rowlandson (watercolour, *c*.1811). This narrow staircase is still in use as the principal access to the Courtauld Institute Gallery, Somerset House.

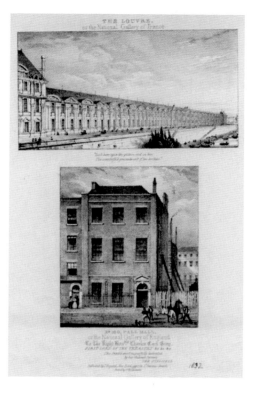

Above: *The Louvre, or the National Gallery of France. No. 100, Pall Mall, or the National Gallery of England*, published by Joseph Hogarth (lithograph, *c.*1832). Published as political pressure was forcing the government to speed the construction of a new building for the National Gallery. The print compares the grand sweep of the Louvre in Paris with Britain's National Gallery, then a dilapidated house in Pall Mall. Below: *Ruins of Fonthill Abbey* by William Westall, after John Buckler (lithograph, 1826). Inscribed: 'The Tower fell 21st. December 1825. / "And thus this unsubstantial Fabrik falling left a sad wreck behind!"'

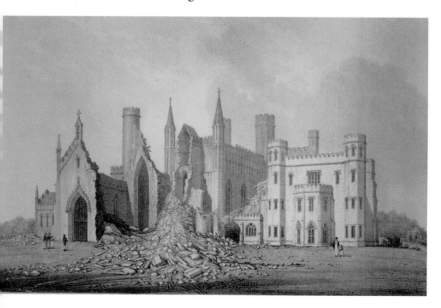

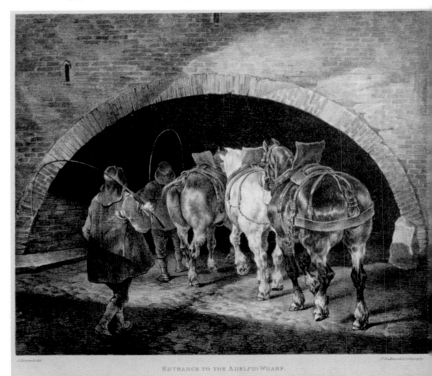

Above: *Pages from Turner's 'Academy Auditing' sketchbook, c.1824.* Figures written out by Turner from Royal Academy accounts are followed in strong contrast by pages of free-flowing drawings of sexual activity (*opposite page*). Below: *Entrance to the Adelphi Wharf* by Théodore Géricault (lithograph, 1821, printed by Charles Hullmandel). One of a set of twelve lithographs of London life that Géricault made across the months in which his painting *The Raft of the Medusa* was exhibited at the Egyptian Hall, Piccadilly.

Below: *Paintings being delivered for selection to the Royal Academy, Trafalgar Square* (wood engraving, from the *Illustrated London News*, 1866). The building, now occupied entirely by the National Gallery, accommodated the Royal Academy on its east side from 1837 to 1868. The popularity and demand for the annual exhibition is self-evident. On the left is a wagon expressly fitted out to transport paintings.

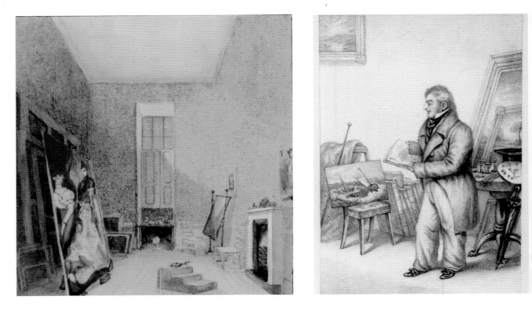

Above left: *Mr Fuseli's Painting Room at Somerset House* by an unknown artist (watercolour, *c.*1825). To the centre of the room is a set of steps to aid the diminutive artist (he was 5 feet 2 inches tall) in reaching the top of the canvas. Above right: *Portrait of J. M. W. Turner* by Charles Turner (stipple engraving, published in 1852). An elegant evocation of Turner's studio which signals the artist's erudition through the folio volumes, and his creative and physical energy, through the maulstick, palette and paints, and hat and umbrella.

Below: *The Artist's Studio* by J. M. W. Turner (sepia drawing, *c.*1808). Possibly a lampoon on the pretensions and industry of artists. Turner has written on the reverse: 'Pleased with his work he views it o'er and o'er / And finds fresh Beauties never seen before'.

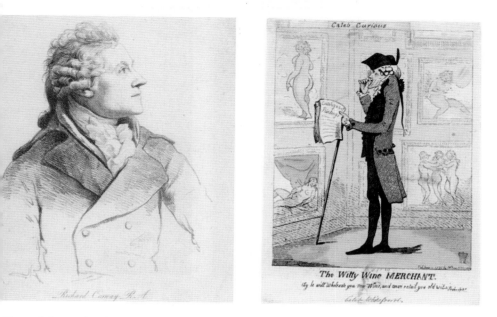

Above left: *Richard Cosway RA* by William Daniell, after George Dance (soft ground engraving, published 1811). Cosway's sharp eye drew characterful details from his sitters, and led him also into a complicated way of life as a philanderer. Above right: *'Caleb curious – the Witty Wine Merchant': portrait of Caleb Whitefoord* by Isaac Cruikshank (hand-coloured etching, 1792). Whitefoord, an influential figure in London, was also a successful wine merchant, and owned a remarkable collection of erotica.

Below left: *Self Portrait* by William Etty (oil on paper, 1823). The speed and bravura with which Etty would paint the nude was remarked upon with admiration by fellow artists. Below right: *Study of a standing nude* by William Etty (oil, 1820–30s). Studies of such naturalistic detail as this would not be shown in public.

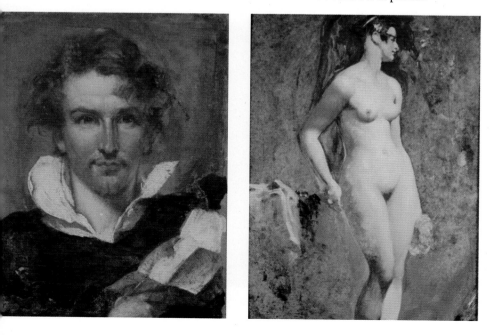

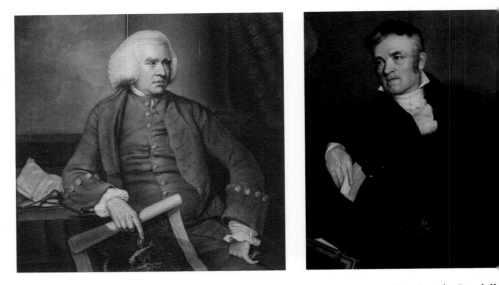

Above left: *John Boydell, Engraver* by Valentine Green, after Josiah Boydell (engraving, 1772). A forthright portrait of a major player in the art business of the late eighteenth century. Above right: *Rudolf Ackermann*, attributed to Francois Nicholas Mouchet (oil on canvas, 1810–14). Ackermann's highly successful art business had branches as far afield as Central and South America.

Below left: *William Seguier*, attributed to John Jackson (oil on card, *c.*1805). Art dealer and picture cleaner of dubious integrity. William Beckford referred to him as 'that execrable Seguier'. Below right: *Sebastian Grandi* by John Opie (oil on panel, 1806). Tucked into Grandi's jacket is the silver medal awarded to him by the Society of Arts in 1806.

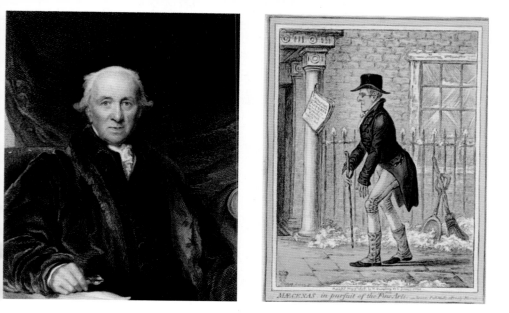

Above left: *Sir John Julius Angerstein*, after Sir Thomas Lawrence (mezzotint, *c*.1815). Angerstein ensured that on his death his house and art collection would be bought by the nation as the foundation for the National Gallery. Above right: *Maecenas, in pursuit of the Fine Arts: scene, Pall Mall; - a Frosty Morning* by James Gillray (hand-coloured etching, 1808). The Marquess of Stafford is seen walking past the rooms of the auctioneer James Christie.

Below left: *Study for 'Patrons and Lovers of Art'* by Pieter Christoffel Wonder (oil on canvas, 1826–1830). Collectors, including William Holwell Carr and George Watson Taylor, are together admiring Titian's *Bacchus and Ariadne*, just acquired by the National Gallery. Below right: *Joseph Gillott* (engraving). The fortune Gillott made from his Birmingham pen manufactory enabled him to build up a peerless collection of Dutch, French and particularly British nineteenth-century painting.

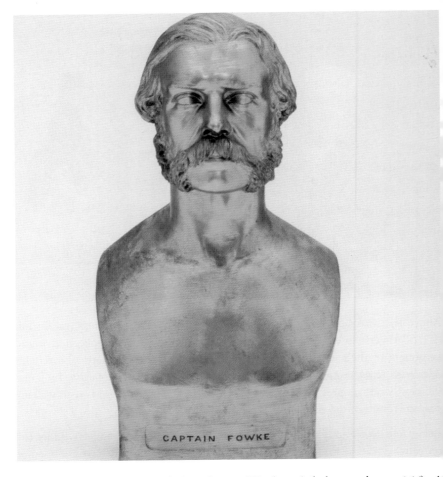

Above: *Captain Francis Fowke* by Thomas Woolner (gilt bronze bust, 1866). A former soldier and military engineer who became a pioneer architect of steel-framed exhibition galleries. Below: The steel-framed picture galleries in the South Kensington Museum, later the V&A, designed by Francis Fowke, 1857.

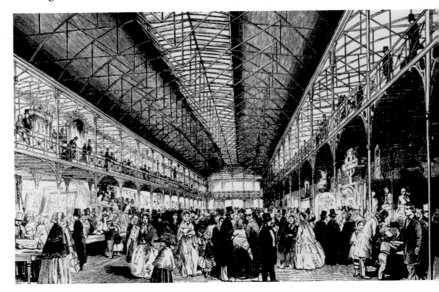

should commit himself or that he is close I cannot determine it. Have frequently had occasion to observe that the information he communicates is rather drawn out of him than voluntarily given.

A revolution in the new commercial production of paints and pigments was made by the entrepreneurial chemist George Field. He had early practised his organizational skills around the first years of the century when in 1803 he was a co-founder of the ambitious 'British School', a permanent display gallery for British artists in rooms in Berners Street, north of Oxford Street. This initiative was intended to be an alternative to the Royal Academy, seen by many to be an exclusive self-selecting organization, already encrusted by rules and hedged about by committees and officers. Five hundred paintings were on the walls at the British School's first, and only, exhibition. Not enough were sold, however, at 5 per cent commission, and the British School rapidly folded. Nothing daunted, Field continued with a more promising scheme which built on his interest in botany and chemistry, and in particular on his successful cultivation of madder (*Rubia tinctorum*), a plant from which red dye and madder lakes are made. The wartime activities of the British army demanded a constant supply of red dye for uniforms, and the textile industry required colour for printed frocks. As a result of cleverly managing to make supply fit demand, Field made a fortune. This he ploughed into realizing his inventions, and in 1808 he built a circular factory for the efficient commercial production of madder and other lakes, at Conham outside Bristol. Conham had been an industrial site for many generations, notably for processing lead, and as a by-product it developed the large-scale manufacture of Prussian Blue (ferric ferrocyanide), which Robert Campbell had described, for use in the Bristol blue-glass industry. At Conham, Field also manufactured Lemon Yellow (from barium chromate), and thus was able to create the three primary colours, red, blue and yellow, in one factory. Theoretically, therefore, he could now mix whatever colours he fancied, though in practice many of these chemicals would react together destructively.

Field came to notice in the world of invention with his chromoscope, otherwise known as the metrochrome, and in 1806 he won a silver medal at the

Society of Arts for his design of a stove 'for heating rooms or drying different articles'. It is a sign of the times changing both rapidly and reluctantly that in the same year the Society of Arts should honour both a practitioner of the old boil-the-bones technology, Sebastian Grandi, and a member of the up-and-coming new generation of colour chemists, George Field. 'I have dried cherries, plums, and other fruits,' Field explained of his new stove, which he demonstrated had many interchangeable and profitable applications:

> I have repeatedly dried colours and most delicate substances without the slightest injury to them, even though the operation proceeded quickly ... Extremely serviceable in drying japanners' goods ... it has been shown to be useful in the confectioners' art, and probably it may be equally so in baking biscuits for the navy; nor less so in drying linen for the laundress, dyer, calico-printer, and bleacher. I have myself found it well accommodated for a chemical elaboratory ... it is needless to enumerate the many economical [i.e. domestic] and philosophical [i.e. scientific] uses to which the stove may be applied.

Field moved to Hounslow Heath around 1812, where he finally killed off the notion of the colourman being the 'apothecary to the painter'. His business of manufacturing colour for artists thrived in a utilitarian commercial manner, but with modern production techniques. Field was a leader among those – including Charles Roberson, William Reeves, and Winsor and Newton – who brought colour manufacturing into the modern age, built factories out of town, and created a sense of competition that kept prices low and maintained a healthy supply of goods to artists. During the following three decades Field also wrote treatises on colour and their usage, and created new systems of colour measurement through the chromoscope.

In his old age, however, the pace of change was such that even George Field had become a mere curiosity, apparently out of touch with the subject that he had so fruitfully advanced. The writer Henry Crabbe Robinson described him in 1846 as

> an old gentleman who lives in retirement in Isleworth where he writes philosophical books which no one reads. He is a metaphysician of the

Greek School and is a sort of unconscious partisan of the German philosophy of which he in fact knows nothing – But he has written practical works on <u>Chromatics</u> and has earned an independence by preparing colours for artists – He is a man of simple habits & lives a sort of hermit life attended by a middle aged female servant.

With such growing professionalism, tied to profit and purpose, old-style colour-grinders had a hard time and gradually died out. Sebastian Grandi was deeply disliked by George Field, who called him 'a most ignorant Italian quack in colours, absorbent grounds and vehicles. A mountebank and a droll.' This, one might suggest, was inevitable from one of the new breed of industrial colour chemists, disparaging the old regime with its kitchen chemistry and whiffs of alchemy. Farington nevertheless seems to have appreciated Grandi's advice for years. Having bought artists' materials from him in 1796, Farington noted down what might well have been an old-fashioned tip from Grandi himself: 'Orpiment calcined & made into paste, if laid upon a picture that is greasy will take off the grease in 2 or 3 days.'

Grandi seems to have been quite an ebullient fellow, good-humoured and extrovert, with hot-blooded Italian characteristics that might have made a more stuffy Englishman uncomfortable. Farington reported how Grandi had broken both his legs at the Westminster Regiment Field Day on Dulwich Common in May 1806, '<u>leaping</u> with others for amusement'. Had he and his friends been jumping for joy at the sight of some spectacular military manoeuvre, or performing acrobatic leaps and twirls to entertain the crowd and come a cropper? 'The pain He sd. was not greater than a man could well bear; but the [ten weeks'] confinement which followed was a punishment.'

Grandi tended to get himself into scrapes, becoming, six months later, involved in a brawl near his premises in Long Acre, in which a man died. 'I am sorry to inform you', wrote another Grandi, perhaps his wife, to a supportive customer of the older generation, James Northcote,

Grandi is in trouble. He was on Wednesday in company with an Italian which is not in his proper senses. He wished to see him home and in

coming down Long Acre a man followed them. Having Paul's colours in
their hats they were insulted by the opposite party. In consequence the man
that was with Grandi cut a man in the arm. They have detained Grandi
being in his company and is in the house of correction until the man is out
of Danger. His situation is shocking. Sir, I shall be humble obliged to you
when he has a hearing if you will speak for him for his character.

Grandi and his friend Giovanni Andrea Nardi, the 'Italian which is not in
his proper senses', got themselves into this fight when they were dressed up
like popinjays in colourful support of the radical James Paull's candidature
in the by-election for the parliamentary seat left vacant by Charles James
Fox's death in 1806. They were both sent for trial at the Old Bailey on
what became a charge of murder; Grandi when arrested was 'fantastically
dressed, with flowers and feathers in his hat, and a [red] sergeant's sash
across his shoulder, he had a common mop stick in his hand and some-
thing like a medal hanging at his button hole'. This medal, as it turned
out from Grandi's own testimony, was 'a silver medal under my great
coat'. Nardi was found guilty but insane, while Grandi received character
references from 'seven respectable gentlemen', among them probably his
friends Farington, Opie and Northcote. They gave him 'the character of a
humane, honest, simple, easy, and inoffensive man', and he was acquitted.
Ironically, the red sergeant's sash that Grandi was wearing when he was
arrested would most likely have been dyed using madder processed in
Field's factory; and presumably the silver medal he was wearing was the
very one he had recently been awarded by the Society of Arts.

The rapid development of pigments in the late eighteenth century and
into the nineteenth was a lucrative by-product of the increase in the under-
standing of chemistry. Humphry Davy went to Rome and Pompeii in 1814
to find out what pigments the ancients had used, and by chemistry he
analysed what he found. Little had changed, as Maria Callcott recalled:

[I have] a clear recollection of a conversation I had with Sir Humphry
Davy ... just after he had been engaged in examining several jars of
antique pigments that had been discovered ... He told me that none of
those he had examined differed in substance from those now used for the
same purpose.

Prussian Blue, however, was a relatively new compound. It was made by a process discovered in Berlin in the early eighteenth century and soon widely industrialized. As Robert Campbell recorded, it was produced in quantity in Southwark in an 'odious, stinking business' and, to George Field's benefit, in Bristol. Faraday's lesser-known mentor at the Royal Institution, the chemist William Brande, perfected the pigment's production in the laboratory by heating dried blood or horn shavings with potassium carbonate to red heat in a crucible. As he expressed it:

> After mixing with alum and iron sulphate, a precipitate falls, at first with a dingy green hue, but which, by copious washings with a very dilute muriatic acid, acquires a fine blue tint . . . Prussian Blue.

To make this stuff, the colourman had to know his chemistry. A painting signed with an 'R' or 'LR' monogram, dated 1827, in the Oxford Museum of the History of Science shows two chemists, quite possibly Brande and the young Faraday, precipitating Prussian Blue. Their laboratory has a historicising look, like a Dutch seventeenth-century subject, but the painting nevertheless indicates that creating new pigments was an exciting and satisfying event, not a mundane process.

The variety of new colours emerging out of chemistry grew from discoveries made independently and in co-operation between chemists across Europe and Scandinavia, a process further promoted by the regular distribution and exchange of scientific journals. The Swedish chemist Carl Wilhelm Scheele discovered in 1775 a new green by reacting copper and arsenic together to make the salt copper arsenate. 'Scheele's Green' was brighter and more durable than the old green from copper carbonate, and it became a standard colour. A new yellow, lead oxychloride, was discovered by James Turner of Millbank, who in 1781 successfully ground together red lead and sea salt. Under the somewhat flimsy protection of a patent, Turner manufactured and sold this pigment to the trade as 'Turner's Yellow'. While he may have been able to protect his income by means of his patent, he could not prevent common parlance from transferring the name of the pigment away from himself as manufacturer. 'Turner's Yellow' is now more generally but erroneously understood to be a pigment that

J. M. W. Turner used, rather than one that James Turner invented. Indeed, so much did J. M. W. Turner use yellows that he was referred to as 'the author of gamboge light'.

As early as 1818 James Ward noticed how yellows were creeping into Turner's paintings: 'Turner becomes excessive[.] Brimstone is not the colour of nature.' Eight years later, a critic wrote of Turner's exhibits in the 1826 Royal Academy exhibition: 'We find the same intolerable yellow hue pervading every thing. Yellow, yellow, nothing but yellow, violently contrasted with blue.' Later still, in 1838, Turner cranked the chromatic volume up to screeching pitch:

> Mr Turner is in all his force this year . . . through such a medium as yellow, and scarlet and orange, and azure-blue, as only lives in his own fancy and the toleration of his admirers.

There were now enough yellows around for J. M. W. Turner and others to be selective in their use of them. Chrome yellow had been isolated in 1797 by the French chemist Nicolas Vauquelin from the mineral crocoite, a lead chromate found in Russia; and cadmium yellow independently in 1817 by the German chemists Friedrich Stromeyer and Karl Samuel Leberecht Hermann.

The evil that paint could potentially do to artists was profound. Lead white caused pallor, blue marks to the skin and ultimately kidney failure; Scheele's Green caused cancer of the bladder and kidneys; chrome yellow caused delirium, seizures and ulcers; while cobalt blue shares a toxin with snake venom which causes heart failure. This was all well known. The health of William Owen, by then an RA, was a particular concern to his friends. He had severe spinal problems and as a result had to give up painting. The physician Anthony Carlisle gave his diagnosis, as Farington reported:

> Carlisle says there is only one chance of Owen's recovery, which is, whether the <u>Colour</u> Owen uses may not be the cause of the dangerous symptoms he labours under. – Thomson observed, that the <u>white</u>, the only dangerous colour, he uses in such small quantities that it cannot be the cause of such effects.

Owen did eventually die of poisoning, not through the effect of paint, however, but because he was given a bottle of opium, in error, to take as medicine. As late as 1878 the curse of colour was very much a reality for artists, as *Dr Ure's Dictionary of Arts, Manufactures and Mines* made all too clear. Citing orpiment, or 'King's Yellow', and verdigris as strong poisons, he lists others which

> occasion dreadful maladies, such as white lead, red lead, chrome yellow and vermilion . . . [and cannot] be safely ground by hand with the slab and muller, but should always be triturated in a mill. The emanations of white lead cause, first, that dangerous disease the colica pictonum, afterwards paralysis, or premature decrepitude and lingering death.

One particularly fugitive but popular colour was indigo, derived from the leguminous shrub true indigo (*Indigofera tinctoria*), found in Asia and Africa. This was the source of a rich blue which could evoke shades between a dark midnight-blue sky to the softly touched palest blue of the noon sky at the horizon. A contributor to *The Builder* wrote in 1857 of a collector who had noticed how the grey clouds that he enjoyed in one of his Turner watercolours had surprisingly become red. When he showed it to the artist, Turner made the shocked response: 'I will never make another watercolour drawing!' He did not of course stick to that line, but on being asked if he would work his magic on the suffering watercolour and blend the faded and unfaded colours together, he retorted: 'Oh no! If I were to do that I should have all my drawings brought to be restored.' Richard Redgrave remembered how risky it was thought to be to use an ultramarine blue from France:

> [Clarkson Stanfield's assistant] was about to give [his palette] into Stanfield's hand on this particular varnishing day, when 'Stanny' saw Turner, palette knife in hand, about to make a swoop upon a tempting lump of ultramarine. Just as the old painter was advancing his hand, Stanfield called out 'French', and Turner gave up his intention.

The critic and painter Thomas Wainewright, who wrote under the pen names Janus Weathercock, Egomet Bonmot and Cornelius van

Vinckbooms, exaggeratedly dismissed Turner's colour in 1820 when the artist exhibited his *Rome, from the Vatican* in London:

> Ho! Ho! This is Mr Turner's Rome is it? Well now, what do you think of it? It appears to me that the foreground is not half finished: it will take three bladders of <u>ivory black</u> and a gallipot of <u>asphaltum</u> before it will advance from its modest retirement in the background.

In advising Turner to use more ivory black and the browny-grey mineral pigment asphaltum, Wainewright is advocating a disastrous method of articulating the complex foreground detail, on the grounds that black accompanying white will allow a detail to advance to the eye. However, had he used asphaltum as Wainewright had suggested, Turner's shining *Rome, from the Vatican* might now have been a wreck. Wainewright, hotheaded and volatile, was in 1837 arrested and tried for poisoning his sister-in-law, and others. It was not paint that he was alleged to have used, but strychnine, then undetectable as a poison. The poisoning charge not being proven, Wainewright was transported to Tasmania for forgery, where he spent the rest of his life becoming a remarkably good and locally appreciated portrait painter.

Such were among the recipes and anecdotes, temptations and dangers that developed around the use of colour in painting since Charles-Alphonse du Fresnoy wrote his extended poem *De arte graphica*. Translated into English in 1783 as *The Art of Painting*, this became well known to artists who read that sort of thing. The wider availability of varieties of colour prompted new courage in the work of artists, of whom Turner was the boldest. In his book *Colour as a Means of Art* (1838), the painter Frank Howard invoked what he described as the 'Principals' of Turner in the management of colour on canvas, in particular Turner's practice of contrasting:

> rich autumn yellows in the foreground, with a brilliant Italian blue sky, graduated through a series of exquisitely delicate pearly tints, to meet the cooler green tints of the middle ground. The warm colours in the foreground are qualified by purply half-tints, and supported by warm shadows and some rich crimsons; or sometimes reduced to comparative sobriety by the opposition of the brightest orange and white.

This passage brings a kaleidoscope of colour to the mind's eye, an experience that in the 1830s was entirely new and dependent entirely on the new palette of bright colours that was now becoming available. Turner was the only nineteenth-century artist whose work as a colourist Howard used to illustrate his thesis, alongside Titian, and Rubens, Cuyp, Jan Both and other Dutch and Flemish seventeenth-century masters. Of the Venetian School 'founded by Titian', Howard wrote that it

> adopted a combination of rich warm browns, yellows and greens, supported by crimsons, all deep in tone, overspreading two-thirds of the picture, opposed by very rich, almost warm, blues, and animated by a point of white, sometimes accompanied by black in the front of the subject. No violent contrasts are admitted, no crude colours.

The caution that Howard observes in Titian, no less a revolutionary in his day than Turner, is an indicator of the distance travelled in the early nineteenth century by the pioneering experimental colour chemists:

> Turner has controverted the old doctrine of a balance of colours, by shewing that a picture may be made up of delicately graduated blues and whites, supported by pale cool green, and enlivened by a point of rich brownish crimson. It requires some care in the gradation and shapes of the masses of blue and white, and in the situation of the point of colour.

As Turner himself put it to a young friend, later Mrs Mary Lloyd:

> [A]lways remember that as you can never reach the <u>brilliancy</u> of Nature, you need never to be afraid of putting your brightest light next to your deepest shadow, in the <u>centre</u>, but not in the <u>corners</u>, of your picture.

While he positioned Turner in the company of the greatest old masters, Howard nevertheless dedicated his book to the recently knighted Sir Augustus Wall Callcott, whom he flatteringly described as having shown that 'the capability to execute in the higher walks of Art does not depend ... upon mechanical skill ... but upon intellectual qualifications and mental refinement, which have ever been conspicuous in your treatment

of the subjects generally adorned by your pencil'. Callcott, married by now to the intrepid but tubercular Maria, was already well established in artistic and administrative circles and admired by the new young queen Victoria, an achievement – two, with the added distinction of a knighthood – that Turner would never attain.

Nonetheless, a dedication to Turner would have been more honest, as Turner's own dedication to colour-making was profound. His sketchbooks contain over twenty different recipes for colour and varnishes, and while they are not advanced as chemistry, they do reveal his staunchly practical bent and his diligent attention to studio practice; but they also betray his essentially outdated, pre-industrial approach. In style and expression they resemble the medical recipes that Turner also scatters through his sketch-books, suggesting that he was as rightly concerned with his own care as he was for the integrity of his materials. His last paint recipe transcription appears in a sketchbook dated 1828, from which we might draw the conclu-sion that after that date he began to go with the flow and use colours that he could buy commercially, rather than ones in which he found an interest in manufacturing for himself. However, his father, by now his studio assis-tant, died in 1829, so the loss of that ready and free source of labour and skill may have prompted him to take the commercial option when he did. The early 1830s, being the decade in which Winsor and Newton, Reeves and Roberson developed and expanded their own methods of production, was also the decade in which Turner could economically cease his.

Many pigment compounds in the nineteenth century were notori-ously unreliable. What was grey one day could be red another; what was white could rapidly become black; what was a rosy flesh tint might within a year or two be death-pale white. This was a failing in Reynolds's early portraits: Sir Joseph Banks refused to have his wife painted by Reynolds, 'being of the opinion that the oil pictures of the present time invariably fade quicker than the persons they are intended to represent'. It became the life's work of the colour manufacturers to create pigments that could be trusted to retain the subtleties created by artists' dexterity of eye and hand, as pictorial aspirations confronted the need to experiment with paint.

The profundity of the changes in the nature of the colour available to artists in the 1830s and 1840s cannot be underestimated: it shines through their work. An hour in an art gallery with a collection as rich as the Walker Art Gallery, Liverpool, or the city galleries in Manchester, Birmingham or Bristol, or indeed Tate Britain, will make this amply clear. In eighteenth-century paintings, by Hogarth, Stubbs, Joseph Wright or Reynolds, we see pinks, dusty blues, quiet yellows and decorous reds, with browns and greens in abundance. Where drama unfolds, it comes not in colour but in composition: thus, in the Walker Art Gallery, *David Garrick as Richard III* (1745) by Hogarth leaps from the canvas by virtue of Garrick's theatrical gesture of terror; Stubbs's *Horse Frightened by a Lion* (1770) screams in fear, but it is the shattered silhouette of the white horse, frozen against a dark background and below a blue sky, that conveys the emotion, quite as much as the stark white against dark that the artist has used. Stubbs has used his limited palette to masterly effect by his breathtaking composition. Even the fireworks in Joseph Wright's *Girandola at the Castel Sant'Angelo, Rome* (1775–6) have a restraint in their explosive redness. It is the nature of the paint that is decorous, not the character or abilities of the artist. Pink flesh in Baroque nudes and martyrdoms can cover many square feet of canvas, but there is an economic imperative here as expensive and poisonous red can be thinned down into a multitude of pinks with more modestly priced white.

When the Pre-Raphaelite Brotherhood – Millais, Holman Hunt, Rossetti, Ford Madox Brown – first exhibited together in 1849, the sharpness of their colour was a vivid public statement of how fundamentally chemistry and the commercial production of paint had changed the way the world could be reflected in the mirror of art. While clarity of detail in a painting is a function of the fineness of the brush, the steadiness of the hand, the thinning of the paint, the smoothness of the canvas or paper, it is also as much a function of the variety and strength of colour and the artist's ability to create subtle and inventive mixtures and juxtapositions of line and tone. The vicious kick at the hound in Millais' *Isabella* (1848–9) would not be half so dramatic were it not for the snarl of the young man who delivered it; the snarl would not have appeared

half so fierce had not Millais used bright modern pigments with their subtle variation to express it, and surrounded it with reflecting silver, high incidental detail, and the threatening interplay of serial profiles in the surrounding protagonists. And none of this would have had such an iron punch without the luminous white ground that the Pre-Raphaelites determined to paint upon.

Nevertheless, the new materials brought new responsibilities in preparation and colour management. The painter Albert Goodwin noticed how Ford Madox Brown adopted a 'slow and laborious' practice: he 'made a practice of cleaning his oil work every night – brushes , palette – everything . . . the secret of all good oil painting was a good turpentine dipper'. Taking great care, the Pre-Raphaelites avoided the trap that the older generation blundered into – over-reliance on two widely available mixers, asphaltum and megilp. Asphaltum, a bituminous material from the Middle East, was better employed in its primary application, being laid on roads and pavements, rather than being painted onto canvas as an underlay. This failing in paintings by artists such as Maclise and Wilkie, both represented in Robert Vernon's collection, has been described lucidly by Leslie Carlyle and Anna Southall:

> Despite the warnings, the delicious working properties of their paint and the hope that their own work might escape the destructive effects, encouraged many to continue using them.

George Field made a concerted effort to use the reason of science to overcome the dogma of alchemy. Nevertheless, he issued stark warnings in his pioneering book *Chromatography*, published in 1835:

> Most of the resplendent pigments, fruits of the fecundity of modern chemistry, have been found deficient of the intrinsic and sterling excellencies which have given value and reputation to some of the ancient and approved . . . Yellow chromates of lead . . . become by time, foul air, and the influence of other pigments, inferior even to the ochres . . . Reds of iodine are chameleon colours, subject to the most sudden and opposite changes . . . Blues of cobalt . . . are always tending to greenness and obscurity.

He warned that Iodine Scarlet should not be used with iron colours, such as Prussian Blue; Scheele's Green is destroyed by Naples Yellow; indigo is 'injured by impure air', and so on. Of asphaltum he wrote:

> [Its] fine brown colour, and perfect transparency are lures to its free use with many artists, notwithstanding the certain destruction which awaits the work on which it is much employed.

Megilp, an improvised mixture of varnish, resin, plant oil and white lead, caused rapid cracking, drying and darkening, creating islands on the canvas which shrank and split away like landmasses in continental drift. The painter William Muckley observed: 'So pleasant [it was] to work with, that it allured many painters to the indiscreet use of it.' Field's contribution as a scientist and entrepreneur to advances in colour chemistry enabled artists to achieve the sharpness, brilliance and clarity that mark out painting from the 1840s. William Holman Hunt paid particular tribute to Field's professionalism and skill not only as a chemist, but as the agent through whom new and more reliable colours came to be available. The yellow in Turner's *Approach to Venice*, Hunt asserted, 'you will recognise as Field's lemon yellow, and so it is a justification of the maker's boast that it was absolutely permanent'. Field, he said,

> much improved the range and the beauty of the colours to choose from. His madders were far superior to those which preceded them. His lemon-yellow was believed to be a perfectly permanent dandelion-tinted pigment, destined to entirely supplant the light chrome . . . his orange-vermilion won so good a reputation that the tint is still always sold with his name as its best recommendation . . . The pictures of forty, thirty, twenty years ago gained the advantage of this careful chemist's scientific labours, for the colourmen were discriminating enough to value the products of his laboratory, and the artists, without care, were fortunate enough to be supplied with what would now be above price.

However, despite Field's new scientific methods and those being adopted by rival colour-making companies, the application of paint to canvas could still present unpredictable outcomes. The making of a painting, despite

centuries of practice and improvement, remained a laboratory experiment in which the artist toyed more or less innocently on a vertical bench with a series of chemicals, some of which might be self-destructive, and many poisonous. In a long and passionate paper given to the Society of Arts in 1880, Holman Hunt set out some of the dangers that artists faced, if not to themselves, then to the long-term stability of their works. Asphaltum and megilp were among the materials he castigated, while both remained in active commercial production. Concerning the use of asphaltum, Hunt described the dangers that he and his generation could avoid:

> Hilton, and more lamentably Wilkie, both adopted this Dead Sea product from the beginning to the end of their careers. Indeed, in their generation, the use of this pitch was almost universal. . . . Maclise and Landseer were, with others of their time, seduced into its use. The misfortune was greater, because all of these painters had such a passion for the rich tint it gave on a white ground, that they never began their paintings without it . . . [Maclise] has left laborious works which, even within 40 or 30 years, or less, are so ruined, from his ignorance of the art of painting, that the uninformed observer would be led to conclude that they had been done by a process – not which had before been tried for 400 years, but which had never before been put to the test.

Hunt noticed that the issue was particularly regrettable, since the effect was slow to occur and its evil 'may not manifest itself before the death of the artist'. Adding fiction to speculation, it may be that the portrait that Oscar Wilde's Dorian Gray consigned to the attic was painted with an over-reliance on asphaltum and megilp.

Speaking of the speed at which new and untried colours were being marketed, Holman Hunt asserted:

> The evidence given amounts, I think, to this, that in the day – 150 years after the commencement of English art – we have no more mastery of our craft, as such, than that with which Hogarth, Gainsborough and Reynolds commenced their careers. Reynolds' very mistakes testify to his anxiety to establish some certain knowledge of the matter as much as to the blankness of the guidance he had received.

In speaking to the Society of Arts, Hunt was sounding a warning as the colour market – a product of a successful and energetic capitalist society – galloped away. The largest companies of colourmen were William and Thomas Reeves (founded 1766), Charles Roberson (founded 1810) and Winsor and Newton (founded by William Winsor and Henry Newton in 1832). All were still in business in 2014, clear evidence of the demand for and purpose of artists' materials in a civilized society. Together, the colourmen manufactured not only the standard colours for the artist's paintbox, but additional confections of their own on an increasingly industrial scale. Winsor and Newton's catalogue, published from their showroom at 38 Rathbone Place with an illustration of their busy North London Colour Works in Kentish Town, offered more than fifty different tints for watercolour cakes, including three Chrome Yellows, Orpiment, Dragon's Blood, Hooker's Green, Payne's Grey, Chalon's Brown and Prout's Liquid Brown. The company sold everything from the finest sable paintbrushes to pencils, palettes, easels, paper – including 'Solid Sketch Books' whose pages were pressed together and could only be separated with a sharp knife – and japanned tin paintboxes for sketching out of doors. The selection of colour cakes for paintboxes could be varied according to whether the artist intended to paint landscape, figures or flowers, and paint was also supplied in rudimentary glass syringes and in the more successful 'patent collapsible tubes'. These are almost identical in form to the paint tubes supplied today: they had the same small screw-cap, and the same turned-over and pinched ends. The evolution of the paint tube ran swiftly, like the pen-nib, from experiment to perfection.

Nevertheless, the paint companies did not have it quite their own way. John Sell Cotman had his own little colour manufactory in London, selling cakes of watercolour to whomsoever might buy. Writing to John Hornby Maw, he advertised:

Our Articles are all Town Made from the Raw Materials & warranted on the best principles with due allowance to be made for theft from olden time, sanctioned by Apelles & by all artists of high talent to the present day – for there is but little new under the Sun.

Samuel Palmer recalled that William Blake had other sources:

> glue as a vehicle was recommended to [Blake] by St Joseph in a dream
> or vision . . . Don't think I'm laughing: I have not yet shrunk into such
> inspissated [*sic*] idiocy who grins at everything beyond its own tether.

Palmer insisted on following Blake's method of making a hard white:

> Get the best whitening – powder it. Mix thoroughly to water with the
> consistency of cream. Strain through double muslin, spread it out upon
> backs of plates – white tiles are better – kept warm over basins of water
> until it is pretty stiff . . . Mr Eatwell, Artists Colourman of Dorset St,
> Portman Square, W, will grind the whitening as above and send it you in
> a bottle . . . On him you can depend.

Palmer was generous and free with his advice; paint suppliers might have
been concerned. He wrote to the Oxford physician and collector Henry
Acland:

> I enclose a little washed gamboge purified from its green tint & semi-
> opaque, a colour which stands alone for brilliancy here & there but not
> answering the valuable purposes of common gamboges in transparent
> vegetation. I wish I had a little of the washed G: for the light round the
> sun in the little drawing I did with you. No pigment has so much colour
> with so little loss of light – but if kept upon the palette in any quantity it
> will put the eye wrong. Should the paper become damp it can be soaked
> off. It easily dissolves in water & can be rubbed up on a saucer by the
> finger but has a strange trick of coming out of any paper in which it is
> wrapped – so I keep it in a bottle.

To develop their market, colour manufacturers sought to develop mutual
admiration and commercial relationships with well-known artists. This
drew Winsor and Newton and the watercolour painter James Duffield
Harding together to advertise Harding's book *Principles and Practice of Art*
and to publish their own edition of *Harding's Art Lessons*. They also marketed
'Mr Harding's Lesson Desk', a wooden contraption Harding had patented
to enable students to copy drawings and watercolours. Ignoring an evident

personal loathing between Harding and Prout (see page 274), Winsor and Newton also advertised 'Prout's Liquid Brown'. In a further example of clever entrepreneurship they teamed up with the artist and inventor William Brockedon to market Brockedon's 'Patent Pure Cumberland Lead Pencils'. All this inventive marketing with celebrity endorsement carries its echoes into the twenty-first century. Like all the colour manufacturers, Winsor and Newton sought the imprimatur of science. In introducing a new Chinese White, they made the claim:

> The White Oxide of Zinc is pronounced by the highest chemical authorities to be one of the most unchangeable substances in nature. Neither impure air, not the most powerful re-agents, affect its whiteness. It is not injured by, nor does it injure, any known pigments ... Winsor and Newton's Chinese White, by combining body and permanency, is rendered far superior to those whites known as 'Constant' or 'Permanent' White; and not having their clogging or pasty qualities, it works and washes with freedom.

Winsor and Newton encouraged testimonials from artists, such as this from Harding:

> The Art of Painting in Watercolours has been greatly assisted by improvements in the preparation of the pigments; the greatest advantage, however, has been the introduction of Moist Colours, which, I believe, are a French invention, but greatly improved by Messrs Winsor and Newton.

Further testimonials were elicited from a host of artists, including Clarkson Stanfield, Daniel Maclise, David Roberts, John Constable, John Martin, R. R. Reinagle and William Brockedon. Turner, however, was not among them: significant, perhaps, is Turner's reported remark to a persistent William Winsor, hoping to influence the artist's choice of colours: 'Your business, Mr Winsor, is to make colours for artists, mine is to use them.' Products listed in the 1863 trade catalogue, the last published before the death of William Winsor the following year, showed how the company sought out new trends in the use of artists' paints. They now included colours for 'Illumination and Missal Painting' and 'Heraldic Blazoning',

as well as noting a new-fangled technical development in image-making by selling 'Photographic Cut Out Mounting Board'; these were alongside the more traditional products which carried personal endorsements, such as 'Etty Boards' and 'Cattermole Drawing Paper', or suggested commercial exploitation such as 'Imitation Creswick's Drawing Papers'.

Winsor and Newton, and their main rivals Reeves and Roberson, bene-fited from the lucrative trade in art materials generated not only by the growing middle classes and the extended leisure that many enjoyed, but also by increasing demand from the military, whose tasks included offi-cial survey work in Britain and abroad. Not for nothing did Winsor and Newton market for peripatetic artists and surveyors a 'Sketching Tent' – weight under 8 pounds, including iron spikes for pitching – initially at 31s.6d, increased later to 42 shillings. After the end of the wars with France in 1815, the need for cannon and ships for a large standing army and an expensive navy began gradually to decline: up-ended cannon used as bollards in mid-nineteenth-century civic development is evidence of the imaginative reuse of redundant military hardware. Many can be seen in Albert Dock in Liverpool, for example. The requirement for paint-brushes and colours expanded greatly as the armed services developed new roles as agents for scientific and territorial exploration and land surveying and as the policeman of the world. The companies also were at pains to stress the suitability of their products for the tropics. Winsor and Newton proclaimed that their

> Moist Water Colours retain . . . their solubility and dampness for an unlimited period . . . These qualities are preserved to the fullest extent in the hottest climates . . . particularly adapted and recommended to parties going out to INDIA . . . dry cake colours . . . generally break up and crumble into small pieces, when they are of course useless; this never occurs with the Moist Colours.

The military academies at Woolwich and Addiscombe, the latter run by the East India Company, employed drawing masters, including William Wells (the painter, not the ship-builder), J. C. Schetky, George Bryant Campion and Theodore Fielding. The academies ran compulsory courses

in landscape drawing, in which each student had a pocket paintbox, palette and paints, and many of the keener ones might even have invested in a Sketching Tent. The ledgers maintained by Charles Roberson's company from 1820 give clear indication of the exponential rise in sales of paints and art equipment, a growth reflected across the whole of the colour-making industry. Roberson's clients included established artists such as Francis Danby, Sir Charles Eastlake, W. P. Frith and William Holman Hunt; amateur artists of military, aristocratic and ordinary background; art dealers; art schools; theatres; and agents for military or government institutions in the empire. Benjamin Robert Haydon bought material from Roberson briefly in 1841–2, as did Edward Lear, with greater reliability, from 1850 to 1886. The great colour chemist himself, George Field, was a customer between 1841 and 1853. Artists meant business, as the young Augustus Callcott had already contemplated as early as 1805:

> In the evening [John] Opie dropt in – conversing on the singularity of Girtin's never being able to execute anything worth seeing till he got Cartrage paper. O— observed that Painters were as much governed by their tools as their tools were by them, seeming to consider that much of the art was dependent on the materials.

Modern colour chemistry was opening a whole new range of possibilities for artists. 'What a fine broad fleshy colour you can get by mixing Indian Red & White & Ultramarine White', Haydon wrote at the start of the second volume of his diaries in January 1809. Chemistry, in colour, was king, and scientists and artists were beginning to realize that if they worked together, and if artists learned something of the new language of science, they would be able to weave the rainbow together again. In Rome, Thomas Lawrence borrowed samples of colour from the paintbox of the German artist and amateur colour chemist Anton Raphael Mengs, and sent them to Field for analysis when he returned to London in 1820. 'The Red I find', Field reported,

> to be a Sulpheret of Mercury or Cinnabar, having all the qualities of the best Vermilion. The two others are Sulpherets of Arsenic or Realgar which

have all the properties of orpiment in painting. They differ however considerably from those pigments as we usually find them, and as Mengs was addicted to Chemistry I think it probable that they may have been his own productions. And no doubt it may be possible to reproduce them.

Field's laboratory reports have all the fluidity and clarity of those written by Faraday for industrialists and government agencies at about the same time. From his analysis of Mengs' colours, Field set about creating his own vermilion, which by the mid-1830s was in general use. However, this was not without time-consuming experiment which, as Field later told Holman Hunt, had cost him 'so much time it was so thoroughly an invention, that he had applied to the Government and to learned bodies for an award of £100 in return for the mode of preparation, which not one had consented to give'. Hunt added: 'I believe he carried his secret to the grave.' It was not surprising that many artists were unable to keep up with, or even care about, the chemical subtleties of the paint they used. All they required was that the colour should remain stable, and preferably not poison them. The artist and writer Philip Hamerton quoted a remark of Samuel Palmer's which expresses something of the frustration that artists felt about the new language of chemical colour that not all of them were able wholly to understand:

> painting is a matter of such chemical complexity and intangible subtility, that, as I have heard Mr Mulready say more than once, two men shall paint off the same palette with the same vehicle, A's picture shall dry, B's picture shall not dry. A's picture shall stand, B's picture shall fade.

After fifty-seven years in Somerset House, the Royal Academy moved in 1837 to the eastern half of the National Gallery building in Trafalgar Square. Twenty years later the Royal Society moved to new premises in Burlington House, Piccadilly. Thus the quasi-university of the liberal arts that Somerset House had been in its early nineteenth-century heyday was falling apart, with the Society of Antiquaries, the Geological Society and the Royal Astronomical Society following the procession from Somerset House to Burlington House in 1874, as competition for space in the former building grew from government departments in the increasingly

bureaucratized Victorian state. The slow fragmentation of scholarly disciplines at Somerset House, just as much as galloping increases in knowledge, led to a diminution of collective interest and a shift in the centres of gravity of art and science in London.

For painters, it is a short step from a mixture of interest, opportunity and confusion in the face of new scientific developments in colour-making, to a collective excitement at the possibility that scientific instruments could sharpen perceptions of the world. The key purpose of the manufacture and trade in scientific instruments was to enhance observation and understanding. While artists, armed with pencils, brushes and an infinite variety of colours, prepared the way through art and diagram, the ingenuity of inventors, engineers and instrument-makers enabled observation of the world and its horizons to go closer, wider and deeper. In his treatise on the microscope published in the 1760s, *Micrographia illustrata*, a catalogue of all the optical products he made or could supply, the instrument-maker George Adams described his variation on the camera obscura: an instrument where art and science met, the 'New Camera Obscura Microscope, designed for drawing all minute objects, either by the light of the sun, or by a lamp in winter evenings, to great perfection'. Here the requirements of art are met through the perseverance of science. Where Adams had prospected, artists followed: improved variations of the camera obscura – the camera lucida and the graphic telescope – were made in the nineteenth century by the watercolour painter Cornelius Varley, brother of the incautious John.

In the 400 years between the days of Cennino Cennini and Sebastian Grandi, the practice of commercial colour manufacture had moved forward through the ingenuity and invention of chemists. The practice of scientific-instrument making also gathered pace to keep up with and affect the discoveries that shaped the modern world. In Cennini's day, when he was advising on the grinding of cinnabar, knowledge of electricity was limited to the curious properties of amber when rubbed; by the time Grandi was grinding and boiling sheep's trotters and filling pigs' bladders with pigment, electric current could be created at will in batteries, measured, stored and put to work, or released in a dramatic discharge. If the modern world had had to wait for the development of colour manufacture to get

going, we might be in the steam age still. The largely untested riches of newly available colour clarified artistic expression and productivity; while the possibilities opened up by the development of scientific instrumentation enhanced receptivity, information gathering and ideas, and broadened the landscape of knowledge.

ENGRAVER:
'BROTHER SCRAPERS'

Engraving on copper was a slow, laborious process demanding high skills, patience, long experience and sharp focused eyesight. As age enveloped an engraver, so eyesight would dim:

> Bending double all through a bright, sunny day, in an attic or closework-room, over a large plate, with a powerful magnifying glass in constant use; carefully cutting out bits of metal from the plate . . . working for twelve or fourteen hours daily, taking exercise rarely, in early morning or late at night; 'proving' a plate, only to find days of labour have been mistaken, and have to be effaced and done over again . . . such is too commonly the life of an engraver.

Thus went the daily routine of the Birmingham engraver William Radclyffe, whose son Charles described the dismal day-to-day existence that his father's profession offered. But the thrill from the shimmer of an engraved copper plate, the joy when an image was pulled off its inked surface, the wonder of multiplication – all this was a seduction in itself. Such delights lost none of their appeal for succeeding generations, to the extent that the Birmingham-born printmaker of the twentieth century, Raymond Cowern, wrote of his 'absolute compulsion to etch'.

Engraving became big business where profits could be made, and it is no surprise that the more entrepreneurial engravers – those with business sense and acumen like John Boydell, John Britton and Charles Heath – moved on from daily practice themselves to manage and employ others to produce the work for them. Another engraver, Abraham Raimbach, looked

back at the eighteenth century and wrote of the skills and self-presentation of William Woollett, the engraver whom all admired:

> In person Woollett was rather below the middle stature, and extremely simple and unpretending in manner and demeanour. He had been apprenticed to a general engraver in Cheapside. His great works were executed at his house, the corner of Charlotte and North Streets . . . till a comparatively recent period, the window of his workroom, which he had adapted to his purpose, and had a northern aspect, remained unaltered. He was accustomed, on the completion of a plate, to assemble his family on the landing-place of his study, (the first floor) and all give three cheers.

Wood engraving, in which the image is engraved into the hard end-grain of a block of boxwood, offered slightly better conditions than engraving on copper, if only because wood shavings were less dangerous to have on the workbench than sharp little bits of cut metal. The early twentieth-century artist William Heath Robinson, the son and grandson of wood engravers, remembered the old days when his father employed a team of artists producing engraved blocks as illustrations to books, journals and newspapers:

> They were all bent low over their work. Glass globes filled with water increased the light that came from the green shaded lamps. Each engraver wore a protruding eyeglass like a watchmaker's glass fixed to one eye. This he brought as close as possible to the woodblocks, for it was the finest work they were executing . . . After each cut was made in the wood, the graver was brought up to the lips or moustache to clear the tool. One poor man in this little group was suffering from consumption.

Note the similarities in Radclyffe's and Robinson's accounts: the bending low; the long hours; the optical accessories; the eye strain; the need for steady light; the close work; the health risk. Engravers on both wood and metal were thus close-knit self-supporting groups: 'brother scrapers', as Thomas Lupton described their shared profession to John Pye.

The reproduction of works of art was overwhelmingly performed on a polished or wax-coated copper plate across which an engraving needle, or

burin, could pass with a sharp and flexible grace. The skills demanded for this work embraced the ability to manage the straightforward topographical view, or complex figure subject, and to have the potential to interpret the colour and style of a painter of renown. James Ward appreciated this crucial role only too well. Writing to his son the engraver George Ward ARA, he observed:

> A fine Engraver must be something more than a meer [*sic*] Tool in the hand of the Painter. What would a <u>Wilson</u> and <u>Stubbs</u> &c have been <u>without</u> a <u>Wollet</u> [*sic*]?

Letters to the topographical artist and engraver John Buckler indicate the kind of prices that workmanlike and accurate engravings of local interest might fetch. A Lincoln dealer in prints sent Buckler an account for the five coloured and thirty-seven plain engravings of Lincoln and Norwich cathedrals that he had resold in 1800: Buckler charged 1 guinea each for plain (i.e. uncoloured) prints, and a further half guinea for the ones he had coloured by hand. Business was good, and the dealer wanted more to be supplied. Prices remained stable for years: Buckler charged another client, Lord Clarendon, the same prices for plain and coloured prints fifteen years later.

The various techniques of engraving are well known: there is the direct engraving of marks on the metal, needle scratching copper; etching, in which wax coating and an acid bath are additional requirements; mezzotint, in which the polished plate has first to be pitted all over with a toothed rocker, like a half-moon horse-brush armed with teeth, so that when inked the plate prints a deep, smooth black; and drypoint, which does not concern us here. The greatest engravers, such as Woollett and Pye, could create in their engravings extraordinary evocations of paintings by making marks that range from small dots and flecks to curvy lines, ruled lines and solid gouges. These together create varieties of tone that evoke the impression of colour. Engravings were themselves works of art; engravers paid homage to great originals certainly, but as brothers-in-arms with painters, not as their below-stairs servants. Engravers took paintings into realms of visual pleasure that the painter might never have conceived. As the advances in science met the demands of art, so by the 1820s it became

possible to face copper plates with steel, through electrolysis, and thus extend their working lives.

Wood engraving, though capable of the finest detail in the hands of artists such as Thomas Bewick, Edward Calvert and Thomas Robinson, was sucked rapidly into journalism as a quick fix, and deprived of its good name. Bewick's wood engravings of animals and birds are magnificent works of art, to the extent that he and his pupils began to rival copper engravers in detail and quality. They certainly rattled the French. The engraver Pierre-François Godard remarked of wood engraving in the 1820s:

> [The English] are taking this art so far that one can scarcely distinguish the burin that they use from that of copper engraving . . . It is clear that if the English example is not quickly [followed], they will take over the printing from all countries of current publications in which illustrations play an essential role.

Engravers, being contractors rather than self-directed creative artists, had to be prepared to take instruction, and to accept brisk opinion. A client wrote to John Buckler about an architectural print he had commissioned from one of Buckler's drawings:

> I cannot find anything like a fault in the building &cc But I think yr Engraver has made your Clouds too heavy: they have not that light appearance which the Drawing has, & they look too much like distant Land . . . you required my real opinion & you have it.

William Cobbett gave Thomas Robinson no room for the personal inter-pretation of a subject in his treatment of a wood-engraved illustration for *Rural Rides*:

> In the landscape, leave out the houses, town &c entirely. Leave the figures as I saw them: leave the hop-ground, which you will extend over part occupied by the farm-house; and enclose all with high trees in the foreground, as you have them now, and keep the gate and hedge which will remain; and also a gate at the further side of the ground may improve the picture. You will be so good as to lose no time.

A third reproductive technique, lithography, was popular and cheap and could carry the finest detail and the most elusive atmospherics. Invented in Germany, lithography was developed and improved independently in centres all over Europe, and particularly in England, where the émigré German printer-businessman Charles Hullmandel set up a printing works in Marlborough Street, London. Hullmandel printed illustrations for books and pamphlets, journals and flyers, finding among those crossing his threshold people as varied as Michael Faraday and the revolutionary French painter Théodore Géricault. The illustrations in Frank Howard's *Colour as a Means of Art* were created and printed by Hullmandel. Faraday himself made lithographic drawings and was fully attuned to the art both scientifically and artistically. He gave Hullmandel high praise and credit for the advances he had made in the technique:

> I have no hesitation in stating . . . that having been made acquainted with, and having witnessed your method, and other methods of preparing Lithographic Drawings, I know yours to be strikingly peculiar and different from the others, and from consideration of the chemical principles of the art, should expect your process to possess the superiority which the testimony of Artists, competent to judge, assure me that it has.

John Britton's role as go-between for artist and patron was far-reaching and influential, and his volumes which embrace engraving, lithography and texts remain a rich mine of information about the history and antiquities of the British Isles from a nineteenth-century perspective. He was a pioneer in dealing and in publishing, on a par in his field with John Murray (see chapter 9); he not only produced high-volume print runs of multiple titles of topographical works, but was also instrumental in widening and encouraging the market for illustrated books of landscape views and history. In this he helped to create the market that also offered William Daniell's *A Voyage Round Great Britain* (1814–25) and the many landscape series published from Turner's work such as *The Southern Coast* (1814–26) and *Picturesque Views in England and Wales* (1827–38). In Britton's heyday, in which he produced the twenty-one-volume series *The Beauties of England*

and Wales (1801–15), *Architectural Antiquities of Great Britain* in five volumes (1807–27), and *The Cathedral Antiquities of England* in fourteen volumes (1814–35), the market for such publications continued for perhaps thirty years in healthy fluctuations. *Beauties* cost £50,000 to produce, a formidable amount of money that was probably never recouped. Britton's entrepreneurship created employment in its wake – for artists willing and able to travel, engravers, paper-makers, publishers and booksellers – and also contributed to ancillary trades such as bookbinders, transporters and the manufacturers of ink. Britton's determined efforts in the first half of the nineteenth century were the direct antecedents of the Murray Guides of the middle and latter part of the century and, further into the future, of the Shell Guides of the 1930s and Sir Nikolaus Pevsner's *Buildings of England* series from the 1950s.

Britton and his business partner Edward Brayley travelled around the country with their platoons of artists from bases in Bath and London. When John Flaxman's monument to the Baring family was set up in St Mary the Virgin, Micheldever, in 1810, it was Britton whom the family engaged to engrave it: 'three fine engravings, his new work of modern art', Ann Flaxman told a friend. Volumes in general series were accompanied by individually commissioned publications such as *Delineations of Fonthill and its Abbey* (1823) for Beckford, a *History of Deepdene* (1821–6, never published) for Thomas Hope, *South Wiltshire* (1812–19) for Sir Richard Colt Hoare, and *The Union of Architecture, Sculpture, and Painting* (1827) for Sir John Soane. With his draughtsmen on parade, Britton met clients, walked their landscapes, and admired their mansions and their ruins. In Britton's offices in St Pancras, then a village on the edge of London, the draughtsmen returned to join the small army of topographers and engravers to produce the images for the books.

Wood engravers worked to even greater pressure of time than did engravers on metal, to keep up with the relentless deadlines for the illustrated journals. Steam-driven machinery was by the 1820s revolutionizing the speed and quantity of printing. Engraved wood blocks, which matched the depth of type, could be set in the same frame with metal type, and inked and printed together so that image and text would appear with ease on the same sheet of paper. Engraved metal plates were different; their printing

was slower and more complex, the ink being taken into the engraved lines by the 'intaglio' process, rather than being wiped across the uncut surface as in the 'relief' process of wood engraving. To keep up with the pressure of the modern world, metal engraving just had to become quicker and produce more impressions per plate. The printing of bank-notes for the Bank of England was the catalyst for a very necessary change in practice, in an area where engravers and engineers found a surprising new synergy. The question from the Bank of England was: could bank-notes be produced rapidly and in quantity, and be made resistant to forgery? What underpinned the relationship between engineering and engraving was not the market for landscape views or portraits, lucrative though this could be, but the demand for bank-notes in large quantities, every one identical but individually numbered, and with elegant but complex lettering and decoration. As early as 1819, 30,000 bank-notes were struck at the bank every day, a volume that demanded high-speed printing machines and hardened printing plates that could be engraved with delicate lines that would not wear out.

Forgery was an ever-present problem for all banks. *The Times* reported official figures of bank-note forgery, a capital offence, revealing that in 1812 nearly 18,000 forged notes of all denominations had been discovered in circulation, rising in 1817 to above 30,000. Farington observed that:

> It is well known that the principle forgers reside in Birmingham; that they are well known to the Bank Directors but sufficient evidence against them has not been attained . . . They are reputed to sell the notes for 5 shillings.

The Society of Arts took the initiative in grappling with the problem of forgery, commissioning a report from its Committee of Polite Arts on ways to proceed. Suggestions included 'superior engravings by eminent artists', and engravings by Indian artists 'of such mathematical exactness as to wholly exceed the artist's skill in lineal varieties'. The idea of engaging artists from India came as a direct consequence of experiments being carried out by the cutler James Stodart and others, including Michael Faraday, on wootz, an Indian steel that had been imported into Britain

since the eighteenth century through the East India Company. The hardness of wootz was legendary; this was the material from which were made the sharp, durable and highly decorated swords from India and Arabia.

Other suggestions put to the Society of Arts committee included the proposal that the type that printed the lettering on bank-notes should be cut in diamond, 'imitation of which would present insurmountable difficulties, the expense being prodigious . . . and the length of time necessary for finishing a font of type for the purpose several months'. Diamond typefaces would have been a prodigious expense for the bank, let alone for a forger, and this recommendation did not go forward. The number of notes printed at the bank each day made it essential that copper plates should be replaced by steel. Here, once again, art and science went hand in hand, and indeed to find a solution to the problem the committee requested that 'a union between the engravers and printers' should be pursued. The enthusiastic young Michael Faraday described in 1820 the method of softening steel plates for engraving, and the subsequent hardening of them for printing. This process was then being developed by the American émigré inventor and engineer Jacob Perkins, who cornered the market for supplying paper money to dozens of country banks. Abraham Raimbach saw ruin in the common usage of this industrial technique. Of electrotype plates – those made chemically, by electrolysis – he wrote:

> To the introduction of steel-engraving by multiplying almost indefinitely the number of impressions each plate would produce, may in a great degree be attributed the decline and debasement of the art, exercised on a small scale. The embellishments of books are no longer what they have been, and the recent discovery and application of the electrotype bids fair to affect similar results as regards works of a large size.

The process could reproduce any number of copies,

> consequently greatly lessening the value of the aggregate, and destroying at the same time, root and branch, the long-established system of proofs and early impressions, which contributed so much to the advantage and respectability of the profession, by holding out inducements to connoisseurs and lovers of rarity, to form collective choice exemplars.

Some things in image reproduction rolled on as before, however, until the introduction of photography in the early 1840s forced a change. The fundamental requirement remained for the engraver to pore for months, even years, over the original painting, retaining it often to the frustration and fury of artist and owner. Landseer and his engravers endured odium and even threats of violence, while John Pye's engraving of Turner's *Ehrenbreitstein* was delayed for ten years, from 1835 to 1845. 'Year after year rolls on,' the artist wrote to the engraver, 'and no proof of Ehrnbtein appears.' There was no owner to complicate the issue in this case, as Turner had painted *Ehrenbreitstein* specifically so it could be engraved by Pye, 'free of all cost to Mr Turner'. Nevertheless ten years was more than he had expected: Turner's share of this deal was his continued ownership of the painting and 100 impressions of the print; while Pye would make his money out of the prints sold, and a half-share with Turner in the ownership of the plate. This was a deal cooked up between them, with no publisher involved, though in the event the process did not take the route intended. First of all, Pye expected Turner to produce a small picture that he, Pye, could take with him to engrave while travelling Europe with his daughter; but in the event the painting Turner delivered was 3 feet by 4 feet, much too large to transport with ease. Secondly, the long delay in the project, caused principally by Pye not being able to travel with the painting because it was so big, meant that the work could not be completed in the agreed five years. *Ehrenbreitstein* was sold to Elhanan Bicknell in 1844, before the print was published, but nevertheless Bicknell was not allowed to collect his purchase. He wrote to Pye in 1845:

> My getting the painting appears as distant now as it was in March 1844.
> I thought I had only to send to Queen Anne Street to have it – but the
> grim master of the Castle Giant Grimbo [i.e. Turner] shakes his head and
> says he and you must first agree that all is done to the plate that is neces-
> sary, and the picture will be wanted to refer to.

These local difficulties were the inevitable consequence, and an indicator, of the rise in value of paintings by artists of substance, the growing influence and reach of the entrepreneurial art dealer, and the widening

market for fine art from the grand house to the terrace. Further, they demonstrate that the accrued market value of an edition of prints, sold on to upper- and middle-class households, significantly rivalled the value of the original work of art. Pye put it succinctly: 'By the graver's art, it has been as truly as elegantly said, "*copper has been turned into gold*", for it is a vein of wealth both to the artist and to the state.' He went on to point out that foreign trade in British prints brought £200,000 a year into the country – that would be an export value of £10 million in the early twenty-first century:

> By this art alone it may be said . . . the British school is known and admired in every country of Europe and America; in which its productions form an important article of commerce. By engravings the high moral and intellectual character of England has been displayed and acknowledged by honours, by volumes, and by imitations . . . The superiority of the English school of landscape painting especially is known only by engraving, and the illustrious masters in this department of our Academy will, perhaps, be immortalised by the graver rather than the pencil, since their original works may perish. Wilkie, Flaxman and Turner's works have been the indexes to the character of our intellectuality in art, and the foundation of our artistic reputation, both in design and engraving, in the countries of the Continent generally.

Turner's work with engravers is a classic case, dividing itself broadly into three distinct phases, of trade following art. The phases are indicative of the fact that Turner's career is a transition between the generation of artists whose work was conditioned by requirements of the patron, and the era of artists who were able to maintain some measure of contractual control over their paintings, by working with dealers and publishers, or entirely for themselves. During the eighteenth century, engravings after the landscape painter Richard Wilson, for example, might include a florid inscription reflecting the artist's indebtedness to the owner of the painting or the landscape depicted. This was commonplace. In Turner's early career, many of his watercolours were commissioned specifically to be engraved. The engraving was the end; the painting merely the means to that end. Thus, for 20 guineas, Turner delivered in 1799 two watercolour drawings of

scenes in Oxford for the Oxford University Press. These became university property and were engraved by James Basire to decorate the 1799 and 1801 Oxford Almanack, a single-sheet fly-poster about 3 feet high, which listed the university's senior officers and carried the year's calendar.

In the following decade Turner produced for the Press eight more watercolours, one in 1801 and seven in 1804, a clear sign that by 1804 the Delegates of the Press had noticed his assiduity, his approach and the quality of his work. For the very modest outlay of 10 guineas each in 1804, the Press now had seven years' supply of drawings for the Almanack, quite enough at a time when they were being troubled by persistent inaccuracies in the calendar and blaming Basire for them. Turner was doing them a favour: since they took him on in 1799 he had risen first to become an Associate member of the Royal Academy, then an Academician, then the owner and manager of his own gallery, and was rising immeasurably in public and professional stature. By the time his last Oxford Almanack drawing was engraved and published, he had sold large and complex paintings for high prices to patrons who included, rising up the social scale, Walter Fawkes Esq., Sir John Leicester, the Earl of Egremont and the Duke of Bridgewater. Turner had, from his youth, developed a sincere respect for Oxford, mixed with loyalty and esteem for the academic community. He also had the professional canniness to know that his work would be seen by all, from Chancellor to servants, and that each Almanack would be circulated and displayed prominently for at least a year in the best university rooms, pasted on walls, and sold at 2s.6d a time. This was a very good business deal, in which Turner could trade off low income against high public exposure.

The second phase of Turner's work with engravers, where the relationship turns from 'for' to 'with', began with his initiative to create his own portfolio of engraved pictures, his *Liber Studiorum* ('Book of Studies'), itself a means to maintain control over the copyright of his paintings. By the end of the twelve-year process, 1807 to 1819, he had produced, with his engravers, ninety plates. Many of these were begun with etched outline by Turner himself, and a handful were made by him in their entirety. The finish to most of the plates, whether in aquatint, mezzotint

or etching, was nevertheless made by engravers under Turner's close supervision, the artist inspecting every inch of the way and pencilling terse instructions in some of the margins. Despite, or perhaps because of, his desire for control, Turner's *Liber Studiorum* was a commercial failure. One of the problems initially was poor advertising. In 1808 Turner bitterly castigated his engraver (and namesake) Charles Turner in the margins of one print:

> Respecting advertising you know full well that every thing ought to have been done long ago!! I have not seen a word in the papers, take it away from the *Times*: if you can get advertised any where <u>do so</u> . . . In short everything has conspired against the work.

The *Liber Studiorum* suffered from mixed motives on the part of the artist. Was he doing it purely to protect his ownership of the images, or was he hoping to expand the pool of knowledge of his work, from the aristocratic gallery to the modest family parlour? Both, probably. John Pye remarked that for Turner the purpose of the *Liber* was 'to demonstrate' that he 'could delineate everything that is visible under the sun'. This may have been in the back of Turner's mind, but he will have known that his exhibited paintings were already making that perfectly clear.

Turner was his own highly erratic business manager. He kept costs of producing the *Liber* down by tending to pay the engravers rather less than they asked: for example, he paid F. C. Lewis 5 guineas for engraving the first subject in the series, *Bridge and Goats*, though Lewis wanted 8. He made sure that Charles Turner did not buy any more paper for the prints than was necessary, and set print prices low enough to anticipate a modest flow of orders: 15 shillings for a folio of five prints, and £1.5s for the better-quality proof impressions. At 3 shillings a print, then, for the standard issue, the purchaser was paying what might today be around £7 or £8 for an unframed image. That seems about par for a frameable art gallery reproduction these days.

Nevertheless, they did not sell, a failure that Turner immediately and roughly put down to poor advertising on the part of others. Maria Callcott (then Maria Graham) wanted to buy a set of the *Liber Studiorum*, but

ran into difficulties in trying to track one down. She told John Murray, 'I believe that it is only to be gotten at his own house so that I must write to him for it.' When John Ruskin went to Turner's studio after his death, he found

> neatly packed and well labelled as many Bundles of Liber Studiorum as would fill your entire Bookcase, & England and Wales proofs in packed and Labelled Bundles like reams of paper . . . piled nearly to ceiling.

Volume marketing was clearly not among Turner's strengths – a problem that, with the engravings of his *Picturesque Views in England and Wales*, which were also not selling, was lifelong. In the 1840s Turner chastized the print-seller Halsted for breaking up sets of the *Liber*. On being told, quite reasonably, that some plates sold better than others, he responded mysteriously: 'A pack of geese! A pack of geese! Don't they know what *Liber Studiorum* means?' We might also ask what Turner meant by such a gnomic statement, worthy of the Sphinx, or the epigrammatic footballer Eric Cantona. My guess is that he saw the collection as one might see a gaggle of geese: that is, all equal, all similar in kind, but having their best effect when banded together.

The third and final phase of Turner's professional life with engravers shows his work being reproduced at extremes of scale, both very small as vignettes for book illustrations, and relatively large to be framed for domestic display in such series as *The Southern Coast* and *Picturesque Views in England and Wales*, each plate being about 6 by 9 inches. Over the final two decades of his life, and after his death, new engravings after Turner tended to be yet larger, growing to as much as 22 by 32 inches for the largest, John Burnet's 1853 steel engraving after *The Shipwreck*. In the 1830s his vignettes – small images usually oval in shape and without a fixed border – were engraved and published as illustrations to octavo, or small-format, books of poetry or prose. These, embracing the work of Scott, Byron, Campbell, Moore and Rogers, entered the mass market and carried his already famous name into every household where books flowed freely. Turner was, to readers, an exemplary interpreter of contemporary literature, an artist published by

John Murray and Robert Cadell; thus he straddled two normally separate worlds, being also, to visitors to art exhibitions and collectors, an artist of gravitas, status and conscience, and the creator of extraordinarily chromatic paintings. In addition he contributed illustrations of subjects on the Loire and Seine to three annual volumes, 1833 to 1835, for armchair travellers. 'Turner's Annual Tour', articulated with texts by the journalist and novelist Leitch Ritchie, was eagerly awaited by those planning or dreaming of foreign travel. He showed what distant places looked like; readers knew they could trust Turner. By the 1840s his work and name were closely and particularly connected to the book trade, and were key factors in the commercial success of the publications he illustrated. Publication of the larger-scale engravings drew in art dealers such as Thomas Griffith, Francis Moon, and Hodgson and Graves, who sought large profits by speculating in single-image engraving contracts. Turner was deeply involved in all negotiations concerning his paintings, more or less successfully. He cautioned William Miller, who wanted to engrave his *Mercury and Herse*, 'I told more than one Publisher about it without any result.'

Turner's career overlapped significantly with the new era of dealer-led mass reproduction. In his agreement with Hodgson and Graves in 1836 for Miller to engrave *Venice, from the Porch of Madonna della Salute*, Turner was to be paid 100 guineas for the copyright of the image, with fifty 'first proofs' – that is, the best – from the finished plate, specified in the contract as copper and to be 'the same size as The Temple of Jupiter by Mr Miller'. The agreement on the fifty best proofs was a special (and expensive) courtesy to Turner, reflecting both on his eminence and on his expectation to be involved in the money-making side of the process. The fifty, creamed off a copper plate, were a particularly valuable asset to be relinquished by the dealers, who would have considered this concession when agreeing the artist's fee. Further, the painting was to be insured against fire and 'all risks of carriage by Land or Sea' for 350 guineas. As Miller lived in Edinburgh and the painting had to be transported from London, this was a significant requirement.

Already, with insurance being part of the deal, engraving processes were becoming professional and systematic, involving a new complex

of interests. Turner's copyright fee for *Venice* would not become due for twelve months, and the painting was to be returned to him two years after the agreement with Hodgson and Graves was signed. Turner was a fully involved businessman where the engraving of his work was concerned. He always expected full insurance of his paintings when they were away at the engravers – 'insurance &c. &c. shall be fully attended unto; rely upon my enforcing them' – while his insistence on close control of the way the engraver handled his image, tone and detail, went beyond mere concern to become involved, obsessive, proprietorial guidance. In short, Turner recognized the full value of the highest-quality engraving, expected the best, and knew engraving to be an art of distinction on a par with his own. He would have understood and echoed the engraver John Landseer's remark, 'engraving is no more an art of copying painting than the English language is an art of copying Greek or Latin.'

Over the course of his career, and until a few years after his death, nearly a thousand different print subjects were engraved after works by Turner, from the first, a view of Rochester, when he was nineteen years old. In all he seems to have engaged about sixty different engravers, indicating a high degree of loyalty from some of them, despite the quarrels that were a regular feature of his professional relationships with engravers. By comparison, Edwin Landseer had the modest output of 434 subjects engraved. Other differences are equally revealing, however, if we consider that in career terms the two were more or less on a par: their working lives were of a similar length, both being of about fifty-three years; they both had high public fame from widely reproduced images; and they had similar levels of productive energy and personal financial security. Compared with Turner's sixty-odd engravers, Landseer and his dealers employed 126; and while we have no accurate figures to make comparison of the number of proofs taken off each print, it is the case that Landseer benefited from the durable steel plates which for Turner were introduced when he was well into middle age. What is clear is that Landseer used twice the number of engravers to make half the number of print subjects. This reflects the growth and improved organization of the art engraving trades since the 1820s, a direct consequence of improvements in printing technology brought on by

industrialization, mechanization, and the need to print secure bank-notes in extreme quantities and at speed.

There is extensive surviving correspondence that evokes the turbulence in the relationships between artist, dealer and engraver. One exchange prompted by Ernest Gambart's approach in 1848 to Jacob Bell concerning the copyright of Landseer's paintings is direct and unpleasant. It opens with the young engraver Charles Lewis, the son of Turner's engraver F. C. Lewis, writing to Bell to complain in the strongest possible terms about Gambart's persistence:

> I should be very much obliged if you would ask Mr Gambart not to call any more with his promises; he has now been, in all, twenty times, making arrangements & settling things, that, when they are seen into, are not so substantial as bubbles, all this you are well aware is not pleasant or expected. You will merely be so good as to explain that we English are not used to these unsolid modes of doing business.

A month later, Lewis appeared to have got over his antipathy towards Gambart, perhaps on Bell's advice, and wrote to him:

> Mr Bell has written to me requesting that I should call upon you about the Picture of the 'Random Shot'. I should like to understand the terms you have jointly to offer . . . I will promise to be very amiable, as I am sure your willingness has always been most complementary to me, but there are so many obstacles in the way.

Gambart immediately sent Lewis's letter to Bell, complaining that Lewis's prices for engraving were extravagant and suggesting a more reasonable figure. A fortnight later Lewis wrote to Bell about a meeting he had had with another dealer, Henry Graves, who offered improved terms. He was, however, inclined to stick with Gambart:

> I saw Mr Graves last night he would like to see the Picture [A Random Shot] & would call upon you this morning if you will allow him to see it with me; he seems inclined to pay the very small copyright you have named, although if he would not allow us a fair price for engraving,

I would rather be subject to <u>Gambart's</u> plans or take the copyright myself. I think you would kindly understand my meaning . . . I dare say you are almost heartily tired of these matters.

Landseer stepped in, after a year had gone by, with more invective against Gambart, and spoke his mind to Bell:

It is quite time to give that Frenchman up. He only thinks of himself. Not the least feeling for art or the reputation of the author or authors, a heartless flattering humbug. If possible I should like to take other things in progress out of his hands . . . Any written agreement signed? No? That letter of his is mostly <u>insolent</u> . . . Get his money or rather our honest share out of the concern and send him to the Devil.

Despite demonstrations of bad temper from Landseer, Gambart found ways of publishing prints after the artist. Indeed, he contracted Edwin's brother, the engraver Thomas Landseer, to create three prints of hunting dogs. When these were published in 1850, *The Times* observed that 'for spirit, accuracy of delineation, and character, [they] are amongst the very best things produced by that eminent artist'.

Martin Blackmore, despite his philanthropic support of the Artists' Benevolent Fund, was a particularly difficult client. Lewis had had Blackmore's Landseer painting *Collie Dogs* in his studio for some time (see pages 100–101), but he needed it again and appealed to Bell for its return: 'I wd really not lose a moment on its completion, & keep it a month.' Writing subsequently to Landseer, Lewis wrote:

I am very sorry to trouble you, while you are away from home, but Mr Blackmore has now had his Picture for 8 or 9 months, & says he will not again allow it to go away without your written order . . . If I do not get the picture so as to finish it at once, I fear I shall get into serious trouble, which I am sure it is not in your nature to recognize.

And then to Bell again:

I still hope you will get the Picture for a short time. If you can not oblige me I can foresee a tedious Lawsuit which it is the power of

yourself & Sir E. Landseer to prevent . . . You are in error that I told
Mr Blackmore a fortnight would suffice to finish with the Picture, he
said he would lend it to me for 21 days & then take it <u>away for good</u>,
without consulting me . . . As you wish for <u>security</u> that Mr B. should
have his Picture returned in three months, I will of course promise he
shall h[ave] [tear] whenever he may wish for it; if you do not consent
to this I shall consider, as I before said, you are the instrument of the
Lawsuit, as you are the prevention to the completion of the plate I have
so nearly done for Mr Graves. Last night I had a writ served upon me.
I cannot really understand the meaning of it, from gentlemen like you
& Sir Edwin.

And again, now reporting a threat of violence:

I am still very sorry to learn Mr Blackmore is so strongly biassed against
my interest in the present case . . . Without wishing to renew any old
grievances respecting any angry words between Mr Blackmore & myself,
I have a perfect recollection of his saying he would shoot any one who
detained his picture.

Graves clearly took no notice of Lewis's needs and summoned him to
court in 1855 for failing to produce the engraved print on time. Graves
won damages; Lewis went home in sorrow. The law courts were a recur-
rent recourse for publishers, engravers and artists to establish their mutual
rights. The entire weight of this particular saga of intemperance and impa-
tience, fought out between men of substance and influence, fell upon the
poor bloody engraver.

In the creative process, all kinds of erratics creep in. The engraver of
illustrations by Abraham Cooper RA to Walter Scott's *Rob Roy* wrote in
concerned tones bearing Scott's opinion to Abraham Cooper. This had
come, handed along like a relay baton, from Scott, to the print dealer
Moon, to the engraver, to Cooper:

Messrs Moon & Co transmitted to me a few days since your drawing
of Baillie Jarvie which I transmitted to Sir Walter without any delay. I
fear you have not put the Baillie in sufficient peril – he is not sufficiently

dangling – there is one tree only, but I had as well tell you what Sir Walter says.

'Mr Cooper is too tame and has mistaken the position which is the face of a Highland precipice a tree projecting from the face of the rock which has caught the Baillie in his fall and holds him suspended between earth and sky, his wig gone and his coat rending, all fours off the ground and hanging, as he says himself, like the sign of the golden fleece. In Mr Cooper's sketch the Baillie has only slipt a foot in a swampy woodland and fallen into a thorn bush. He can do nothing however but what is marked by genius.'

I have no doubt you can Doctor all this very easily. Tis important as far as possible to come near the author's views.

In this particular case, a twitch upon the thread in Abbotsford was quickly and sharply felt by relays in the artist's home in Greenwich.

Contracts regularly specified quantity and quality of the prints ordered. In an agreement with the engraver William Giller, Hodgson and Graves insisted that his engraving of the portrait of Lady Peel, made after Charles Heath's print which was itself made after Sir Thomas Lawrence's oil portrait, should be engraved on steel

in mezzotinto, 6½ x 8¾ inches, finish and deliver by 25 September 1836 for 40 gns. Plate to work 1000 good impressions without further expense which William Giller agrees it should do.

Note the process here: an earlier print of the painting, and not the painting itself, becomes the source of the new engraving.

Turner's 100 guineas for copyright of his *Venice* is put into the shade by comparison with the £1,200 that another star of the engraved painting world, David Wilkie, was paid in 1829 for the copyright of *Chelsea Pensioners Reading the Gazette of the Battle of Waterloo*. This was in addition to the £1,260 that the Duke of Wellington paid for it on commission. The engraver, John Burnet, was to receive £1,575 for his work engraving this large plate, size 28¼ x 17 inches, plus one-third of the profits from the sale of the prints. The top engravers' fees were gradually encroaching on the

copyright payments to artists, so when a publisher brought together an
artist of Wilkie's stature with an engraver like Burnet it is not clear which of
the two is the real star. The scene became further complicated when Moon,
Boys and Graves engaged James Stewart to engrave Wilkie's *Scotch Wedding*
in the collection of King George IV. The detailed, expensively and neatly
drawn up contract between the parties – clearly top lawyers were used – in
which Wilkie would earn £367.10s [i.e. 350 guineas] for the copyrights and
Stewart £1,207.10s [1,150 guineas] for the engraving, contained the clause
that the picture was to be left with James Stewart for the period of engrav-
ing, unless the king wanted it to be returned, in which case all payments
would be suspended.

Business was so good that, as Pye pointed out, there were about twenty
print-sellers in London whose transactions averaged £16,000 a year (i.e.
c.£750,000 turnover in the early twenty-first century). In 1844 Graves's
sales reputedly totalled £22,000. In 1837 Landseer completed the sale of
the copyright of *The Drover's Departure: A scene in the Grampians* to the
engraver James Henry Watt for 200 guineas. This marked the beginning
of the fame of this work, which turned inevitably into tedium as fashions
changed, and the engraving, proudly bought by one generation, was dis-
missed to backstairs and junk shops by another. *The Drover's Departure* was
one of the first mass-marketed images of a crowded and complex contem-
porary scene with plenty of niggling anecdotal detail. It would be followed
twenty years later by such highly populated show-stoppers as W. B. Frith's
Derby Day (1856–8), *The Railway Station* (1862) and *Private View at the
Royal Academy* (1883), and *Meeting of Wellington and Blücher* and *Death of
Nelson* (1858–64) by Daniel Maclise.

In the case of *The Drover's Departure*, ownership, and profits, were
spread across the trade. Watt had bought the copyright, but ownership
of the engraved plate was different again. Initially, Watt, and Hodgson
and Graves, each owned half the rights in the plate, but even before the
engraving was finished, Hodgson and Graves had sold half of their 50
per cent to the art dealer Thomas Agnew, then of Manchester, for 350
guineas. Thus investment in the process, and the prospect of lucrative
profits, racked upwards, divided and subdivided by shares, long after

the artist had sold out his part of the deal. Abraham Raimbach, a good friend of David Wilkie, expressed the engravers' view. He saw the painters to be the root cause of the problem of 'the change that had come over the good old legitimate art of line-engraving ... the enormous sums now for the first time exacted by the painters under the claim of copyright':

> The printsellers, in yielding to these claims, sought to indemnify themselves by adopting a more expeditious and lower-priced mode of engraving (mezzotinto), and which, being also executed on steel, enabled them by printing much longer numbers than copper-plates will produce to obtain their usual regular profits ... A noble lord, a great collector of the modern as well as of the old masters, was desirous of befriending a young engraver of talent by allowing him to make an engraving from a picture in his gallery; when the painter, hearing of the circumstance, interfered and prevented the fulfilment of his lordship's benevolent intention, the patron being unwilling to enter into a contest on the subject.

In the matter of Landseer's *The Drover's Return*, a companion painting to *The Drover's Departure*, Watt complained bitterly to Hodgson and Graves when the latter party

> departed the strict letter of the parsimonious agreement which your house insisted on in consequence of my unlucky oversight and Mr Hodgson's repeated refusals to advertise the plate [of *The Drover's Return*] properly ... [They] have hitherto completely destroyed my confidence in his intentions of vigorously promoting the success of the publication. But his present voluntary departure from the strict letter of the agreement [by payment of £25] restores my confidence in your house, and shall be met with renewed exertions to finish the plate quickly.

Nine months later Watt accepted £700 from Hodgson and Graves for his remaining quarter-share in *The Drover's Departure* and his half-share in his engraving of C. R. Leslie's *May Day in the Time of Queen Elizabeth*. These evanescent, long-dead deals are impossible to reconstruct fully, but what

we can grasp of them does nevertheless give a clue to the activity, energy and passion which ran behind the creation of what may now be mere anachronistic curiosities. They also reveal the fluctuations in the structures of art-dealing firms as they take on, then shed, new partners, associates and directors.

The process of engraving was dogged by quarrels, which were more about money than aesthetics or interpretation. John Murray and Charles Heath agreed in 1818 to pay £10 or guineas each for drawings for an edition of Byron's poems, and £20 or guineas each for the engravings. Murray was then furious when he received a bill of £300, a 40 per cent increase, for six completed plates. Constable and S. W. Reynolds lambasted each other over the engraving of Constable's painting *The Lock*. 'Get whom you please to make Engravings from your Works,' Reynolds told him:

> I don't care who, or how bad they may be when done. All I know, is that I will finish the Lock myself, and that I have prevailed upon a Friend of mine a la Paris to have Engraved Your two Wretched Works, that [John] Arrowsmith Bought of You [*The Hay Wain* and *View on the Stour*], and which made such a Fuss in Paris, so behave Yourself or I'll make Devils of things from them . . . I hope to see something in the Louvre of Yours next Opening in the Autumn. You was to have painted me a companion to the Lock, Avez vous.

This was not a good relationship.

The 1830s were the golden age of reproductive engraving; the high prices and the commercial quarrels reflect something of the churn of the market. This had regained its buoyancy after the crash of 1825/6, and the new methods of reproductive technology were bedding down with a vibrant professional network of engravers. Under the leadership and inspiration of John Pye – 'truly . . . a gigantic man . . . a stupendous life', as one of his descendants recalled – engravers developed their own effective system of apprenticeships and career aspiration in which the experience of age could be passed on through the enthusiasm of youth. A clause in the contract drawn up in 1836 between Hodgson and Graves and the young engraver

Frederick Bromley, to engrave Abraham Cooper's *Wellington at Waterloo*, contained an endorsement by Frederick's father, the distinguished engraver John Charles Bromley:

> I promise and undertake not to interrupt my son, Frederick Bromley, in the performance of his agreement with you . . . I will do all I can to enable him to fulfil his engagement.

As they were employing a young untried engraver, for the modest fee of 100 guineas, Hodgson and Graves inserted a cautious caveat: they would pay for the steel plate, but that 'if the engraving is not satisfactory to them [the plate is] to be then cut up and destroyed'.

The destruction of an engraved plate would soon become an event of commercial celebration rather than an indication of failure. Edward Whymper noted with interest in his diary the dramatic event prior to the retirement of Thomas Boys from the business of print dealing in 1855:

> The celebrated plate of the Waterloo banquet [engraved by William Greatbach after the painting by William Salter] has been destroyed along with 11 other celebrated ones . . . [Mr Boys] wishes to render some service to printmakers in general, by raising the price of impressions that they have, and also to hasten the sale of his stock.

The sight of an executioner smashing the steel plates to pieces both fascinated and shocked the witnesses to the event, and 'so unexpectedly called forth so much public interest', as Boys put it in a letter to *The Times*. The plates of Salter's *Waterloo Banquet*, *The Christening of the Princess Royal* by C. R. Leslie, and subjects by Landseer including *Shoeing: The smith's forge* and *The Return from Hawking* were destroyed at this event, and then, so that there should be no doubt in the matter, the metal fragments were nailed up as if they were magpies shot by a farmer, and displayed at the Albion Tavern, Aldersgate Street, while the remaining prints from the plates were auctioned off to the trade around them. This was 'the most extraordinary epoch in the annals of the fine arts', according to Boys's extravagant claim. Boys's justification of his act was that the steel plates

were capable of producing a further 3,000 copies each, and that if these were printed and entered the market, they would destroy the value of the otherwise limited editions:

> If the high price demand ceases the cost cannot be obtained back; if the cost cannot be reimbursed the undertaking cannot be entered into; and thus high art, however high it may be, so far as engraving is concerned, will be smothered in its birth, and such noble and beautiful specimens of the graver . . . will cease to be produced.

The ruthlessness of the trade, as exercised by Thomas Boys, came to justify Abraham Raimbach's fear that steel-faced engraving would debase the market. The destruction of the plates may also be a tacit but demonstrative admission that the prints were not selling in sufficient quantities to justify their release to a wider market, and so drastic steps were required. Thus the *Art-Union*'s misgivings of 1846 (see p. 98) might be seen as a premonition.

An artist who, unlike Turner and Landseer, looked after his own business, keeping well clear of dealers and publishers, was John Martin. He had no fear of images losing their value through multiplication: therein lies the essential difference between the artist and the dealer, and indeed between Martin and Landseer. Martin's career as a painter and printmaker rose like a bubble during the 1820s, filled out, burst and then practically collapsed during a decade or more of financial disaster in which he wandered the world of civil engineering, haemorrhaging money to further his plans to create a healthy and wholesome London. In the late 1840s he got back on track and found renewed fame through new paintings of apocalyptic dimension and subject matter. These he, and after his death his sons, exhibited to great acclaim in the major cities of the British Isles. Martin came from a simple Northumbrian family, from which no fewer than four male siblings – John, Jonathan, Richard and William – all having been apprenticed to trades, achieved the extraordinary distinction of becoming in due course subjects whose lives came to merit inclusion in the *Oxford Dictionary of National Biography*. Within their period, that is a turn of events usually reserved only for aristocracy or royalty.

Martin came to London in 1806 to seek success and fortune as an artist, having been trained in Newcastle to paint and polish coach bodies and to give them the kind of shiny surfaces, bright decorative flourishes, lettering and heraldic devices which drew attentive glances as they clattered around the county. In this training he mirrored the early career of that other entrepreneur, Rudolf Ackermann (see pages 157–162). He found in the capital decorative work of a similar kind, in which a light hand and close attention to detail were constant requirements, painting china and glass with landscape views and other charming devices. While he made additional money by teaching and selling landscape drawings, Martin did not himself have an orthodox art education – there was no enrolling in the Royal Academy Schools for him, or being apprenticed to an exhibiting artist. Instead, driven by his own extraordinary energy and even a bloody-mindedness that led to the occasion of his leading an apprentices' strike and facing his employer in court, he was able within six years to break out and surprise the art world with his apotheosis of coach-painting, the smoothly detailed, heated and showy canvas *Sadak in Search of the Waters of Oblivion*, all dressed up like a postillion in its red and orange. The reception of this painting seems to have given Martin a taste of what it was that the unreal and the uncanny, the lurid and the shocking, could convey beyond the pages of the Gothic novel of the previous century. Far from leading him to the waters of oblivion, *Sadak* showed Martin the way to seek the sunshine of fame.

The growing popularity of what became Martin's characteristic theme – civic disarray, collapsing authority and the insignificance of the individual against the overwhelming power of nature – led him to create new opportunities for his work. His light hand, his close attention to detail, his polish, and his experience and understanding of the factory system empowered him to produce a series of engravings after his exhibited work which developed his paintings' popularity and lengthened their shelf-life. His experience of successful litigation in the business field caused him also to have no fear of opposition, and a strong sense of self.

John Martin was highly organized as an engraver of his own work, sending out prospectuses, chivvying potential buyers: for example, in the

case of fellow artist James Northcote, he requested an 'early answer' in 1817 to the invitation to subscribe to the print of *Joshua Commanding the Sun to Stand Still*. While he had published engravings in the 1810s without much commercial success, Martin found a fertile source of income with the engraving he made of his *Belshazzar's Feast* (1821). This etching and mezzotint, published in 1826, came onto the market as a national exhibition tour of the painting itself was coming to an end. *Belshazzar's Feast* had become the star attraction at its first exhibition at the British Institution, where it won a £200 prize from the directors and had to be fenced off from the crowds that came to see it. The painting was bought for 800 guineas, Martin's advertised price, by William Collins, the man whom Martin had courageously challenged in court over the terms of his apprenticeship. Collins subsequently toured it around the country, to Leeds, Liverpool, Manchester, Edinburgh, Glasgow, Dublin, Bristol, Bath and Cheltenham. Such public exposure and acclaim were unheard of. In terms of the numbers of people who had seen it during the first half of the 1820s, when forty-five editions of the accompanying pamphlet were printed, John Martin's *Belshazzar's Feast* was the most widely seen modern painting with serious moral and historical intent, reaching more people than any other before the advent of film and television. Compared to Martin, in terms of market share and public profile, Wilkie, Turner, Frith, Maclise and Holman Hunt were beginners.

Martin had a strong following wind for the marketing of his *Belshazzar* print, of which he made three versions and tolerated, to a greater or lesser extent, many more. He produced his first engraving of the subject in 1826, despite another legal attack from the disagreeable Collins, who claimed that he had acquired copyright when he bought the painting. Martin's defence boiled down, somewhat pedantically, to his claim that the engraving was based on a new version of the painting that he had made, not the one bought by Collins. The proliferating number of versions from the artist had tended to obscure the situation, to Martin's eventual, and probably unexpected, benefit.

From this point, John Martin's career as a commercial art printmaker and publisher took off. On the floor below his studio in Allsop Terrace,

Marylebone Road, he maintained a print workshop and a team of assistants. The workshop was described in detail by his son, Leopold, 'as nearly perfect as art could make it':

> He had fly-wheel and screw-presses of the latest construction; ink-grinders, glass and iron; closets for paper French, India and English; drawers for canvas, blankets, inks, whiting, leather-shaving etc; outdoor cupboards for charcoal and ashes; in fact every appliance necessary for what my father was converting into a fine art.

While he carried out much of the preliminary work on the copper plates himself, Martin had his own efficient 'marketing department' in the person of his 26-year-old daughter Isabella, who kept his books carefully and made sure his customers got what they ordered and paid up. Martin's customers comprised all the leading print dealers, including Ackermann, Colnaghi, Moon, Boys and Graves, Bulcock of the Strand, Lambe of Gracechurch Street, and, in Manchester, Agnew and Zanetti. Other dealers, in Bath, Norwich and Liverpool, also bought prints in some quantity, as did those whom his surviving ledger, kept by Isabella, lists as 'Chance subscribers'. These run into more than 200 entries between 1826 and 1836, the peak years being 1826 to 1829, when Martin's print factory sold nearly 450 prints to individuals. Over these three years the trade bought many hundreds of prints, the largest single purchaser by far being Ackermann & Co., who spent £1,410 on 208 prints between 1827 and the end of 1829. In the late 1820s John Martin was making money hand over fist from sales both to the trade and to individuals. As a measure of the strength of the market, Ackermann bought fifteen prints of *The Deluge*, in various proof states, between September and November 1828, and then in the following January he bought fifty-two more, for the price of forty-eight. Martin would give a discount on bulk orders – thirteen prints for the price of twelve, for instance, or seven for the price of six. While this ledger of Martin's accounts is a rare survival, so there is little to compare it with, it clearly shows that Martin was a consummate businessman, well able to allow production to meet demand, and Isabella Martin a consummate business manager.

Among Martin's 'chance' or private subscribers were the architect A. W. N. Pugin, who bought a *Joshua* and a *Deluge* in November 1829 for £5.2s; the artists' paint manufacturers Messrs Rowney, who bought a *Belshazzar* in 1829 for 6 guineas; the engineers, inventors and bank-note printers, Perkins & Bacon, who bought three *Deluges*, three *Joshuas*, three *Ninevehs* and three *Babylons* for a total £30.16s, including discounts; and St John Long, briefly Martin's only pupil in the mid-1820s, who went on to become a controversial physician specializing in consumption. In 1830 Long bought from his former employer one *Deluge* for 6 guineas, one *Joshua* for 7 guineas, and one *Belshazzar* for 8 guineas.

Martin's was the old manner of art reproduction, a system tried and tested over 400 years by woodcuts, wood engraving and engraved copper and steel. Developing to take its place, however, was photography, an infant art in the 1840s, but one whose potential was being relentlessly pursued by artists and scientists alike. Its baptism of fire came in 1851 at the Great Exhibition, an event that gave photography the opportunity to begin its inexorable rise to become the principal twentieth-century means of image reproduction. The photography of art developed slowly in the wake of the 1851 exhibition, as it could not yet match engraving or lithography for reproductive volume. The official photographers for the Great Exhibition, Henry Fox Talbot and Nicholas Henneman, were commissioned to take enough photographs to illustrate 140 sets of the four-volume *Report of the Juries of the 1851 Exhibition*. Had the project been completed, they would have produced 21,700 separate prints of overwhelmingly three-dimensional objects and exhibition views.

Pioneers in the photography of works of art were Leonida Caldesi and his partner Mattia Montecchi. They had been commissioned by Agnew's and Colnaghi's to record 100 of the exhibits in the 1857 Manchester Art Treasures exhibition and to create the sumptuous two-volume *Photographs of the 'Gems of the Art Treasures Exhibitions', Manchester 1857*, priced at the exhibition at £42: old masters in one volume, modern masters in the other. This was the first extensive test of photography's ability to capture the tone and detail of paintings and drawings in both quantity and quality. There were mixed results, the photographers having to contend with reflections,

shine, wear, bloom, and wide variations in scale and available light. The evident technical difficulties faced by Caldesi and Montecchi when they photographed the paintings in Manchester were being confronted in the 1850s by photographers all over Britain. The 1858 Photographic Society exhibition at the South Kensington Museum was rich with photographs of paintings and drawings, a category that was clearly active and growing. The *Athenaeum* praised their technique as 'minute, careful and successful – truer, softer and surer than engravings, and expressing more of the colour and sentiment of the picture'.

Francis Hawkesworth Fawkes, the son and heir of Walter Fawkes, embarked in 1864 on his own entrepreneurial photographic scheme. In partnership with Dominic Colnaghi, Leonida Caldesi and Thomas Griffith, he aimed to create and publish an album of photographs of Fawkes's Turner watercolours. 'There is a novelty about to burst onto the critical world, of which & your opinions upon it, I shall be anxious . . . to learn', Fawkes told Griffith. In its own modest way, their project was quite as pioneering as the Manchester initiative. Fawkes continued:

When the bubble bursts . . . I am . . . certain that you will not be the one (if there be such a one in existence) who will blame me for extending to the world in Photograph so perfect a Representation of the Beautiful works of Turner's best period & that adorn the Walls of the Saloon here.

When I made Colnaghi the offer I had little expectation that Photography practised in so hazy & gloomy an atmosphere as our own could adapt itself to the <u>Warmest</u> as well [as] cold suggestions of the originals. Both theses, whether aiming to remind us of the Sketcher perspiring from every pore, or obstructed in his Work by an Alpine Winter & frostbitten Fingers, seem to me equally successful . . . I have had the whole collection (shortly as I hear to be published) on my Table . . . I rise nearly daily from the attractive review of them, with ever increasing admiration of the powers of Photography.

Griffith's and Colnaghi's connection with Fawkes's initiative reflects something of the mid-nineteenth-century art market's never-ending search for the new. While photography was already a well-established technology,

new depths in its possible commercial applications were being explored energetically as a realistic economic alternative to the time-consuming and expensive art of the engraver. Photography was art's steam-engine, the revolutionary new means to carry its message, further, quicker.

PUBLISHER:
'SIX HUNDRED AND EIGHTY-FIVE
WAYS TO DRESS EGGS'

In 1812 the gregarious and wily publisher John Murray moved his growing business from rooms in Fleet Street into elegant new premises in Albemarle Street, off Piccadilly. This was Murray's expression of faith in himself and in his business. As the owner of the publishing house which he had inherited from his father, the first John Murray of that tribe, he had made a series of courageous and perceptive (or foolhardy) business decisions which led to the creation of bestsellers. These included an early example of what was to become and remain the staple of successful publishers, the cookery book: Murray published *A New System of Domestic Economy* by the capable domestic goddess Maria Rundell in 1805. Cookery, in Murray's list, was joined by pacy historical romance: he took a quarter-share in an extended narrative poem by Walter Scott, a rising and prodigious Lowlands poet, who could produce verse with the speed and colour with which a loom can weave ribbon. So while Maria Rundell taught her many readers how to carve a joint, how to make a potato pudding, how to make chicken curry in a book which soon found its place at thousands of kitchen hearths, with *Marmion* (1808) John Murray introduced Walter Scott, a young man who brought a new hero to the world with the lines:

So daring in love, and so dauntless in war,
Have ye e'r heard of gallant like young Lochinvar?

Within five years *Marmion* had sold 28,000 copies, and John Murray, the Young Lochinvar of publishing, was rightly satisfied. So was his author: Scott wrote admiringly of the 'capital and enterprise' of this personable

bookseller who had visited him on the banks of the River Tweed and who had 'more good sense and propriety of sentiment than fall to the share of most of his brethren . . . I found his ideas most liberal and satisfactory.' By these publishing successes Murray had gathered enough wind in his sails to propel himself west to Albemarle Street. Using the copyrights of *A New System of Domestic Economy* and *Marmion* as security, he bought for nearly £4,000 the freehold of 50 Albemarle Street, and began to sell books from its downstairs front rooms and to publish them from its first floor.

The year before he departed Fleet Street, Murray had ninety-four titles either lately published or in the press, and was publishing the literary journal *Quarterly Review*. This was not, however, enough to bring the family firm the security it needed. Such an outlay, before the certainty of a balancing income, was a potentially crippling liability, containing as it did printing, paper and binding costs, storage and packing, distribution and delivery, as well as the sums promised or advanced to authors. Murray's books went to booksellers all around Britain and Ireland, and over the seas to India and Australia, the West Indies and America. Such wide potential readership demanded clean texts, on which the company lavished great care, expecting due diligence from authors and editors. But care cost. Murray's editor William Gifford pointed out proofing errors in an article to be published in *Quarterly Review*:

> In Southey's article there are two slight alterations which, if it falls your way, you might make. Sieks is in one place misspelt Seeks: and Persic should be printed instead of Persian . . . I hope you will see that the corrections of the Proof are all made. The Printers, you see, cannot be relied on.

Authors themselves tended to make poor copy-editors, as Gifford warned Murray in the case of Isaac D'Israeli, whose 'pencil marks are so loose & imperfect, that I cannot discover, with any certainty, what he means to omit'.

With hindsight, John Murray – all seven generations of that name and line – had marked success and influence through their business acumen and courage. However, the business was on a knife-edge in the early nineteenth

century, and the second John Murray realized only a year after moving to Albemarle Street that he might have made a big mistake. Spitting with rage, he expressed himself to William Miller, the former publisher (not the engraver) who had sold him the house:

> Your Good Will and Business for which I paid so liberal a sum comprised all your customers generally and particularly with such exceptions as were either specified in our contract or mutually agreed afterwards . . . The fact is – Miller – I have never received from you any one act of friendship since I purchased your house, where you appeared to leave me to my fate, never entering the door, as was remarked even by the common porter in my shop, except for your own service. Your Good will has never produced me an Hundred pounds – & the books, which you said 'were you upon our deathbed, as my friend, you would advise me to take of you' will prove a considerable loss. There are heavy disadvantages and such as must have prevented me, were it not from my own connexions and ulterior views, <u>forever</u> from realizing even your kind, but scanty wish, 'every prosperity which I could <u>reasonably</u> look for'.

Like all publishers, Murray was a gambler on futures, and a regular sufferer from problems of cash flow. 'Mr Murray is really so very poor at this time,' his clerk wrote to a customer in Enfield in 1811. 'He trusts you will excuse his sending again his Account. Mr Murray desired me to say He will feel very happy if you will occasionally favour him with an order.' A new gamble that Murray took at this difficult time for his business was to publish in March 1812 the first two Cantos, or sections, each of over 200 verses, of a poem by a mouthy and unreliable young peer, Lord Byron. Murray had not yet moved into Albemarle Street before *Childe Harold's Pilgrimage* appeared, but with its rapidly increasing notoriety it sold out reprint after reprint, reaching 4,500 copies in six months. Byron, as he himself put it, awoke one morning and found himself famous. He was of course being disingenuous: he was already famous enough, not least because a week earlier he had made trouble in the House of Lords by attacking in his maiden speech the Tory government bill which proposed to make machine-wrecking an offence punishable by hanging. 'How will you carry this bill into effect?' he asked the Lords.

Can you commit a whole country to their own prisons? Will you erect a
gibbet in every field, and hang up men like scarecrows? . . . Are these the
remedies for a starving and desperate populace?

And further, he was famous within a limited social circle as a traveller,
lover and altogether irresponsible sexual adventurer, a worry to his friends
and a danger to young women. So becoming famous overnight was false
modesty, a bit of a tease on the future. Byron and John Murray were well
matched as author and publisher. Both were buccaneers in the way they
ran their affairs, risking in Byron's case social opprobrium, in Murray's
business disaster. In business Murray could hope beyond his present dif-
ficulties and survive handsomely, while Byron would separate from his wife
and in April 1816 would leave England, never to return. But the pair were
forever bound together, as Byron so perfectly expressed it:

> Along thy sprucest bookshelves shine
> The works thou deemest most divine –
> The 'Art of Cookery' and Mine
> My Murray.

In correspondence in 1839 with Edward Copleston, Bishop of Llandaff,
Murray ruminated on the 'risque' he ran as a publisher. Copleston, who
was editing the letters between himself and the Earl of Dudley for publica-
tion by Murray, had complained about the great distance between St Paul's
Cathedral and Albemarle Street, and about the 'inordinate profits' of the
publisher. Murray considered his reply:

> My Lord when I had the honor to publish for Sir Walter Scott & Lord
> Byron the one resided in London, the other in Venice – & with regard
> to the supposed advantage of a publisher they are only such as custom
> has established and experience proved to be no more than equivalent to
> his peculiar trouble and the inordinate risque that he incurs . . . After
> what has passed on your Lordship's side . . . I feel that it would be
> inconsistent with my own character to embarrass you any longer and I
> therefore release your Lordship at once from any promise or supposed
> understanding whatever regarding the publication.'

In the event the bishop backed down, and the letters were duly published.

John Murray was just one of a powerful group of commercial publishers in early nineteenth-century London who carefully considered the market potential of an increasingly literate population, rapidly developing towns in the regions of Britain, a freer money supply, and expanding trade to English-speaking colonies and communities overseas. The trick he had continually to perform was to balance bestsellers such as Byron's *Childe Harold* with books of very limited appeal such as the Llandaff–Dudley letters. While the one made the money, the other, along with a multitude of specialist titles, made his company's solid and reliable reputation. As a company, John Murray would not have survived as long as it did without a careful balance being maintained between the two principles. As we have seen in the case of Turner, Martin, Landseer, Chantrey, Flaxman, Pye and Lewis, the conditions of success for a painter, sculptor or engraver included business acumen, an understanding of market forces, and a willingness to give the public what it wanted; at the same time it was necessary for these men to push at the boundaries of taste and practice, and to accept the imperative of attention to detail, distribution and material supply. Just these same conditions applied to a publisher such as Murray.

Central among Murray's competitors was Thomas Longman, whose company published *Robinson Crusoe* and had early responsibility for Dr Johnson's *Dictionary*. Another was Archibald Constable, who first negotiated the £1,000 advance for Scott's *Marmion*, later sold off in part to Murray, and came to publish the *Encyclopaedia Britannica*. These were big players, the founders of two leading publishing houses whose names continue in business into the twenty-first century. Others included the brothers James and John Ballantyne, and the Rivington family, who had been the first publisher of Samuel Richardson's *Pamela* (1740) and became the leading publishers for the Church of England.

An author who continually dogged John Murray's footsteps and accepted his hospitality, but was largely the creature of Murray's rival Longman, was the Irish poet, song-writer and biographer of Sheridan and Byron, Thomas Moore. Famous for his lyrical poems, Moore became to Ireland what Robert Burns has been to Scottish lore and culture, though without such lasting international resonance. His charming versification

was, at the time, widely read, sung and admired, the jokes in his songs, poems and prose duly raised a laugh, without having the pinch of any couplet by Byron:

> 'Come, come', said Tom's father, 'at your time of life,
> There's no longer excuse for thus playing the rake –
> It is time you should think, boy, of taking a wife' –
> 'Why, so it is father – whose wife shall I take?'

Before he had written anything, Moore was given in 1817 a £3,000 advance by Longman for his oriental verse saga *Lalla Rookh*. This caused Byron in a flush of jealousy to refuse Murray's offer of 1,500 guineas as an advance for the fourth Canto of *Childe Harold's Pilgrimage*. 'I won't take it. I ask two thousand five hundred guineas . . . if Mr Moore is to have three thousand for Lalla.' Literary gossip of this kind was rife in the circles that John Murray frequented. Thomas Moore noted down a classic example in his journal, concerning the ageing dandy George 'Beau' Brummel:

> Much talk in town about Brummel's Memoirs – Murray told me a day or two ago that the report was that he had offered Brummel £5000 for the Memoirs, but that the Regent had sent Brummel £6000 to suppress them! – Upon Murray saying he really had some idea of going to Calais to treat with Brummel, I asked him . . . what he would give me for a volume, in the style of the Fudges, on his correspondence & interviews with Brummel? 'A thousand guineas' he said, 'this instant'.

Moore's most successful work in his lifetime was his satire in comic verse on the English abroad, *The Fudge Family in Paris* (1818). Within its first year of publication it had reached its fourth edition and was being read throughout the nation. Even en route to Leamington Spa by coach Moore had no peace from its fame, as a fellow passenger talked to him about the book, without realizing he was the author. 'I have always found it a trying thing to be spoken of behind-my-back-before-my-face in this manner', he wrote later in his journal. The Fudges, an English family visiting Paris after the restoration of the Bourbon monarchy, demonstrate

all the characteristic rivalries and prejudices between the now triumphant English and the French. In length and metre Moore parodies Byron and Scott, though his writing falls far short of both these contemporaries in wit and narrative drive. Here is the son, Robert Fudge, writing home about French cooking:

> Yet spite of our good-natur'd money and slaughter –
> They hate us, as Beelzebub hates holy water!
> But who the deuce cares, Dick, as long as they nourish us
> Neatly as now, and good cookery flourishes . . .
> Forbid it, forbid it, ye Holy Allies,
> Take whatever ye fancy – take statues, take money –
> But leave them, oh leave them their Perigord pies,
> Their glorious goose-livers, and high pickled tunny!
> Though many I own, are the evils they've brought us,
> Though Royalty's here on her very last legs,
> Yet, who can help loving the land that has taught us
> Six hundred and eighty-five ways to dress eggs?

Moore, Byron and Scott were the three giants of early nineteenth-century literature, holding the stage before Dickens, Thackeray and the Brontës had taken their places, and before Jane Austen became an institution. Their popularity followed different tracks: Byron becoming notorious in absentia, both by deliberately absconding and by his romantic early death; Scott by gripping his readers by the throat and bouncing them through one costume drama after another; and Moore by becoming the people's poet, an easy and stylish read and a light laugh in the early years of mass-produced books and journals. This communicated itself easily to Moore himself:

> Received a letter from a gentleman (or Lady, perhaps) in Scotland . . . telling me he is the centre of a little circle of admirers of mine, who all feel interested about me as a man, not less than as a poet, & entreating I would tell them the ages, names &c of my children – as they had seen in the papers lately that I had just had a fourth child – The letter is intel-ligently and feelingly written . . . It is strange how people can summon

up all this interest & take all this trouble about one who is a perfect
stranger to them.

A popular writer of a rarer and quieter kind, and one who had a particular
influence on artists, was Maria Callcott. During the twenty-eight years of
her working life she witnessed the initial influence of Byron, Scott and
Moore, the final victory over Napoleon in 1815, the Peterloo Massacre in
Manchester in 1819, a rampant cholera epidemic across the country in
1830, and the early turbulent years of parliamentary reform. The reigns of
four monarchs cross these years, as do astronomical discoveries that began
to widen human horizons, the dawning awareness of the manifold uses of
electricity, the spread of gas lighting in city streets, improvements in the
steam-engine, early flights of balloons, and the railway boom that began
to knit Britain together and revolutionize its time-keeping. It also saw the
beginnings of the rise of women in the arts and sciences.

As the eldest child of a naval officer turned revenue inspector, Maria
Callcott had an upbringing that provided all the ingredients for the breadth
of interest and understanding that she came to reveal in later life. From a suc-
cession of homes in the Isle of Man, Cheshire, Oxfordshire and Edinburgh,
Maria travelled with her father, George Dundas, on visits to lighthouses,
bridges and canals. Her knowledge of languages smoothed her way across
the world; the liberal arts gave her an understanding of science and society;
and instruction in drawing gave her the foundations she needed to look,
select and record people and landscapes in India, Italy and South America.
However, even in these early years, Maria suffered intermittently from the
tuberculosis that was to dog her throughout her life.

Maria Callcott is an important paradigm figure, as she straddles four
fertile sources for intellectual life: world travel, in the nineteenth century
still a rare experience, particularly for a woman able to reflect and to write
about it; literature, an area that women had long occupied but in a second-
ary role to the men who called the shots and commanded the world of
publishing; art, a form of expression which she practised at an amateur
level but wrote about percipiently and with profound understanding; and
society, in which her charm, engagement and evident beauty brought

her to some challenging social environments in Edinburgh, London and Rome. While she travelled in India, Italy, Brazil and Chile, some of Maria Callcott's toughest encounters were in the drawing rooms of Kensington and Mayfair.

Before leaving for India with her father, sister and brother in December 1808, she was Maria Dundas. In India, however, she married a young naval officer, Thomas Graham, whom she had met on the voyage from England. Maria Graham, as she had now become, looked closely at the country she found herself in, and wrote her *Journal of a Residence in India* in which she spotted a new perspective, an exploration of the country's scenery and monuments, and 'the manners and habits of its natives and resident colonists'. In her Preface she explains why this is necessary, and why her observations are so fresh:

> [F]ew people go to this remote region as mere idle or philosophical observers . . . Of the multitude of well-educated individuals who pass the best part of their days in it, the greater part are too constantly occupied with the cares and duties of their respective vocations as statesmen, soldiers, or tradesmen, to pay much attention to what is merely curious or interesting to a contemplative spectator.

In *Journal of a Residence in India*, which she illustrated with her own drawings, Maria Graham introduces readers to some strange new words, including: 'Bungalo – a garden-house, or cottage'; 'Cummerbund – literally waist-band'; 'Kooli – a porter. This is a very low caste'; 'Sherbet – a drink little different from lemonade'; 'Tank – a reservoir for water'; 'Tomtom – a kind of drum'. The originality of Maria Graham's approach was immediately obvious to the Edinburgh publishers Archibald Constable and Longman, who published the *Journal* in 1813. It sold well immediately; Maria noted:

> I have been six weeks in London, and in that period I have made some agreeable acquaintance, and my Indian Journal has been published. It has drawn upon me the public's eyes and perhaps might have made me a little vain of the entrances I have made into the world of Literature, especially by a yet untrodden path.

Hesitant and finding it extraordinary to be successful, Maria blinked her way from the Indian sun into the limelight of both Edinburgh and London. However, in doing so she came under fire from her own family, and added:

> But it is said no man is a hero to his valet de chambre and a prophet has no honor in his own country. So my own family not only keep me in humility on my own account but affect to despise my little work which after all considering it is the first of its kind is not so <u>very despicable</u>. It has procured me the acquaintance of the Romillys and I think their esteem, also that of Rogers, the Marcets, Tennant, Wishaw, the esteem tho unknown of the Hollands the Landsdowns [*sic*] etc, can it be so <u>very very despicable</u>? Besides to use even a bookseller's argument in less than a month 400 copies were sold – 300 in London and 100 in Edinburgh, and my publisher offers terms for a second edition!

An extract from her journal of 1813 shows just how deep into London society this intelligent young woman from Edinburgh had travelled:

> I spent the day with Mrs James Abercromby, whom I find more kind & amiable than ever. She was good enough to say that her party was on purpose for me. It consisted at dinner of Lord Landsdown, Ld Mulgrave [Melgrue?], Wishaw, Sharp, Hallam, Dupont, Horner & ourselves in Mr & Mrs A[bercromby]: & me.

They talked about Walter Scott's new long poem *Rokeby*, Samuel Rogers's interminable poem *Columbia*, and the new configuration of the House of Commons after the Tory victory in the 1812 parliamentary election. Maria found that Robert Smith, widely nicknamed 'Bobus' Smith, well known as an eloquent speaker and just elected to Parliament,

> in his first speech disappointed expectation, was abashed & faltered like a blushing youth. Horner augurs well of his speeches not on the side of eloquence but <u>reason</u> & <u>sense</u> & hopes for wit. A new member <u>Courtenay</u> seems to have the suffrage of all parties, he is apparently enlisted under Canning's banners.

After dinner the party was joined by others including the senior lawyer and politician Sir Samuel Romilly and his wife, and the distinguished physician Alexander Marcet and his equally if not more distinguished wife, the mathematician Jane Marcet. With these and the politician Francis Horner and the businessman Richard 'Conversation' Sharp, so called because he would talk a great deal, this was indeed a starry gathering. Maria left a clear record of her conversations, which were typical, no doubt, of the high and colourful standard of political and literary talk that would go on in intellectual society. She held her own because she could, and she knew what she was talking about:

> Horner, Sharp, & I got upon critical topics – Thompson [*sic*] – Milton – Gray – Dryden – Corneille – Racine – Sir Saml Romilly joined us. I seldom have passed such an hour!

The next morning conversation kicked off again: 'I breakfasted tête à tête with James [Abercromby] more & more delighted with him.' At the weekend Maria's social round continued at the home of the author Mary Berry in North Audley Street:

> [T]here were the Davys, J[ame]s Abercrombys, Mr Ward, Fred. Douglas, Mrs Tighe the sister of Psyche & two or three others some for ornament & some for use.

There she heard more about Rogers's agonies as a poet:

> I saw Rogers' strange publication – for 12 years he has so touched & retouched Columbia that at length it is only a bundle of fragments of 12 cantos, the 11th being quite wanting, made up with woodcut vignettes. Now he has published it he is so ashamed of it that he is buying up all the copies in order to suppress it entirely. He came into the room at Miss B's.

It was the literary fruits of Maria's Indian adventure, her *Journal of a Residence in India*, that had so marked her as a magnet for hostesses. She was on her own now, unaccompanied by her husband, as Thomas

was presumably at sea. Her first hostess, Mary Anne Abercromby, was the wife of the Whig MP for Calne, James Abercromby, who would one day become Speaker of the House of Commons: 'She was good enough to say that her party was on purpose for me.' This was a serious political salon, where Maria met Whig grandees, including Richard Sharp, the MP for the pocket borough of Castle Rising in Norfolk. She was particularly taken by 'Conversation' Sharp, a glamorous, witty bachelor who had made his fortune in the hatter's trade; thence he had moved to a house in Park Lane and another in the country, with an easy-going parliamentary seat to occupy during the week. What struck Maria particularly about Sharp was the route he had taken to reach his eminent social position, and the energy he had put into getting there:

> He was a manufacturing hatter who spent all his spare time at the Theatres, & was amazingly struck with Henderson the actor; not knowing how to get introduced to him he called upon him. Henderson pleased with his promising disposition gave him literary helps to cultivate himself. His circle of acquaintance enlarged and by his own meritorious exertions he is now a partner in Boddington's house, passes his time most agreeably in the best circles in London and is respected and well received everywhere as a man of <u>taste</u> and letters.

Sharp was one of the leaders of fashion: his hats bobbed about at all great social gatherings, from a Royal Academy exhibition to a Sunday walk in Hyde Park. The money he made from making and selling hats, and from his business partnership with West Indies sugar merchant Samuel Boddington, ensured his prosperity, while his sunny, talkative personality drew him to the best drawing rooms. Sharp's interest in theatre, politics, literature, trade and art caused him to spread his friendship widely, and as a result sightings of him and accounts of his character are plentiful. 'Thoroughly amiable, good-tempered, well-informed, sensible' was the verdict of his friend John William Ward, the foreign secretary in George Canning's government in the 1820s. 'He is a very extraordinary man', wrote Francis Horner. 'His great subject is criticism, upon which he always appears to me original and profound.' Sharp had met everybody, and

talked freely and fairly of those 'great men of the last generation and he appears to have seen them well . . . [he] makes you live for a moment in their presence'. 'Conversation' Sharp was a junction through whom many people passed. Charles Dickens ran across him and, nearly twenty years after Sharp's death, wound him into *Bleak House* (1853) in the person of the chancery lawyer Conversation Kenge:

> He appeared to enjoy beyond everything the sound of his own voice . . . it was mellow and full and gave great importance to every word he uttered. He listened to himself with obvious satisfaction and sometimes gently beat time to his own music with his head or rounded a sentence with his hand.

Such were the beginnings of Maria's journey into literary and political society in London. Her example throws a strong light on the way art, politics, literature and expression met, and thus how the wheels of the art and publishing businesses would turn by talk and encouragement.

Maria Graham continued her practice of exploring 'untrodden paths', travelling in 1818 with her husband to Italy, where she gathered material for an illustrated book about life in the bandit-ridden mountains around Tivoli and for a biography of the painter Nicolas Poussin, both books also to be published by Longman and Constable. Four years later, in a steam-powered sailing ship captained by Thomas Graham, she crossed the Atlantic, rounded Cape Horn, and entered the waters off Valparaiso. There Thomas died of fever, stranding his widow in Chile. But refusing offers of a passage home, or the cool comfort of the English community in Chile, Maria Graham went travelling some more, experiencing the terrible Chilean earthquake of 1822, making long journeys by land and sea, and, in Brazil, becoming tutor to the princess Maria. Her controversial report on the earthquake was published by the Geological Society. Maria Graham was a doughty correspondent, determined, in her writings and through the many illustrative drawings she made for her book about Chile and Brazil, to bring the rich lives and landscapes of South America to the British fireside, by living that life even in the faint but persistent tubercular shadow of what would develop into her terminal illness. *Journal of a Residence in*

Chile during the Year 1822; and a Voyage from Chile to Brazil in 1823 was published in 1824 by Longman, this time in partnership with John Murray. 'Yes I have been ill,' she wrote to John Murray on a brief home visit in 1821,

> but I am sick of saying so for every half hour changes 'I have been' for 'I am'. This day I am particularly unwell with a cough, perhaps tomorrow I shall feel as if I were fifteen, well and merry. I shall be much the better for something to be busy about.

On her final return to England in 1826 Maria Graham wrote anonymous articles for *Quarterly Review* and became one of John Murray's readers. Sending him ideas for publications and suggesting artists to be engaged as illustrators, she showed herself in her long and detailed correspondence to be a hawk-eyed reader and a perspicacious adviser.

Marrying Augustus Wall Callcott in 1827, Maria Callcott successfully reinvented herself as an influential opinion-former and a distinguished, gregarious and independent woman of letters. She was always frank and direct with Murray, writing a note marked 'Private' to disarm a misunderstanding:

> Nothing would be further from my intention than to write anything unkind to you or yours – if it seems so forgive me and attribute it to the real illness that leaves me often without power to think.

One of Maria's particular successes with Murray, when she had become Maria Callcott, was *Little Arthur's History of England*, published in 1835 and written for children with a Preface addressed 'For Mothers': 'I have endeavoured to *write* it nearly as I would *tell* it to an intelligent child.' She uses the classic pedagogic method of starting a chapter by recalling what she had told in the previous chapter; then by telling the story of the chapter, sometimes even highlighting what she is about to say; and finally by saying what she will tell in the next chapter. In a small octavo format, and with large, clear type, *Little Arthur* went into many editions and became a healthy source of revenue for both author and publisher. More specialized

was the book Maria Callcott published the following year with Murray, *Essays towards the History of Painting*. This she admitted was written as 'the best means of alleviating the weariness of an increasing and incurable disorder', her tuberculosis. The book reads as if it is just the beginning of an entire history of art, but gets bogged down in Egyptian and classical art to the extent that the Renaissance is touched on lightly, and the author becomes attracted most particularly to discussion of painting materials and methods. This suggests a close reading of sources, and her attentiveness to conversations with Humphry Davy.

To sell in the large quantities they did, the books published by Murray, Longman, Constable and others required the word of mouth and buzz that could be generated in the soirées and parties that Maria attended – both as 'Graham' and 'Callcott' – and that John Murray, Samuel Rogers, the Hollands, the Abercrombys, the Berrys, the Lansdownes and others might arrange. They also required the shelf and table space provided by such booksellers as John Hatchard in Piccadilly and George Lackington at the Temple of the Muses in Finsbury Square; and they needed the conviviality and cosiness of a club, the traffic of a high street, and the whiff of gossip and intrigue that coffee-houses or taverns provided.

In 1797 John Hatchard, a devout, industrious evangelical Christian with Tory leanings, set up his bookshop at 173 Piccadilly with £5 in his pocket. As his business grew, he moved first, in 1801, to number 190, buying for 1,000 guineas a twenty-four-year lease on the house, indicating that his profits were great and his confidence sufficient to contemplate such a move. Then, in 1823, he moved the shop to the present premises of the firm, number 187. Hatchard rapidly became a fixture in the life of Piccadilly, attracting to his shop royalty and churchmen, philosophers and artists, politicians, pamphleteers and the passing crowd; members of the Clapham sect of evangelical Christians, including John Venn, Hannah More, William Wilberforce and Richard Heber, met there. His stock of books reflected the rich productions of the early nineteenth-century publishing trade: his fifty-page catalogue of 1814 listed 7,000 titles, including, of course, *Childe Harold's Pilgrimage* – 'new and neat', as it was described. Hatchard's was also a centre for the distribution of tracts and pamphlets,

many of which he published himself. The causes he supported included the Society for the Bettering of the Condition of the Poor, the Anti-Jacobins, the anti-slavery movement, and, from its foundation in 1804, the Royal Horticultural Society. John Hatchard's conservative nature led him to dress in a black frock coat like a bishop, and like Joseph Baxendale in the allied trade of inland transport, he encouraged his staff, from errand-boys to floor-walkers, to hard work, diligence and self-betterment. In Longman's *Guide to London* the booksellers of the metropolis are pigeon-holed one by one:

> Nicholl in Pall Mall is bookseller to the King, Hatchard to the Queen, Murray to the Admiralty, Black & Co to the East India Company, and Egerton to the War Office.

William Beloe, a writer, translator and one-time curator in the British Museum, put it more drily. He lists London booksellers thus: the Dry Bookseller, the Finical Bookseller, the Opulent Bookseller, the Honest Bookseller, the Queer Bookseller, the Cunning Bookseller, and the Godly Bookseller, whom he names as Hatchard, 'a worthy and conscientious man'.

George Lackington was a bookseller of a very different temper. Trained by his cousin James Lackington, the proprietor of the Temple of the Muses, then Europe's largest bookshop, he maintained the Lackington policy of displaying books in quantity and selling them cheap. The motto 'Cheapest Bookseller in the World' was written up over the entrance to the busy shop, which in the 1810s employed over 100 people. Lackington published catalogues listing books in their tens of thousands, and bought not only from publishers, but also entire libraries, thus dominating the second-hand book market. James Lackington was a staunch Methodist, writing two books of memoirs proclaiming the Methodist way of life and the joy of bookselling. The first, *Memoirs of the Forty-Five First Years of the Life of James Lackington* (1791), was dedicated to '1. The Public; 2. To Respectable Booksellers; 3. To Sordid Booksellers'. With respect to the first group, his customers, he hoped for 'a progressive increase in the number and extent of your commands'; to the second, he acknowledged their 'candour and

liberality [that] he has in numerous instances experienced'; and to the third, 'those sordid and malevolent booksellers, whether they resplendent dwell in stately mansions, or in wretched huts of dark and grovelling obscurity', he promised, 'I'll give every one a smart lash in my way.' Bookselling in the late eighteenth and early nineteenth centuries was a cut-throat, dangerous and vengeful business. The Lackingtons made a fortune out of it, however, and they themselves provided a major part of publishers' income and a vibrant economic life for Finsbury. Then, as now, big profits in publishing were made by printing trash, and it was with the continuation of profit in mind, and the promotion of his business, that Lackington brought out his volumes of memoirs. 'Many gentlemen, who are my customers', he wrote,

> have informed me, that when they asked for [my memoirs] at several shops, they received as an answer, that they already had too much waste-paper, and would not increase it by keeping Lackington's Memoirs: and some kindly added, 'You need not be in haste to purchase, as in the course of the Christmas holidays, Mr Birch in Cornhill will wrap up all his mince-pies with them, and distribute them through the town for the public good.'

The connections between author, publisher, bookseller and reader form perhaps one of the simplest, even most primitive, economic chains of events that carry a product to its user. There are no primary essential external requirements here, such as land and fertilizer, factory and engine, coal and heat, disease and treatment, whose failure (or in the case of disease, presence) would damage the process of bringing the product to the consumer. It is a straightforward commercial transaction in which the author provides the words, the publisher makes the book or journal and sells it on to the bookseller, and the reader hands over the money to buy the product. Of course, a publisher requires a printing machine, but not any one machine in particular. A wet summer might damage crops, increase the price of a loaf and lead to social unrest, but it will not have a direct effect on book prices. An author might suffer from consumption, as did Maria Callcott, but his or her absence from the scene would make

no noticeable difference to the overall picture; there will always be another author, and books still sell posthumously. Authors, publishers and book-sellers do not need casts of thousands. Much the same can be said about the link between artist, dealer and patron, in which there is rarely any true rationale in the pricing structure, except comparison. The process is an organism of minimal complexity, and the transaction may be essentially bluff or barter.

When a further element is introduced – for example, the publisher adds the personality and economic requirements of an artist to that of an author – things become more complicated and interesting. John Murray found himself tied in knots when he allowed one of his authors, the architect and amateur topographical draughtsman James Hakewill, to get too far ahead of himself in commissioning illustrations for his book *A Picturesque Tour of Italy* when it was in production in 1818. Murray was being tempted to enter the world of print publishing in instalments, a process that had ruined many competent engravers and publishers, and one which was the initial format of Hakewill's venture. Murray had undertaken to publish engravings after Turner's improvements to a series of painstaking pencil drawings Hakewill had made on a tour of Italy in 1816 and 1817, and in June 1818 he paid Turner 200 guineas for ten completed watercolours. These gave the kiss of life, and a little harmless wit, to Hakewill's works, but cost twice the amount that Turner was being paid by George and William Cooke for watercolours of the south and west of England for engraving as the *Southern Coast* series. Hakewill, however, a highly organ-ized, determined and bossy individual, had not only engaged his friend Turner, but played the entrepreneur himself by inviting other fashionable topographers, including John Varley, Frederick Nash and Copley Fielding, to fan a sense of place and atmosphere into his drawings. Hakewill had also engaged distinguished engravers, including George Cooke, John Pye and John Landseer, to turn them into reproducible images at some considerable cost.

With all this expensive talent piling up on the costs side, Murray real-ized that it was he who would have to foot the bill in the end, and he hit the roof. 'I will not be answerable in any way for any drawings, engravings

or other expense that you may choose to incur for the Views in Italy,' he told Hakewill, 'without my positive consent being first given in writing.' Acting swiftly to contain matters and to focus on the work of the one artist whom he knew would attract paying customers, he added:

> It is necessary for me to say explicitly it was never my intention to extend this work beyond twelve numbers unless after making a reasonable trial of a portion of the said twelve numbers I found the sale of the work to prove sufficiently advantageous . . . it is not my intention to give out any other drawings to the engraver except those of Mr Turner. If you have of your own accord without my concurrence given orders for any other drawings or engravings it is at your own expense and risque and it is for this reason I advise you if you have done so, to order them to be immediately stopped.

Troubles with engravers came in their battalions for Murray in 1818, for in that same year he had a quarrel with Charles Heath over engravings for an edition of Byron's works.

> The cause of my suffering myself to be persuaded by you to engage in a new set of plates for Ld Byron's works which I neither wanted nor contemplated – was your dwelling on the cheapness, dispatch, ability & absence of all trouble even as to payment with which they would be executed. The Drawings were to be done for 10£ or Guineas and the engravings in no instance to exceed £20 or Guineas. I was not to be asked for a shilling until the whole should be completed and be put into my hands for publication . . . You may have said differently – but if so it is the last transaction I ever will enter into with you. The whole of these engravings were to have been executed at least Eight months ago, & you now send me home only six that are finished & asked me to give you £300 . . . upon what principle of common justice do you expect your demand to be attended to the moment it is made when you set the example of such shameless deviation from all punctuality yourself – to say nothing of the gross indelicacy of making so instantaneous demand at a period of the year when my man of business is doing his books [i.e. accounts].

While illustrations made books and journals more attractive to buyers, the expense and complexity of publication led to a high increase in

'risque' to the publisher. This in turn led to a financial fragility in firms of publishers and engravers, and a lucrative flow of bankrupt property: Charles Heath, like Hurst and Robinson, went bust in 1825 when banks failed; and Francis Moon bought up Hurst and Robinson's stock of engravings.

The wheeler-dealing publisher Charles Tilt, who muddied the waters for artists and publishers, was considered by many to be among the lower life in print publishing. Working for the publishers Thomas Longman and for John Hatchard at his bookshop in Piccadilly, Tilt learned the book trade from back to front, and discovered new ways to make money within it. Among his innovations, introduced to the market from his shop at 86 Fleet Street, was a miniature-format almanac that could be carried under a hat, and tiny volumes of *Tilt's Miniature Classics*, which came in luxury rosewood gift boxes lined with satin, behind glazed doors with a little brass lock. Hundreds were given as Christmas presents; most would be opened once and left unread, their minuscule print requiring a magnifying glass, sharp eyes, good light and determination. Eliding innovation with invention, Tilt made a fortune. His shop on the corner of St Bride's Passage and Fleet Street, near George Adams's scientific-instrument shop, had extra window space and had to have rails fitted at peak times in the booksellers' calendar to contain the crowds that pressed to look inside. One *cause célèbre* that Tilt took advantage of, and which brought crowds to his windows, was the case of the 'Burkite' murderers Williams and Bishop, who had killed a boy in 1831 to sell his body for dissection. After their conviction and hanging at the Old Bailey in front of a huge crowd – 'a vast lake of life', as *The Times* expressed it – Tilt published and sold a print of the condemned men.

Tilt operated across the spectrum of publishing, from lurid imagery such as the Burkite murderers, to complex productions such as the booklet *Sketches of the Works for the Tunnel under the Thames from Rotherhithe to Wapping* (1829). This celebrated the completion of Marc Brunel's extraordinary engineering achievement with statistics, descriptions, a series of exquisite engravings by Robert Cruikshank and Thomas Blood, fold-outs and hinged flaps clearly showing how breathtaking and technically difficult

the tunnelling was. In terms of engineering prowess it was on a par with the Crystal Palace of twenty years later, but with the additional challenge of being underground, underwater, and with the ever-pressing danger of influx from above. Tilt's publication, one of many celebrating Brunel's tunnel, was produced to catch the public mood of amazement that such heavy engineering evoked. Another of Tilt's consummate productions was George Field's *Chromatography*, published in 1835 (see page 190), a high-quality folio volume which had a limited market, but was paid for by subscription from interested parties, and dedicated to Sir Martin Archer Shee, president of the RA, and to the 'Artists of Britain'.

Creating complex publications and lurid imagery was only one side of Tilt's business. With authors and artists he made a practice of sailing close to the wind and would land himself in court in front of artists, authors and publishers incensed at his methods. John Martin, Augustus Callcott and a benchful of artists came to the Mansion House in October 1833 to support Turner in his formal complaint to the Lord Mayor of London against Tilt's practice of employing artists to re-engrave images which were in copyright. In this case, three of Turner's illustrations for Walter Scott's *Provincial Antiquities of Scotland*, originally published about ten years earlier, had been re-engraved in a smaller format and passed off as Turner's own work after the original copper plates for the Scott publication had been sold at auction and bought by Tilt. A similar infringement had been suffered by Callcott.

'They were sold without my consent', Turner told the court, but Tilt insisted that he had bought copyright in the images along with the plates themselves and had invited Turner to retouch, or correct, the image to be printed.

'I don't see why an artist should retouch without remuneration,' Turner added. 'But how could I retouch when the originals are in the possession of Sir Walter Scott's executors?' Tilt claimed that he had offered the artists involved the opportunity to retouch the plates, but Turner had refused. 'I wished for a division of labour and profits, but Mr Turner wished to monopolize, and would not give a share to his brother artists. He knows he has not a leg to stand on', taunted Tilt, 'or he would not resort to this

mode of complaint. I am proprietor of the plates, and I dare him to the test of our claims in a court of law or equity.'

Thus challenged, Turner responded: 'I trust . . . that the public will be put in possession of the way in which these things are done, that works by other persons are foisted upon them as the works of distinguished men.'

'Oh, Mr Turner,' retorted Tilt, getting the last word, 'you ought to let your brother artists have a little slice.'

The case revolved around the quality of the revised engraving, and the loss of income and reputational damage that Turner and other artists might suffer. It also had the added ingredient of legal uncertainty, which Tilt exploited, as many of Scott's copyrights had been sold after the author's bankruptcy in 1826. The plates to *Provincial Antiquities* were bought by William Cooke, who auctioned them. So it was not wholly clear what Tilt had acquired at auction and what he had not, and the only place to test it was in court. Nevertheless it was too much for the Lord Mayor, who gently suggested that Turner should take out an injunction in the Court of Chancery. That would have got him nowhere slowly, a process that Dickens would later painfully illuminate in *Bleak House*, and Turner wisely withdrew. Some weeks later, a notice appeared in the periodical *Atlas* advertising Tilt's edition of *Illustrations . . . to the Poetical Works of Sir Walter Scott*. The note drew particular attention to the inclusion of

a rather rabid but effective representation of sea, rocks and castle at Tantallon, one of the restored plates from TURNER'S drawings for 'the Provincial Antiquities of Scotland,' which TURNER begs the world will not believe to be his.

Tilt also abused the gentle and vulnerable Mary Lamb, the co-author, with her brother Charles, of *Lamb's Tales from Shakespeare*. She applied for a restraint on him for invading her copyright in this very popular book when publishing a new edition two years after Charles's death. Tilt should certainly have known that Mary was co-author, but he omitted her name from the title page of early editions. *The Times* reported the matter partially and

brutally, stating that, Miss Lamb having entirely failed to make her case, it was 'unnecessary to give any detail of facts, which contained no interesting feature'. The court refused the injunction, on the grounds that, as Mr Lamb had been held out to be the author of the tales with his sister's assent for a period of twenty-three years, the public had a right to assume there was no copyright existing in Miss Lamb. This was a complete rip-off, compounded the next day by Tilt's solicitor, Thomas Hepworth, who pointed out in a letter to *The Times* that the copyright had not in fact expired, but that Tilt had not been told of Mary Lamb's copyright claim until after printing had commenced. Tilt was aggrieved that he remained liable for further action in the courts and had not been granted costs.

Soon after his death in 1861, Tilt was described by an amateur genealogist researching the Tilt family as 'Charles Tilt – the millionaire'. While that may have been an exaggeration, Tilt nevertheless made a fortune. In his portrait, representing the letter 'T' on the back cover of George Cruikshank's *Comic Alphabet* (1836), Tilt stands self-possessed behind the counter of his shop, with a neat quiff in his well-cut hair, high collar, and cleft chin. He resembles no one so much as a scientist at a laboratory bench, or a teacher addressing his class. Around him are piles of books and printed sheets, one reading 'National Gallery', another 'My Sketchbook' by George Cruikshank in nine parts, yet another 'The Epping Hunt' by Thomas Hood. Charles Tilt, hero, victim and villain, is the epitome of the successful publisher, happy and able both to go with the flow and to seize his moment, and in the end to come out on top, ahead of fashion, technology and the market.

CURATOR:
'THE AWFUL CARE'

When the director of the Berlin Museum, Gustav Friedrich Waagen, made his first crossing of the North Sea in 1835, the paddle-steamer from Hamburg creaked and rolled, and he was as sick as a dog. In the round-about way characteristic of his writing he observed that in his sea-sickness he was on classic ground:

> the powerful sea-god Neptune belongs to the family of Aesculapius, and in his own element shamefully meddles in the profession of his relation, by administering powerful emetics.

Such baroque circumlocution about bodily functions on the first page of his three-volume work on art collections in England sets the scene for the detail and chromatics of the observation and writing to come. It was first published in Germany in 1837, and in England the following year; a revised and expanded edition appeared in English in 1854, translated by Elizabeth Eastlake, the wife of the director of the National Gallery. While this was not the first survey of art collections in Britain – Waagen was preceded four years earlier by the German painter and author J. D. Passavant – it was the most thorough and influential to date, and set a standard of research on the subject which was followed until far into the next century.

As director of a great and ambitious museum, Waagen was the proto-type for the profession of museum curator that spread worldwide across the succeeding 150 years, into our own time. He combined the disciplines of art history, of which he was a pioneer in Germany, with sociability, splendid contacts, a talent for gaining admittance to fine houses, and a way with words. Further, he had an eye for the opportunity of making

judicious purchases for the ambitious Prussian government of art collections from declining aristocratic families and impoverished churches throughout Europe. As a young man he had lived and studied in Rome, where he associated with ex-patriate German artists, and having served in the Prussian army from 1813, he was able to study the looted collections in the Louvre when the allied armies occupied Paris from 1814. He would not have known the London diarist Emilia Venn's shocked reaction when she heard how Field Marshal Blücher had behaved in the Louvre in 1815, soon after Waterloo. On her visit to the battlefield less than eight weeks after the slaughter, she heard gossip that all the Prussian field marshal could say, as he clomped around the galleries in his high boots, was 'I'll have that!' The curator of which Waagen was the prototype required skills that could distil the rapacity of a Napoleon and the determination of a Blücher into an acquisitiveness for the public benefit that anticipated both a national glory and a humane civic outcome.

Waagen's was a spectacular and successful career in which he helped to lay the pathways required to make great art accessible to the public in Germany. However, to get a full understanding of the subject a visit to England was essential. When he arrived in London, Waagen was already a living foundation stone for a new profession whose purpose he would exemplify. Like all foreign visitors arriving in London by water, Waagen was overwhelmed by the volume of shipping on the Thames, its forest of masts, its pavement of decks, its polyglot nationhood. The river sparkled in the sun, and he was soon translating the scene into familiar territory and preparing himself mentally for his task by finding paintings everywhere:

> Now, for the first time, I fully understood the truth of [Dutch marine] pictures, in the varied undulations of the water, and the refined art with which, by shadows of clouds, intervening dashes of sunshine . . . and ships to animate the scene, they produce such a charming variety in the uniform surface of the sea.

Observing, as he was driven to his hotel, how like Dutch paintings were the workshops open to the London streets, he remarked how such paintings 'far surpassed by their *naiveté* the artfully arranged living pictures'.

While the National Gallery had been open in Pall Mall since 1824 and would move to its own new building in Trafalgar Square in 1838, Britain was still a nation of private collections. The most comfortable places in London to see pictures remained the grand houses of the great – the old money. Waagen visited them all, and visited also the town houses of gentlemen whose comparatively new wealth came out of manufacturing and industry, banking and agriculture, minerals and transport. He enjoyed his quest hugely: 'my life is here filled with a succession of rich and interesting enjoyments!' Waagen received generous hospitality to the extent that his book is also a hymn to English cooking, one that Maria Rundell might have appreciated:

> The celebrated and truly excellent national dish, the plum pudding . . . forcibly calls to mind the petrified primeval fluid mass, the conglomerate of the mountains, aptly called pudding-stone. It is likewise a symbol of the English language, in which the flour very properly represents the German, and the plums the French part.

Enjoying the display of Spanish paintings in the collection of the historian of Spain, Richard Ford, Waagen was treated to another fine dinner:

> A succession of savoury and characteristic dishes initiated us gradually and agreeably into the mysteries of the Spanish cuisine, while a complete harmony of keeping was further insured by the accompaniment of most legitimate Spanish wines.

As much as Waagen's volumes are about the treasures in Britain, they are also a travelogue exploring British life and manners, setting the nation's artistic wealth into its rich social context. It took a German art historian to suggest it, but plum pudding with Spanish cuisine is a pretty good, if unintentional, metaphor for the variety of art collecting in Britain in the nineteenth century.

Touring the grand palaces of the West End of London and out into the country, Waagen was able to marvel at the accumulation. He noted

how the English ruthlessly took advantage 'of the circumstances of the times' – wars, revolution and social unrest – to collect works of art from the continent. Drawings, engravings, manuscripts, gold and silver objects and sculpture – anything, indeed, that could be moved and had beauty and value – were harvested by English collectors, creating what Waagen saw as an '*embarras de richesses*'. He wished he had had 'the hundred eyes of Argus' to take it all in. It is these avid, enthusiastic and ruthless instincts that marked British collectors out, and without them Britain's rich public art collections would never have come together. Waagen greatly enjoyed meeting the grandees, for there is none so grand as an English grandee. He got up as far as the prime minister, the collector-politician son of a cotton king, Sir Robert Peel, who he found had 'engaging manners and the most refined and polished address'. Among Peel's pictures was *The Chapeau de Paille* by Rubens, now in the National Gallery. This was one of Rubens's own favourite works, which he had refused to part with during his lifetime. It was sold at auction in Antwerp in 1822, and then to the picture dealer John Smith for £3,000. Failing to sell it to George IV, Smith displayed the painting the following year in Old Bond Street, where 20,000 people saw it – among them Turner, who drew a sketch with colour notes. Peel bought the painting for £3,500.

Another collector, the horticulturalist founder of Westonbirt arboretum, Gloucestershire, Robert Stayner Holford, gave admission to his collection 'with the greatest liberality to all lovers of art'. Holford's wealth came from an unexpected source:

> Hereditary thrift, along with a cache of bullion buried on the estate of an uncle in the Isle of Wight during the threat of Napoleonic invasion, contributed to the fortune which enabled Robert Holford to accomplish his life's work.

Holford came to build Westonbirt House in Gloucestershire, and from 1849 he built Dorchester House in Park Lane. Waagen saw Holford's manuscripts, sculpture, paintings and other treasures at the collector's then home in Russell Square, the house formerly owned by Sir Thomas Lawrence, where he was left alone to study the works, 'a kindness contrasting

favourably with the habits of other owners of MSS in England'. Waagen
needed time with the treasures:

> I always endeavour if possible, to see pictures of . . . excellence twice; sur-
> prise and admiration not allowing me at first that calm, composed enjoy-
> ment which is necessary to penetrate into the essential and fundamental
> properties of important works of art.

Waagen's task of reporting back to the Prussian government on art and
artists in England, and on collecting habits across the North Sea, came
at the time when the aristocratic connoisseurs of the Grand Tour genera-
tions were being joined in the hunt by the heirs of fortunes from trade
and commerce, such as Robert Peel, Robert Holford and Robert Vernon.
Money flowing through the agency of dealers buying for private clients
was to be joined in the 1850s by money allocated to such figures as Charles
Eastlake and Henry Cole, director of the South Kensington Museum,
later the Victoria and Albert Museum, who were buying for the nation.
They were able to continue to travel around Britain and the continent and
bring a harvest home. On being made director of the National Gallery in
1854, Eastlake was given 'carte blanche' by the then prime minister, Lord
Aberdeen, to reinvigorate the collections. With £10,000 a year allocated to
him by the government to spend on works of art, Eastlake crossed Europe
in search of old master paintings.

Collections are by their nature personal and severely temporal. The
melancholy of a collection dispersed was evoked by Peter Patmore, writing
of the empty walls of Fonthill after Beckford's sale in 1823:

> The works which composed its principal ornaments exist, and will even
> (in imagination) keep their places on the walls where they have once
> hung . . . *there* they will continue to hang, till we shall chance to see them
> in some other place; as the image of a lost friend for ever occupies the
> spot where we *last* saw him.

Few collections are complete, requiring countless routes via the agent, the
banker and the address book to approach a wholeness that can never come.
The art critic and dealer William Carey, a character on the edge of the art

world in the first decades of the nineteenth century, acted as agent for Sir John Leicester. He satirized the blind fashion for collecting art from the continent by observing that British collectors tended to reject the evidence of their eyes 'as unfit to be trusted, and looked at pictures with their ears'. Carey was a member of the unreconstructed English school of curatorship, involving himself less in rigorous art history and strategic acquisition in the Waagen manner, but variously in opportunist art dealing from premises in Piccadilly, in published criticism, and in taking instruction from Leicester on managing a great man's art collection.

Carey's career began in Dublin, where as an art critic he wrote under the pseudonym Scriblerus Murtough O'Pindar, thus demonstrating that art critics such as Carey and his contemporary Thomas Wainewright the Poisoner (a.k.a. Janus Weathercock, Egomet Bonmot, Cornelius van Vinckbooms) had a lively sense of the ridiculous. He had tried to be a painter, but an accident to his eye put paid to that ambition. Moving from Ireland to London, taking the long route via Philadelphia, he fearlessly banged the drum for British art by British artists, commending for example the work of the young Francis Chantrey in the Sheffield press, and mocked the prejudice of the connoisseur. A collector in London, 'of rank', he averred,

> would have considered his character as a Connoisseur irretrievably forfeited, by having a landscape or an historical picture, by an English painter, hung up in his apartments. With a very few exceptions, this humiliating and groundless prejudice continued to prevail among the higher classes.

Carey made enemies: he was described in print as 'one of the greatest pests in English art'. Nevertheless, he stuck to his guns and opined that the measure of a painting to British collectors was not what it looked like, but what tribulations it had experienced, how wild and incredible a history it had had:

> *The how many* Royal, Princely, and Noble Galleries and Cabinets it had passed through; *the miraculous good fortune* by which it had been

obtained on the Continent; *the when* it had arrived in England; *the dangers* which it had escaped in its voyages and travels; *the awful care* with which it had been enshrined and kept up from the profanation of vulgar eyes after its arrival; all of these important particulars, which were wholly *extrinsic* of the picture or statue, formed the tale of mystery, the source of admiration, and the true value of the purchase.

Sir John Leicester called upon Carey in the development of his collection, but nevertheless muddles occurred. Writing to James Northcote, Leicester apologized for slow payment:

> I regret . . . very much your Angelic Picture [listed as 'A Group of Angels'] should have remained so long unsettled for, but it always [..?..] in my Head that it had been settled for by Carey. I enclose 40 gns which I believe was the sum.

Leicester steered clear of the art of the continent in bringing together his pioneering collection of British painting. Carey campaigned in support of Leicester's taste, remarking on the state of collecting in Britain:

> Nothing could be more prosaic and dull to a true Anti-British *Absentee* accustomed to *judge of pictures by a tale of wonder*, than the simple information, – *this picture* was painted only a few months ago, by *Mr. Hogarth*, or by *Mr. Wilson*, or by *Mr. Gainsborough*, or by *Mr. West*, each of which is an English Painter, living within half an hour's walk in London, in such and such a street, lane, or alley.

Carey was a driving force behind Leicester's championing of Turner. He saw Turner as

> the enchanter, whose magic pencil had created the chief wonders of this temple . . . Nature, in endowing his mind, appears to have been indifferent to his person; but his brow is a page on which the traits of his high calling are stamped in capital letters, and his dark eyes sparkle with the fires of inspiration . . . It is more than seven years since I saw this extraordinary exhibition; and even now the remembrance affects me. It is as the sound of thunder, above me, in the firmament, and my blood

is moved. It is as the coming of one in clouds and lightning, and I feel a lifting up of my spirit. I see the sublime and beautiful of the mighty master! The powerful spell of the modern Titian is upon me! I own I am an enthusiastic worshipper of Turner's genius; and I would never quit the attitude of adoration; but that I am sometimes obliged to start from my knees, and to strain my eyes down the immeasurable descent to which he is occasionally hurried, by the glorious, but dangerous ambition of extending the circle of his fame and the dominion of his science.

Temporary art exhibitions were largely outside Waagen's remit. These had come together since the late eighteenth century through the energy of entrepreneurs and artist-organizers, working both together and in rivalry to create a dynamic exhibition network as a means to sell pictures. Earlier in our period individuals such as John Boydell, Count Truchsess and Michael Bryan ran galleries that rose and fell according to the market and the pattern of taste. By the mid-nineteenth century commercial and cultural evolution had produced a mix of exhibition species that were at once vivid, raucous, humdrum and inventive. Among the inhabitants of the exhibition world from the 1810s to the 1830s were William Bullock, the owner of the Egyptian Hall in Piccadilly; the publishers and engravers Charles Heath and the Cooke brothers, who mounted exhibitions of paintings and the engravings after them; the collector John Hornby Maw, who dabbled in curatorship; artists such as Turner, Martin and Benjamin West, George Garrard, Flaxman and Chantrey, whose studios were more or less open for interested people to call by appointment; institutions, principally the Royal Academy and the British Institution, which mounted truly public exhibitions for all comers at advertised times; and the promoters of panoramas, which were open daily. All public exhibitions of this kind charged an entrance fee, or one disguised as an obligatory catalogue purchase. Turner described something of their plethora in a letter of 1827 to James Holworthy:

Come and see all the shows of the great town . . . The water colour opens next Monday, the British artists last Monday, the roundabout Monday week, the shop Monday fortnight. The lions are fed every night at eight

o'clock and bones made use of every Thursday and Monday evenings at Somerset House during the winter season.

The exhibitions Turner refers to are the Old Water-Colour Society, of which John Varley was a stalwart, the British Institution, the Royal Academy ('the roundabout'), and the lions at Exeter 'Change (see pages 311–12). The 'bones' are the ivory free-entry tickets to the Royal Academy, issued to members for their friends, while 'the shop' was his own gallery in Queen Anne Street West.

Until 1806 the most popular and best-known institution for showing art publicly in London was the Royal Academy in Somerset House. There, each year from late April until the end of June, the members and associates of the Academy opened their doors to all comers to show the paintings, sculpture and architectural designs that they had created over the preceding year. By the end of the century this event had evolved into the annual Summer Exhibition of the Royal Academy, which runs still. An alternative and rival emerged when the 'British Institution for Promoting the Fine Arts in the United Kingdom' was formed and moved into the former Shakespeare Gallery at 52 Pall Mall. The failure of John Boydell's business in 1805 after sixteen years of trading had left the building vacant, and it was sold by lottery (see pages 151–52). A consortium of connoisseurs bought the lease from the lottery winner William Tassie for £4,500 as the home for their new counterpoint to the Royal Academy. These 'angels', who balanced a constructive concept for the public appreciation of art and an art school with a healthy self-interest, included the bankers Sir John Julius Angerstein and Thomas Baring, and collectors and taste-makers Sir John Leicester, Sir George Beaumont, Sir Richard Payne Knight, Lord Lowther, Samuel Whitbread, Caleb Whitefoord and the Rev. William Holwell Carr. They were attempting to echo the purpose of the Royal Institution for science in Albemarle Street and to create an institution which aimed to

improve and extend our Manufactures, by that taste and elegance of design, which are to be exclusively derived from the cultivation of the

Fine Arts, and thereby to promote the general prosperity and resources of the Empire.

This altruism also allowed collectors to exercise a refreshed influence over the production of art and its public demand. An additional purpose behind the British Institution was to counter the perceived excess of power held by artists, through their creature the Royal Academy, which for the previous three decades had been the only effective institutional link between artists and patrons.

Sir Joseph Banks was a leading advocate of the British Institution. He expressed his trenchant and considered view that three great schools of painting of the past were the direct result of the 'moneyed prosperity of the three countries in which they flourished':

> The Venetian School arose when that Town was the Emporium of the East; the Flemish when Antwerp was that of the Western World; and the Roman when appeals to the Roman Ecclesiastical Courts made their Lawyers almost as rich as our Civilians are now . . . In this Point of view the time is come when England has the means through her commercial prosperity to foster a fourth school . . . If half of the money that has of Late years been lavished upon Repainted originals had been divided among our artists, the business would by this time have been done . . . The Arts will always flourish in Proportion to the patronage given them by the Rich.

Beginning with a series of annual selling exhibitions of the work of living British artists, diplomatically organized to open in January and to close in late April so as not to clash with the Academy, the British Institution also developed a programme of exhibiting 'Ancient Masters and other deceased artists', drawn from the collections of subscribers, in various configurations of nationality and period. The British Institution did not claim directly to be a rival of the Royal Academy, but from the beginning it nevertheless made sideswipes at Somerset House, proclaiming itself to be the most patriotic of art institutions. A thoroughly partisan article in *The Times* in 1806 put its case, asserting extraordinarily that 'the Royal Academy has given some éclat to the Arts, but done them no service':

It has been asserted carelessly, unreflectingly, and, we might add, impudently, by the Abbé Du Bos, and other superficial writers on the Fine Arts, that the English nation, from its character and climate, would never form a School of Painting.

Jean-Baptiste Dubos, the French Enlightenment historian and critic, had died over sixty years earlier, but his criticisms in *Réflexions critiques sur la poésie et sur la peinture* (1719) still seemed to carry a sting, which was the more potent during these decades of war with France. The writer in *The Times* went on to observe maliciously that the arts have 'certainly wanted encouragement in Great Britain', and that a characteristic of British patronage was that it came 'principally through commerce, of a nature by no means calculated to advance their progress towards perfection'. The phrase 'principally through commerce', which evokes the purpose of the Society of Arts, was intended here to drive a wedge between the old money and the new. Still leaning towards the old money, *The Times* declared that the British Institution was

> formed on such principles, governed by such regulations, supported by such munificent liberality, and patronised by persons of such high distinction, superior knowledge, and refined taste, that everything is to be expected from it, in favour of the Fine Arts in the United Kingdom.

The first exhibition at the British Institution was a celebration of living British art, with over 250 works both lent for sale by artists and loaned by subscribers. This emphasis on, indeed celebration of, rich men's property defined the difference in stance between the Institution and the Royal Academy. So did the public face of the Institution: their porter was dressed up in a scarlet gown trimmed with blue and he wore a gold-laced hat. In co-operation with the Academy, the time-tabling of the Institution's exhibitions ensured that they did not show living artists at the same time. While the Institution encouraged copying of 'ancient Masters' from its walls, was developing its own collection, and had its own art school, the Academy considered itself to be the nation's leading school of art,

responsible for training and nurturing artists from youth. The Academy's income came from exhibition entry fees and sales of catalogues, and its prestige from the talents of its past pupils, its present Academicians, and the promise and prospect of current and future students. The British Institution, however, initially had the ready money it needed because its sponsors – bankers, businessmen and aristocrats – ensured it, and these connections were all the social and financial prestige it needed at first to match that of the Academy. But the Academy also had a royal charter, something that the Institution lacked. Thus, for the good health of art it was essential that the two powerful organizations should find a way of working together.

In its early years, the exhibitions at the British Institution covered subjects that touched on Academy territory. Thus in 1813 there was an exhibition of 143 paintings by Sir Joshua Reynolds, and in 1814 an exhibition featuring works by Gainsborough, Hogarth, Wilson and Zoffany – all artists safely dead, but nevertheless closely aligned with Academy interests. In the following two years there were exhibitions of Flemish and Dutch art (1815) and Spanish and Italian (1816), and following those a series that tended to rehash old topics with 'Deceased British' (1817), and 'Italian, Flemish, Dutch and French', and so on. It was an ambitious mix and match, climaxing with two exhibitions from the Royal Collection lent from Carlton House in 1826 and 1827, but one which drew on a diminishing supply as owners increasingly refused to risk or repeat the loan of their treasures. The rise of the British Institution took place against a background of severe difficulty for the Academy and partisan dismissal of its achievements. The British Institution's first keeper, or curator, Valentine Green, rescued now from poverty by an annual salary of £100, oversaw the exhibitions and sales, while his successor, John Young, produced catalogues of the collections of a number of the Institution's supporters, including Leicester, Lord Grosvenor and the Marquess of Stafford. Young wrote in the introduction to his catalogue of Sir John Leicester's collection that 'the establishment of the British Institution was the first public demonstration in favour of modern artists'. That was patently not the case. He went on to say:

This institution having solely in view the promotion of art, by bestowing bounties, purchasing pictures, and providing, through the medium of an annual exhibition, a Mart for the disposal of works of Art, has been the means of producing performances of the highest class.

When the Institution's first exhibition closed in July 1806, *The Times* announced that 5,000 guineas' worth of paintings had been sold, 'a sum thus distributed in the encouragement of the Arts, and in the promotion of taste and talent in the manufactures of this country'. While it was attempting to promote itself as a more effective way of channelling money to artists than the Royal Academy, it is nevertheless clear that this grand gesture masked the level of mediocrity of those artists whose work had been bought by grandee purchasers. The British Institution's president, Lord Dartmouth, bought a cottage scene by William Owen; and the Earls of Stafford, Carlisle and Egremont bought works by William Westall. The comparison to be made here is that at home these aristocrats hung paintings by Rubens, Rembrandt and Van Dyck, ludicrously strong competition for Owen and Westall, to the extent that one might suspect that at the British Institution they were just marking time. Other artists purchased at the British Institution in 1806 included Academicians Robert Smirke, John Opie, James Northcote, Sir William Beechey, John Singleton Copley and George Dawe. Only Opie and Copley had a level of merit that shows them in the twenty-first century to be significant of their period. That some Academicians, notably Turner, exhibited at both the British Institution and the Royal Academy indicates that the rivalry between the two institutions was carried on at managerial rather than practitioner level.

The subscribers and directors of the British Institution really did seem to believe in 1807 that they were saving the nation's artistic soul:

This laudable zeal on the part of our Nobility and Gentry Amateurs, which appears to be now bursting forth to rescue the National character from the aspersions cast upon it by several foreign writers, cannot fail of exciting the gratitude of every Englishman who possesses the happiness of being able to appreciate the dignity and importance of the Fine Arts, whether considered either in an individual or political, point of view . . .

we trust that this splendid patronage will stimulate the best exertions of British artists to meet this honourable encouragement.

Within ten years, however, the level of enthusiasm for the British Institution had dropped as the Royal Academy found renewed strength. 'We entered the rooms of the British Gallery [sic]', wrote The Times of the current exhibition of Paintings by Deceased British Artists,

> with tremulous expectations. We came away with disappointed hopes and feelings . . . the general effect is painful and unsatisfactory. The pictures which are at present exhibited of the best of English artists – we mean Hogarth, Reynolds and Wilson – are in truth little more than the refuse of the works of those artists which were omitted in the late exhibitions. The rest are, in general, inferior even to these.

Terse comments rounded on individual works. Of John Hamilton Mortimer's *Bacchanalian Dance* the critic wrote: 'Mortimer was in his day called the English Poussin. Those who saw the pictures of Poussin in the Gallery last year, and who see Mortimer's in the present collection, will not insist very strenuously on the comparison.' And of the great Sir Joshua Reynolds's *Holy Family, painted in Italy*: 'It is well Sir Joshua left this manner behind him when he left Italy.'

As the years went on, the exhibitions at the British Institution began to falter as public demand for a continuous exhibition programme coincided with an increasing disinclination of owners to lend their paintings for display. Most of the lenders were subscribers to, if not directors of, the British Institution, and while they were all collectors, or had inherited art collections, they evidently came gradually to feel that enough was enough, as the value and rarity of their possessions increased and as transport risks grew greater. *The Times* began to notice a fall-off in quality and put its finger on the reasons when reviewing the British Institution's exhibition of Italian, Spanish and French masters in 1824:

> The collection appears to be less numerous than usual, but this we are not surprised at; the only wonder is that the directors should be able to

go on year after year furnishing as they do a fresh supply of food for the
increasing appetite for works of art. It is evident, however, that they find
it more difficult to procure specimens of excellence than of novelty, and,
small as the collection is, we would rather see it reduced to one-third
of its extent than made up as it is in great measure of works that can
neither be profitable to the arts nor creditable to the artists whose names
they bear. We are satisfied that there are many works in this and other
galleries which were never even seen by the great masters to whom they
are attributed.

In the later 1820s *The Times* uncovered what it saw to be serious mal-
practices and collusion between the British Institution and the National
Gallery nearby in Pall Mall. Both institutions employed the art dealer and
picture cleaner William Seguier: at the British Institution he had succeeded
John Young as keeper, while at the National Gallery he was also keeper. In
addition, Seguier was Surveyor of the King's Pictures. This was an elegantly
tight monopoly of all the top jobs in the field. Seguier had been trained
as a painter, and appears to have gone into picture dealing and cleaning
when he married money. Over the years he bought paintings for Henry
Hope, Samuel Rogers, George Watson Taylor MP, Sir George Beaumont,
Lord Grosvenor, the Duke of Wellington and Sir Robert Peel. The list of
his clients ran long and deep into influential territory, leading eventually
to unrest amongst interested members of the public and accusations of
collusion. Seguier was described by John Constable to the young C. R.
Leslie thus:

> When your pictures arrive at that state to deserve patronage, Seguier will
> provide it for you, as he is hand in glove with all the picture-buyers in
> England.

The Times published a series of letters from an unidentified correspondent,
'Alfred', complaining about the 'ruin of the British Institution . . . which
had declined with the increased influence of [a director] Sir Charles Long
and the "picture cleaner" engaged by the National Gallery, William Seguier'.
Alfred was convinced that jobbery and humbug were already influencing
the management of both the British Institution and the National Gallery,

and revealed that Seguier and Long were advising both institutions. Seguier, as Surveyor of the King's Pictures, also advised George IV on purchases. He was behind the acquisition by the National Gallery of Parmigianino's *Madonna and Child with SS. John the Baptist and Jerome*, which, as Alfred alleged, 'was originally . . . in the possession of a frame-maker in Conduit Street, but at length found a purchaser at the price of 40 guineas'. This is bizarre, as Farington had long before reported that the painting had been bought in Rome in 1795 by Lord Abercorn for 1,500 guineas. It eventually entered the collection of George Watson Taylor, at whose sale in 1823 its price had multiplied over seventy times from the alleged 40 guineas to £3,050, and was purchased by the Rev. William Holwell Carr. Holwell Carr lent it to the British Institution and then in 1826 presented it to the National Gallery:

> Here is an increase in value without example! The reason shall appear as
> I proceed, to the full development of the system, and total discomfiture
> of picture-jobbing.

Holwell Carr was an ordained priest less attached to his flock in Menheniot, Cornwall, than he was to his life as an art collector and dealer in London. Paid well by his rich Cornish living (which he delegated to a curate), Carr bought and sold paintings, to some of which he gave optimistic attributions, and others which he improved: 'priest patcher and picture dealer', as he was described in 1816. Nevertheless, he was an early and supreme benefactor to the National Gallery, bequeathing thirty-five paintings, including Rembrandt's *Woman Bathing in a Stream* and Tintoretto's *St George and the Dragon*. Another of Seguier's clients was the collector and sometime MP George Watson Taylor, whose riches ebbed and flowed in concert with the fortunes of his plantations in the West Indies. As he sowed, so he reaped: having married money and collecting further riches from the sugar trade, Watson Taylor took a decidedly pro-slavery stance in Parliament. His extravagance went uncontrolled until he approached bankruptcy in 1832 and his collection at Erlestoke, Devizes, was sold over twenty-one days. Among the paintings he owned was Hogarth's *Shrimp Girl*. Watson Taylor, Holwell Carr, Robert Peel and many other clients of Seguier, and

Seguier himself, appear proprietorially among their paintings in the composite portrait *The Imaginary Picture Gallery* painted by the Dutch artist P. C. Wonder in the late 1820s.

Seguier 'cleans, buys and sells pictures', 'Alfred' alleged:

> If a nobleman or collector dies, who values his collection but Mr Seguier? When they are brought to the hammer, who names the price to be given for them but Mr Seguier? He formed Mr George Watson Taylor's collection, and it was in his interest that they should sell at high prices.

Alfred's fury at the state of affairs at the British Institution had been roused by the recent decision of the directors to spend £4,000 to build an extension to the Boydell building to house its own 'National Gallery', in rivalry to the real one down the road.

> Was there ever such a misapplication of funds? An institution, established, according to their own showing, for the encouragement of native talent in Great Britain, but which has declined into a broker's mart for the interested display of old pictures! This, I presume, was with the advice of the picture cleaner [William Seguier], or perhaps the rev gentleman [Rev. William Holwell Carr] who advised the purchase of the Parmegiano, presented to the National Gallery, at the enormous sum of £3,050. I shall take occasion to say more on that subject at a future time, as it happily illustrates the unfitness of the picture-broker for the place which he holds in the National Gallery, and may effectually expose the system of humbug adopted in the picture world at present.

Alfred concluded his correspondence by calling for the establishment of an organization in which the National Gallery and the Royal Academy could unite: this 'must now appear an event in the highest degree desirable, not only to artists, but to the whole nation'. It came to be ten years later in 1838, when the Royal Academy and the National Gallery moved as joint occupants into the new building in Trafalgar Square, designed by William Wilkins.

A measure of the healthy appreciation of art is the published criticism that is engendered around it. The exhibition at the British Institution

in 1830 honouring the life and work of the past president of the Royal Academy, Sir Thomas Lawrence, attracted opprobrium not for the manner of the show, which was assembled within nine months of Lawrence's death, but on account of the fact that it was mounted to raise money to support Lawrence's surviving family. Lawrence was forever in debt, largely because he would spend large sums on old master drawings, and despite the fact that he was always in work, charging the highest prices for his portraits. Further, according to the journalist Alaric Watts, he appears to have been paid £3,000 a year by the publishers Hurst and Robinson 'for the privilege, which did not belong to him, of engraving his portraits'.

> It is highly honourable to His late Majesty, and the liberal directors of this powerful institution, that the present exhibition was got up for the advantage of the surviving relatives of the distinguished artist; but it would have been better, and more creditable to Lawrence's memory and fame, had there been no occasion for this call upon public favour; for no artist that ever exercised a pencil derived more emolument from his occupation while living than Lawrence, and we are sure that we do not exceed the amount when we state, that in every way he must have received, during his professional career, little short of a quarter of a million sterling. How it has disappeared seems utterly unaccountable, and excites surprise.

Criticism of the British Institution became relentless. Constable was scathing in 1830: 'I recollect nothing in the Gallery but some women's bums by Etty RA.' Even in the relatively minor matter of exhibition catalogues the Institution faced the lash of a disgruntled visitor who found that, while the Old Water-Colour Society charged sixpence for a catalogue of sixteen pages listing 346 paintings, and the Royal Academy asked one shilling for fifty-eight pages listing 1,474 works, the British Institution demanded one shilling for seventeen pages listing only 181 paintings. Five of these pages carried a list of the governors, and a sixth spelled out fulsome praise to the directors and proprietors.

Moving pictures around from country house to exhibition was then a risky business. James Northcote commiserated with Sir William Pole, the

owner and subject of one of his portraits, who had lent the work to an
annual exhibition in Exeter in 1823:

> After the kindness you had shown to the proprietor of the Exeter
> Exhibition I think the careless conduct in respect to your portrait is abso-
> lutely unpardonable and he ought to be told that if he is not more atten-
> tive to the packing and carriage of the picture when returned nobody will
> let him have any to exhibit in future . . . I shall be happy to have it again
> in my hands and will carefully restore it to its original state. I have always
> considered it as one of my very best portraits and if the picture is much
> hurt it will be best to have it backed or as it is called lined by a canvas
> on the back which will give it great strength and safety from injury. I
> am happy to find that the picture was much admired and it is said my
> pictures did credit to the Exhibition.

Northcote went further and recommended an emergency treatment for
general purposes:

> If at any time the picture gets a misty or cloudy appearance on its surface
> which the varnish is apt to get from our damp atmosphere you have
> nothing to do but with an old soft silk handkerchief made hot to wipe
> over the surface of the picture and it will then appear as well as if it had
> a fresh coat of varnish on it . . . [I]n respect to the present crudeness of
> the colours time will correct that much better than if it is in the power
> of the best artist to do it. And all those pictures which we look at with so
> much wonder have had infinite good done them by time alone as far as
> relates to colour.

The care of pictures was at best rough and ready: some picture cleaners might
have been scrubbing floors. The painter W. R. Biggs RA was employed by
collectors and dealers to make dull paintings look bright again. 'I remem-
ber most of Turner's early paintings [at Petworth]', Constable recalled to
Leslie,

> as they came occasionally to be <u>rubbed out</u> at Mr Biggs; I must say
> however, some of them came to him in a most miserable state of filth,
> shined on in haste for the exhibition.

The moving of pictures gradually improved as the century progressed. In 1820 Haydon had his 13-by-15-foot canvas *Christ's Entry into Jerusalem* carefully rolled up in his Lisson Grove studio and carried off to the Egyptian Hall in Piccadilly by three large soldiers from the King's Life Guard. However, on practically the same date a monstrously large canvas, 21 by 35 feet, James Ward's *Waterloo Allegory* (now destroyed), suffered when being rolled up for moving. The artist wrote in his journal: 'The figure of Belona cracked by rolling yesterday – obliged to scrap[e] it off but improve it. Good comes out of evil!' Nearly thirty years later Etty considered all the curatorial requirements, and carried out a similar operation by rolling his colossal three-part painting *Joan of Arc* around a cylinder and sending it by wagon from his studio in Soho Square to the Royal Academy:

> The cylinder for the great Picture was one foot in diameter . . . It was, of course, hollow: of deal, smoothly planed, then rubbed with sand-paper; so that the surface could not injure. The volume of the cylinder being so large, would take nearly a yard of canvas to go round it. We did not put paper on anything; but rolled the Picture face in, contrary to general recommendation: as I felt assured the contrary would be fatal.

By the 1850s and 1860s picture transport had become a speciality of its own, with vans being fitted with deep shelves so that a dozen or more paintings could be laid out flat in the same vehicle.

Exhibitions outside London, in Exeter, Birmingham, Liverpool or Manchester, were organized by local societies, while others came together on the initiative of collectors determined to promote a particular kind of art or to show their own collections as a social event. Walter Fawkes showed his large collection of watercolours in 1819 at his London house in Grosvenor Place. This attracted such fashionable crowds that in a crush on the stairs 'rouge melted, teeth dropped, feathers broken, bonnets crushed' as the guests tried to circulate. Turner himself was present, and although he was not the only artist with works on display, he made his presence known there, as William Carey noticed:

he leaned on the centre table in the great room, or slowly worked his
rough way through the mass, he attracted every eye in the brilliant crowd,
and seemed to me like a victorious Roman General, the principal figure
in his own triumph.

John Hornby Maw was another who organized drawing-room exhibitions
of his collection and of works submitted by his artist friends. One show
hosted by Maw in his Hastings house proved difficult for Samuel Prout, a
Hastings man. Having a local reputation to protect, Prout became exceed-
ingly upset at the way a drawing of his had been treated. He heaped his
odium on fellow artist James Duffield Harding, who appears to have done
most of the work in arranging the show. Prout's drawing, of a shipwreck,
had been hung in obscurity over the piano:

> The disappointment at seeing it so heart-less-ly hung at the exhibn you
> know . . . I acknowledge that when I looked over the quantity of first-rate
> talent you had to dispose of in your drawing room, I saw but little prob-
> ability of its finding a place; yet I had indulged the hope that in some way
> your estimation of it would have made him [Harding] blush to see the
> injustice he had done me.

> I am persuaded it was your intention to do me honor, as you wish'd to
> have the drawing before the smaller ones could be arranged.

> Had the affair happened at Guildford it would not have concerned me,
> being unknown in the place . . . No one values your friendship more than
> myself. I have been proud to discover congeniality of sentiment, espe-
> cially with respect to art, & your residence at Hastings greatly quickened
> my restlessness to remove, as I had found in you what no other person in
> the town could give.

Prout went on about it in another letter:

> I am ready to believe that you have done the best for my drawing, that,
> to you, Mr Harding is a gentleman, & that, to you, his observations were
> most respectful, but he has called me 'mean, narrow-minded & unmanly'
> & has 'expressed his conviction that my tendency to crooked behaviour
> makes me shiftly persist in accusing others.' You cannot but consider that

these feelings still exist, from the injustice done to the picture in the late Exhbtn.

And on:

> With a candour which I know you will readily allow, permit me to assure you that my not accepting the favour of Mrs Maw's kind invitation, is far, <u>very far</u> from wanting personal respect, either to Mrs Maw or yourself.
>
> It would have given me real pleasure to have joined your party as usual, but I feel that my drawing of the wreck, as it hangs, is unworthy of a place in your collection. It is unfortunate for me that you were obliged to give it the worst situation in the room & <u>the only place</u> where it could be disposed of.
>
> As a proof that it was hid, the Lady & Gentm I accompanied to see your Turners noticed every drawing in the room but mine (<u>which I was heartily glad of</u>) & left the house without knowing that I was among the number.

William Seguier, the multi-tasking wheeler-dealing art dealer, picture cleaner, display arranger and curator, 'that execrable Seguier', as Beckford called him, died in 1843. His career trajectory was of a kind which would not survive long into the middle years of the nineteenth century, being largely dependent on volatile royal and private patronage at a time when the public purse was increasing its influence on the acquisition of art for the nation. The next generation was characterized by the work of Charles Eastlake, Seguier's successor as keeper, who was appointed director of the National Gallery in 1854. This was despite some public discussion that Prince Albert had hoped to appoint Gustav Waagen to that post. Eastlake had already reached the pinnacle of the establishment as a knight of the realm and president of the Royal Academy, conveniently the National Gallery's neighbour. By now he had ceased to paint, having fulfilled his ambitions as an artist, and directed his energies into committee work, management and travelling Europe in search of old master paintings to acquire for the nation. At home, running the

gallery, was his reliable and highly responsible colleague Ralph Wornum, appointed keeper and secretary of the National Gallery in the following year.

Wornum had enjoyed an orthodox training before he began his pioneering career as an art gallery curator. His father had been a successful London piano-maker, and invented the machinery required in upright pianos at a time when every home had to have a piano. Ralph Wornum attempted to study law at University College, but soon abandoned that to become an artist. He studied at Henry Sass's art school near the British Museum and took painting lessons from George Reinagle. Then, from 1834 to 1839, he travelled Europe, exploring many of the places that Charles Eastlake would come to trawl for paintings twenty years later. Writing long letters to his father from Germany in 1834, Wornum reflected on his life and purpose:

> You wish me health. I really think of all things on Earth, health is the most desirable. At present thank God my health is furiously strong and I am getting broader and more Herculean every day.

He was robust in his opinions, as well as in his body, and was not a man to be pushed about in his later career by a difficult director:

> I hate the Prussians, they are too much like the English for me – the most impudent, independent rascals you can imagine, but they are a fine people and I dare say the higher classes are most agreeable and pleasant company. Cologne is not worth a visit, it is composed of soldiers and pipe shops – they are all soldiers, every third man you meet is in uniform. There is nothing to see on the Rhine till you pass Bonn, I may say Coblenz Ehrenbreitstein is a most awful looking place, its full garrison is 18,000 men.

However, he firmly declared his early credentials in a way that would stand him in good stead as the nation's first curator of Turner's paintings:

> The other day I told a man, who is considered to be a judge of the Arts, of our Turner. When I had finished, he coolly asked me 'is he as good as our

Rothman?' Rothman!!! Said I, 'Why Sir, Lorraine, Vernet, Salvator Rosa, are nothing to him, he is the only Landscape painter in the world. If I call the paintings of your Masters landscapes, I have no name for Turner's, but if I call Turner's <u>Landscapes</u>, your Masters are <u>daubed canvases</u>.' I find the only way to make these fellows understand me is to <u>come it strong</u> – but that's my real opinion of Turner.

Returning to London, Wornum began to paint portraits, but when that failed to go well enough, he turned to writing about art. His *Outline of a General History of Painting among the Ancients*, published in 1847, sold in large quantities and was later reissued as the popular text-book, *Epochs of Painting*. He lectured and taught drawing at the National School of Design, by now in the vacated former exhibition rooms at Somerset House, and was an early and productive junior curator at the developing South Kensington Museum.

Wornum kept a private diary from 13 August 1855, the day he received his appointment as keeper and secretary of the National Gallery in Trafalgar Square. The diary is a unique, touching and frank record of day-to-day gallery life; it is a foolscap suede-bound volume inscribed on its opening page 'Not official. For my own use and ready information.' After five days he notes that 'Sir Charles Eastlake left for Italy'. By and by Eastlake came back to the gallery from his travels, and would then go off again; but, as the diary records, in the interim Wornum both held the fort and busied himself with radically revitalizing the displays in the gallery in a way that may not have been effectively achieved since the building opened eighteen years earlier. By the end of September Wornum had taken all the pictures down in groups both at Trafalgar Square and at Marlborough House, the gallery's temporary outstation in Pall Mall. With the help of his staff, Mr Critchfield, Mr Bentley and other assistants, the paintings had, he reported, been dusted, rubbed with cotton wool and rehung. Dabbing with damp cotton wool, linen and sponge was a standard conservation and care technique for paintings, alongside the hot silk method used by James Northcote. The only pictures that left them daunted were three that would daunt any curator without access to lifting gear – the largest works in the gallery at that time, Sebastiano del Piombo's *Raising of Lazarus*,

Parmigianino's *Madonna and Child with SS. John the Baptist and Jerome*, and Benjamin West's *Christ Healing the Sick*.

Wornum writes jauntily about the refreshment that Eastlake's appointment as director had brought to the gallery:

Apartments repaired and painted . . . 12 cwt of paint used in my rooms, and I was nearly poisoned by the smell.

Small landscape by Wilson (Garnons' Bequest) hung at Marlboro' House – rest of bequest rubbish.

Raising of Lazarus placed on the north wall . . . a much better lighting for it.

Eastlake returned to the gallery in March 1856 in time for a visit by Queen Victoria, Prince Albert and two of their daughters to mark the gallery's new look. 'Red cloth laid down – gallery kept quite clear', Wornum reported. 'Was presented to Her Majesty by Sir Charles Eastlake!' Subsequently, when Eastlake disappeared like the White Rabbit into Europe once more, Wornum got on with glazing some of the pictures and having many of them backed for protection with glazed Holland, a material similar to that used today for roller-blinds. He had new bars and locks fitted in the gallery, doors given sheet-iron coverings, steps repaired, and the outside of the gallery painted – 'two coats'. Now the National Gallery was spruce and smart and ready to welcome a new generation of visitors. It was ready also to welcome a new generation of pictures: on 25 September 1856, five years after the artist's death, Wornum records the beginning of the love affair between Turner, his art and the nation. In the diary he wrote: 'This day Mr [Phillip] Hardwick [one of Turner's executors] broke the seal of the key of the Rooms containing the Turner pictures, and thereby gave those into my charge.'

There is a distinct air of disappointment in Wornum's first response to the Turner Bequest, made available to the nation after a long-drawn-out court case had settled its future. He noted the numbers of works in his store:

Finished pictures, say 100; Unfinished pictures, including mere beginnings, and the majority worthless 182; Drawings and sketches of all kinds (about 400 superior) 19,049. Total 19,331. About 15,000 of these are small pencil sketches, mostly quite superfluous, and an annoying incumbrance.

For Wornum, the next few years are taken up with hanging the Turners and arranging the display of paintings from the Vernon, Sheepshanks and Jacob Bell (Landseer) collections at Marlborough House. In an important eight-page letter Hawkesworth Fawkes tells Thomas Griffith how this all came about, and describes the powerful impact that Turner's paintings had even in storage:

> All [Turner's] pictures, drawings, sketches and prints are now safely deposited in the National Gallery; I was called away from my visit in Yorkshire to assist [George] Jones the RA in their removal; it occupied a long time but was ultimately effected without the slightest accident or injury, and although the object in placing them in their present receptacle is one exclusively of security & not exhibition, I am sure that Jones will be but too happy to shew them to you, if ever you dream of coming to town again. [T]hey occupy three of the Rooms formerly [appropriated ?] to the Vernon collection and such a blaze of Turner brightness [asterisk to the bottom of the page: '*in oil'] has never before been seen; it was thought better to divest them of their old frames – not so much on the score of shabbiness, as to make the most of the little wall-room allotted to us, and it is somewhat singular that not one of the pictures hanging up, was fastened by nail or otherwise in its frame, showing I think pretty clearly that Turner himself must always have been apprehensive of fire; this very much aided us in the removal as it was unnecessary to take any of the frames down, and there they hang in their old places like some unhappy Ghosts.

The first Turners from his bequest to be seen at Marlborough House included *Snowstorm: Hannibal crossing the Alps* (1812), *Ulysses Deriding Polyphemus* (1829), *The Fighting Téméraire* (1839) and *Snowstorm: Steamboat off a harbour's mouth* (1842). All had been sponged to clean off accumulated dust and dirt. By early December 1856 the number on show had

risen to thirty-four, being joined by *War: The exile and the rock limpet* (1842), *Undine* (1846) and *Angel Standing in the Sun* (1846): these three Wornum had noted in his diary as 'absurd'. Thus, almost simultaneously, there also appeared the beginning of the crack through the understanding of Turner's work which divided those paintings which the public could readily enjoy and celebrate, and those which they would increasingly find to be puzzling, even, to use Wornum's word, 'absurd'. At this early stage in the Turner Bequest's exhibition history, critics and public tended to occupy the same side of the divide, and it was a slow and difficult business to encourage even the most broad-minded of them to make the crossing.

Marlborough House did not remain long as the outstation of the National Gallery after the arrival of the Turner Bequest. Within three years the Turners, along with all the British School paintings in the National Gallery, the Vernon Bequest and the Jacob Bell collection, were displayed in six large galleries in the South Kensington Museum, each 50 feet by 25, adjacent to the Sheepshanks collection. Turner had three of these galleries to himself. British art had never before had such a spectacular and gener-ous space for its display, either in private or public collections anywhere in the country. What John Leicester had begun in 1806 the nation was at last continuing fifty years later. The rooms were gas-lit, a system which caused teething problems:

> The middle Turner Room at South Kensington lit up this evening, much gas escaped during the lighting causing a most disagreeable smell, and doubtless spreading all over the room and pictures.

Turner was not the only artist whose work would suffer agonies from mod cons. Holman Hunt remembered what the central heating did to Hogarth's paintings in the 1840s:

> Unfortunately, about twenty years since, they had to be removed to Marlborough House and to South Kensington, where, with hot air blown over the surfaces of the pictures, from pipes since changed, but then placed immediately below them, they were being treated like dishes rather than pictures.

The way pictures were being cared for and displayed began gradually to attract the attention of scientists and the opinion-forming professional classes. Their physical care progressed according to current scientific lights, while their display methods regressed at the expense of clarity. Michael Faraday, called in by Eastlake and Wornum to advise, objected to the glazed Holland cloth that Wornum had found so useful and recommended 'common worsted stuff' to be used to back paintings in preference. Faraday was also brought in to consider the effects of the new gas lighting on the pictures and their frames. John Ruskin wrote to *The Times* to condemn the lighting. 'I suspect he is right,' commented Wornum: 'It dries the air too much.' This may have exacerbated one of the curator's constant anxieties, the worsening condition of Sir Joshua Reynolds's paintings: 'The cracks in Sir Joshua's *Holy Family* appear to be progressing. Query, is this caused by the gas.'

Francis Fowke, a captain in the Royal Engineers, designed the new galleries at South Kensington. He was in the vanguard of modern gallery design, lending a new factory and military aspect to the classical style of country-house architects of the Wyatt, Holland and Soane generations. Describing the care he took over the lighting and heating of his buildings, Fowke identified a particular nuisance in picture galleries to be 'glitter', where light shone on the painted surface causing reflections which obscured the image. Fowke cured this by ensuring that the 'opening for the admission of light be exactly half the floor area of the gallery': a precise functional measurement that appeared to give clear glitter-free enjoyment of the paintings. The heating of the new gallery was effected by the method recently invented by Galsworthy Gurney for the Houses of Parliament: a fan of iron plates set in a circular trough of water surrounding the cylindrical coal-fired stoves. The cooling effect of the water on the iron gave a particular humidity to the air in the gallery, more efficiently than by simply exposing trays of water on top of the heaters. As Fowke described it, 'instead of the air being roasted and then moistened, it is as it were moistened and then stewed.' In the Victoria and Albert Museum science met art not only in the collections but also in gallery design.

The hanging method used at the National Gallery and by now at South Kensington favoured quantity over clarity, extolling what Giles Waterfield

has described as the 'cluttered hang'. In this style, paintings are spread all over the gallery wall in an attempt to fit everything in; frame avoids frame by a hair's breadth. Other styles in Waterfield's analysis include the 'picturesque or decorative hang', favoured by private collectors in large houses, in which paintings are hung more or less symmetrically around a large central canvas or pair; and the 'historical hang', which developed out of a growth in interest in art history among collectors, in which different schools are hung together – all the Italians, all the Dutch, all the French together, and so on. Later styles include the 'single-row hang', so beloved of late twentieth-century public gallery curators, which was introduced by the Prince Regent in Carlton House. It is interesting to see that in the second decade of the twenty-first century the single-row hang is being abandoned in some public galleries in favour of a return to the cluttered hang. A further, rarer, hanging style, the 'magnate hang', still flourishes, perfectly exemplified in the West Gallery of the Frick Collection in New York, in which size and eminence are the measure. There, in order on the walls, like muddled chapters in a novel, we see Hals, Turner, Rembrandt, Constable, Velázquez and Vermeer, followed by Bronzino.

But gas or no gas, the new galleries at South Kensington were a triumph. When the museum's governing committee, the Council on Education, invited MPs to see the displays, Wornum reported proudly that 'many attended, with ladies, but I observed that while the iron building and lower rooms of the Museum were comparatively empty, the rooms of the National Gallery were crowded'. It was now time for another royal visit, and the queen and Prince Albert duly attended South Kensington Museum on 17 February 1860. This time Wornum was more than just another subject on the red carpet, for

> I showed her majesty round. She observed on the excellence of the arrangement, and noticed that the Callcott Pisa and the Turner Golden Bow [*sic*] were very dirty.

Wornum adds that he 'amused her by telling her some anecdotes about Turner. She was very gracious. Carried a catalogue away with her.'

There is no record of what 'amusing anecdotes about Turner' Wornum

told the queen, but they are unlikely to have been wholly complimentary, and may have been among the early reinforced prejudices that continued to make the royal family shy away from fully acknowledging Turner's genius into the early twentieth century. Nevertheless, the queen's remark about the state of *The Golden Bough* had the desired and rapid effect: on 12 May Wornum writes: 'Saw the Turner <u>Golden Bough</u> cleaned by Mr Bentley.' Just over a year later the Turner oil paintings returned to Trafalgar Square, while two large galleries at South Kensington were hung with his sketches, 198 frames of them.

During Wornum's tenure of the keepership of the National Gallery he sent long queues of paintings to the 'Repairing Room'. They were careful but tough with the pictures, adopting robust 'repairing' practices to match the robust treatment paintings were subjected to in their travels. On returning to London from the 1857 Manchester Art Treasures exhibition James Ward's *Bull* was found to be 'covered with great cracks owing to its being folded . . . with the <u>paint inwards</u> – an absurd proceeding'. Not only absurd, but culpable in the light of the great efforts Etty went to in 1847 in rolling his *Joan of Arc* around a custom-made deal cylinder. Some Turners, a Wilkie and a Maclise were found to be 'slightly damaged' on their return from exhibition in Dublin in 1865, 'owing to a Turner getting loose' in the packing case and knocking the others. Then there were environmental problems to deal with: 'Pictures at Kensington seem to be cracking generally – this must I think arise from changes of temperature – <u>great heat</u> with the gas and <u>cold</u> without.'

In the decades when science was triumphant, Eastlake and Wornum explored new patent picture-cleaning schemes inspired by science:

Mr Charles Vogt called by appointment, and explained and illustrated Professor Pettenkofer's method of restoring the old varnish of pictures, which <u>washed</u>. Explained and permission given to use it without any other condition than that we should recommend it if approved. Not to be divulged. A small portion of Sir John May's Ruysdael restored before Sir Charles Eastlake and myself.

The gallery's practice in the 1860s included the washing of paintings with water and pea-meal, dried peas ground to a rough paste; four at least of

Turner's greatest paintings were treated in this way. Wornum and Eastlake, convinced by the efficacy of another new treatment, Professor Pettenkofer's 'method' of restoring the varnish, submitted fifty-nine paintings to it in 1864, each one being carefully noted in the diary with the number of hours the treatment had taken. Thus:

Poussin Nursing of Bacchus	3 hours
Claude Death of Procris	5 hours
Rembrandt Jew Merchant	13 hours
Titian Venus and Adonis	2½ hours
Rubens Chateau de Steen	4 hours

Two years later, after Eastlake had died, Wornum and his new director William Boxall RA entertained yet another picture-cleaning method, one presented by Herr Hahn of Stettin, who

> made some experiments with reference to the preservation of pictures. The regeneration of varnish. The removal of varnish without touching the paint. Also the straightening of curved panels.

> Mr Hahn continuing his experiments. His straightening of panels and regeneration of varnish seem successful. Wants a thousand pounds! for his recipes.

Clearly the results from the Repairing Room were impressive, as *Punch* declared:

> Bravo, Boxall! Well done, Wornum! They have dared to brave the bray of the noodles and the nincompoops . . . and have the dirt taken off some of the National Pictures! Not off all, unhappily, but off just enough to give us a relish of the beauty that lies drowned, fathom deep, under Sir George Beaumont's liquorice-water and the late Mr Seguier's favourite brown varnish. These men have actually had the pluck to dive to the bottom of these filthy brown standing pools, and to bring up the jewels of Rubens, and Poussin, and Salvator Rosa, as bright as when they left the hand that set them.

Gustav Waagen and Ralph Wornum began their careers after long periods of European travel and the careful but detached study of art and artists; they

shared a desire to spend their working lives in the company of great art. Though of different kinds, Waagen the diplomat, Wornum the worker, both were pioneer scholar-curators, who appreciated the importance of clarity, order and interpretation in the way they organized public picture displays. William Carey and William Seguier came from the world of art sales, dealerships and shady transactions, publishing polemical articles and having the willingness and ability to take a chance. Their career pattern evolved, for Carey, into the profession of freelance critic-agent-curator, unattached, unbridled and loyal only to the subject; and for Seguier, into the dealer in the art trade. It is fairly safe to say that Seguier would never be employed as keeper of the National Gallery today. James Northcote, an artist typical of his period but of modest talent, was a practitioner of make-do-and-mend studio curatorship, while William Etty, who rolled his huge *St Joan* around a deal cylinder, is an example of the careful proto-modern artist who took sensible action to prevent damage to his work. Together, their technical innovations contributed to the development of the work that went on behind the door of the National Gallery's Repairing Room, and beyond that into the picture-conservation expertise of the twentieth century.

Behind them in the studio or gallery workshop were cadres of loyal and reliable men and women who in an earlier generation might have been domestic servants. In his diary Ralph Wornum carefully and affectionately noted, with a heavy outline of ink, the deaths of National Gallery staff, from the director to the housemaid, recording their lengths of service – in a few cases this had been since the gallery's foundation in 1824. These staff members grew with the job, beginning perhaps as a humble messenger and rising to be the uniformed public face of the gallery. For a classic case of a fine career in public art gallery management starting in the later nineteenth century, we need look no further than George Kirby of York, who announced:

> Just a line to say that after 52 years service as Supt of the Exhibition Bldgs and Curator of the City Art Gallery, I have decided to retire at the age of 90 years.

SPECTATOR:
'SO USEFUL IT IS TO HAVE MONEY, HEIGH-HO'

Three particularly perceptive and industrious foreign visitors came to London during the 1820s and 1830s, to have a good look: one came from France, one from Germany, one from the United States of America. Each saw the city and nation from a different perspective, and each in his own way expressed surprise and wonder at the way the metropolis displayed and spent its money, and enjoyed itself.

The French painter Théodore Géricault arrived in April 1820 to make a business proposition to the showman and entrepreneur William Bullock, owner of the Egyptian Hall in Piccadilly. Géricault's outrageous and moving painting *The Raft of the Medusa* had been shown the previous year at the Paris Salon, the French equivalent of the Royal Academy. There it had garnered both praise and repulsion, and Bullock could immediately see that in showing it in London he would be bound to have a commercial success on his hands, if through controversy alone. Over the six months in which 'Monsieur Jerricault's Great Picture' was displayed it was seen by up to 50,000 people, and made a healthy sum for both Bullock and Géricault. The artist stayed, worked and wandered in London until the end of 1821, experimenting on lithography with Charles Hullmandel. A miserable and solitary individual, Géricault wrote to a friend describing his London life:

> I don't amuse myself at all . . . I work a lot in my room and then roam the streets for relaxation. They are so full of constant movement and variety . . . I work and turn out lithographs with all my might. I have for some time been devoting myself to this art which is a novelty in London

and is having an incredible vogue here. With a little more tenacity than I possess, I am sure one could make a considerable fortune . . . As soon as the true connoisseurs have come to know me they will use me for work worthier of myself . . . I renounce the buskin and Scripture, to lock myself into the stables, from which I expect to return covered in gold.

Géricault found darkness and tumult in London, but also invention, ingenuity and acceptance for his uncompromising art. He also saw how freely the English would spend their money, an observation that tempered even his driving pessimism. When he left England, his friend the architect C. R. Cockerell recorded a touching memoir of the Frenchman:

Singular life . . . lying torpid days & weeks then rising to violent exertions, riding tearing driving exposing himself to heat cold violence of all sorts . . . Often said that England was the best place for study he had . . . the air contributed to the habits of the People.

The German architect Karl Friedrich Schinkel had a sunnier outlook on life. He made the journey in 1826, arriving on a coach drawn by four horses 'in the finest harness just like the English ambassador's in Berlin':

It was driven by a huge great coachman sitting up on a box. The man looked like a fine gentleman, he wore many bright scarves, a handsome hat, thigh-boots, an elegant black under-coat and a large beige overcoat. Every two miles [from Dover] we changed horses, by turns greys, chestnuts, bays, and blacks. The countryside is a lovely green, full of trees and like one enormous park.

Schinkel visited the Regent's Park Panorama, the Tower of London, 'where the two princes were murdered', as well as private art collections, mills, museums, factories, businesses, and architecture both notable and ordinary. He was in England and Wales on business from Prussia, as Waagen would be nine years later, though in Schinkel's case it was as a civil servant, the Privy Counsellor for Public Works for the Prussian government, and Professor of Architecture at the University of Berlin. His mission in London – and in Birmingham, Sheffield, Leeds, Manchester and Liverpool

– was to bring home detailed knowledge of architecture, manufacturing and society in England, for the interest of the burgeoning Prussian state. Britain, then, was the model economy that European governments paid to watch. Schinkel visited the inventor Jacob Perkins's factory and inspected machinery and its manufacture in the factories of Henry Maudsley and Joseph Bramah. He quizzed Marc Isambard Brunel on the construction of the Thames Tunnel and may well have taken home with him a copy of Charles Tilt's neat booklet on the works: 'when everything is finished', Brunel assured Schinkel, 'everything would be as dry as a living room.'

For entertainment and subsistence, Schinkel ate in the local manner: 'Dinner in an eating house in Piccadilly, in booths in the English style, a joint of roast beef was taken from one table to another to be sliced.' He went to Astley's Theatre, a permanent circus amphitheatre near Hyde Park with dramatic and alarming horses and 'elephants':

> Indian play. Magnificent costumes, a battle and storming of a castle with red and white Bengal flares, 12 horses galloped up and down the steepest mountains, 4 elephants, the black ones made up from big London horses, very convincing.

A third visitor from afar who came to see what ideas he could take away with him was the Boston sugar merchant Isaac Schofield. Coming to England in 1840, with £300 to spend on refining equipment for his business, Schofield reflected that he had arrived in paradise. He took a train from Liverpool to London:

> The verdure is luxuriantly rich, the farms highly cultivated and the prospects on all sides presenting a delightful variety of tilled and meadow lands, gardens, fields of grain, groves & forests. The rout[e] does not admit of many of the gentlemen's seats being seen but the few that we glided by appeared to be laid out with the perfection of good taste. I allude to the grounds for the houses had very plain if not ordinary appearance.

Schofield experienced the full panoply of early Victorian engineering when travelling south via Birmingham:

The roads are very thoroughly made, the bridges beautiful, the tunnels grand and the depot buildings magnificent particularly the Euston depot in London. We passed through 6 or 7 tunnels, one of them a mile & ¾ in length, taking 2¾ minutes to go through.

The twenty-first-century equivalent of Schofield's budget is £15,000, a healthy sum to spend on a trip to Europe: 'Of one thing I am certain that I should be able to give a good a/c of the £300 and the only fear I have is that I shall not have time to make all the investigations I wish to.' With money of this order he travelled in comfort from Liverpool:

The first class cars are beautifully cushioned and lined and are so divided that only six persons occupy one compartment, each seat being separated from the next by a cushioned partition about as high as the arm of a chair and a similar but narrower partition extends up to the top of the car . . . Being in the mail train we stopped only at Birmingham for a few moments, just long eno' to allow of swallowing a cup of coffee without waiting for it to cool.

Schofield was in England to do business with the sugar brokers of Mincing Lane and to investigate refining equipment then being produced in London by Perkins and Bacon, the new partnership of Jacob Perkins's former firm, since passed on to his son.

I have seen Jacob Perkins who lives now quite secluded in consequence of some disappointments wh: I have not time to explain – the fate of genius. His son is doing an excellent bus^s with his hot water stoves and I passed a most agreeable day with him and Mr Bacon who is connected with him at their factory. I shall see more of them on my return and think I can turn to good account for the benefit of the Refinery & other purposes some ideas I have acquired from seeing their machinery.

The visit combined, he tells his family back home, travel around England, business and pleasure in London, and further travelling into Russia to St Petersburg, then back to England via Lübeck, Hamburg, Amsterdam, Antwerp, Brussels and Paris. 'I fancy the whole Island must be a garden',

he wrote, when describing his journey to Windsor. Compared to Dickens's frantic and furious descriptions of railway travel in *Dombey and Son*, this is bucolic and courteous in the extreme.

Nevertheless, Schofield, an ordinary businessman on an ordinary business trip, did leave an evocation of the roar and riot of London, its pains and its pleasures – an account that is extraordinary in its richness and clarity. Earlier we read his description of a coach journey down the Strand (see pages 53–4). Schofield stayed at a hotel in Charing Cross, from where he had only to go to the front door,

> hold up my finger to an omnibus, wh: are continually passing and <u>presto</u> we are whisked through the Strand, Fleet, Ludgate, past St Paul's, down Cheapside & the Poultry to the Bank, in the vicinity of wh: that is within half a mile to a mile, wh: are short distances here, I find most of my commercial friends.

Schofield was a businessman in a hurry, dining in 'fast food' chop-houses: 'I always make a real good John Bull feast on Beef, dumplings, cheese and a pint of stout. I work too hard to grow fat fast.' In his time off he visited the Adelaide Gallery, the Tower of London, the Panorama of London in Regent's Park, Swiss Cottage and the zoo, and walked in London's parks. These sights were the staple entertainment for the passing visitor, the men and women for whom John Murray published his *Modern London* guide in 1849, and who contributed not only additional income to the local economy, but sent home accounts of their experiences to enrich the literature.

There were countless ways of spending money in London on enjoyment. Géricault the artist, Schinkel the government inspector, Schofield the businessman – each had his own preference and priorities. Arthur Hugh Clough in his poem 'Spectator ab Extra', written in the 1850s, looks at the world around him with a more detached, cynical view than any of the three foreign visitors:

> It was but this winter I came up to town,
> And already I'm gaining a sort of renown;

Find my way to good houses without much ado,
And beginning to see the nobility too.
So useful it is to have money, heigh-ho!
So useful it is to have money.

Oh dear what a pity they ever should lose it,
Since they are the people that know how to use it;
So easy, so stately, such manners, such dinners,
And yet, after all, it is we are the winners.
So needful it is to have money, heigh-ho!
So needful it is to have money . . .

There's something undoubtedly in a fine air,
To know how to smile and be able to stare,
High breeding is something, but well-bred or not,
In the end the one question is, what have you got.
So needful it is to have money, heigh-ho!
So needful it is to have money.

'So needful it is to have money', wrote Clough, while 250 years earlier the philosopher Francis Bacon, Lord Verulam, had taken a different angle, one echoed in the 1770s by Adam Smith (see page 4). Bacon wrote:

> Above all things, good policy is to be used, that the treasure and moneys in a state be not gathered into few hands. For otherwise a state may have a great stock and yet starve. And money is like muck; not good unless it be spread.

Consumers of the products of the business of art who used the common lubricant of money ranged from those of effectively infinite wealth who could buy more or less anything they wanted, to foreign visitors in search of business and information, to an indigenous family such as the Venns, suppliers of clergy to the Anglican church generation by generation since the Reformation. The Venns are an ideal counterpoise between the rich who could spend as they liked, the poor who observed and struggled, and those who asked casually, in Clough's words, 'High breeding is something, but well-bred or not,/ In the end the one question is, what have you got.'

Rooted as it was in the loam of English middle-class society, the Venns' respectable and modest way of life, handed down from parson to parson, was easily put off balance by even the smallest shift in stock market prices. Rev. John Venn, rector of Clapham, Surrey, had died nine years earlier, leaving a younger generation to handle a serious financial crisis. Anxious about the fluctuation in the value of their assets, the Venns had little to cut when the crash came, and much to lose. They were intellectual, charitable, ruminative people, Cambridge-educated, and among the founders of the Church Missionary Society. Marrying into and forming friendships with the Macaulays, Trevelyans, Wilberforces and Stephens, they were at the heart of the intellectual aristocracy that came to embrace university teaching and the writing of history and fiction, and, eventually, spawned the Bloomsbury Set. The Venns were the kind who picked up the banner of influence, curiosity and social conscience from people such as Maria Callcott, and who bought their books at Hatchard's, the 'Godly Bookseller'. Travelling east and south, they spread the Christian gospel as missionaries, and published devout pamphlets, sermons and memoirs. John Venn had followed his father as a leading figure in the Clapham Sect, while Henry became a Prebendary of St Paul's Cathedral, and the secretary and mainstay of the Church Missionary Society. Their younger brother John was in 1822 coming to the end of his prize-winning school career at the East India Company's college at Haileybury.

The Venns' liberal, reformist views echoed those of their friends and associates. They dined with the Macaulays; they heard Wilberforce, Macaulay and O'Connell speak against slavery at the Freemasons' Hall:

> Could not get a seat, & stood in much heat & discomfort under the platform all the time. The uproar very tremendous . . . The audience thrown almost into fits by Mr Wilberforce's speech.

Holidays included trips to the continent and a visit by steam-packet to Margate and Broadstairs, and in 1820 there was much family fuss over the 'taking' of their portraits by the careful and observant portrait artist Joseph Slater. Emilia gives a blow-by-blow account in her diary of visits to this busy artist whose likenesses combine the intimacy of Richard Cosway and

the glamour of Thomas Lawrence with a touch of worthy dullness that suited his clients' habit. Slater was already familiar with the Venns: he had drawn John Venn's portrait a decade or more earlier, and may have been prepared for the fuss the family would make:

> 2 March 1820: Went to Slaters together to settle about having our pictures taken for dear John: – a gift from Jane.

> 16 March: Thursday: Had my 1st sitting for my own frightful picture.

> 7 April: To Slater's to see our own pictures. All met in his room & made a great confusion there.

> 10 April: Catherine & I took Mrs Venn to Mr Slater's, to have <u>her</u> picture taken; & I am quite tired of the sight of Slater's room, & his face, & everything about it.

These were people for whom art was probably a strange business, interesting and enjoyable to touch upon, but stressful when it came too close.

How did visitors, and those residents with money, enjoy city life and consume the products of culture? In the theatre and in art exhibitions the excitement and dread to be found daily on the streets could be experienced vicariously through performance and picture. In public lectures learning and understanding, entertainment and experiment illuminated instruction that could also be found at home in books and journals. In clubland and chop-houses, in parties, soirées and conversation, the traces of company and friendship have come down to us in family likeness, the milking of grandparents' memory, correspondence, memoirs, and from the chance and challenge of life.

In families with only the slightest sense of continuity, the practice of commissioning portraits was a given where there was money enough to accomplish it. The Venns were not unusual in this respect, just typical. When Emilia Venn says that she is 'quite tired of the sight of Slater's room, & his face, & everything about it', she reveals the ordinariness of the activity of sitting for a portrait. Portrait drawing for those of modest circumstances stretched in its reach to the making of engravings to circulate the image further, when there was the family demand to do so. It follows

that there came a point where the engraving of the portraits of notable individuals became less of a family and more of a commercial opportunity, opening up the market both for admirers to collect and for subjects to distribute. Ackermann and Colnaghi published portraits because they provided a real commercial benefit; they wrestled, for example, over the copyright of Nelson's image in 1805, part of a battle for leadership in a lucrative and crowded market. When photography developed in the 1840s, it was no wonder that its most immediate and commercial application, evidenced by the burgeoning of photographic studios in every town and city, was to create a market for the reproducible portrait photograph. As photography rose and spread, so commercial engraving, in particular of portraits, began to change its nature, to invest in new technology, and then, inevitably, to fall away.

Portrait collecting beyond family use had become an established practice by the mid-nineteenth century. The engraving of portraits followed on naturally as a broadcast medium, the images sweeping across the nation and empire in the baggage of surveyor, trader and memsahib. Benjamin Robert Haydon noticed the trend in 1817:

> Portraiture . . . is one of the staple manufactures of the empire. Wherever the British settle, wherever they colonise, they carry and will ever carry trial by jury, horseracing and portrait-painting.

The result of this passion is, 200 years on, an unending stream of paintings of 'unknown sitters' in auction rooms across the country, and the ready availability of instant ancestry for those in need of it. Engravings shake off their identities less easily, as they usually have a name and date engraved beneath the image.

The collections of portraits that have survived the centuries more or less intact tend to be those that come from established and continuing families, usually with historic houses to keep them in, or they are of men and women connected to cultural or academic institutions. The danger to family portrait collections posed by careless heirs was neatly expressed at an early date by Sheridan in *The School for Scandal* (1777), when Charles Surface sells his family by auction:

This is a maiden sister . . . my Great Aunt Deborah, done by Kneller, thought to be one of his best pictures, and esteemed a very formidable likeness. There she sits, as a shepherdess feeding her flock – you shall have her for five pounds ten. I'm sure the sheep are worth the money . . . Knock down my Aunt Deborah, Careless.

It would not be long before Aunt Deborah lost her identity.

Institutional portrait series were more secure. The Royal Society, the Royal Institution, the Royal College of Surgeons, the Royal College of Physicians, livery companies, the Inns of Court – all and many more have recorded and displayed their officers, benefactors and celebrities with pride, as have (and still do) hospitals, universities and colleges worldwide. Portraits bring a sense of history, continuity and gravitas, and signal an institution's sense of place in intellectual, professional or commercial life. Particularly significant collections for private or limited circulation include the thirty or more portrait profiles drawn by George Dance the Younger in the 1790s for the Royal Academy; the *One Hundred Etchings*, mainly of portraits made and circulated in the 1830s, by Mary Turner, the wife of Dawson Turner (see page 83); William Brockedon's drawings of 'Prominent People' from the 1830s and 1840s; and the collection made for himself by Michael Faraday of portrait engravings of fellow scientists and other notables.

Faraday had collected and distributed engraved portraits at least since the early 1830s. He received a proof from Colnaghi of the engraving of Henry Pickersgill's youthful portrait painted in 1829:

I always thought it much flattered but when I look in the glass just now and then think of the Engraving I cannot help but laugh out to imagine it meant to represent me especially as the real Common Cause usually now appears with his head in a handkerchief.

Many portraits were given to him as gifts. Thomas Phillips gave Faraday S. W. Reynolds's engraving of Phillips's portrait of Humphry Davy. Angela Burdett Coutts sent him an engraving of her father's portrait: 'I have received, and thank you heartily for, the fine portrait of Sir Francis Burdett

that true old English gentleman', Faraday responded. A most touching
gift and letter came from Jane Davy, Sir Humphry's widow, a woman who
had been particularly nasty to Faraday when he was a young man touring
Europe as Davy's valet in 1813–15. By 1847 repentant and reflective, Lady
Davy asked Faraday to accept a copy by Henry Pickersgill of a portrait of
her late husband:

> My finances are not so low even in this year of demands heavy & sad, as
> to deprive me, of the real pleasure of gratifying you <u>entirely</u>, in this little
> memorial of earlier Time. Pray do not therefore from mistaken caution,
> or delicacy, deprive me of my wish.

The purpose of these portrait collections, as Jane Davy knew and used to
her purpose, was the prompting of memory and pleasure in recollection.
Faraday told the French scientist Quetelet in 1851:

> I do not think much of my own face but I have very great pleasure in
> looking upon yours & it brings by association all your kind feelings
> towards me back to my mind and very pleasant they are.

The artist, traveller and inventor William Brockedon was a particularly
prolific maker and collector of portraits of notables. One hundred and
four sitters in his collection of pencil drawings, 'Prominent People', reflect
the extraordinary breadth of Brockedon's apparent circle of friends and
acquaintances. Drawn for his own pleasure, and ultimately for his son
Philip, the collection reveals that Brockedon was highly selective in choos-
ing who amongst his circle he would portray. Despite the fact that he
referred to it later as 'little Philip's book of his father's friends', Brockedon
wanted his collection to be not a living diary of his intimates, but a small
'national portrait gallery' in itself. To be worthy of Brockedon's album, a
subject had to have achieved something.

Brockedon's 'Prominent People' represent all aspects of British intellec-
tual, cultural and entrepreneurial life in the mid-nineteenth century. Some
of them we have already met in these pages: there are painters (Clarkson
Stanfield, Thomas Phillips, Samuel Prout), sculptors (John Gibson, John

Flaxman, Richard Westmacott), scientists (William Wollaston, Michael Faraday, John Dalton), engineers (Jacob Perkins, Marc Brunel, Thomas Telford), writers (Sir Walter Scott, Alaric Watts, Thomas Campbell), travellers (Richard and John Lander, Charles Latrobe, George Croly), and so on. Other categories might include 'miscellaneous writers', archaeologists, soldiers, administrators, musicians, architects, botanists, geologists and encyclopedists. Indeed, one could say that the collection is itself encyclopedic. We might deduce from this that in describing the sitters as 'Philip's father's friends' Brockedon was stretching a point. So controlled is the collection that one might hazard that the artist sought many of them out. Categories that are significant by their absence include politicians, churchmen, British aristocracy and royalty.

Brockedon was one of the most prolific men of the nineteenth century, energetic, driven and omnipresent. He was active as a history painter influenced by Haydon, as a portrait draughtsman as intimate as Cosway, as an inventor encouraged by Faraday, and as a traveller obsessed with discovering the true route taken by Hannibal and his armies over the Alps in pursuit of which he claimed to have crossed the Alps fifty-eight times in the 1820s. The only area of creativity that seems to have escaped him was the writing of novels, though perhaps some may turn up one day. As a practising artist Brockedon had many friends in and around the Royal Academy, including John Martin, Samuel Prout, David Roberts, Clarkson Stanfield and Turner. His activity as a traveller led him to become a founder member of the Royal Geographical Society (1830), and he was in addition an active member of the Athenaeum Club, a founder member of the Graphic Society, and a Fellow of the Royal Society elected in 1834. As an author he contributed articles to Charles Dickens's *Household Words*, and wrote passages on Egypt, the Holy Land, Italy and Switzerland for illustrated publications by David Roberts, Clarkson Stanfield, Samuel Prout and others.

Soon after his son Philip died of consumption in 1849, aged twenty-five, Brockedon went into a decline. The young man, a civil engineer who worked for Marc and Isambard Brunel, had been the apple of his father's eye, and his early death brought an end to the growth of the collection of 'Prominent People'. When Brockedon himself died in 1854, the *Illustrated*

London News reported that 'English artists are mourning the loss of an old friend'. Dickens was rather more circumspect, describing Brockedon as knowing 'a good deal about some curious places – is very ingenious – and may be useful'. The collection, now in the National Portrait Gallery, was left by Brockedon to his daughter Elizabeth and her husband, the transport entrepreneur Joseph Baxendale, whom we met in chapter 3.

Faraday's and Brockedon's portrait initiatives were intimate collecting for private enjoyment. At the other end of the scale was collectors' particular, and not always secret, delight in erotica. Caleb Whitefoord was one such silent collector, though his predilection for naked female flesh was well known: the cartoon 'Caleb curious. The Witty Wine Merchant' by Isaac Cruikshank, of 1792, shows him alone enjoying a gallery of paintings of voluptuous beauties. In his letter of thanks for hospitality to Whitefoord, one guest, signing himself only 'W. P.', remarked on his host's collection:

> Without any compliment I must confess I have no where in my travels seen a <u>bedchamber</u> so well furnished as yours – & I must consider its ornaments as the most valuable part of your collection. When I awoke this morning the Venus & all her attendants presented themselves to my imagination & produced an impromptu [poem].

There follow six verses extolling the pleasures of Whitefoord's bedroom, including

> For a bigot the third Charles of Spain may be reckon'd,
> Who, shock'd at his nudities, sent them away,
> But you wisely resemble our own Charles the Second,
> Preserving them all in your chamber to stay.
>
> If your Sanctum Sanctarum to <u>strangers</u> you shew
> Beware, my good friend! Lest you meet a free-booker,
> Who a <u>piece</u> might purloin while, in joys of <u>Virtu</u>,
> Italians cry – <u>cazzo!</u> – & Frenchmen cry – <u>foutre!</u>

Turner, spending a night at the Earl of Morley's house, Saltram, near Plymouth in 1813, found his friend and travelling companion Cyrus

Redding had been given a bedroom hung with paintings of frolicking figures of nymphs and shepherds. 'Good night in your seraglio', he said to Redding, as they departed for bed.

Nude subjects were commonplace in art exhibitions, the opportunities for titillation and arousal that they presented being neatly contained in classical or literary subjects, such as Andromeda, Phryne and Pygmalion: Andromeda was manacled naked to a sea rock and attacked by a dragon; Phryne was paraded naked around Athens to the delight of elderly philosophers; and the sculptor Pygmalion, carving the figure of a woman from cold marble, immediately fell in love with her smooth and shining form when he had finished. William Etty pushed directly at the boundaries of acceptability and received inevitable criticism for his sensual and often explicit nudes, dressing them up in classical subjects such as *Candaules, King of Lydia, Shews his Wife by Stealth to Gyges, One of his Ministers, as She Goes to Bed* (1830). Bought by Robert Vernon, this rare subject explores moral transgression followed by the impossible choice between execution and murder. While the depiction of pubic hair was very rare, cleverly avoided and otherwise compromised in exhibitions, it nevertheless found its way into a number of Etty's oil and chalk studies, and into some of the erotic drawings that Turner made for his own pleasure. For all their directness, John Gibson's *Tinted Venus* (c.1851–6) and Albert Moore's many standing nude figures are determinedly incomplete. Pubic hair was avoided by artists in exhibition pieces as if its electric shock could kill. Etty, however, made a calculated practice of setting a level of explicitness appropriate to the patron. His niece and assistant Betsy wrote to Joseph Gillott, who bought dozens of nude studies from him:

My dear Uncle is at work on your Little Scribe. Mrs Bullock wanted that, the one that Mr Etty painted for Mr Bullock is not so modest.

A reviewer in *The Times* was deeply upset by Etty's contributions to the 1835 Academy exhibition:

This painter has fallen into an egregious error. He mistakes the use of nudity in painting, and presents in the most gross and literal manner

the unhappy models of the Royal Academy for the exquisite idealities in which Titian and the other Masters who have chosen similar subjects revelled ... Mr Etty has permitted many unpardonable abominations. [*Phaedra and Cymocles*] is a most disgusting thing, and we wonder that in these times the people who have the direction of this exhibition venture to permit such pictures to be hung ... Such pictures are as shocking to good taste as they are to common decency; they are only fit for the contemplation of very old or very young gentlemen, and ought to be reserved for the particular delectation of these classes of persons.

Etty had his own direct view on his intentions: 'People may think me lascivious, but I have never painted with a lascivious motive. If I had I might have made a great wealth.' Nevertheless, he did not do too badly: on his death, Etty left £17,000 in 3 per cent bank stock and his house in York, where he had lived as a country gentleman, 'to cultivate cabbages, keep pigs and live pretty!'.

In demonstrating the inadequacies of the Obscene Publications Bill as presented to Parliament by the then Lord Chief Justice Lord Campbell in 1856 and 1857, Lord Lyndhurst described to the House of Lords an engraving that might be found in a printshop of a painting depicting 'a woman stark naked, lying down, and a satyr standing by her with an expression on his face which shows most distinctly what his feelings are, and what is his object'. The painting, Lyndhurst revealed, was *Jupiter and Antiope* by the sixteenth-century Italian artist Correggio, a favourite in the Louvre, 'right opposite an ottoman, on which are seated daily ladies of the first rank ... who resort there for the purpose of studying the works of art in that great gallery'.

Lord Campbell's bill, which by a small majority became an Act of Parliament, was principally aimed at publishers and book- and print-sellers. It did nevertheless also put the fear of prosecution into those trustees and curators responsible for the display of the national collections of paintings, principal among them the director of the National Gallery, Sir Charles Eastlake, and the keeper, Ralph Wornum. The importation by a Paris dealer of a painting of *The Three Graces* caused Wornum consternation when it was held at Newhaven and there came to the attention of the customs authorities, as it

represented three naked women [and] was stopped . . . under the imagi-
nation that it was contrary to the spirit of Lord Campbell's Act suppress-
ing indecent pictures. This caused some days delay in the arrival of the
picture in London.

In the event the painting was released and delivered to Trafalgar Square
where Eastlake, as Wornum noted, pronounced it to be 'Not a Raphael, of
very little merit and less value'.

The Turner Bequest caused considerably longer-lasting concern to
the National Gallery trustees, containing as it does groups of more or
less explicit erotic drawings within its interstices. These crop up from all
periods of Turner's life, from his young manhood in the first decade of the
nineteenth century to the 1840s when he was in his sixties. They are almost
exclusively drawn and painted within the covers of sketchbooks, sometimes
bizarrely juxtaposed with pages of financial calculations, incidental land-
scape detail and observations of the rising sun. They demonstrate clearly
that sex was an active and fruitful part of Turner's life, and while he took it
in his stride as a man of the Regency, it gave those Victorians who came to
assess his bequest after his death some considerable anxiety.

Whether Turner got his material at home or in brothels is not clear, but
if it was the latter, there was plenty of scope. Renton Nicholson, the editor
of *The Town*, a weekly newspaper of intimate and sexual gossip and rev-
elation published between 1837 and 1842, estimated that there were 1,500
brothels in London, ranging from the 'private aristocratical nunneries' of
the West End to low and disease-ridden dives. In the West End

the 'birds of paradise' nestle in flocks, supported in splendour and luxury,
in open defiance of popular prejudice and parochial interference . . . In
York Street, Baker Street, we find a brothel kept, positively, for the sole
accommodation of a noble duke, and he far advanced in years. Of this
house, and some others we shall treat more fully, under the heads of
Sketches of Courtezans in the future numbers of *The Town*.

Notable society figures were pursued by *The Town*, in energetic efforts to
expose them. This was in a tone of enthusiasm and applause, courtesans
being treated like celebrities:

> Within the purlieus of the patrician vortex of St James-street resides Ellen
> Clark. This woman is of surpassing beauty; and from her connection with
> a certain duke, we may greet her: 'Hail, star of Brunswick!' She is truly
> a title hunter, and in her bearing and liaisons, is completely aristocratic,
> that it may be said, that rank is a necessary qualification to be admitted
> to her favours. It is certain, however, that wealth is indispensible . . .
> [T]he beauteous Ellen has a perfect knowledge of commercial transac-
> tions and business.

The bibliographer, collector and textile exporter Henry Spencer Ashbee,
who wrote under the pseudonym 'Pisanus Fraxi', collected, studied and
catalogued erotic literature in a unique compendium which presented
an overview of sexual exercise available for payment in London across
the nineteenth century. The son of a gunpowder manufacturer, Ashbee
exploded into the near-silent and invisible world of English sexual practice,
finding sex and its practical literature to be a fascinating and absorbing
subject. He acquired much of his material on business trips to Paris,
Brussels and Amsterdam, and noticed an interesting sociological phenom-
enon at home – flagellation, he found, was a practice particularly favoured
by the English:

> This vice has certainly struck deeper root in England than elsewhere,
> and only here, I opine, can be found men who experience a pleasure
> rather in receiving than administering the birch. Nevertheless this is a
> fact, and did not discretion forbid, it would be easy to name men of the
> highest positions in diplomacy, literature, the army, &c., who, at the
> present day, indulge in this idiosyncrasy, and to point out the haunts
> they frequent.

Ashbee goes on to list some female flagellants, women of the town who
served 'as it were, an apprenticeship in order to acquire the art of gracefully
and effectively administering the rod'. He gives a forensic account of the
activities and offices of these businesswomen: Mrs Collett had premises
in Tavistock Court, Covent Garden, then Bedford Street, where she died.
Her niece, Mrs Mitchell, was taught by Aunt Collett, and carried on a
successful business of her own, first in the Waterloo Road, and finally in

St Mary's Square, Kennington, where she died. Colleagues in the profession included Mrs James, a maid to the family of Lord Clanricarde, at 7 Carlisle Street, Soho, who eventually retired from business 'with a good fortune, and dwelt at Notting Hill in luxury, her house being decorated in pictures, and her person covered in jewels'. The queen of the profession, according to Ashbee, was Mrs Theresa Berkley, of 28 Charlotte Street: 'she was a perfect mistress of her art, understood how to satisfy her clients, and was, moreover, a thorough woman of business, for she amassed during her career a considerable sum of money.'

Theresa Berkley was fully equipped to amuse her clients:

> Her supply of birch was extensive, and kept in water, so that it was always green and pliant . . . Holly brushes, furze brushes; a prickly evergreen called butchers brush; and during the summer, glass and China vases, filled with a constant supply of green nettles, with which she often restored the dead to life. Thus, at her shop, whoever went with plenty of money, could be birched, whipped, fustigated, scourged, needle-pricked, half-hung, holly-brushed, furse-brushed, butcher-brushed, stinging-nettled, curry-combed, phlebotomized, and tortured till he had a belly full.

In the late 1820s Berkley's business was going so well that an inventor of her acquaintance built a flogging machine for her which, she was assured, 'would bring her into notice, and go by her name after her death'. The 'Berkley Horse' became an instant hit among her clients, and according to Ashbee brought her much business. Ashbee claims that she made £10,000 over the eight years during which she used the flogging machine at Charlotte Street. When she died in 1836, her machine was presented by her executor to the model collection of the Society of Arts. It is now, however, untraced.

The commonplace sexual activity that Turner depicts in his sketchbooks almost invariably concerns men and women in pairs; in a few, however, the figures are numerous, and in one, painted in Switzerland in 1802, the participants seem to be two women. In all of these, it seems clear, Turner was the observer, the voyeur, as he was of landscape. There are at least four further drawings which are patently gynaecological, if not pornographic.

In Turner's mainly minuscule erotic watercolours, arms, bodies and legs well up entwined and emerge out of atmospheric backgrounds, where the swish of a curtain or the tug of a sheet adds a jaunty counterpoint to the action. Pencil drawings depict single female nude figures in poses which are clearly relaxed and intimate, as well as poses adopted in the life class. Subjects with a particular erotic undercurrent are among the groups of watercolours and gouaches that Turner made at Petworth in the 1820s and 1830s, and in Venice in the 1830s and 1840s. These reflect just another aspect of the life that Turner experienced in the places where he was at his most relaxed: in the Venice examples the women are likely to have been prostitutes, while at Petworth, the Liberty Hall in Sussex overseen by the Third Earl of Egremont, life was easy-going and straightforward for visiting artists. Their host, himself the father of many illegitimate children, seems to have had no difficulty in accommodating additional unexpected overnight guests.

Walter Thornbury, Turner's first biographer, took a typically Victorian attitude to Turner's evident sexual appetite, principally by not discussing it directly. He wrote that Turner

> would often, latterly, I am assured on only too good authority, paint hard all the week till Saturday night; he would then put by his work, slip a five-pound note in his pocket, button it securely up there, and set off to some low sailors' house in Wapping or Rotherhithe, to wallow till the Monday morning left him free again to drudge through another week. A blinded Sampson, indeed – a fallen angel, forgetful of his lost Paradise.

If this is the case, the evidence of the sketchbooks suggests that he did not entirely 'put by his work' on these weekends. Thornbury also observed that Turner left four illegitimate children (two is the currently accepted number) and reports a curious conversation:

> 'I once,' said a friend, 'heard Mr Crabbe Robinson . . . casually mention a remark dropped by the late Miss Maria Denman [John Flaxman's sister-in-law], when the two were out for an excursion with [Samuel] Rogers (I think), and had put up at an inn in a village near London.'

'That,' said the lady, pointing to a youth who happened to pass, 'is Turner's natural son.'

This fourth-hand story, with its dropped and uncertain remarks, should be taken with caution, but not necessarily dismissed. Turner's achievement as an erotic artist was unlike any other, not only because his work was so accomplished and lively, but because he chose to keep it to himself and, escaping destruction, it has survived more or less intact as a group. He worked closely with engravers to broadcast his landscape and subject pictures, but the erotica was just for himself. Comparison with Etty is revealing, in that Etty's nudes are distinctly posed studio models, not intimate actual or would-be companions. The doors of propriety had slammed closed with a crash on the subject of nudity in painting by the time Benjamin Disraeli published his novel *Lothair* in 1870.

> When the curtain was withdrawn they beheld a life size figure exhibiting in undisguised completeness the perfection of the female form, and yet the painter has so skilfully availed himself of the shadowy and mystic hour and of some gauze-like drapery which veiled without concealing his design that the chastest eye might gaze on his heroine with impunity.

Market forces and the desire for spectacle created a demand for exhibitions that presented themselves as 'experiences'. Among these were 'panoramas', massive art machines for which circular buildings such as Barker's Panorama in Leicester Fields (later Leicester Square) were built, bringing wide-screen entertainment to all. The term 'panorama' (from the Greek *pan-*, 'all', and *-orama*, 'view'), a word now so deeply embedded in the language that it might always have been there, was not coined until 1789 when the painter-entrepreneur Robert Barker and his son Henry devised it to describe their 360-degree prospect of Edinburgh from Calton Hill. This was shown first in Edinburgh and Glasgow, and then in the Haymarket, London. He may have patented the word 'panorama', but nevertheless Barker's initiative set off a wave of imitations and improvements, prompting rival panoramas of the Battle of the Glorious First of June, followed by a view of Brighton and another of Plymouth from Mount Edgcumbe.

Thomas Girtin came into the business in 1801 to create what he called an Eidometropolis, a word hammered out of 'Eidophusikon' (*eido-* = 'form' or 'shape'; *-phusikon* = 'physical'), coined by the painter Philip de Loutherbourg to describe his theatre of moving pictures that entertained audiences in the 1790s. Girtin's creation was an enveloping view of London, painted on a canvas about 200 feet in circumference, as seen from the roof of a warehouse near Southwark Bridge; it included a stark and telling view of the shell of the burnt-out Albion Mills. Though from a lower perspective, this is more or less the view that can be seen daily from the pods of the London Eye. Girtin went on to produce a panorama of Paris, before his early death in 1802.

From these beginnings productions came thick and fast, showing at the Panorama in Leicester Square, and in Spring Gardens just off Trafalgar Square. Subjects included Boulogne, Constantinople, the Battle of Trafalgar, Weymouth, Copenhagen, and even, in the Athenaeum Rooms, Leicester Square, 'A Grand Panorama of the World'. Competition was intense, 'the largest, most beautiful and instructive panorama ever offered to the public' being the claim of the Astronomical Panorama at Savile House, Leicester Square. Within months of the Battle of Waterloo, on 18 June 1815, Henry Barker's panorama of the scene was displayed in Leicester Square. The great and the good attended this, *The Times* reporting that the Duke of Wellington had visited a later version, of 1823, as if he had not seen enough of that particular battle already. Topicality was a constant theme, along with geographical splendour. The young architect Thomas Donaldson, recently home from touring and studying in Rome and Naples, illustrated the speed of turn-round in panorama production, and promoters' hunger for the exotic and extraordinary. Pompeii was in the 1820s crawling with archaeologists, artists and architects, all digging and measuring and coming home with souvenirs. The smothered city was a rich source of detail for Donaldson, who would become a distinguished London architect and a founder of the Royal Institute of British Architects. He wrote to his friend and mentor Robert Finch in Rome, displaying how he was putting his new knowledge to good use as an adviser to a panorama-maker:

> A Panorama is now open of a view of the Forum of Pompeii. It is painted most exquisitely, every object is given with great fidelity & the Harmonious warm glowing atmosphere of the Contorni of Naples is represented so as to complete the illusion . . . Another view will be open'd in about 12 days . . . I have written the little Pamphlets for both which tho' it does not produce any profit yet serves to make me known as my name is mentioned as the author at the beginning in the 'Avviso'.

Panoramas were the newsreels of the nineteenth century: Pompeii emerged onto their walls in the 1820s, distant landscapes of Canada, Egypt and India became subjects as their horizons opened to British travellers in the 1830s and 1840s, battles in the Crimea came into the repertoire in the mid-1850s. Realism was crucial. Robert Burford, who succeeded the Barkers as the most prominent of panorama promoters, displayed a view of Benares complete with 'strange conical edifices', 'motley population' and 'the obscene form of a corpse, carefully laid out on the frame to which it has been consigned by some pious relative'. As Henry Mayhew expressed it as late as 1851, the year of the Great Exhibition:

> New amusements were daily springing into existence [in London], or old ones being revived . . . The geographical panoramas had rapidly increased, no less than three Jerusalems having been hatched, as it were, by steam – like eggs, by the patent incubator – within the last three weeks. 'Australia' and 'New Zealand', like floating islands, had shifted their quarters from Miss Linwood's Gallery to the Strand.

The Times reported in 1860 on a further evolution of the form, the 'Stereorama':

> We have one panorama, properly so called, in Leicester Square; we have had moving pictures, improperly called 'panoramas', in such numbers that the world has at last become fairly tired of them, and they are fast falling into desuetude; we once had a diorama in the Regent's Park, which consisted of two stationary pictures shown under varying influence of light and shade, and which is now a matter of history. Cosmoramas have always been abundant . . . and we now have an exhibition at Cremorne called the Stereorama.

The Stereorama was an elaborate stage-set in which segments of Alpine views were constructed in a circle around the viewer, with 'the effects of real water', and an 18,000-square-foot canvas backdrop. The novelty, like all panoramas, reverses the principle of the circus, by putting the audience in the middle and the attraction itself in the surrounding stalls.

The fashion began to fade in the 1860s. John Ruskin remembered Burford and his clarity of vision, writing in his autobiography *Praeterita* of the 'greatly felt loss' that the vanishing of panoramas was to him in later life:

> Burford's panorama in Leicester Square, which was an educational institution of the highest and purest value . . . ought to have been supported by the Government as one of the most beneficial school instruments in London. There I had seen, exquisitely painted, the view from the roof of Milan Cathedral, when I had no hope of ever seeing the reality, but with a joy and wonder of the deepest.

With Burford's death in 1861, *The Times* foresaw the end of the panorama as public entertainment and, in Ruskin's view, instruction. 'In consequence of the lamented death of Mr Burford,' *The Times* announced,

> it appeared highly probable that the two panoramas daily exhibited at the Colosseum would soon be the only specimens of their kind . . . Year after year [Burford] remained the pictorial illustrator of his times, and an event of public interest seemed scarcely to have received its due acknowledgement until the spot where it had occurred had formed the subject of one of his beautiful panoramas.

A final step in the disappearance of the panorama was the incorporation of the word in the language, and its easy use as a noun describing Queen Victoria's diamond jubilee in 1897:

> A long and splendid panorama of Empire was unrolled yesterday in the chief thoroughfares of London before the Queen and a vast gathering of her subjects.

While panoramas were one method of mass communication of knowledge about exotic places and events, attendance at public lectures became

during the course of the nineteenth century another mass activity, comparable in some centres to theatre. The dramatic moments and spectacle to be found at the Royal Institution, for example, could be as enthralling as that on hand in a theatre in Drury Lane. Lecturing at the Royal Institution and establishing a new level of intellectual showmanship, Humphry Davy and, following him, Michael Faraday drew crowds sometimes exceeding 1,000 to the Institution's auditorium. Faraday, who began his lecturing career in the shadow of Sir Humphry, had stepped nervously for the first time onto the lecturing stage when he addressed an audience at the City Philosophical Society in 1816:

> With much diffidence I present myself before you this evening as a lecturer on the difficult, and refined Science of Chemistry, a Science that requires a mind more than mediocre to follow its progress.

Such anxieties did not last long, and Faraday soon became a star attraction. Friedrich von Raumer, the German historian and Anglophile, was impressed by his delivery:

> He speaks with ease and freedom, but not with a gossipy, unequal tone, alternately inaudible and bawling, as some very learned professors do; he delivers himself with clearness, precision and ability.

Raumer added later: 'Why have we [in Germany] nothing similar? . . . This British institution combines, in a laudable manner, external convenience, literary resources, agreeable conversation, and welcome instruction.'

The Royal Institution was one of many places where the public, or members of a loose and informal society, could experience scientific lectures. Open more or less equally to both men and women, the Royal Institution in Albemarle Street had weekly 'discourses' on Friday evenings in the season, linking central principles and recent discoveries in science to matters of topical note. A discourse that Faraday gave in 1835 was 'The manufacture of pens from quills and steel', outlining the past, present and future of pen-nib making, and drawing together the results of the invention and entrepreneurship of pen-makers including Joseph Gillott

and William Brockedon. Five hundred and twenty-eight people attended.
Others included surveys and explanations of the science behind the work
of Marc and Isambard Kingdom Brunel, details of experiments in vapori-
zation that Sir John Franklin was to carry out on his ill-fated expedition to
the Arctic in 1846, and an account of the latest studies of how black-figure
glazes were made on Greek pots.

Dozens of other institutions put on series of lectures including the
Surrey Institution, the North London Institution, the Russell Institution,
the National Gallery of Practical Science (the Adelaide Gallery) and the
London Mechanics' Institute. The setting-up of institutes and institutions
in London and beyond was an early Victorian industry. Some concentrated
on public instruction, others were geared to formal education courses. A
subject that generated particular excitement was electricity, and on the day of
the publication by John Murray of the four-volume collected edition of *The
Poetical Works of Lord Byron*, 5 February 1816, an evening course of lectures on
'Electrical Philosophy' began at the Russell Institution, Great Coram Street,
Russell Square, given by Mr Singer. Thus poetry with a shocking line in emo-
tional assault and exotic travel was launched in London at the same time as
new understanding of the shock and power of electricity was revealed.

There was an early wildness in claims about what electricity could do,
from its use in medicine to its appearances in nature. In the 1780s the quack
doctor James Graham filled his rooms in his Temple of Health and Hymen
at Adelphi Terrace, and later in Schomberg House, Piccadilly, with electri-
cal apparatus, wires, glass insulators, metal globes and a flying dragon with
electric sparks coming out of its eyes. People came for miles to find their
cures in all this nonsense. *The Times* reported in 1822 on a claim by the bota-
nist Linnaeus's daughter that 'Nasturtium blossoms have been observed to
emit electric sparks towards evening . . . It is seen most distinctly with the
eyes partly closed.' In electrical lectures there were sparks and shocks, and
hair-raising demonstrations, as members of the audience were encouraged
to come up to the stage and hold a terminal while static electricity was
generated to raise their hair and cause showers of sparks. When the Duke of
Wellington visited the Adelaide Gallery, he fiddled about with a battery and
got a nasty shock: 'the hero of a hundred fights, the conqueror of Europe,

was as helpless as an infant under the control of that mighty agency.' While Faraday chose not to make money out of his discovery of electromagnetic induction in 1831, leaving that to others, the market for scientific instruments that his discoveries had spawned became flooded with bizarre and yet more bizarre pieces of equipment in which handles were turned, levers pulled, coils of wire revolved in magnetic fields, and sparks flew.

From Leicester Square, down across Trafalgar Square to the Strand, there was entertainment of a more or less educational kind. Opposite what is now the Savoy Hotel was the Exeter Exchange – generally known as Exeter 'Change – where the air was filled with growls and roars of lions and tigers, barely drowned by the noise of traffic. The menagerie at Exeter 'Change managed to maintain a thin veil of respectability, by attracting the respectable to a place where wild animals could be studied, until it was demolished in 1829 to widen the road. Haydon and Landseer both went there to draw, and it was one of the sights that moved the young Wordsworth when he first came to London in the 1790s. An advertisement in *The Times* in 1818, placed by the proprietor Edward Cross, announced the birth of a pair of lion cubs at Exeter 'Change and encouraged thinking people to come along and see them, because 'so far from partaking of the ferocious spirit of their noble sire and dam, [they] are even more docile than the tamest of our English dogs':

> it really is curious to see how quiescently they receive the embraces of ladies and children . . . it affords the philosophic mind a rare opportunity of appreciating the correctness of Buffon on natural history.

Another prize exhibit was Chunee the elephant. Cross acquired the beast in 1812, and rapidly it became one of the most famous creatures in London. Byron was deeply impressed by its apparent courtesy, writing in his journal that 'the elephant took and gave me my money again, took off my hat, opened a door, trunked a whip, and behaved so well, that I wish he was my butler'. The animal performed at the Theatre Royal, Drury Lane, and was regularly paraded along the Strand. But Chunee could not take the strain for ever. He suffered agony from an infected tusk in 1826 and became enraged – or as *The Times* put it, showed 'strong symptoms of madness'

– and crashed about in his cage. He 'refused the caresses of his keepers' and rammed the 3-foot-thick oak and iron bars so violently that he was in danger not only of breaking himself free, but of releasing the other wild animals into the streets. The soldiers guarding government offices down the road at Somerset House were sent for, and they and a dozen other men with guns rallied round, formed an orderly firing squad, and eventually, after loosing a barrage of bullets at him and piercing him with spears, killed him. The commotion drew crowds to gather, causing the surrounding streets to be closed, but with the dead elephant still warm and its blood 'flood[ing] the den to a considerable depth . . . the public were admitted (upon payment of the accustomed charge)', and the room 'kept crowded till a late hour at night'. Lurching as it did from cod-education to horrific sensationalism, the menagerie in the Strand fed a voracious but equivocal appetite.

Half a mile from the Strand, in Piccadilly, William Bullock ran a show that was as busy and as popular as Exeter 'Change, but quieter and not so smelly. His elephant, like all his other animals, was stuffed, and silent. To the designs of the architect Peter Frederick Robinson, Bullock built a grand Egyptian temple fronting Piccadilly to house his ever-increasing natural history and ethnography collection. Opening the building to the public in 1812, Bullock proclaimed his museum to be a genuine establishment for the 'Advancement of the Science of Natural History'. Two hundred yards south from the Royal Institution, where discoveries in chemistry were made and taught daily, this was a challenging claim. 'One department of the Museum (the Pantherion)', Bullock wrote,

> is entirely novel, and presents a scene altogether grand and interesting . . . the lofty Giraffa, the Lion, the Elephant, the Rhinoceros, etc are exhib-ited as ranging in their native wilds and forests; whilst exact models, both in figure and colour, of the rarest and most luxuriant Plants from every clime, give all the appearance of reality.

Bullock goes on to suggest that, while in Paris the Louvre is 'enriched with the spoils of nearly the whole Continent' and 'contains more treas-ure in Painting and Sculpture than perhaps will ever be amassed in one

Collection', the British Navy and colonies have such extended reach that he will 'shortly be enabled to make a collection of Natural History far surpassing anything of the kind at present in existence'.

From beginnings in Birmingham and Liverpool, where as a young man he was an apprentice and then a practising silversmith, Bullock came with his collection to London, having first shown it in Liverpool. He had, quite simply, global ambitions as an exhibitor, which he expressed in his early thirties in London in the presence and activities of his splendid Egyptian Hall. 'When the information and delight which may be derived from this Exhibition, especially by the rising generation, are considered,' he continued,

> the great sum expended in forming it, and the erection of the present large and commodious building for its reception, the Proprietor trusts that the terms will be approved of. Admission to each exhibition, One Shilling . . . Subscriber for life £10.10s.

Bullock claimed to have gathered together 15,000 species at a cost exceeding £30,000. Donations came from individuals all over Britain, including some from Sir John Leicester of Tabley, who had made himself an expert in the study of fish, Mrs Polito, the widow of Stephen Polito, the original owner of the menagerie at Exeter 'Change, and the naturalist Sir Joseph Banks. Bullock was continually on the lookout for more specimens, and broadened his ambition to collect man-made objects. In an advertisement in his *Companion* to the museum he announced:

> The full value given for rare and uncommon Quadrupeds, Birds, Fishes, Reptiles, Shells, Old Paintings, Carvings on Wood or Ivory, Stained Glass, ancient and foreign Arms and Armour, or any uncommon production of Art or Nature.

Broadly, then, Bullock's ambitions were not only global, but Napoleonic. The establishment that he was nurturing was beginning even to encroach on the territory of the British Museum in Bloomsbury.

Always having an eye out for the spectacular, and in a purposeful move

to outdo the panorama-makers with a stupendous show of scale, Bullock displayed in 1816 the 26-foot-long canvas *Brutus Condemning his Sons* by the French artist Guillaume Lethière, and the following year the 30-foot-long canvas *Christ Raising the Son of the Widow of Nain* by Jean-Baptiste Joseph Wicar, one of the enablers of Napoleon's short-lived plan to denude Europe of its treasures. Stealing a march on the panorama men, this was spectacular art; the panoramas were merely spectacle. Showing at the Egyptian Hall at the same time as the Wicar in 1817 was the 11-foot-high statue by Canova, *Napoleon as Mars the Peacemaker*. This had been commissioned for Napoleon, but was never delivered to him; instead it was bought as spoils of war by the nation as a gift for the Duke of Wellington. Shipped to London in 1817, the work lingered at the docks before being moved slowly to Apsley House by way, briefly, of the Egyptian Hall. There the Prince Regent saw it, incognito, as *The Times* reported:

> Yesterday the Prince Regent went to Bullock's Museum, to see the grand picture by Wicars [*sic*], of Christ raising the Widow's Son; the colossal statue of Bonaparte; and the portrait of the Empress Josephine. His Royal Highness mixed among the spectators without being recognised.

Bullock sold his collection in 1819 and went to Mexico to look for more and different artefacts for display. He maintained his commercial interest in large paintings, displaying Géricault's *The Raft of the Medusa* and Haydon's *Christ's Entry into Jerusalem* in 1820, and an exhibition of John Martin's paintings in 1822. He sold out of the Egyptian Hall in the mid-1820s and went back to the United States on another characteristically bold venture, this time to set up a utopian housing scheme on the banks of the Ohio River. The Hall itself began a new lease of life as a place for the exhibition of paintings and watercolours, for parties and soirées, and gradually lost its special Bullock shine. Being hired out for entertainments, it was the venue for the masquerade and carnival to commemorate the twenty-first birthday of Princess Victoria in May 1837, a month before she became queen. A scene 'of unparalleled grandeur' was promised for the evening, at a price of one guinea for a single ticket, to include supper and a bottle of wine, and a guinea and a half 'for a lady and gentleman'.

The Royal Panopticon of Science and Art opened in 1854 in Leicester Square, the brainchild of Edward Marmaduke Clarke, a scientific-instrument maker who had been one of the many technicians and inventors to take quick advantage of developments in the manufacture of electrical machines. Clarke saw a good business in bringing science to a metropolitan audience. The Panopticon was to be a place of entertainment and education, in the manner of the by now defunct Adelaide Gallery, where the enjoyment and understanding of the science of electricity was but one of the many plums on offer. The Panopticon offered everything: it tried to combine the splendour of art with the aroma of animals and the prick of science.

> The artisan and mechanic may learn how to avail themselves of the discoveries and inventions of the master-minds . . . The artist may take the initiative from the admirable works around him . . . The manufacturer . . . will be better prepared to meet that competition which . . . is ever fatal to the indulgence of inactivity and ignorance . . . The agriculturalist [could determine] the value of the one-thousand-and-one species of manure offered to his notice as the acme of perfection.

In short, education was the thinnest of wrappings for entertainment in this spectacular building, which brought the most exotic Moroccan architectural manner to central London, where the Odeon cinema now stands. It had a frontage of 104 feet and a central rotunda 97 feet in diameter supported on iron columns; it glowed with coloured Minton tiles, prickled with statuary, boasted with armorial bearings, and had an 'Ascending Carriage', or hydraulic lift, to take visitors to the upper galleries. Conceived in 1850 in the midst of the enthusiasm and national drive which brought the Great Exhibition to its successful completion – the latter achieved only with the combined energies and bullying power of Prince Albert, Henry Cole and British organizational and industrial zeal working in concert – the Royal Panopticon opened with enormous fanfare in 1854, soon attracting 1,000 visitors a day. Clarke had invested five years of his life in it and had spent more than £80,000, but nevertheless through poor management, lack of vision and the interference of religious organizations, it became 'a total, irretrievable failure'. It was sold up in 1856, the building

and remaining equipment being bought by the entrepreneur E. T. Smith for £9,000. Smith turned it into the Alhambra Theatre for drama, dance and practically everything else on two legs, including one of the first performances of the 'Parisienne Quadrille', better known as the Can-Can.

With the Royal Academy, the British Institution, the National Gallery, the panoramas, Exeter 'Change and Bullock's Piccadilly emporium all in a relatively restricted geographical area, public exhibitions in London were a reflection of how the subsidized and the unsubsidized sectors responded to supply and demand. The National Gallery was a creature of the state, displaying the nation's paintings as a government service. There was no public subsidy for the Academy and the British Institution, and both organizations could remain active and open to the public only through heavy influx of funds from the interested public and the independent rich. The panoramas, Exeter 'Change, the Egyptian Hall and the Royal Panopticon, on the other hand, succeeded or failed by the hard hand of commerce. Attracting income through clever footwork from a multiplicity of sources, the Royal Academy is with us still. The British Institution, still going strong in 1867, was only dissolved by its directors when its lease in Pall Mall expired that year; it had plenty of money in the bank: its capital at closure was £15,000 in consols, with £1,057 cash in hand. The Institution was mourned by the *Art-Journal* on behalf of the interested general public:

> It has afforded a source of gratification to circles widely exterior even to those comprehending the third and fourth social removes from the proprietorship of the paintings; and by these alone . . . its lapse will be sincerely deplored.

Set up as the national bastion in support of old master and modern painting, the tide of change had swept over it, and in a post Pre-Raphaelite era it was out of touch. Or as the *Art-Journal* put it enigmatically:

> Could the authorities of the British Institution have foreseen that painting would lapse into the scenery of society and familiar life, they would probably have cultivated their bank accounts in such wise as to make their successors masters of the present situation.

Exactly 100 years after James Graham had brought electricity and medicine together, understanding of electricity had reached the stage when in 1882 a deputation of professors from King's College, London, could approach the London Livery Companies for money to develop the teaching of the subject, and demonstrate how the teaching of electricity at the College sent electricians around the world and into pioneering industries:

> There are at least six of our students who are engaged in Messrs Siemens' works; among them the chief electricians in the cable testing department, and one of their chief engineers on board the cable ship 'Faraday', and another who had the entire charge of Messrs Siemens exhibit at the Crystal Palace electrical exhibition.

Electricity had come a long way in those 100 years into the culture of art, science and entertainment, and gradually superseded steam as the nation's driver. In 1883 Sir Coutts Lindsay installed electric lighting in his Grosvenor Gallery in New Bond Street, where it was powered by a coal-fired generator. Within two years Lindsay was supplying half the street with electricity and had created a cellar under the gallery to take a larger generator and a larger furnace. With its 110-foot-high chimney, the Grosvenor Gallery, the cradle of the Aesthetic Movement, became 'the real cradle of the modern power station industry'. Thus, the first British power station resided in the basement of an avant-garde art gallery: in its early years, industry was once again being nurtured by art.

A GIGANTIC BIRDCAGE

'That I call clever', Thomas Carlyle wrote to his brother in January 1851. He had walked home in the frost to Chelsea from Hyde Park after taking another look at progress on the construction of the Crystal Palace. Like many of the London intelligentsia, Carlyle, a popular historian whose eyes fell on the present as much as the past, was sceptical about the whole extraordinary enterprise, launched with such clamour by Prince Albert two years earlier, during what the prince described as 'a period of most wonderful transition'. Standing in Rotten Row, near the park's southern boundary, Carlyle watched as steam-driven cranes raised high into the air their burdens of glass sheets. 'Our Crystal Palace . . . is nearly glazed in: you never saw such a monster of a Gigantic Birdcage in your life.'

The Crystal Palace was built to house the greatest display of manufacture yet assembled, in which every nation would offer the fruits of its industry for assessment, comparison and display in London, in what was to be grandly called 'The Exhibition of the Works of Industry of All Nations', the Great Exhibition. The world's manufactures would flow into the capital in a manner and quantity matched only by the flow over the past century of works of art, antiquities and curiosities to enhance the nation's museums and private collections. While not reversed, the flow was now radically changed in content and purpose, and allowed Britain to show itself as an integral part of a worldwide web of trade and fruitful contact with manufacturing nations, rather than as a recipient of treasure and tribute.

The campaigning journalist and social reformer Henry Mayhew described the exhibition's purpose:

The Great Exhibition is . . . the first attempt to dignify and refine toil; and by collecting the several products of scientific and aesthetic art from every quarter of the globe into one focus, to diffuse a high standard of excellence among our operatives, and thus raise the artistic qualities of labour, so that men, no longer working with their fingers alone, shall find that which is now mere drudgery converted into a delight, their intellects expanded, their natures softened, and their pursuits ennobled by the process.

This was not a new ideal. The House of Commons Select Committee enquiring in 1836 into arts and manufactures in Britain stressed the importance of good design in manufacture, clear and informative public displays of products, a museum in every workplace, and widespread access to education in art, science and literature. They took evidence from many influential and thoughtful people, including Francis Chantrey, Benjamin Robert Haydon, John Martin and John Pye.

What Carlyle found particularly clever about the Crystal Palace was the revelation that Joseph Paxton had designed it so that its steel girders and glass could be dismantled when the exhibition was over, taken away, and re-erected somewhere else like a nomad's tent. The Crystal Palace was itself just one more exhibit: 'he can build it again into streets of dwelling houses, into a village of iron cottages, or a world of garden greenhouses, without losing a pound of the substance employed (putty excepted).' Paxton submitted his design at a moment of desperation for the exhibition planners, breathing new life into a venture that, in May 1850, was noticeably faltering. When Prince Albert announced plans for the Great Exhibition, an international competition was launched for a building which would serve a purpose never before required in Britain. The weekly journal *The Builder* was still announcing the competition as late as 22 June 1850, less than a year before the proposed opening of the exhibition. Two hundred and forty-five designs were finally submitted, ranging from the grandiose to the ludicrous, including 'huge palaces, porticoes as large as that of the Exchange, sculpture, polychromy, copies of the Tuileries and Invalides . . . cast-iron ribs that would span St. Paul's . . . a collection of sheds without effect or architectural character'. The design submitted by the commissioners

themselves was a huge brick building with a slate roof and a low dome 200 feet across engineered by Isambard Kingdom Brunel as a 'striking feature to exemplify the current state of the science of construction in this country'. It would have looked like a bosomy railway station.

The preparations for the Great Exhibition gave Londoners endless opportunities to mock the cost and magnificence of the festivities to come. Carlyle planned to escape: 'I already have my own thoughts about flying away from London until it is all over.' Nevertheless his fascinated concern remained, and he worried about the structure 'letting in rain at every pore, and the sappers baling it, and the glaziers wringing their hands'. And then there were the birds: 'thousands of sparrows have got into it, by the ventilators &c; and can't be got out; they have called in the aid of <u>arsenic</u>.' But worse:

> bearded foreign people are already beginning to encumber the streets; and I suppose in six weeks hence, there will really be a great and very ugly crowd of British and foreign blockheads gathered here.

London was seriously disrupted as plans for the exhibition progressed. Not only were the streets congested by blocked roads (and 'blockheads'), but many roads were up for repair, and those from the railway stations and the docks were encumbered with delivery traffic:

> In all the main thoroughfares . . . heavy vans, piled high with unwieldy packing-cases, or laden with some cumbrous machine, and drawn by a long team of horses, crawled along, creaking, on their way towards the Crystal Palace.

London's road system, crowded and dirty under normal use, was not designed for the quantity of traffic that the Great Exhibition demanded. Indeed, it had never been designed.

Henry Mayhew and the illustrator George Cruikshank collaborated on an account of the adventures of a northern family who came to London to see the show. It takes Mayhew twelve chapters of jaunty story-telling, through misadventure and comic mishap, to get his family to London, but

once they have arrived he is able to engage his calling as a polemical writer. *1851: or, the Adventures of Mr and Mrs Sandboys and Family* allows Mayhew to project his views on the efficacy and potential of the Great Exhibition, using language that would never have found its way into official reports. The year of the exhibition happened to coincide with the first publication, in three volumes, of *London Labour and the London Poor*, the compilation of his articles first published in the *Morning Chronicle* in the 1840s. These drew attention to the depths of poverty and hopelessness in London, previously hidden or ignored. In writing about the Great Exhibition, Mayhew was able to highlight the social, as opposed to the commercial, opportunities that the exhibition offered. He was not particularly moved by the splendour of the event, but by how it might lead to social change and financial improvement for all.

In the weeks before the opening by Queen Victoria, the Crystal Palace was alive with painters painting, glaziers glazing, and drivers driving horse-drawn and steam-drawn wagons loaded with everything from piles of bricks from Essex to a carved sideboard from Germany. Against every column leant a ladder; at the top of every ladder was a painter with a can of blue, white, yellow or red paint, painting the girders following the strict decorative scheme devised by Owen Jones. On the roof glaziers walked with grace and elegance, making silhouettes on the skyline, 'some walking along the crystal covering, and making one wonder how the fragile substance bore them'.

> At the end of the building were steam engines puffing out their white clouds of steam, and amid the <u>debris</u> of a thousand packing cases stood giant blocks of granite, mammoth lumps of coal, stupendous anchors, and such huge articles as were too bulky to be placed within the building itself.

Nevertheless, there were critical moments of industrial tension: the painters went on strike, and three weeks before the opening the building was full of scaffolding and no exhibitor could get in. The weather was foul: two days before the opening a violent hailstorm ripped across Hyde Park, letting off a cannonade of sound as the ice stones hit the Crystal Palace.

The Times reported that exhibitors doubted that the exhibition would open on time:

> How after the many positive and authoritative intimations they have had, they should still in many instances refuse to be convinced, we are at a loss to understand.

Nothing changes: in mid-July 2012 the London Olympics were widely expected to be a disaster.

But 1 May 1851 turned out to be a sparkling May Day morning, a happy and clement beginning to weeks of fine weather. The queen opened the exhibition to a salute of cannon, the cheers of the crowd, and the Hallelujah Chorus. The event prompted superlatives in the press and wonder in the people. 'There is an education which is not taught by books. It is working out its mission in the Crystal Palace.' Mayhew went on to say:

> No other people in the world could have raised such a building – without one shilling being drawn from the national resources, or have stocked it with the same marvellous triumphs of industry and art. The machine room alone, with its thousand iron monsters snorting and chattering, was a sight to overwhelm the mind with a positive sense of awe; stories were current of the strongest minds having been affected to tears by the spectacle; and most assuredly, what with the noise and the motion, there was a sense of reverent humility forced upon the mind, together with a feeling of gratitude to the Almighty . . . that filled the bosom with the very pathos of admiration.

Even the weather came up trumps, according to Mayhew:

> One of the greatest and rarest curiosities that England presents at this moment to foreigners, who come to see the Exhibition, is decidedly the sun . . . For some days London has had a factitious air of Naples. Piccadilly and Regent Street are as scorching as Santa Lucia and the Chiaia . . . The Crystal Palace somewhat resembles a hot-house. One spends one's time in looking for seats as near as possible to the fountains and basins of filtered water, and in eating those eternal creams, which are something like iced pomatum.

However, despite the celebrations the exhibition was not complete on
1 May. One early visitor, Isabella Mary Hervey, who attended only five days
after the royal opening, reported that 'the inside [was] not nearly finished'.
Nothing had yet arrived from the United States, there was very little on
show from Russia and France, and the Dutch exhibit was shoddy in the
extreme. The Dutch poet Jacob van Lennep later reflected that this revealed
a lack of interest from the Dutch government, and a refusal to spend
money on the exhibition. In his poem 'Thoughts on the Exhibition in
London' van Lennep wrote of his excitement at all the 'miracles' gathered
in the Crystal Palace, but found there 'a dark wasteland' where the Dutch
contribution should have been, on account of 'the ice-cold word budget
cut' ('*Bezuiniging*'). So distraught was the Dutch commissioner for the
exhibition that he killed himself in his London hotel room.

What Isabella Mary Hervey particularly recalled, however, and described
in her diary was the sound of organ music, the extraordinary drama of the
trees in their May green, the sculpture and flowers, and the colour and the
conglomeration of objects: 'when I first went in I felt quite bewildered.'
And while there were lots of people present, the vast structure seemed to
swallow up the crowds:

> We staid there till near 6 & then came away very tired feeling we had only
> seen superficially about one quarter of what there is to be seen. We went
> in at the South Entrance in the transept and certainly the coup d'oeil on
> entering is one of the most curious and beautiful sights possible, the trees
> looking so green, the statues, the flowers, the red cloth in the galleries &
> all the different thing[s] exhibited look so curious all together & when
> I first went in I felt quite bewildered. The inside is not nearly finished.
> Russia and France have as yet very little. The United States nothing.
> Many of the Organs and Pianos were being played. There are 5 or 6 of the
> former some of them very large. There were a great many people but no
> crowd. The building is so immense it would take an enormous number of
> people really to fill it. There were not nearly so many foreigners in curious
> drapes as I expected to see.

'Every body else the last fortnight has been <u>living</u> in the Exhibition',
Isabella added a few days later. 'All people who can afford it having season

tickets which for two pounds enables one to go as often as one likes; but we have been only once as many 5 shillings would soon ruin us.' Nevertheless, she returned for another three hours to catch the missing exhibits:

> Went to the Exhibition principally to see the Russias which is just opened. The Malachite things are quite beautiful there being doors tables cabinets & chairs all made of it . . . We went at ½ 4 & came away at 7 the best time I think on shilling days as the crowd begins to disperse.

Above all the activity, the building emitted such a volume of noise, with organs and pianos being played against each other in cacophony, all against the background of puffing and rattling machinery and the hubbub of the humans. Then the colour in the Crystal Palace struck the visitor most profoundly, and the way light changed things. Never had there been such an acreage of glass covering a roof; never had the sun shone and sparkled so spectacularly from a man-made construction; never had the science of optics had such a public outing; never had anybody seen or heard anything like it. A journalist writing for the *Illustrated London News* put it most succinctly:

> As the eye wanders up the vistas, the three primitive colours of Sir D[avid] Brewster, red, yellow and blue, strike the eye by the intensity of their brightness in the foreground; but by blending in the distance, by the effect of parallax and diminished visual angle, the whole as in nature vanishes into a neutral grey . . . Looking up the nave, with its endless rows of pillars, the scene vanishes from extreme brightness into the hazy indistinctness which Turner alone can paint.

When it was all over in mid-October 1851, after five-and-a-half months of display, nearly six-and-a-quarter million people had visited the Great Exhibition at the Crystal Palace in Hyde Park – more than twice the population of London. As it would be for the 2012 Olympic Games in London, they had come from all over the world. A measure of the extraordinary pressure that this put on London's transport was revealed by the official figures: two-and-three-quarter million people were carried to London by

rail and steamer in 1850, while in the year of the Great Exhibition – long before the underground railway had been built, and a decade before any serious action had been taken over sewage disposal – the number had nearly doubled to four-and-a-quarter million. After all the costs had been paid, the exhibition made a profit of £115,000. With immediate effect the Crystal Palace was cleared of its contents, dismantled, and taken away piece by piece to be re-erected on the hill at Sydenham.

In its financial, popular and organizational success, the Great Exhibition heralded a new attitude to the public consumption of art in Britain. Its immediate outcome was the Victoria and Albert Museum, founded in 1852 and built out of its profits. It also heralded another great temporary exhibition in Britain, the 1857 Manchester Art Treasures exhibition held at Old Trafford, south-west of the city centre, near to where the Manchester United football stadium now stands. The Manchester art palace, temporary glass and steel like its larger Hyde Park predecessor, was connected to its city and beyond by a railway line that ran along its southern edge, and with a station that was effectively part of the palace structure. With the Bridgewater Canal to the north and a good road system around it, all possible transport infrastructures were in place before building began, and were part of the consideration for choosing Old Trafford as the exhibition's site.

The Manchester exhibition displayed, for the twenty-two weeks of its existence, more than 16,000 works of art lent from private collections all over Britain – none from abroad – and attracted over one-and-a-quarter million visitors. Not only was it a glittering showcase for the paying visitor (ticket prices from one shilling), it was also a stamp of approval for the art market, and a voluptuous parade for future art collectors in search of a sharp and shining point for their capitalist ventures. Among the masterpieces of world importance shown in Manchester, which were later whisked off to America after money had changed hands, were Giovanni Bellini's *St Francis in the Desert*, Titian's *Rape of Europa*, Gainsborough's *Blue Boy* and Lawrence's *Elizabeth Farren*. Nevertheless, many paintings found their way to British public collections, including another Giovanni Bellini, *Portrait of a Young Man*, Hogarth's *David Garrick as Richard III* and Gainsborough's *Mrs Siddons*.

The Manchester exhibition had a profound effect on the development of the history, public understanding and accessibility of art. That it was held in Manchester, not in London, is an indication of the rapid economic growth of British provincial cities, and the dependence of the national economy by mid-century on manufacture and trade, and in particular the cotton industry. The exhibition heralded the growth from the second half of the century of civic art galleries including Manchester City Art Gallery (1882) and Birmingham City Museum and Art Gallery (1885); and art galleries and museums, opening decade by decade, that bear their founders' names – Atkinson in Southport (1875), Barber in Birmingham (1932), Burrell in Glasgow (1944); running all the way through the alphabet, via Glynn Vivian, Higgins, Laing, Mappin, Tate, Towner and Usher, to Walker in Liverpool (1873), Whitworth in Manchester (1889) and Williamson in Birkenhead (1928). The names and dates of the foundations of these museums reflect the changing pattern of patronage, and thus the changing sources of disposable wealth.

Time goes into reverse when money or assets are given away, and so these gifts tend to reflect the aspirations of previous generations, as the collections themselves reflect past effusions of taste. The Seventh Viscount Fitzwilliam bequeathed his art collection and library to the University of Cambridge in 1816; the banker Sir John Julius Angerstein and the land-owner Sir George Beaumont gave founding collections to the British Museum, in trust for the National Gallery. But then a bricklayer's son, the architect Sir John Soane, bequeathed his house and collection to the nation in 1837; the horse-dealer Robert Vernon gave his collection in 1848; and the barber's son J. M. W. Turner intended at his death in 1851 that a Turner Gallery be built for the nation. Following on over the decades, corporations, boroughs and the nation received the fruits of a lifetime's collecting from brewer Sir Andrew Barclay Walker (Liverpool, 1873), machine-tool manufacturer Sir Joseph Whitworth (Manchester, 1889), sugar refiner Sir Henry Tate (London, 1897), copper entrepreneur's son Richard Glynn Vivian (Swansea, 1911) and ship-owner Sir William Burrell (Glasgow, 1944).

In intention and vision, these men share the impulse in which private passion leads directly to civic outcomes. Their common root lies in the

sense of enquiry that leads to the discovery of a new yellow pigment, the commercial and artistic daring that brings that colour to canvas, the intellectual and physical stamina that completes a complex and hard-won engraving of the painting, and the business sense and ruthlessness that allow the destruction of engraving plates that risked devaluing a greater asset.

While an art market may be the pinnacle circumstance of a capitalist economy, it can also, when the machinery is put into reverse, be the means whereby capitalism regenerates itself. Three towns at extreme points of Britain – Liverpool in Merseyside, St Ives in Cornwall and Margate in Kent – suffered serious economic decline in the latter decades of the twentieth century. In the 1980s and 2000s, these towns were furnished against the odds, and perhaps counter-intuitively, with public art galleries of international standing and aspiration. Subsequently, the magnetic attraction of art is working its natural magic and is contributing fundamentally to the regeneration of these communities and their hinterland, and to the revival and variation of local businesses. Three towns that might have been closing in on themselves began gradually to blossom again. The final benefit of an art market, public and private display, has found its civic outcome in Liverpool, St Ives and Margate.

DRAMATIS PERSONAE

The men and women whose lives interact within the pages of this book.

Ackermann, George (1803–91) — Art dealer and publisher
Ackermann, Rudolf (1764–1834) — Art dealer and publisher
Ackermann, Rudolph (1793–1868) — Art dealer and publisher
Adams, George (1709–72) — Scientific-instrument maker
Angerstein, Sir John Julius (c.1732–1823) — Banker, collector
Ashbee, Henry Spencer (1834–1900) — Bibliographer and collector

Baily, Edward Hodges, RA (1788–1867) — Sculptor
Banks, Sir Joseph (1743–1820) — Naturalist and traveller
Beaumont, Sir George, Bart (1753–1827) — Collector
Baxendale, Joseph (1785–1872) — Transport entrepreneur
Beckford, William (1760–1844) — Collector, author
Bell, Jacob (1810–59) — Chemist, collector
Beloe, William (1758–1817) — Writer, translator, curator
Bewick, Thomas (1753–1828) — Wood engraver
Bicknell, Elhanan (1788–1861) — Whaling entrepreneur, collector
Boydell, John (1720–1804) — Engraver, businessman
Boys, Thomas (fl. 1805–55) — Art dealer
Brande, William (1788–1866) — Chemist
Britton, John (1771–1857) — Engraver and publisher
Brockedon, William (1787–1854) — Artist, inventor and traveller
Brown, Ford Madox (1821–93) — Painter
Bryan, Michael (1757–1821) — Art dealer
Buchanan, William (1777–1864) — Art dealer
Buckler, John (1770–1851) — Topographer, businessman
Burnet, John (1784–1868) — Engraver
Byng, John, Fifth Viscount Torrington (1743–1813) — Soldier, diarist
Byron, George Gordon, Lord (1788–1824) — Poet

Callcott, Augustus Wall, RA (1779–1844) — Painter
Callcott, Maria (1785–1842) — Traveller, author, artist
Calvert, Edward (1799–1883) — Wood engraver
Carey, William (1759–1839) — Writer, art critic

Carlyle, Thomas (1795–1881)	Writer, critic, historian
Carr, Rev. William Holwell (1758–1830)	Art collector, dealer, benefactor
Champernowne, Arthur Harrington (1767–1819)	Collector, art dealer, landowner
Chantrey, Sir Francis, RA (1781–1841)	Sculptor
Christie, James, I (1730–1803)	Auctioneer
Christie, James, II (1773–1831)	Auctioneer
Clarke, Edward Marmaduke (c.1806–59)	Scientific-instrument maker, entrepreneur
Colebrooke, Sir George, Bart (1729–1809)	Merchant, entrepreneur
Coleridge, Samuel Taylor (1772–1834)	Poet
Colnaghi, Dominic (1790–1879)	Art dealer
Colnaghi, Martin (c.1792–1851)	Art dealer
Colnaghi, Paolo (1751–1833)	Art dealer
Constable, John, RA (1776–1837)	Painter
Cosway, Richard, RA (1742–1821)	Painter
Cotman, John Sell (1782–1842)	Painter
Coutts, Thomas (1735–1822)	Banker
Cruikshank, George (1797–1878)	Artist, illustrator
Cunningham, Allan (1784–1842)	Poet, sculptor, administrator
Davis, John Scarlett (1804–45)	Painter
De La Beche, Henry (1796–1855)	Geologist
Desenfans, Noel (1744–1807)	Art dealer
Devis, Anthony (1729–1816)	Painter
Dickens, Charles (1812–1870)	Writer
Donaldson, Thomas L. (1795–1885)	Architect
Dunbar, David (1793–1866)	Sculptor
Egremont, Lord, *see* Wyndham, George	
Etty, Willliam RA (1787–1849)	Artist
Farington, Joseph RA (1747–1821)	Diarist and artist
Fawkes, Francis Hawkesworth (1797–1871)	Landowner, collector
Fawkes, Walter (1769–1825)	Landowner, collector
Field, George (1777–1854)	Colourman
Flaxman, John, RA (1755–1826)	Sculptor
Fowke, Capt. Francis (1823–65)	Soldier, engineer, architect
Gahagan, Lawrence (c.1735–1820)	Sculptor
Gahagan, Lucius (1773–1855)	Sculptor
Gambart, Ernest (1814–1902)	Art dealer
Gandy, Joseph ARA (1771–1843)	Artist, architect
Garrard, George, ARA (1760–1826)	Sculptor, painter, modeller
Géricault, Théodore (1791–1824)	Painter
Gillott, Joseph (1799–1872)	Entrepreneur, collector

Goblet, Lewis (*b.* 1764) Sculptor
Graham, Maria, *see* Callcott, Maria
Grandi, Sebastian (*fl.* 1789–1822) Colourman
Graves, Algernon (1845–1922) Art dealer
Green, Valentine, ARA (1739–1813) Engraver
Griffith, Thomas (1795–1868) Art dealer

Hatchard, John (1768–1849) Bookseller
Heath, Charles (1785–1848) Engraver, publisher
Heffernan, James (1788–1847) Sculptor
Hervey, Isabella Mary (1830–1911) Diarist
Holford, Robert Stayner (1808–92) Collector
Holland, Henry (1745–1806) Architect
Hope, Thomas (1769–1831) Banker, collector
Hullmandel, Charles (1789–1850) Lithographer and entrepreneur
Hunt, William Holman (1827–1910) Painter

Irvine, James (1757–1831) Painter, art dealer

Jenkins, Thomas (1722–98) Art dealer

Knight, Charles (1791–1873) Publisher

Lackington, James (1746–1815) Bookseller
Landseer, Sir Edwin RA (1802–73) Artist
Landseer, John ARA (1769–1852) Engraver
Legé, Francis (1779–1837) Sculptor
Leicester, Sir John, Bart (1762–1827) Landowner, collector
Lennep, Jacob van (1802–68) Dutch poet
Leveson-Gower, George Granville, Second Landowner, collector
 Marquess of Stafford and First Duke of
 Sutherland (1758–1833)
Lewis, Charles George (1808–80) Engraver
Lewis, Frederick Christian (1779–1856) Engraver
Long, Sir Charles (1760–1838) Politician, connoisseur

Magoon, Rev. Elias Lyman (1810–86) Cleric and collector
Martin, John (1789–1854) Painter
Maw, John Hornby (1800–85) Entrepreneur, collector
Mayhew, Henry (1812–87) Journalist, social reformer
McGregor, Gregor (1786–1845) Swindler
Moon, Sir Francis (1796–1871) Art dealer
Murray II, John (1778–1843) Publisher

Nash, John (1752–1835) Architect
Nollekens, Joseph, RA (1737–1823) Sculptor

Northcote, James RA (1746–1831) Painter

Opie, Amelia (1769–1853) Author, activist
Opie, John, RA (1761–1807) Painter

Palmer, Samuel (1805–81) Painter
Paxton, Sir Joseph (1803–65) Architect, gardener
Peel, Sir Robert (1788–1850) Politician, collector
Pye, John (1782–1874) Engraver
Pyne, William Henry (1769–1843) Artist

Raimbach, Abraham (1776–1843) Engraver
Raumer, Friedrich von (1781–1873) Historian, traveller
Reynolds, Samuel W. (1773–1835) Engraver
Ritchie, Leitch (1800–65) Journalist
Robinson, Thomas (1806–85) Wood engraver
Rogers, Samuel (1763–1855) Banker, collector, poet
Rossi, Charles, RA (1762–1839) Sculptor
Rundell, Maria (1745–1828) Cookery writer

Schinkel, Karl Friedrich (1781–1841) Architect
Schofield, Isaac (*fl. c.*1800–50) Sugar merchant
Scott, Sir Walter (1771–1832) Author
Seguier, William (1772–1843) Curator, art dealer, picture cleaner
Shee, Sir Martin Archer, PRA (1769–1850) Artist, writer
Sheepshanks, John (1787–1863) Collector
Sheridan, Richard Brinsley (1751–1816) Playwright, impresario
Silliman, Benjamin (1779–1864) Traveller, scientist
Slater, Joseph (*c.*1779–1837) Artist
Smith, Adam (1723–90) Economist
Smith, Frederick William (1797–1835) Sculptor
Stewart, James (1791–1863) Engraver

Taine, Hippolyte (1828–93) Writer
Thomas, Serjeant Ralph (1803–62) Lawyer, collector
Tilt, Charles (1797–1861) Publisher
Tresham, Henry (*c.*1750/51–1814) Painter and art dealer
Truchsess, Count Joseph (*fl.* 1800–10) Collector and art dealer
Turner, Charles, ARA (1774–1857) Engraver
Turner, Dawson (1775–1858) Banker, botanist, correspondent
Turner, James (*d.* 1808) Colourman
Turner, Joseph Mallord William, RA (1775–1851) Painter
Turner, Mary (1774–1850) Artist, wife of Dawson Turner

Uwins, David (1780–1837) Physician, homeopath

Varley, Cornelius (1781–1873)	Artist, inventor
Varley, John (1778–1842)	Painter
Venn, Emilia (1794–1881)	Diarist
Venn, Rev. John (1759–1813)	Clergyman
Vernon, Robert (1774/5–1849)	Transport entrepreneur, collector
Waagen, Gustav Friedrich (1797–1868)	Museum director, writer
Wainewright, Thomas (1794–1847)	Artist, critic, poisoner
Ward, James, RA (1769–1859)	Artist
Watson Taylor, George (1771–1841)	Politician, collector
Wells, William (1768–1847)	Shipbuilder and collector
Wells, William Frederick (1762–1836)	Artist and teacher
Westmacott, Sir Richard, RA (1775–1856)	Sculptor
Whitbread, Samuel, the Elder (1720–96)	Brewer, landowner, collector, politician
Whitbread, Samuel, the Younger (1764–1815)	Brewer, landowner, collector, politician
Whitefoord, Caleb (1734–1810)	Wine merchant, administrator
Whymper, Edward (1840–1911)	Wood engraver; mountaineer
Wilkie, David, RA (1785–1841)	Painter
Wilson, Andrew (1780–1848)	Painter, art dealer
Windus, Benjamin Godfrey (1790–1867)	Transport entrepreneur, collector
Winsor, William (1804–1864)	Colourman, businessman
Wonder, Pieter Christoffel (1780–1852)	Artist
Woodburn, Samuel (1786–1853)	Art dealer
Woollett, William (1735–85)	Engraver
Woolner, Thomas, RA (1825–92)	Sculptor
Wordsworth, William (1770–1850)	Poet
Wornum, Ralph (1812–77)	Curator, writer
Wright, Joseph, ARA, 'of Derby' (1734–97)	Artist
Wyatt, James, RA (1746–1813)	Architect
Wyndham, George, Third Earl of Egremont (1751–1837)	Landowner, collector
Young, John (1755–1825)	Engraver, curator

BIBLIOGRAPHY

Published in London except where stated.

Primary material

Barker, Elizabeth E., 'Documents relating to Joseph Wright "of Derby" (1739–97)', *Walpole Society*, vol. 71, 2009

Beckett, R. B. (ed.), *John Constable's Correspondence*, 6 vols, 1962–9

Belcher, Margaret (ed.), *The Collected Letters of A. W. N. Pugin*, 4 vols, 2001–2012

Brigstocke, Hugh, 'James Irvine: A Scottish artist in Italy – picture buying in Italy for William Buchanan and Arthur Champernowne', *Walpole Society*, vol. 74 (2012), pp. 245–79

Brigstocke, Hugh, *William Buchanan and the Nineteenth Century Art Trade: 100 letters to his agents in Italy*, 1982

Callcott, Maria, *Essays towards the History of Painting*, 1836

Carey, William Paulet, *Some Memoirs of the Patronage and Progress of the Fine Arts in England and Ireland . . . with Anecdotes of Lord de Tabley, of Other Patrons, and of Eminent Artists, and Occasional Critical References to British Works of Art*, 1826

Chambers, Neil (ed.), *The Letters of Sir Joseph Banks: A selection, 1768–1820*, 2001

Croft-Murray, Edward, 'An Account Book of John Flaxman, RA, British Museum Add MSS 39784 B.B.', *Walpole Society*, vol. 28 (1940), pp. 51–94

Dowden, Wilfred S. (ed.), *The Letters of Thomas Moore*, 2 vols, 1964

Dowden, Wilfred S. (ed.), *The Journal of Thomas Moore*, 6 vols, 1983–1991

Eastlake, Sir Charles, *Contributions to the Literature of the Fine Arts with a Memoir Compiled by Lady Eastlake*, 2nd edn, 1870

Farington, Joseph, *The Diary of Joseph Farington RA 1793–1821* (ed. Kenneth Garlick, Angus Macintyre and Kathryn Cave), 16 vols, 1978–84

Field, George, *Chromatography; or, A Treatise on Colours and Pigments and their Powers in Painting, &c*, 1835

Fraxi, Pisanus, *Index Librorum Prohibitorum: being Notes Bio- Biblio- Icono-graphical and Critical on Curious and Uncommon Books*, 1877

Gage, John, *The Collected Correspondence of J. M. W. Turner*, 1980

Gage, John, 'Further Correspondence of J. M. W. Turner', *Turner Studies*, vol. 6, no. 1 (1986)

Griggs, E. L. (ed.), *The Collected Letters of Samuel Taylor Coleridge*, 1956–71

Hall, Douglas, 'The Tabley House Papers', *Walpole Society*, vol. 38 (1960–2)

Hewins, W. A. S. (ed.), *The Whitefoord Papers: The correspondence and other MSS of Charles and Caleb Whitefoord from 1739 to 1810*, 1898

Howard, Frank, *Colour as a Means of Art*, 1838

James, Frank A. J. L. (ed.), *The Correspondence of Michael Faraday 1811–1831*, 6 vols, 1991–2012

Jerdan, William, *Autobiography*, 1852–3

Jones, George, RA, *Sir Francis Chantrey RA: Recollections of his life, practice and opinions*, 1849

Knight, Charles, *Passages of a Working Life*, 1864

Lackington, James, *Memoirs of the Forty-Five First Years of the Life of James Lackington* (2nd edn), 1793

Maltby, William (ed.), *Recollections of the Table-Talk of Samuel Rogers*, 1856

Millais, J. G., *The Life and Letters of Sir John Everett Millais*, 1899

Nicholson, Andrew (ed.), *The Letters of John Murray to Lord Byron*, 2007

Nygren, Edward, 'James Ward, RA (1769–1859): Papers and patrons', *Walpole Society*, vol. 75, 2013

Pope, W. B. (ed.), *The Diary of Benjamin Robert Haydon*, 5 vols, 1960–3

Pye, John, *Patronage of British Art: An historical sketch*, 1845

Pye, John (J. L. Roget, ed.), *Notes and Memoranda Respecting the* Liber Studiorum *of J. M. W. Turner . . .*, 1879

Raimbach, M. T. S. (ed.), *Memoirs and Recollections of the Late Abraham Raimbach, Esq., Engraver*, 1843

Raumer, Friedrich von, *England in 1835: Being a series of letters written to friends in Germany*, 1836

Redding, Cyrus, *Fifty Years of Recollections*, vol. 2, 1858

Redgrave, Richard and Samuel, *A Century of British Painters*, 1866 (Phaidon edn, 1947)

Schinkel, Karl Friedrich, *The English Journey: Journal of a visit to France and Britain in 1826* (ed. David Bindman and Gottfried Riemann), 1993

Sebag-Montefiore, Charles, with Julia I. Armstrong-Totten, *A Dynasty of Dealers: John Smith and his successors, 1801–1924*, 2013

Smith, Adam, *An Inquiry into the Nature and Causes of the Wealth of Nations*, 1776

Smith, Ian (ed.), *The Apprenticeship of a Mountaineer: Edward Whymper's London diary, 1855–1859*, London Record Society, vol. 43, 2008

Smith, J. T., *Nollekens and his Times*, 1828

Smith, Thomas, *Recollections of the Rise and Progress of the British Institution, 1805–1859*, 1860

Taine, Hippolyte, *Notes on England*, 1873

Taylor, Tom (ed.), *Life of Benjamin Robert Haydon Historical Painter, from his Autobiography and Journals*, 1853

Thornbury, Walter, *The Life and Correspondence of J. M. W. Turner RA*, 1862, revised edn 1897

Uwins, Sarah, *A Memoir of Thomas Uwins RA*, 1858

Waagen, Gustav Friedrich, *Works of Art and Artists in England*, 1838

Waagen, Gustav Friedrich, *Treasures of Art in Great Britain*, 1854

Waagen, Gustav Friedrich, *Galleries and Cabinets of Art in Great Britain*, 1857

Watts, Alaric, *A Narrative of his Life*, 1884

Woodcock, Sally with Judith Churchman, *Index of Account Holders in the Roberson Archive, 1820–1939*, Hamilton Kerr Institute, 1997

Yarrington, Alison et al., 'An Edition of the Ledger of Sir Francis Chantrey, RA, at the Royal Academy, 1809–1841', *Walpole Society*, vol. 56, 1991–2

Young, John, *A Catalogue of Pictures by British Artists in the Possession of Sir John Fleming Leicester, Bart*, 1825

Secondary material

Akel, Regina, *Maria Graham: A literary biography*, 2009

Alexander, Boyd, *England's Wealthiest Son: A study of William Beckford*, 1962

Avery-Quash, Susannah and Julie Sheldon, *Art for the Nation: The Eastlakes and the Victorian art world*, 2011

Baker, Malcolm, *Figured in Marble: The making and viewing of eighteenth-century sculpture*, 2000

Baker, Malcolm and Brenda Richardson, *A Grand Design: The art of the Victoria and Albert Museum*, 1997

Balston, Thomas, *John Martin 1789–1854: His life and works*, 1947

Bayer, Thomas M. and John R. Page, *The Development of the Art Market in England: Money as Muse, 1730–1900*, 2011

Baynton-Williams, Roger, *The Art of the Printmaker, 1500–1860*, 2009

Bindman, David (ed.), *John Flaxman RA*, 1979

Bindman, David and Malcolm Baker, *Roubiliac and the Eighteenth-Century Monument: Sculptor as theatre*, 1995

Bonython, Elizabeth and Anthony Burton, *The Great Exhibitor: The life and work of Henry Cole*, 2003

Brown, David Blayney, *Augustus Wall Callcott*, 1981

Butlin, Martin and Evelyn Joll, *The Paintings of J. M. W. Turner*, 2 vols, revised edn, 1984

Carlyle, Leslie, *The Artist's Assistant: Oil painting instruction manuals and handbooks in Britain, 1800–1900*, 2001

Carpenter, Humphrey, *The Seven Lives of John Murray*, 2008

Chapel, Jeannie, 'The Papers of Joseph Gillott (1799–1872)', *Journal of the History of Collections*, 2007, pp. 1–48

Chapman, Guy, *Beckford*, 1940

Chenciner, Robert, *Madder Red: A history of luxury and trade*, 2000

Coltman, Viccy, *Classical Sculpture and the Culture of Collecting in Britain since 1760*, 2009

Craske, Matthew, *The Silent Rhetoric of the Body: A history of monumental and commemorative art in England, 1720–1770*, 2007

De Marchi, Neil and Craufurd D. W. Goodwin (eds), *Economic Engagements with Art*, 1999 (Annual supplement to vol. 31, *History of Political Economy*)

Deuchar, Stephen, *Paintings, Politics and Porter: Samuel Whitbread (1764–1815) and British art*, 1984

Eitner, Lorenz, *Géricault's Raft of the Medusa*, 1972

Eustace, Katharine, '"Questa Scabrosa Missione": Canova in Paris and London in 1815', in Katharine Eustace (ed.), *Canova Ideal Heads*, 1997

Faberman, Hilaire and Philip McEvansoneya, 'Isambard Kingdom Brunel's "Shakespeare Room"', *Burlington Magazine*, vol. 137, no. 1103, Feb 1995, pp. 108–18

Farr, Dennis, *William Etty*, 1958

Finberg, A. J., *The Life of J. M. W. Turner RA*, 1961

Finlay, Victoria, *Colour*, 2002

Ford, John, *Ackermann 1783–1983: The business of art*, 1983

Forrester, Gillian, *Turner's 'Drawing Book', The Liber Studiorum*, 1996

Fothergill, Brian, *Beckford of Fonthill*, 1979

Fox, Celina (ed.), *London: World city, 1800–1840*, 1992

Fulford, Roger, *Samuel Whitbread (1764–1815): A study in opposition*, 1967

Gage, John, *Colour in Turner*, 1966

Gage, John, *Turner: Rain, Steam and Speed*, 1972

Gage, John, *George Field and his Circle: From Romanticism to the Pre-Raphaelite Brotherhood* (exhibition catalogue), Fitzwilliam Museum, Cambridge, 1989

Gage, John, *Colour and Culture*, 1993

Gage, John, *Colour and Meaning*, 1999

Gaunt, William and F. Gordon Roe, *Etty and the Nude*, 1943

Gilchrist, Alexander, *Life of William Etty*, 1855

Hamilton, James, *Turner: A life*, 1997

Hamilton, James, *Turner and the Scientists*, 1998

Hamilton, James, *Faraday: The life*, 2002

Hamilton, James, *Turner's Britain*, 2003

Hamilton, James, *London Lights: The minds that moved the city that shook the world*, 2007

Hamilton, James, '"The time must come": Turner and royalty', *Turner Society News*, vol. 118 (autumn 2012), pp. 8–17

Hamlyn, Robin, *Robert Vernon's Gift: British art for the nation, 1847*, 1993

Herrmann, Luke, *Turner Prints: The engraved work of J. M. W. Turner*, 1990

Hobhouse, Hermione, *The Crystal Palace and the Great Exhibition – Art, Science and Productive Industry: A history of the Royal Commission for the Exhibition of 1851*, 2002

Holmes, Richard, *Coleridge: Early Visions*, 1989

Howard, Jeremy, *Colnaghi: The history*, 2010

Insley, Jane, 'James Watt and the reproduction of sculpture', *Sculpture Journal*, vol. 22, no. 1, pp. 37–65

Irwin, David, *John Flaxman, 1755–1826: Sculptor, illustrator, designer*, 1979

Jackson-Stops, Gervase, 'Southill Park, Bedfordshire', *Country Life*, 28 April 1994

Kauffmann, C. M., *John Varley (1778–1842)*, 1982

Kelly, Jason M., *The Society of Dilettanti*, 2009

Kenworthy-Brown, John, 'Joseph Nollekens: The years in Rome', *Country Life*, vol. 165 (7, 14 June 1979), pp. 1844–8 and 3–74

Kynaston, David, *A World of its Own: The City of London, 1815–1890*, 1995

Lennie, Campbell, *Landseer: The Victorian paragon*, 1976

Lloyd, Stephen, *Richard and Maria Cosway: Regency artists of taste and fashion*, 1995

Lukacher, Brian, *Landscapes of Retrospection: The Magoon Collection of British drawings and prints, 1739–1860*, Vassar College, Poughkeepsie, 1999

Lukacher, Brian, *Joseph Gandy: An architectural visionary in Georgian England*, 2006

Maas, Jeremy, *Gambart, Prince of the Victorian Art World*, 1975

Macleod, Dianne Sachko, 'Art Collecting and Victorian Middle-Class Taste', *Art History*, vol. 10, no. 3 (Sept 1987), pp. 328–50

Macleod, Dianne Sachko, *Art and the Victorian Middle Class: Money and the making of cultural identity*, 1996

Mason, Shena (ed.), *Matthew Boulton: Selling what all the world desires*, 2009

Miles, Margaret M., *Art as Plunder*, 2008

Miller, James, *Fertile Fortune: The story of Tyntesfield*, 2003

Morus, Iwan Rhys, *Frankenstein's Children: Exhibition, electricity and experiment in early-nineteenth-century London*, 1998

Motion, Andrew, *Wainewright the Poisoner*, 2000.

Myrone, Martin (ed.), *John Martin Apocalypse*, 2011

Nead, Lynda, *Victorian Babylon*, 2000

O'Keeffe, Paul, *A Genius for Failure: The life of Benjamin Robert Haydon*, 2009

Ormond, Richard, *The Monarch of the Glen: Landseer in the Highlands*, 2005

Penny, Nicholas (ed.), *Reynolds*, 1986

Pergam, Elizabeth A., *The Manchester Art Treasures Exhibition of 1857: Entrepreneurs, connoisseurs and the public*, 2011

Petter, Helen Mary, *The Oxford Almanacks*, 1974

Piggott, Jan, *Turner's Vignettes*, 1993

Prescott, Gertrude, 'Gleams of Glory: Forging learned society portrait collections', in James Hamilton (ed.), *Fields of Influence: Conjunctions of artists and scientists, 1815–1860*, 2000

Purbrick, Louise (ed.), *The Great Exhibition of 1851: New interdisciplinary essays*, 2001

Reitlinger, Gerald, *The Economics of Taste: The rise and fall of picture prices, 1760–1960*, 1961

Robinson, John Martin, *James Wyatt, Architect to George III*, 2012

Robinson, Leonard, *William Etty: His life and art*, 2007

Rolt, L. T. C., *Isambard Kingdom Brunel*, 1957

Roscoe, Ingrid (ed.), *A Biographical Dictionary of Sculptors in Britain, 1660–1851*, 2009

Sicca, Cinzia Maria and Alison Yarrington (eds.), *The Lustrous Trade: Material culture and the history of sculpture in England and Italy, c.1700–c.1860*, 2000

Smith, Greg, *Thomas Girtin: The art of watercolour*, 2002

Stourton, James and Charles Sebag-Montefiore, *The British as Art Collectors: From the Tudors to the present*, 2012

Taylor, Brandon, *Art for the Nation: Exhibitions and the London public, 1747–2001*, 1999

Tomalin, Claire, *Charles Dickens: A life*, 2011

Trethewey, Rachel, *Mistress of the Arts: The passionate life of Georgina, Duchess of Bedford*, 2002

Ward-Jackson, Philip, *The Public Sculpture of the City of London*, 2003

Warrell, Ian, *Turner's Secret Sketches*, 2012

Waterfield, Giles, *Palaces of Art: Art galleries in Britain, 1790–1990*, 1991

Whinney, Margaret, *Sculpture in Britain, 1530–1830*, 1964

Whitbread, Sam, *'Plain Mr Whitbread': Seven centuries of a Bedfordshire family*, 2007

Whitley, William T., *Art in England, 1800–1820*, 1928

Whitley, William T., *Art in England, 1821–1837*, 1930

Whittingham, Selby, '"A most Liberal Patron": Sir John Fleming Leicester, Bart, 1st Baron de Tabley, 1762–1827', *Turner Studies*, vol. 6, no. 2 (winter 1986), pp. 24–36

Whittingham, Selby, 'The Turner Collector: Benjamin Godfrey Windus, 1790–1867', *Turner Studies*, vol. 7, no. 2 (winter 1987), pp. 29–35

Wilton, Andrew, *Turner in his Time*, 1987; new edn, 2006

Wood, Lucy, *The Upholstered Furniture in the Lady Lever Art Gallery*, vol. 2, 2008

Manuscripts consulted

Acland Family Papers	Bodleian, MSS Acland, d.
Artists' Annuity and Benevolent Fund Archive	London Metropolitan Archives, GB 0074 CLC/114
Beckford Papers	Bodleian, MSS Beckford, c.27, 28, 36
British Institution Minutes	V&A, NAL, RC.V.11
Buckler Papers	Bodleian, MS Eng. Lett., a. 1
Callcott Papers	Bodleian, MS, Eng. d. 2263, 2274
Chantrey Correspondence	V&A, NAL, 86.YY.17
Etty-Gillott Correspondence	University of Birmingham, Cadbury Research Library, XMS 94
Flaxman Papers	BL Add MS 39780–39791
Graves Papers	BL Add MS 46140
Griffith Papers	1831–69, #11021-z, Rare Book, Literary and Historical Papers, Wilson Library, University of North Carolina at Chapel Hill
Lucas Correspondence	V&A, NAL, 86.WW.12
Murray Archive	National Library of Scotland
Landseer–Bell Papers	Royal Institution of Great Britain Archive, London, RI MS LAN
Landseer Correspondence	V&A, NAL, 86.RR.2
Maw Papers	BL Add MS 45883
Northcote Correspondence and papers	V&A, NAL, 86.AA.26
Pye Correspondence and papers	V&A, NAL, 86.FF.73
Schofield Correspondence	BL Add MS 88892
Venn Papers	University of Birmingham, Cadbury Research Library, CMS/ACC81
Whitefoord Papers	BL Add MS 36592–36597
Wornum Diary	National Gallery Archive, London

NOTES

Abbreviations used in footnotes

B&J	Butlin, Martin and Evelyn Joll, *The Paintings of J. M. W. Turner*, 2 vols, revised edn, 1984
BL	British Library, London
BM	British Museum, London
Bodleian	Bodleian Library, University of Oxford
Chantrey Correspondence	V&A, NAL, 86.YY.17
Constable's Correspondence	Beckett, R. B. (ed.), *John Constable's Correspondence*, 6 vols, 1962–9
FD	Farington, Joseph, *The Diary of Joseph Farington RA, 1793–1821* (ed. Kenneth Garlick, Angus Macintyre and Kathryn Cave), 16 vols, 1978–84
Flaxman Papers	Flaxman Papers, BL Add Ms 39780–39791
Graves Papers	Graves Papers, BL Add MS 46140
Griffith Papers	Thomas Griffith Papers, 1831–69, #11021-z, Rare Book, Literary and Historical Papers, Wilson Library, University of North Carolina at Chapel Hill
Hamilton, *Faraday*	Hamilton, James, *Faraday: The life*, 2002
Hamilton, *London Lights*	Hamilton, James, *London Lights: The minds that moved the city that shook the world, 1805–1851*, 2007
Hamilton, *Turner*	Hamilton, James, *Turner: A life*, 1997
Haydon Diary	Pope, W. B. (ed.), *The Diary of Benjamin Robert Haydon*, 5 vols, 1960–3
John Murray Archive	John Murray Archive, National Library of Scotland
Landseer–Bell Papers	Royal Institution of Great Britain Archive, London, RI MS LAN
Landseer Correspondence	V&A, NAL, 86.RR.2, MSL/1962/1316
Lennie	Lennie, Campbell, *Landseer: The Victorian paragon*, 1976
Maw Papers	BL Add MS 45883
Northcote Papers	James Northcote, Correspondence and papers, c.1797–1830, V&A, NAL, 86.AA.26
NPG	National Portrait Gallery, London

Nygren Nygren, Edward, 'James Ward, RA (1769–1859): Papers
 and patrons', *Walpole Society*, vol. 75, 2013
O'Keeffe O'Keeffe, Paul, *A Genius for Failure: The life of Benjamin
 Robert Haydon*, 2009
ODNB *Oxford Dictionary of National Biography*, 2004
Phil. Trans. Philosophical Transactions of the Royal Society
Pye Papers John Pye, Correspondence and papers, 1813–84, V&A,
 NAL, 86.FF.73
Pye, *Patronage* Pye, John, *Patronage of British Art: An historical sketch*, 1845
RA Royal Academy of Arts, London
Roscoe Roscoe, Ingrid (ed.), *A Biographical Dictionary of Sculptors
 in Britain, 1660–1851*, 2009
TB Turner Bequest, Tate Britain
Thornbury Thornbury, Walter, *The Life and Correspondence of
 J. M. W. Turner RA*, 1862, revised edn, 1897
Turner Correspondence Gage, John, *The Collected Correspondence of J. M. W.
 Turner*, 1980
V&A, NAL National Art Library, Victoria and Albert Museum, London
Waagen, 1853–7 Waagen, Gustav Friedrich, *Treasures of Art in Great
 Britain, being an account of the chief collections of paintings,
 drawings, sculptures, illustrated MSS etc*, 1853–7, 4 vols.
Whitefoord Papers BL Add MS 36592–36597
Wornum Diary Diary of Ralph Wornum, National Gallery Archive,
 London
Yarrington, *Ledger* Yarrington, Alison et al., 'An Edition of the Ledger of Sir
 Francis Chantrey, RA, at the Royal Academy, 1809–1841',
 Walpole Society, vol. 56, 1991–2

Introduction: A Sharp and Shining Point

page no.
1 'to give a sterling and lasting value': *Times* advertisement, 23 Oct 1855.
2 Thomas Boys's justification: *Illustrated London News*, 27 Oct and 3 Nov 1855;
 Times, 22 Nov 1855, letter from Thomas Boys.
3 William Woollett's celebrations: Louis Fagan, *A Catalogue Raisonné of the
 Engraved Works of William Woollett*, 1885, introduction, p. xv; M. T. S. Raimbach
 (ed.), *Memoirs and Recollections of the Late Abraham Raimbach, Esq., Engraver*,
 1843, p. 15, footnote.
3 'Engravings and casts of statuary': Pye, *Patronage*, epigraph.
4 'It is the highest impertinence and presumption': Adam Smith, *The Wealth of
 Nations*, 1776, book 2, ch. 3, 'Of the Accumulation of Capital . . .' Penguin edn,
 ed. Kathryn Sutherland, 1993, p. 209.

1 Conditions of Success

5 Meeting outside a print shop in Bath: Admiral Croft and Anne Elliot. Jane
 Austen, *Persuasion*, 1818, ch. 18.

6 Reynolds's prices: M. Kirby Talley, '"All Good Pictures Crack": Sir Joshua Reynolds's practice and studio', in Nicholas Penny (ed.), *Reynolds*, Royal Academy of Arts, 1986, p. 58.

7 Opie's view on Turner's prices: FD, 22 May 1804, vol. 6, p. 2328.

8 Albion Flour Mill: The whole was demolished in the 1860s. Edward Walford, *Old and New London*, 1878, vol. 8, p. 383.

8 For insight into the early social consequences of the coming of the steam-engine, see Shena Mason (ed.), *Matthew Boulton: Selling what all the world desires*, 2009.

9 'wild beast': L. T. C. Rolt, *Isambard Kingdom Brunel*, 1957, p. 133 (1989 edn).

9 Etty's *Joan of Arc*: The central canvas is now in the Musée de Beaux Arts, Orléans; the left-hand canvas in Llantarnam Abbey, Cwmbran, Wales. The painting was 9 feet 9 inches high by 28 feet long overall. Dennis Farr, *William Etty*, 1958, pp. 134–5. 'Great Room' observation in Alexander Gilchrist, *Life of William Etty*, 1855, vol. 2, p. 224. See also Leonard Robinson, *William Etty: His life and art*, 2007.

10 'Lantern Yard's gone': George Eliot, *Silas Marner*, 1861, ch. 21.

11 Farington on Beckford: FD, 20 July 1796, vol. 2, p. 612; FD, 4 Oct 1797, vol. 3, p. 901.

11 Defoe's economic classes: Daniel Defoe, *A Review of the State of the British Nation*, vol. 6, no. 36 (25 June 1709), p. 142.

12 'Abominably rich': Castalia, Countess Granville (ed.), *Lord Granville Leveson-Gower: Private correspondence 1781–1821*, 1917, vol. 2, p. 363. Henry Reeve (ed.), *Charles Greville Memoirs*, vol. 3, ch. 21, p. 20 (July 1833); FD, 16 April 1806, vol. 7, p. 2720.

13 Leicester's obituary: *Gentleman's Magazine*, 1827, pp. 273–4.

13 Hope's carved furniture: William Maltby (ed.), *Recollections of the Table-Talk of Samuel Rogers*, 1856, p. 158.

13 Leveson-Gower's gallery visitors: John Britton, Preface to *The Marquess of Stafford's Collection*, 1808, p. v.

13 'her largeness and her overflow': from Samuel Taylor Coleridge's poem 'The Blossoming of the Solitary Date Tree', verse 3 (1805)

14 Hairdressing prices: F. A. Pottle (ed.), *Boswell's London Journal 1762–1763*, 1950, p. 336; A. R. Ellis (ed.), *The Early Diaries of Frances Burney 1768–1778*, 1913, vol. 2, p. 289; *The Mawhood Diary*, 17 Aug 1778, Catholic Record Society, 1956, vol. 50, p. 130. See also Hamilton, *Turner*, p. 13.

14 Turner's youthful prices: Thornbury, p. 25.

15 Faraday the bookbinder: Hamilton, *Faraday*, p. 9.

15 'Mr Dance's kindness': Michael Faraday to George Riebau, 5 Jan 1815; Frank A. J. L. James (ed.), *The Correspondence of Michael Faraday, 1811–1831*, vol. 1, 1991, no. 44. See also Hamilton, *Faraday*, p. 110.

15 Coleridge's early life: E. L. Griggs (ed.), *The Collected Letters of Samuel Taylor Coleridge*, 1956–71, vol. 1, pp. 347, 388, 412; Richard Holmes, *Coleridge: Early visions*, 1989, pp. 2, 24, 112, 187, 271. See also Tom Mayberry, *Coleridge and Wordsworth: The crucible of friendship*, 1992, rev. edn, 2000.

17 John Julius Angerstein: see *ODNB*.

18 Angerstein considers an elderly marriage: FD, 9 Sept 1819, vol. 15, p. 5405.

19 'Italy for ever I say': Richard Cosway to Charles Townley, 24 Feb 1772, BM

Townley Archive, TY7/2028 [sold Sotheby's 27 July 1992, lot 334], quoted Viccy Coltman, *Classical Sculpture and the Culture of Collecting in Britain since 1760*, 2009, pp. 181–2. See also Stephen Lloyd, *Richard and Maria Cosway: Regency artists of taste and fashion*, 1995, pp. 30–1.

20 Cuguano's baptismal name was John Stuart. He campaigned against slavery in correspondence and publication. *ODNB*, Ottobah Cuguano.

20 'toujours riant': William Hazlitt, 'On the Old Age of Artists', Essay IX in *The Plain Speaker: Opinions of books, men and things*, vol. 1, 1826, p. 266.

20 'What a fairy palace': A. R. Waller and A. Glover (eds), *The Collected Works of William Hazlitt*, 1902–6, vol. 12, pp. 95–6.

21 Lawrence to Farington: Royal Academy Archive, Lawrence MSS, LAW/1/289, 29 Oct 1811.

21 Green's 'total want of employ': Granted £30 by the Royal Literary Fund, 21 June 1804. British Library, Loan 96 RLF 1/156.

21 Breakfast with Rogers: Diary of Isabella Mary Hervey, 21 May 1851, p. 167, University of Birmingham, Cadbury Research Library, MSS 7/iii/6 MS 557/vol. 1.

22 Recollections of Rogers: Thomas Moore to Lady Donegal, 13 Aug 1812, Wilfred S. Dowden (ed.), *The Letters of Thomas Moore*, vol. 1 (1793–1818), 1964, no. 246; FD, 8 March 1814, vol. 13, p. 4463.

23 'Dined at Lord Lovelace's': John Cam Hobhouse, *Recollections of a Long Life*, 10 May 1849, vol. 6, p. 238.

23 'they who bear all the heat of the day': Liverpool Papers, British Library, Add MSS 38334, 29 ff.

24 'the furniture of that room': Friedrich von Raumer, *England in 1835: Being a series of letters written to friends in Germany*, 1836, p. 47.

25 'In my bedroom': Hippolyte Taine, *Notes on England*, 1873, pp. 182–3.

25 Emilia Venn Diary, 4 March, 12–13 Dec 1825, 23 Jan, 1 Feb 1826; University of Birmingham, Cadbury Research Library, Venn MS F9.

26 Thomas Donaldson to Robert Finch, 12 April 1824; and letter received 21 Feb 1825. Finch Papers, Bodleian, vol. 5, ff. 148–9, 154–5.

27 John Dickens loses his job: Claire Tomalin, *Charles Dickens: A life*, 2011, p. 32.

27 'The Great Panic': Alaric Watts, *A Narrative of his Life*, 1884, vol. 1, p. 219.

27 Woolletts' daughter's losses: FD, 28 May and 5 June 1819, vol. 15, pp. 5370, 5374.

28 'Funds for the Windsor Bank!': Charles Knight, *Passages of a Working Life*, 1864, vol. 2, pp. 39–41.

28 Failure of Strahan, Paul & Co.: 22 June 1855. Ian Smith (ed.), *The Apprenticeship of a Mountaineer: Edward Whymper's London diary, 1855–1859*, London Record Society, vol. 43, 2008, p. 16.

28 Death of Merdle: Charles Dickens, *Little Dorrit*, 1857, ch. 25.

2 Patron Old Style: 'Business is often friendship's end'

30 'The Arts will always flourish': Joseph Banks to William Smith MP, 14 May 1805. Chambers, Neil (ed.), *The Letters of Sir Joseph Banks: A selection, 1768–1820*, 2001, letter 101, pp. 268–9.

31 'Persons of worship': Amelia Opie, 'A Memoir of John Opie' in John Opie, *Lectures in Painting*, 1809, p. 43.

31 'Painting of old': Richard and Samuel Redgrave, *A Century of British Painters*, 1866. Phaidon edn, 1947, p. 55; quoted in M. Kirby Talley, *op. cit.*, p. 55.

31 Sale-ravaged Bowood: James Miller, *The Catalogue of Paintings at Bowood House*, 1982.

31 Lord Egremont to Francis Chantrey, 12 Oct [n.y.], Chantrey Correspondence, V&A, NAL, 86.YY.17.

32 'I have been a Whig': Creevey Papers, 3 Feb 1806. Quoted in entry for Walter Fawkes, in R. G. Thornes (ed.), *The History of Parliament: The House of Commons, 1790–1820*, 1986.

33 *Fairfaxiana*: James Hamilton, *Turner's Britain*, 2003, pp. 169–72.

33 Fawkes's finances: Hamilton, *Turner*, 1997, pp. 186 and 224–5.

33 'you must stay a few days with me': Walter Fawkes to John Buckler, n.d. [prob. *c*.1819–20]. 'Letters and papers which were much prized by John Buckler FSA', Bodleian, MS Eng. Lett a 1, 91.

33 the 'delight I have experienced': Open letter to J. M. W. Turner from Walter Fawkes, published in the catalogue to the exhibition of Turner's works at 45 Grosvenor Place, April 1819. Turner Correspondence, 83.

34 Whitbread and Fawkes: 9 April 1807, Change of Administration debate, *Hansard Parliamentary Debates*, series 1, vol. 9, cols 284–349.

34 'a black bottle of English porter': William Maltby (ed.), *Recollections of the Table-Talk of Samuel Rogers*, 1856, pp. 42–3.

34 Whitbread's brewery: Sam Whitbread, *'Plain Mr Whitbread': Seven centuries of a Bedfordshire family*, 2007, p. 15. I would like to thank James Collett-White for his comments on this chapter.

35 'The wonder of everybody': Sam Whitbread, *'Plain Mr Whitbread': Seven centuries of a Bedfordshire family*, 2007, p. 16.

35 'lost too much by kindness': Roger Fulford, *Samuel Whitbread (1764–1815): A study in opposition*, 1967, pp. 31–47; R. G. Thornes (ed.), *The History of Parliament: The House of Commons 1790–1820*, 1986, vol. 5, entry on Samuel Whitbread I.

36 'You express yourself handsomely': Samuel Whitbread I to Samuel Whitbread II, 25 Jan 1785. Waldegrave Papers, Chewton Mendip, quoted in Fulford, *op. cit.*, p. 14.

36 'a tolerably easy source of income': Recalled by Sam Whitbread in Foreword to Stephen Deuchar, *Paintings, Politics and Porter: Samuel Whitbread (1764–1815) and British art*, 1984, p. 7.

36 'very very very much with Fox and co.': Thornes, *loc. cit.*

36 Southill Park purchase: Gervase Jackson-Stops, 'Southill Park, Bedfordshire', *Country Life*, 28 April 1994.

37 'a collection of the works of English Artists': FD, 24 June 1796.

37 *Blind Milton*: Whitbread bought this painting in 1793. FD, 19 May 1796. Oliver Millar, *Southill: A Regency house*, 1951, p. 46, note 4; www.npg.org.uk/research/conservation/directory-of-british-framemakers/g.php.

37 Whitbread's purchases: Deuchar, *op. cit.*, p. 11.

38 'nearly bankrupt in hope': S. W. Reynolds to Tom Adkin, 10 Oct 1801, Bedfordshire Record Office, W1/4030, quoted in Deuchar, *op. cit.*, p. 21. FD, 9 Sept 1803.

39 'Garrard is a very ingenious little fellow': Samuel Whitbread to Lee Antonie, 1 Oct 1811, Bedfordshire Record Office, UN/460. Quoted in Deuchar, *op. cit.*, p. 39.

39 'formed a collection of models': Rudolph Ackermann, *Views of London*, 1816, p. 49.

41 'jack-of-all-trades': J. T. Smith (ed. William Whitten), *Nollekens and his Times*, 1920, vol. 1, p. 314. See also entry for George Garrard in Roscoe.

41 'New Renters': Tracy C. Davis, *The Economics of the British Stage 1800–1914*, 2000, pp. 256 ff.

42 Cartoons of Whitbread: Charles Williams, 'Clearing Away the Rubbish of Old Drury', October 1811; Charles Williams, 'Act the 2d of the New Drury Lane Brewery or a Managers Spur to Progress', January 1812; George Cruikshank, 'Management – or – Butts & Hogsheads', December 1812, *Catalogue of Personal and Political Satires in . . . British Museum*, vol. 9, 1811–19, nos 11767, 11936, 11940, 1949.

42 Edmund Kean: FD, 7 March 1814, vol. 13, p. 4462.

42 'It is no slight homage': Thornes, *loc. cit.*

43 'supreme Dictator': FD, 6 July 1809, vol. 10, p. 3508.

43 'permanent public school prefect': Gerald Reitlinger, *The Economics of Taste: The rise and fall of picture prices 1760–1960*, 1961, p. 85.

43 Beaumont's income: FD, 2 June 1804, vol. 6, p. 2341.

44 Ward's *Gordale Scar*: Nygren, p. 210.

45 'they did nothing, morning, noon or night': Tom Taylor (ed.), *Life of Benjamin Robert Haydon Historical Painter, from his Autobiography and Journal*, 1853, vol. 1, p. 123.

45 'the greatest Lion hunters of the day': Sir Augustus Wall Callcott commonplace book, n.d.; Bodleian, MS Eng. e.2425; f.356 53.

45 Haydon's abusive letters: O'Keeffe, p. 98.

45 'It is over three years': Jan 1810. Haydon Diary, vol. 1, pp. 124–5.

46 Leicester's gallery: Selby Whittingham, '"A most Liberal Patron": Sir John Fleming Leicester, Bart, 1st Baron de Tabley, 1762–1827', *Turner Studies*, vol. 6, no. 2 (winter 1986), pp. 24–36.

46 'Leicester/ Should feel . . .': S. B., *Literary Gazette*, 1819. Quoted in Douglas Hall, 'The Tabley House Papers', *Walpole Society*, vol. 38 (1960–2), p. 122.

46 'The only thing we can say': *Examiner*, 2 July 1826, p. 418.

47 Leicester's 'unclouded temper': William Paulet Carey, *Some Memoirs of the Patronage and Progress of the Fine Arts in England and Ireland . . . with Anecdotes of Lord de Tabley, of Other Patrons, and of Eminent Artists, and Occasional Critical References to British Works of Art*, London, 1826, p. 15; Augustus Wall Callcott to Sir John Leicester, 7 Nov 1805, Hall, *op. cit.*, letter 11, p. 66. On Carey: *Notes and Queries*, 4th series, vol. 5, 21 May 1870, pp. 481–4.

47 'the Owen, Callcott and Thompson squad': James Ward to George Ward, 19 Dec 1823. Nygren, p. 162 (letter 83).

47 Gainsborough's *Cottage Door*: John Britton to Sir John Leicester, 23 Oct 1808, Hall, *op. cit.*, p. 70 (letter 41).

47 'I well know the utter impropriety': Benjamin Robert Haydon to Sir John Leicester, 6 July 1819, *ibid.*, p. 73 (letter 57).

47 'It has often I confess': Sir John Leicester to James Northcote (not John Martin, as catalogued), 20 April 1823, James Northcote, Correspondence and papers, *c.* 1797–1830, V&A, NAL, 86.AA.26; MSL/1930/2534/93. *The Alpine Traveller* is thought to have been destroyed in 1916; see Hall, *op. cit.*, p. 86, note 4. FD, 26 Dec 1810, vol. 10, p. 3836.

48 David Wilkie's *Village Holiday* (1809–11), then known as *The Ale-House Door*, belonged to Angerstein and was included in the purchase of his collection. It is now in Tate Britain. Wilkie died in 1841.

48 Beckford's affair: See FD, 16 March 1799, vol. 4, p. 1175; 14 Dec 1807, vol. 8, p. 3167.

49 'Beckford wishes me to go to Fonthill': 18 Oct 1818, Wilfred S. Dowden (ed.), *The Journal of Thomas Moore*, 1983, vol. 1, p. 67.

49 On Fonthill: John Martin Robinson, *James Wyatt: Architect to George III*, 2012, pp. 234–8, 331–2.

49 'might drive a coach and four': FD, 20 July 1796, vol. 2, p. 612.

50 On Fonthill's cold and Samuel Rogers: Lady Bessborough to Lord Granville, 28 Oct 1817, Castalia, Countess Granville (ed.), *Lord Granville Leveson-Gower: Private correspondence, 1781–1821*, 1917, vol. 2, p. 545.

50 'This spot alone shall be my heaven': Mary Ann Britton to William Beckford, 5 Sept 1822. Beckford Papers, Bodleian, c.27, ff.14–15.

51 Fonthill: FD, 31 Dec 1796 and 6 Jan 1797, vol. 3, pp. 734 and 739; 1 July 1801, vol. 4, p. 1571; 14 Dec 1807, vol. 8, p. 3166.

52 'as mad a picture': Reitlinger, *op. cit.*, p. 83.

52 'cold unfocused gaze': James Hamilton, '"The time must come": Turner and royalty', *Turner Society News*, vol. 118 (autumn 2012), pp. 8–17.

52 'It is a bad thing to refuse the "Great"': John Constable to C. R. Leslie, 5 July 1831, Constable's Correspondence, vol. 3, 1965, p. 41.

3 Patron New Style: 'The delicate lips of a horse'

53 Schofield in London: Isaac Schofield to Messrs. J. Schofield, Boston, 21 Aug 1840, BL Add MS 88892.

54 'cheerful little villa': John Ruskin, *Praeterita*, 1859, 35.253n. William Robinson, *The History and Antiquities of the Parish of Tottenham in the County of Middlesex*, 1840, vol. 1, p. 84. Selby Whittingham, 'The Turner Collector: Benjamin Godfrey Windus 1790–1867', *Turner Studies*, vol. 7, no. 2 (winter 1987), pp. 29–35.

54 John Scarlett Davis, *The Library at Tottenham, the Seat of B. G. Windus, Esq., showing his Collection of Turner Watercolours*, signed and dated, 1835. British Museum, Department of Prints and Drawings, 1984.0121.9.

55 Gothic Hall, Hackney: See *Gentleman's Magazine*, 2nd series, 43, 1855, pp. 432–4.

55 Windus coach-makers: Corporation of London General Purposes Committee minutes, vol. 4, 1805–8, p. 200; General Purposes Committee minutes, 1818–21, 20 Oct 1820, COL/MH/LM/07. Masters of the Worshipful Company of Coachmakers: Arthur Windus 1794, Edward William Windus 1810, Thomas Windus 1823, Benjamin Windus 1826.

55 Godfrey's Cordial: J. Burnby, 'Godfrey's Cordial Again', *Pharmaceutical Historian*, 23/2 (1993), 2.

56 'I believe the really first sight': Ruskin, *loc. cit.*

56 'I am now engaged': John Scarlett Davis to J. M. Ince, 1835; quoted in Thornbury, vol. 1, p. 327, and A. J. Finberg, *The Life of J. M. W. Turner RA*, 1961, p. 353. See also Eric Shanes, 'Picture Notes: John Scarlett Davis, *The Library . . . of B. G. Windus Esq . . .*', *Turner Studies*, vol. 3, no. 2 (winter 1984), pp. 55–8; and Selby Whittingham, *op. cit.*

57 'the very brightest of blue eyes': J. G. L. Burnby, 'Pharmaceutical Connections: The Maw family', *Pharmaceutical Historian*, vol. 15, no. 2 (June 1985), pp. 9–11.

58 'I have duly entered your order': John Sell Cotman to John Hornby Maw, 23 Nov 1835, Maw Papers, f. 5.

58 'if you will let me know': William Henry Hunt to John Hornby Maw, 17 July 1837, Maw Papers, f. 22; Samuel Prout to John Hornby Maw, n.d. [?1836], Maw Papers, f. 31; John Sell Cotman to John Hornby Maw, n.d., Maw Papers, f. 18.

59 'over these same encaustics': From John Betjeman's poem 'St Saviour's, Aberdeen Park, London, N'.

59 'I will do anything in my power': C. W. Cope to John Hornby Maw, 2 Sept 1862, Maw Papers, f. 64.

60 'I left your house': John Sell Cotman to John Hornby Maw, n.d. [1838, before 15 March], Maw Papers, f. 13.

61 On collectors: Dianne Sachko Macleod, 'Art Collecting and Victorian Middle-Class Taste', *Art History*, vol. 10, no. 3 (Sept 1987), pp. 328–50.

62 A valuable source on Vernon's collection is Robin Hamlyn, *Robert Vernon's Gift: British art for the nation 1847*, 1993.

62 'Every room in his mansion': 'Visits to Private Galleries: The mansion of Robert Vernon Esq. in Pall Mall', *Art-Union*, vol. 1, March 1839, p. 19.

63 'The Art Union is a perfect curse': William Maltby (ed.), *Recollections of the Table-Talk of Samuel Rogers*, 1856, p. 112.

63 Joseph Gillott: See Jeannie Chapel, 'The Papers of Joseph Gillott (1799–1872)', *Journal of the History of Collections*, 2007, pp. 1–48.

65 Etty–Gillott Correspondence, University of Birmingham, Cadbury Research Library, XMS 94.

65 *View of the Temple of Jupiter Panellenius*: The full title continues – *in the Island of Ægina, with the Greek National Dance of the Romaika: the Acropolis of Athens in the Distance. Painted from a sketch taken by H. Gally Knight Esq. in 1810.*

65 'Turner's a rum chap': William Etty to Joseph Gillott, 14 April 1846; Gillott Papers, Getty Research Institute, 4WE-4, quoted in Chapel, *op. cit.*, p. 13.

65 'a most voracious collector': Thomas Balston, *John Martin 1789–1854: His life and works*, 1947, p. 145; J. G. Millais, *The Life and Letters of Sir John Everett*

Millais, 1899, pp. 17–18; Whistler: http://etchings.arts.gla.ac.uk/catalogue/biog/?nid=ThomS.

66 'the good star which had presided': Waagen, 1853–7, vol. 4, pp. 401–4. Quoted in Chapel, *op. cit.*

66 'trains from Euston Square': Robert Peel to John Lucas , 1 Sept [1843]. A collection of letters mainly to John Lucas, and the artist's son John Seymour Lucas, RA. V&A, NAL, 86.WW.12. MS.L.5116/626–1979.

66 Tyntesfield: See James Miller, *Fertile Fortune: The story of Tyntesfield*, 2003.

67 'Amongst our wealthy manufacturers': [S. C. Hall], 'The Prospects of British Art', *Art-Union*, vol. 9, 1847, p. 5.

68 'The old nobility and land proprietors': Thomas Uwins to John Townshend, 14 Jan 1850, in Sarah Uwins, *A Memoir of Thomas Uwins RA*, 1858, vol. 1, p. 125.

68 'For one sign of the good sense': Sir Charles Eastlake, *Contributions to the Literature of the Fine Arts with a Memoir Compiled by Lady Eastlake*, 2nd edn, 1870, p. 147. Quoted in Dianne Sachko Macleod, *Art and the Victorian Middle Class: Money and the making of cultural identity*, 1996, p. 5.

69 Dickens in Rochester: Charles Dickens, *The Uncommercial Traveller*, XII, 'Dullborough Town', from *All the Year Round*, 30 June 1860.

69 'make yourself a perfect master': Baxendale Papers, quoted in Gerald L. Turnbull, *Traffic and Transport: An economic history of Pickfords*, 1979, p. 49.

69 'the Benjamin Franklin of business': Sam Smiles, *Thrift*, 1875, pp. 189 ff. See entry for Joseph Baxendale, *ODNB*.

70 'My self-conceit': 13 Oct 1827. Personal Diary of I. K. Brunel, University of Bristol Library, Special Collections, DM 1306/II.1.

72 Brunel's Shakespeare Room: Hilaire Faberman and Philip McEvansoneya, 'Isambard Kingdom Brunel's "Shakespeare Room"', *Burlington Magazine*, vol. 137, no. 1103, Feb 1995, pp. 108–18. Brunel's letter to Landseer, 27 Dec 1847, quoted.

74 'This room, hung with pictures': Isambard Brunel, *The Life of Isambard Kingdom Brunel*, 1870, p. 507.

75 'It must be borne in mind': Pye, *Patronage*, pp. 66–7.

4 Painter: 'Painting is a strange business'

76 Gandy 'hunted down': John Constable to C. R. Leslie, 4 Nov 1831, Constable Correspondence, vol. 3, p. 50. Brian Lukacher, *Joseph Gandy: An architectural visionary in Georgian England*, 2006, p. 56. Soane Notebook, 24 Nov 1816, Sir John Soane's Museum. John Constable to C. R. Leslie, 26 Nov 1831, Constable's Correspondence, vol. 3, p. 51.

78 'Young Eastlake has determined': Jan 1809. Haydon Diary, vol. 1, p. 45.

78 Quoted in O'Keeffe, p. 139.

78 Haydon's tuition charges: 1 Jan 1820 fMS ENG 1331 (158), Harvard University, Houghton Library. Quoted in O'Keeffe, p. 140.

79 'If there be any noble-minded boy': Benjamin Robert Haydon, *Lectures on Painting and Design*, vol. 1, p. 104, quoted in O'Keeffe, p. 360.

79 'Suppose we employ Callcott?': O'Keeffe, p. 358.

79 Cold Bath Fields: O'Keeffe, pp. 124–7.

79 Turner, 'Old London Bridge' sketchbook, TB CCV, f. 1. In the same sketch-
 book (f. 44) is a pencil study of Rubens's *Chapeau de Paille* with colour notes.
 This painting was exhibited in London in 1823.

80 'Sir, Will you permit me': *Times*, 12 May 1835, p. 3.

80 Wellington's frock coat, etc.: O'Keeffe, p. 394.

81 'Harrass, threats, harrass': O'Keeffe, p. 357.

81 'to relieve . . . present difficulties': 14 Jan 1830, fMS ENG 1331 (24), Harvard
 University, Houghton Library, quoted in O'Keeffe, p. 360.

81 'spare my life': O'Keeffe, p. 127.

81 Mary Haydon: O'Keeffe, pp. 217, 343.

82 'God bless thee, dearest love': O'Keeffe, p. 496.

82 'The art is becoming a beastly vulgarity': 4 Oct 1844. Haydon Diary, vol. 5,
 p. 393.

82 'limning or drawing is a bad trade': C. M. Kauffmann, *John Varley (1778–1842)*,
 1982, p. 11. Varley's biographical details come from here and *ODNB*.

84 'It is not enough to tell you': *Ibid.*, p. 39. Quoted from S. D. Kitson, 'Notes on
 a Collection of Portrait Drawings Formed by Dawson Turner', *Walpole Society*,
 vol. 21 (1932–3), pp. 67–104; John Linnell, *Autobiography*, quoted in A. T.
 Storey, *The Life of John Linnell*, 1892.

84 'Varley's Hot Rolls': Kauffmann, *op. cit.*, p. 33; Jenkins MS, Bankside
 Gallery.

85 'I have bought a little drawing': John Constable to C. R. Leslie, 22 Aug 1831,
 Constable's Correspondence, vol. 3, p. 43.

86 'Thompson's caprices': John Constable to C. R. Leslie, ?Nov 1831, Constable's
 Correspondence, vol. 3, p. 51.

86 'for envious hatred': Thomas Lawrence to Joseph Farington, 29 March 1805. RA
 Archive, LAW/1/122.

86 'a vain man': Cyrus Redding, *Fifty Years of Recollections*, vol. 2, 1858, p. 299.

86 'I wish particularly to know': Francis Chantrey to John Constable, 8 Feb 1826,
 R. B. Beckett (ed.), *John Constable: Further documents and correspondence*, Tate
 Gallery and Suffolk Records Society, 1975, p. 193.

86 'He stabbed his mother!': Hamilton, *Turner*, p. 299.

87 'Haydon shunned by them': James Ward Journal, 2 May 1818. Nygren, p. 38.

87 'Mr Phillips . . . caught me by the other ear': John Constable to C. R. Leslie, 5
 Feb 1828. Constable's Correspondence, vol. 3, p. 12.

87 'At the beginning of the present century': Pye, *Patronage*, pp. 3–4.

88 Fund supporters: Artists' Annuity and Benevolent Fund archive, GB 0074
 CLC/114, London Metropolitan Archives.

88 Whitbread's speech: 1 April 1814. FD, vol. 13, pp. 4477–8.

88 Fund claims: 11 Aug 1810. Artists' Fund, minutes of committee and quar-
 terly general meetings, 1810–22. London Metropolitan Archives, CLC/114/
 MS23652; Artists' Benevolent Fund, audited account book 1812–17, LMA
 CLC/114/MS23674. Artists' Benevolent Fund annuitants' book 1831–44, with
 retrospective information from 1816 and continued to 1844. LMA CLC/114/
 MS23676.

88 Fund premiums: Pye, *Patronage*, p. 381.

88 Fund pensions: Artists' Fund minutes, *op. cit.*, 20 Oct 1817.

89 David Uwins, homeopath: Artists' Fund minutes, *op. cit.*, 20 Oct 1817.

89 Chancellor's speech: *Times*, 8 May 1826, cutting in Artists' Benevolent Fund Form Book, 1825–43. LMA, CLC/114/MS23670.

90 'the whole of this money': *Morning Chronicle*, 9 May 1836, cutting, *loc. cit.*

90 J. M. W. Turner's A.G.B.I. notes, 'Old London Bridge' sketchbook, TB CCV, f. 6; 'Academy Auditing' sketchbook, TB CCX(a).

90 Turner's investments will be illuminated by Eric Shanes in his forthcoming biography of J. M. W. Turner.

91 Turner's consols: 'Finance' sketchbook, TB CXXII, receipts in notebook pocket, figures totalling £823.5s.7d and £623.11s.2d, i.e. £1,446.16s.9d. I am grateful to Eric Shanes for illuminating these figures for me.

91 'He has got poor Eastlake': John Constable to C. R. Leslie, 26 Sept 1831, Constable's Correspondence, vol. 3, p. 47. The auction was held in July 1831.

91 'a modest, well behaved young man': FD, 20 March 1805, vol. 7, p. 2532; Pye, *Patronage*, pp. 66–7 and footnote.

92 Callcott's prices: David Blayney Brown, *Augustus Wall Callcott*, 1981, p. 13.

92 'talked to me a great deal': Maria Callcott to John Murray Jnr [i.e. John Murray III], 5 Dec 1835; John Murray Archive, National Library of Scotland.

92 'The intrepid Mrs Graham': Lady Holland to Caroline Fox, in the Earl of Ilchester, *Chronicles of Holland House*, 1937, p. 108. On Maria and Augustus Callcott: John Constable to C. R. Leslie, 9 April 1832, Constable's Correspondence, vol. 3, p. 66; Lady Holland to Caroline Fox, in Earl of Ilchester, *op. cit.*, pp. 108–9; Richard and Samuel Redgrave, *A Century of British Painters*, Phaidon edn, 1947, p. 376. Hamilton, *London Lights*, pp. 159–60. Largely forgotten in the twentieth century, in the twenty-first Maria Callcott is beginning to resurface: in an article about the discovery of a slave graveyard in Rio de Janeiro in 2011 it was she (as Maria Graham) who the *Guardian* quoted as expressing horror at the treatment of African slaves in Brazil; *Guardian*, 4 Dec 2011. See also Regina Akel, *Maria Graham: A literary biography*, 2009.

93 'a dying woman': Callcott Papers, 22 Nov 1840, Bodleian, MS Eng. d. 2281.

93 Harriet Rogers: Callcott Papers, *op. cit.*, 3 Dec 1840.

94 'Edwin himself thrown back': Callcott Papers, *op. cit.*, 25 Nov 1840.

95 On Landseer: John Constable to C. R. Leslie, Constable's Correspondence, vol. 3, p. 22, with sketch; p. 25, 31 Jan 1830. M. W. Chapman (ed.), *Harriet Martineau's Autobiography*, 1877, vol. 1, p. 351; 24 Nov 1837. Queen Victoria's journals (Lord Esher's transcripts), vol. 4, p. 29; Royal Archive, www.queenvictoriasjournals.org. Wilfred S. Dowden (ed.), *The Journal of Thomas Moore*, 1983, vol. 1, p. 44, 16 Sept 1818.

96 Affair with Duchess of Bedford: Lennie, ch. 3; Rachel Trethewey, *Mistress of the Arts: The passionate life of Georgina, Duchess of Bedford*, 2002, chs. 8, 9, 11.

96 Letters to Landseer about prices: From Frederick Goodall, Francis Chantrey (22 July 1836) and Duke of Bedford, Landseer Correspondence.

98 Landseer's earnings: *Art-Union*, June 1846, p. 176, note. The four paintings, all

exibits in the 1846 Royal Academy exhibition, were *Time of Peace*, *Time of War*, *The Stag at Bay* and *Refreshment*.

99 'My unfinished works': Landseer to Count d'Orsay, *c*.1840. Houghton Library, Harvard University, MS Eng. 1272, no. 4. Quoted in Richard Ormond, *The Monarch of the Glen: Landseer in the Highlands*, 2005, p. 107.

99 Bell prescribing 'blue pills': Landseer to Count d'Orsay, 13 July 1840. Quoted in Trethewey, *op. cit.*, p. 279 [Harvard, MS Eng 1272]. I am grateful to Dr Jonathan Reinarz for this identification.

100 'Boys has just been here': Jacob Bell to Landseer, 1 Sept 1842, V&A, NAL, Eng MS, 86 RR, vol. 1, no. 47.

100 Prize money: Charles Dickens to Edwin Landseer, 10 Jan 1856, in Graham Storey and Kathleen Tillotson (eds), *The Letters of Charles Dickens*, vol. 8 (1856–1858), 1995, p. 18. Landseer exhibited paintings including *The Wounded Stag*, *The Blacksmith's Shop* and *The Sailor Mounting Guard*.

100 'I have just heard from my friend Mr Vernon': Capt. Leinster [or Leicester?] Smith, Dublin Castle, to Edwin Landseer, 15 December 1844, Royal Institution Archive, Bell MS, 3/3.

101 'My room is now arranged': Martin Blackmore to Charles Lewis, 15 March 1854, Royal Institution Archive, Bell MS, 3/31.

101 'I have been expecting to see you': Edwin Landseer to Charles Lewis, 5 April 1851, BL Add MS 38608, ff. 38–9. Camden Hill was the Bedfords' estate in Kensington.

101 'Painting is a strange business': The passing and apocryphal remark has sometimes been reported as 'Painting is a rum business'.

102 'Mr Turner, the English painter': 'Letter from Rome', *Literary Gazette*, no. 148 (20 Nov 1819), p. 747. Turner's biographer A. J. Finberg (*The Life of J. M. W. Turner, R.A.*, 1961, p. 261) rejected this evidence of the Prince Regent's patronage.

102 Turner's paintings of the royal visit to Edinburgh: *George IV's Departure from the Royal George* [i.e. his arrival at Leith] (B&J 248b, Tate N02880); *George IV at St Giles, Edinburgh* (B&J 247, Tate N02851); *George IV at the Provost's Banquet in the Parliament House, Edinburgh* (B&J 248, Tate N02858); *Return of the Royal Insignia to Edinburgh Castle* [known as *A Vaulted Hall*] (B&J 450, Tate N05539).

103 Exchange of gifts: Charles Heath appears to have presented a set of *Picturesque Views in England and Wales* to Louis-Philippe in 1838 or 1839; Turner Correspondence, p. 259; *Gentleman's Magazine*, vol. 31 (1849), p. 100. The snuffbox is in the British Museum, 1944, 1001.1. Ian Warrell illuminated the gift further in '"I saw Louis Phillipe land at Portsmouth": Fixing Turner's presence at the arrival of the King of the French, 8 Oct 1844', *Turner Society News*, 120 (Autumn 2013), pp. 8–15.

103 'passed the pleasantest of evenings': Redgrave, *op. cit.*, pp. 253–4.

104 Turner's *Boiling Blubber* and *Hurrah! for the Whaler Erebus! another Fish!* (Tate Britain) began life, as I have shown in '"The time must come": Turner and royalty', *Turner Society News*, vol. 118 (autumn 2102), as paintings depicting the arrival of King Louis-Philippe in Portsmouth in 1844. See also Ian Warrell, *Turner and Venice*, 2003, pp. 256–7; and Ian Warrell, *op. cit.*

5 Sculptor: Creating intelligent life

106 the 'man at Hyde Park Corner': John Cheere's sculpture works was close to where the Hilton Hotel stands today.

107 'the works of Michelangelo': J. T. Smith, *Nollekens and his Times*, 1828, vol. 1, p. 5.

108 Scene from *Taste*: Pye, *Patronage*, pp. 68–72. Extracts from the play *Taste* by Samuel Foote (first performed in 1751): Act II, Scene i, an auction room.

108 Marble merchants: Cinzia Maria Sicca and Alison Yarrington (eds), *The Lustrous Trade: Material culture and the history of sculpture in England and Italy, c.1700– c.1860*, 2000, p. 14; Flaxman notebooks, BL Add MSS 39784 A and B; J. T. Smith, *op. cit.*, vol. 1, p. 281.

108 Shakespeare, *Twelfth Night*, II, iv; *The Winter's Tale*, V, ii.

109 'Granites and Basaltes': John Flaxman to William Gunn, 7 Oct 1802. Flaxman Papers, vol. 11, BL Add MS 39790, ff. 17–18.

109 Marble prices: *European Magazine*, 1815, vol. 67, p. 56. Quoted in Alison Yarrington, 'Anglo-Italian Attitudes: Chantrey and Canova', in Sicca and Yarrington, *op. cit.*, pp. 132–55. Flaxman notebooks, BL Add MSS 39784 A and B; FD, 24 May 1806, vol. 7, p. 2770.

109 Nollekens's economy: J. T. Smith, *op. cit.*, vol. 2, p. 48. See also anon. review in *Gentleman's Magazine*, 98, part 2, pp. 536–9. Roscoe, p. 905, quotes Trinity College payment as £3,000.

110 Nollekens's studio and household: Smith, *op. cit.*, vol. 1, pp. 328 and 341, vol. 2, p. 16; Roscoe, pp. 493–5, 533.

111 Hamilton, *Turner*, Appendix 1.

111 Flaxman's notebooks: Flaxman Papers, vol. 5, BL 39784 A–CC.

111 Some of these names cast their shadows in Roscoe; see the entries for Bone, Bridges, Butterfield, Farrell, Gahagan and Gott, where there are some fragile connections to the Flaxman yard. See below for Hinchliffe. 1805 notebook: BL 39784 M.

112 1795–1808 notebook: Edward Croft-Murray, 'An Account Book of John Flaxman, RA British Museum Add. MSS 39784 B.B.', *Walpole Society*, vol. 28 (1940), pp. 51–94.

112 John Flaxman to 'my very dear madam', 17 Nov 1804, Flaxman Papers, vol. 11, BL Add MS 39790, ff. 13v–14v. The original of this letter, to Mme Hare Naylor, at Weimar, 17 Nov 1804, is in vol. 1, 87.

112 Flaxman on invited competition: John Flaxman to William Hayley, 1 Dec 1805 and 17 Feb 1811. Flaxman Papers, vol. 1, BL Add MS 39780, ff. 91–2, 102–3.

113 'I send you a peep': Ann Flaxman to Rev. William Gunn, 15 March 1810. Flaxman Papers, vol. 11, BL Add MS 39790, ff. 50v–51.

114 Flaxman's production 1808–11: Admiral Millbanke, paid for 1808; Elizabeth Knight, final payment March 1809; William Bingham, final payment Sept 1808; Sir Rowland Winn for Wragby Church, Yorkshire, delivered July 1809; Christian Friedrich Schwartz, delivered Nov 1811; Marquess Cornwallis, delivered in 1813; Anne Hill, delivered 1809; William Pitt the Younger, commissioned March 1808, paid for in August 1812; Rev. Hugh Moises, commissioned

April 1808, delivered December 1810; Walter Long, commissioned July 1808, delivered May 1810; Sir Joshua Reynolds, commissioned September 1808, delivered February 1813; Dean Nathan Wetherell, commissioned October 1808; Ann Bowling, commissioned February 1809, delivered March 1811; Baring family monument, commissioned June 1809, installed August 1810.

115 Flaxman's design, pricing and billing: John Flaxman to John Hawkins, 7 and 31 March 1823, Flaxman Papers, vol. II, BL Add MS 39790, ff. 9v–10. John Flaxman to William Gunn, Dec 1805, Flaxman Papers, vol. II, BL Add MS 39790, f. 18v.

116 Rossi's observation; Flaxman's 'work in hand': FD, 12 Aug 1808, vol. 9, pp. 3328–9; 19 July 1809, vol. 10, pp. 3513–14, 3529.

116 Flaxman's turnover. He was paid the following sums for monuments: £1,060 – Schwartz; £2,100 – Howe; £200 – Cornwallis; £433 – Pitt; £700 – Moises; £1,110 – Long; £144 – Reynolds; £70 – Bowling; £980 – Baring.

116 'As piety or patriotism': John Flaxman to Rev. William Gunn, Feb 1806. Flaxman Papers, vol. II, BL Add MS 39790, f. 19v.

117 Chantrey's ledgers: Royal Academy ledger, transactions 1809–39; British Library ledger, Egerton MS 1911, contains entries as in Royal Academy ledger, up to December 1823; Derby ledger, Derby Local Studies Library, MS 3535, entries from 1814; Derby Day Book, Derby Local Studies Library, MS 6644, 1809–13. For a full account of these ledgers and their contents, see Yarrington, *Ledger*.

118 Chantrey's first assistants, as listed in the Derby Ledger, included William Elliott, Francis Legé, [. . .] Purdy, James Heffernan, David Dunbar, Frederick William Smith, [. . .] George. Yarrington, *Ledger*, p. 9.

118 On Cunningham: Duke of Devonshire's diary, quoted by Yarrington, in Sicca and Yarrington (eds), *op. cit.*, p. 150.

119 On Heffernan: *Library of Fine Arts*, 1831, vol. I, p. 432. *Gentleman's Magazine*, 1842, part I, p. 103; *Builder*, 1863, p. 112; W. G. Strickland, *Dictionary of Irish Artists*, vol. I, 1913, p. 470. Quoted in Roscoe, p. 597, entry for Heffernan by M. G. Sullivan.

119 On Smith: Article by Peter Cunningham in *Builder*, 1863, p. 112; *Athenaeum*, 1835, p. 75. Quoted in Roscoe, pp. 1145–6.

120 On Legé and Dunbar: Roscoe, pp. 733, 380–1.

120 Cleaning city statues: Yarrington, *Ledger*, pp. 33–4.

121 On Carey's support: *Sheffield Iris*, Nov and Dec 1805, quoted *Notes and Queries*, 4th series, vol. 5, 21 May 1870, pp. 481–4. On Mrs D'Oyley's generosity: *ODNB*, Francis Chantrey.

121 Chantrey's youthful talent: FD, 23 Aug 1819, vol 15, pp. 5400–1.

121 Chantrey and Coutts: Sir Augustus Wall Callcott commonplace book, n.d., Bodleian, MS Eng. e.2425, f.362 57; Yarrington, *Ledger*, no. 167a, p. 192, fig. 114.

122 Chantrey's proposed colossus: George Jones RA, *Sir Francis Chantrey RA: Recollections of his life, practice and opinions*, 1849, p. 180.

123 Chantrey and the Royal Society: Hamilton, *London Lights*, ch. 2. Chantrey's nomination form for Fellowship of the Royal Society, Royal Society Archive, EC/1818/03.

124 Academician sculptors in 1818 were Chantrey, Flaxman, Nollekens, Rossi, Theed and the elder Richard Westmacott.

124 Royal Academy plasters: RA Council Minutes, vol. IV (1807–12), 29 May, 17 Nov 1810, ff. 215, 250–1; vol. V (1813–18), 12 Nov 1814, f. 173; 14 Dec 1815, f. 239; 27 Nov 1816, f. 322. I am grateful to Katharine Eustace for these references.

126 Joseph Banks is now in the Natural History Museum, South Kensington.

126 Bateman monument: Yarrington, *Ledger*, no. 132a. 845 letters cost £8.9s.0d, or 2160 pence (240 pence to the pound; 12 pence to the shilling; 20 shillings to the pound), therefore each letter is 2.4 pence, so 100 letters to the pound.

126 Chantrey's hospitality: Jones, *op. cit.*, p. 98.

127 Chantrey and Elwyn: Yarrington, *Ledger*, no. 90a.

127 Chantrey's abandoned figures: *Ibid.*, nos 120a, 121a, 122a, 123a.

127 Chantrey's ideal subjects: *Ibid.*, no. 127a.

128 'I am now deeply engaged': Francis Chantrey to Charles Turner, 4 June 1827; Jones, *op. cit.*, p. 217.

128 Weights of stone samples: Henry de la Beche to Chantrey, 1 Feb 1834. Chantrey Correspondence, V&A, NAL, 86.YY.17.

129 Chantrey's multiple subjects: Yarrington, *Ledger*, nos 189b, 191a, 195a, 304b.

130 *Ibid.*, nos 146a, 196a.

130 Chantrey's bronzes and his furnace: *Ibid.*, no. 214a; David Brewster, *Letters on Natural Magic*, 1832, p. 311; Hamilton, *London Lights*, p. 109.

130 Chantrey's public sculptures: Yarrington, *Ledger*, Pitt (London), 171; Watt, 194a; Munro, 211a; George IV (Trafalgar Square), 217; Pitt (Edinburgh), 247a; Wellington, 282a.

131 'It is done!!!': Francis Chantrey to Charles Turner, 10 April 1838, quoted in Yarrington, *op. cit.*, no. 211a.

131 Wellington's statue and subscribers: *Times*, 1 Feb 1837, p. 2. The sculpture was completed after Chantrey's death by Henry Weekes. It was installed outside the Royal Exchange and inaugurated on Waterloo Day, 18 June 1844. See Philip Ward-Jackson, *The Public Sculpture of the City of London*, 2003, pp. 330–4.

131 Wellington's ear: William Jerdan, *Autobiography*, 1852–3, vol. 3, p. 25.

132 Watt's sculpture-copying machine: Jane Insley, 'James Watt and the reproduction of sculpture', *Sculpture Journal*, vol. 22, no. 1, pp. 37–65. Leo Bridle has made an entertaining short film showing something of the machine's capabilities: www.leobridlefilms.co.uk/headroom/index.html. The permanent display of Watt's workshop is in the Science Museum, London.

133 Nollekens's estate: *ODNB*, Joseph Nollekens.

133 Flaxman's estate: 15 Feb 1827. Flaxman Papers, vol. 12, BL Add MS 39791, f. 27. Extract from minutes of Council, University College, London, 17 Nov 1847, *ibid.*, f. 59. Note from James Christie, 27 Oct 1828, *ibid.*, f. 48.

133 Rossi's non-existent estate and reputation: *Art-Union*, vol. 1, 1839, p. 22, quoted in *ODNB*, Charles Rossi. FD, 24 May 1806, vol. 7, p. 2770.

134 Baily's bankruptcies: *Times*, 11 Nov 1831, 3 March 1838. *Literary Gazette*, 27 July 1833, no. 862, p. 477, quoted in *ODNB*, Edward Hodges Baily.

135 On Woolner: Bodleian, MS. Don. e. 80, letters from Thomas Woolner to F. G. Stephens, 31 Jan 1866, ff. 46–7; 3 Feb 1866, ff. 48–9; 30 June 1867, ff. 66–7; 2 Aug 1869, f. 80. The bust of Gladstone, with its elaborate decorative marble plinth, is in the Ashmolean Museum.

6 Dealer: 'I have picked up a few little things'

137 On Smith: Charles Sebag-Montefiore, *A Dynasty of Dealers: John Smith and his successors, 1801–1924*, 2013. See also James Stourton and Charles Sebag-Montefiore, *The British as Art Collectors: From the Tudors to the present*, 2012; and Bruce Tattersall, 'Art market', in *Grove Dictionary of Art*, 1996, vol. 2, pp. 557–61.

138 Turner as dealer: Lord Egremont to Turner, 2 Dec 1828, Turner Correspondence, 146; Turner to C. L. Eastlake, 16 Feb 1829, *ibid.*, 147.

138 'In troubled waters': Quoted in Stourton and Sebag-Montefiore, *op. cit.*, p. 8.

139 'Og of Bassan', etc.: Hamilton, *London Lights*, p. 168.

139 'Why, now, there's your "Susannah"': From *Taste* by Samuel Foote (first performed 1751), Act I, Scene i, A painting room. Quoted in Pye, *Patronage*, pp. 68–72.

139 '*Esto praeclara*': Jason M. Kelly, *The Society of Dilettanti*, 2009, p. 12.

140 Cost of living in Rome: Joseph Wright to Nancy Wright, 4 May 1775; Elizabeth E. Barker, 'Documents relating to Joseph Wright "of Derby" (1739–97)', *Walpole Society*, vol. 71 (2009), p. 85, letter 20.

140 'a fine head of the Salvator Mundi': Wilfred S. Dowden (ed.), *The Journal of Thomas Moore*, 1983, vol. 1, 19 and 27 March 1819, pp. 151 and 155.

140 Napoleon's loot: Andrew McClellan, *Inventing the Louvre*, 1994, p. 132; Margaret M. Miles, *Art as Plunder*, 2008, pp. 319 ff; Katharine Eustace, '"Questa Scabrosa Missione": Canova in Paris and London in 1815', in Katharine Eustace (ed.), *Canova: Ideal Heads*, 1997, p. 16; D. Vivant-Denon, *Discours sur les monuments d'antiquité arrivés d'Italie*, Paris, an. XII [1804], p. 3. Quoted in Andrew McClellan, *loc. cit.*

141 Research on frames and frame-making is co-ordinated by the National Portrait Gallery, London; www.npg.org.uk/research/programmes/the-art-of-the-picture-frame.php.

142 Champernowne: Hugh Brigstocke, 'James Irvine: A Scottish artist in Italy – picture buying in Italy for William Buchanan and Arthur Champernowne', *Walpole Society*, vol. 74 (2012), pp. 245–479; FD, 9 Oct 1809, vol. X, p. 3576. Champernowne's Titian may have hung in his London house rather than at Dartington. Cecil Gould, *The Sixteenth-Century Italian Schools*, National Gallery, 1975, pp. 276–7. For Muselli provenance, see Waagen, 1853–7, vol. 2, pp. 76–7.

143 'That I purchase for others': James Irvine to George Cumberland, 13 Aug 1803. Quoted in Brigstocke, *op. cit.*, p. 254.

143 'I have been pretty well able': William Buchanan to James Irvine, 23 July 1803, quoted *ibid.*, p. 255.

143 'Scarcely was a country overrun': Pye, *Patronage*, p. 279.

144 'Many pictures have been made to acquire': Pye, *Patronage*, pp. 242–3.

145 On Truchsess: 'I was again enlightened': William Blake to William Hayley, 23 Oct 1804, David V. Erdman, *The Complete Poetry and Prose of William Blake*, 1982, pp. 756–7; Benjamin Silliman, *A Journal of Travels in England, Holland and Scotland*, 2nd edn, 1812, vol. 1, p. 240; quoted in Morton D. Paley, 'The Truchsessian Gallery Revisited', *Studies in Romanticism*, vol. 16 (spring 1977), pp. 165–77; FD, 21 Aug 1803, vol. 4, p. 2111.

146 Martin's sewage scheme: Hamilton, *London Lights*, ch. 14.

146 On Whitefoord: Lord Leicester to Caleb Whitefoord, 17 Sept 1804, Whitefoord
 Papers, vol. 3, f. 118; George Sandilands to Caleb Whitefoord, 15 May 1805,
 Whitefoord Papers, vol. 3, BL Add MS 36594, f. 144; George Wilson to Caleb
 Whitefoord, 18 July 1803, Whitefoord Papers, vol. 3, f. 94; J. T. Smith, *Nollekens
 and his Times*, vol. 1, 1828, p. 271; Noel Desenfans to Caleb Whitefoord, 1802,
 Whitefoord Papers, vol 3, f. 81. See also W. A. S. Hewins (ed.), *The Whitefoord
 Papers*, 1898, pp. 252–7, 260–1, and *passim*.

147 'Give me leave to introduce': George Sandilands to Caleb Whitefoord, 15 May
 1805. Whitefoord Papers, vol. 3, BL Add MS 36594, f. 144.

147 'About 2 years ago': George Wilson to Caleb Whitefoord, 18 July 1803, *loc. cit.*,
 f. 94.

148 'the breakfast of an Alderman': A pointed reference to the print publisher
 Alderman John Boydell. Valentine Green to Caleb Whitefoord, 7 Sept 1801,
 Whitefoord Papers, vol. 3, f. 35.

149 George Colebrooke, *ODNB*.

149 'it may happen': George Colebrooke to Caleb Whitefoord, 10 Feb 1805,
 Whitefoord Papers, vol. 3, f. 138.

150 'Whether we can in the present day': Turner to J. Robinson, 28 June 1822,
 Turner Correspondence, 97.

151 On Boydell: Nicholas Penny (ed.), *Reynolds*, 1986, p. 326; William T. Whitley,
 Thomas Gainsborough, 1915, pp. 269–70; Joseph Wright to John Boydell, 26 July
 1789, Barker, *op. cit.*, pp. 131–2; John Boydell to Joseph Wright, 3 Aug 1789,
 ibid., note 7.

152 Boydell's costs: Pye, *Patronage*, p. 253, note.

152 'By the inclosed from Mr Copley': Henry Hope to Caleb Whitefoord, 21 June
 1806, Whitefoord Papers, vol. 3, f. 223.

153 Alexander Davison, *ODNB*.

153 'I wish to dispose of the Brazen Serpent': Andrew Wilson to Caleb Whitefoord,
 10 May 1807, Whitefoord Papers, vol. 3, f. 255; Hewins, *op. cit.*, pp. 266–7.

153 'The pleasure you expressed': Henry Tresham to William Beckford, 27 Oct 1781,
 Bodleian, MS Beckford c.36, ff. 20–1.

153 'Altieri Claudes': *Landscape with the Father of Psyche Sacrificing at the Temple of
 Apollo* and *The Landing of Aeneas at Pallanteum*. Both now in the collection of
 the National Trust, Anglesey Abbey, Cambridge.

154 'I waited but for a sight': Henry Tresham to William Beckford, 14 April 1799;
 Bodleian, MS Beckford c.36, ff. 24–5.

154 'Many of the pictures at Fonthill': William Beckford to Mr Walker, 1807;
 Bodleian, MS Beckford c.36, f. 72.

155 'I shall not come away empty-handed': William Clark to William Beckford, 25
 June 1824, Beckford Papers, Bodleian, MS Beckford c.28, ff. 80–1.

155 On Beckford and Britton: John Britton to William Beckford, 19 Aug 1822,
 Beckford Papers, Bodleian, MS Beckford c.27, ff. 9–10; John Britton to William
 Beckford, 27 Nov 1823, c.27, ff. 22–3; Mary Ann Britton to William Beckford, 5
 Sept 1822, c.27, ff. 14–15; John Britton to William Beckford, 26 Aug 1834, c.27,
 ff. 30–1; John Britton to William Beckford, 16 April 1830, c.27, ff. 24–5; 21 Oct

1817, Boyd Alexander (trans. and ed.), *Life at Fonthill Abbey, 1807–1822 . . . From the correspondence of William Beckford*, 1957, p. 228.

157 On Britton and Soane: T. E. Jones, *A Descriptive Account of the Literary Works of John Britton FSA (from 1800 to 1849), Being a Second Part of his Auto-Biography*, 1849, p. 101.

157 On Britton: Charles Knight, *Passages of a Working Life*, 1864, vol. 1, p. 31; Pugin to Edward James Willson, 11 May 1834, Margaret Belcher (ed.), *The Collected Letters of A. W. N. Pugin*, 2001, vol. 1, p. 36; Elias Magoon to Phelps, 20 Nov 1860, quoted in Francesca Consagra, 'The "Ever Growing Elm": The formation of Elias Lyman Magoon's collection of British drawings, 1854–1860', essay in Brian Lukacher, *Landscapes of Retrospection: The Magoon Collection of British drawings and prints, 1739–1860*, 1999, p. 98; Calder Loth and Julius Trousdale Sadler Jnr, *The Only Proper Style: Gothic architecture in America*, 1975, p. 56. See also Francesca Consagra, *op. cit.*

158 A full account of Ackermann's model, in the Lady Lever Art Gallery, Port Sunlight, Merseyside [LL4885], is in Lucy Wood, *The Upholstered Furniture in the Lady Lever Art Gallery*, vol. 2, 2008, no. 103, pp. 989–1007. Ackermann's drawing of the proposed coach is in the National Gallery of Scotland [D3326]. See also Simon Jervis, 'Rudolph Ackermann', in Celina Fox (ed.), *London: World city, 1800–1840*, 1992, pp. 97–109. The coach itself is in the collections of the National Museum of Ireland, displayed at Newbridge House, Dublin.

158 Nelson's catafalque: Hamilton, *London Lights*, p. 28.

159 On Ackermann: John Ford, *Ackermann, 1783–1983: The business of art*, 1983, p. 17 and *passim*; 'Rudolf Ackermann', in *Notes and Queries*, 4th series, 4 (1869), pp. 109–12, 129–31, by W. P. [William Papworth]; *Times*, 1 July 1809; Rudolf Ackermann to Caleb Whitefoord, n.d., Whitefoord Papers, vol. 4, BL Add MS 36595, f. 3; *ODNB*. For details of Ackermann's account of Coutts Bank, see www.cradledincaricature.com, website managed by James Baker.

160 'He retained a strongly marked German pronunciation': *Times*, 1 July 1809.

161 Faraday inspired by Ackermann: George Riebau to an unknown journal, Oct or Nov 1813. Frank A. J. L. James (ed.), *The Correspondence of Michael Faraday*, vol. 1 (1811–31), 1991, letter 30.

162 Alan Bennett, *A Life Like Other People's*, 2009, p. 173.

162 Rudolf and Rudolph: to distinguish father from son here, the elder here retains the German spelling Rudolf, while the son is Rudolph.

163 Ackermanns after 1832: *Times*, 9 May 1843, 19 June 1851.

164 On Griffith: http://wc.rootsweb.ancestry.com/cgi-bin/igm.cgi?op=GET& db=towcester&id=I15266. Auctioneers: Griffith, Roberdau and Hopkins, 92 Blackman St, Southwark (see *Times*, 19 July 1792, p. 4).

164 Griffith's activities: J. L. Roget, *A History of the 'Old Water-Colour' Society*, 1891, vol. 1, p. 436; Turner to Heath, ?Oct 1827, Turner Correspondence, no. 128.

165 'The short time I had': Clarkson Stanfield to Thomas Griffith, 4 Jan 1831; Griffith Papers, 3.

165 'I entirely approve': Edward Coleridge to Thomas Griffith, 5 Oct 1835 (1836 in pencil); Griffith Papers, 2.

165 E. T. Cook and A. Wedderburn, *Complete Works of John Ruskin*, 1903–12, vol. 13, p. 478.

166 'You lay me under great obligations': Benjamin G. Windus to Thomas Griffith, 1844; Griffith Papers, 10. The watercolour, W827, was destroyed by fire in 1962.

166 'We have a very large Saloon': The Countess of Morley to Thomas Griffith, Dec 1837; Griffith Papers, 3.

166 Griffith's testimonial: David Roberts to Thomas Griffith, [1840]; Griffith Papers, 31; Thomas Uwins to Thomas Griffith, 4 Nov 1840; Griffith Papers, 7; *Athenaeum*, 1840, p. 893.

167 'I have yielded': Thomas Griffith to Anon [JMWT], Norwood, 13 June ?1829; Griffith Papers, 29. See Turner Correspondence, Appendix 2, p. 237, no. 18, *Straits of Dover*.

167 Jeremy Howard (ed.), *Colnaghi: The history*, 2010.

168 Turner and the Colnaghis: 'Colnaghi's Account' sketchbook, TB CCCXLII, p. 7a. The text is difficult to interpret, but it seems to show that Martin is offering one-third and one-quarter discounts at particular rates, with '6 months settlement by Bill at 4 months. M Colnaghi 28 May 1830', while Dominic offers 'A Discount of one third – should be 7 and 6 [7s 6d?] but that I leave to Mr Turner's discretion. D. Colnaghi & Co.'.

169 'Let your . . . Hay Cart go to Paris': John Fisher to John Constable, 18 Jan 1824; Constable's Correspondence, vol. 6, p. 151.

169 'I hear there is quite a bustle': *Ibid.*, 16 June 1824 , p. 154.

169 'I find Lord Dover': John Constable to C. R. Leslie, 17 April 1832; Constable's Correspondence, vol. 3, p. 67.

170 'We never read of the actions': Quoted in Gertrude Prescott, 'Gleams of Glory: Forging learned society portrait collections', in James Hamilton (ed.), *Fields of Influence: Conjunctions of artists and scientists, 1815–1860*, 2000, pp. 129–62.

170 'a most execrable likeness' of Peel: *The Standard*, London, 27 Nov 1834, issue 2,355.

170 On Gambart: Jeremy Maas, *Gambart, Prince of the Victorian Art World*, 1975; Count d'Orsay to Edwin Landseer, n.d. [?1847], Landseer Correspondence, 97; Edwin Landseer to Jacob Bell, undated, Landseer–Bell Papers, 4/23.

7 Colourman: 'The dangerous symptoms he labours under'

173 Cennino Cennini, *A Treatise on Painting*, trans. Mrs Merrifield, 1844, ch. 40, p. 23; ch. 47, p. 27; ch. 62, p. 35.

175 R. Campbell, *The London Tradesman, being a Compendious View of All Trades, Professions, Arts . . . now practised in the Cities of London and Westminster*, 1747, ch. 19, 'Of the Colour-Man', pp. 105–7.

176 Joseph Emerton's flyer, 1744: BM, P&D, Heal, 89.55.

176 On Grandi: FD, 17 April 1806, vol. 7, p. 2721; *Transactions of the Society of Arts*, 1806, vol. 24, pp. 86–8.

177 The Provis affair is fully documented by John Gage in *Colour and Culture*, 1993, p. 213; and John Gage, *Colour and Meaning*, 1999, pp. 153–61. It is also reported

blow by blow by Farington, FD, mainly Dec 1796–Jan 1797. 'Colouring' and 'very young lady: John Opie, *Lectures on Painting*, 1809, pp. 138 and 145.

178 Martin Archer Shee, *Elements of Art: A poem* (1809), canto 5, p. 288. Shee often has two lines of the poem on a page, followed by twenty-five lines of footnotes to explain them. Footnotes had by 1809 become a pedantic literary fashion, ripe for parody. Little changes.

178 Turner's *Macon*: B&J, no. 47.

179 On Owen: Sir Augustus Wall Callcott's journal for part of July 1805; Bodleian, MS Eng. d. 2263.

179 On the 'British School': Hamilton, *Turner*, pp. 84–5.

179 'Lake' here comes from the same root as 'lacquer' – that is, a pigment mixed with an inert resinous binding medium. See also Robert Chenciner, *Madder Red: A history of luxury and trade*, 2000, pp. 156–73.

180 On Field: *Transactions of the Society of Arts, loc. cit.*, pp. 128–33; John Gage, *George Field and his Circle: From Romanticism to the Pre-Raphaelite Brotherhood* (exhibition catalogue), Fitzwilliam Museum, Cambridge, 1989; Henry Crabbe Robinson to Thomas Robinson, 19 June 1846, Dr Williams's Library, London.

181 Field on Grandi: Quoted in Leslie Carlyle, *The Artist's Assistant: Oil painting instruction manuals and handbooks in Britain, 1800–1900*, 2001, p. 39, note 7; www.npg.org.uk/research/programmes/directory-of-suppliers/g.php.

181 Farington on Grandi: FD, 27 Dec 1796, vol. 3, p. 731; 13 May 1806, vol. 7, p. 2758.

182 'Grandi is in trouble': H. Grandi to James Northcote, n.d. [Nov 1806], Northcote Papers, 97. Punctuation added for clarity. www.oldbaileyonline.org/browse.jsp?id=t18061203-32&div=t18061203-32&terms=grandi#highlight.

182 Humphry Davy, 'Some Experiments and Observations on the Colours used in Painting by the Ancients', from *Phil. Trans.*, 1815, in John Davy (ed.), *The Collected Works of Sir Humphry Davy, Bart*, vol. 6, pp. 131–59; Maria Callcott, *Essays towards the History of Painting*, 1836, p. 251.

183 Prussian Blue: William Brande, *A Manual of Chemistry*, 1830, vol. 2, p. 25.

184 On yellow used by Turner: Hamilton, *Turner*, ch. 10; James Ward's Journal, 27 April 1818, Nygren, p. 37; *British Press*, 30 April 1826, see Turner Correspondence, 115. See also Brian Livesley, 'The Ageing and Ills of Turner: A physician's view', *Turner Society News*, 120 (autumn 2013), pp. 16–20.

184 'Mr Turner is in all his force': *Athenaeum*, 12 May 1838, p. 347.

184 On poisonous colours: Victoria Finlay, *Colour*, 2002, pp. 124–5; FD, 18 April 1819, vol. 15, p. 5353; Paints, Grinding of: *Dr Ure's Dictionary of Arts, Manufactures and Mines*, 1878, p. 471; entry for William Owen, *ODNB*.

185 Remarks on Turner's colour: 'M. I. H.', 'The Use of Indigo. Turner's Drawings', reprinted from *The Builder*, 24 Oct 1857, p. 609, *Turner Studies*, vol. 5, no. 1 (summer 1985), pp. 25–6; Richard Redgrave, *A Memoir*, 1891, p. 343; 'Janus Weathercock's Dialogue on the Exhibition at Somerset House', *London Magazine*, vol. 1 (1820), p. 702.

186 '*White*, when it shines with unstain'd lustre clear,/ May bear an object back or bring it near./ Aided by *black*, it to the front aspires;/ That aid withdrawn, it

distantly retires;/ But black unmix'd of darkest midnight hue,/ Still calls each object nearer to the view.' Charles-Alphonse du Fresnoy, *The Art of Painting*, trans. Mason.

186 An entertaining fictional account of Wainewright's life is Andrew Motion, *Wainewright the Poisoner*, 2000. See also *ODNB*, Thomas Wainewright.

186 Frank Howard, *Colour as a Means of Art* (1838), pp. ii, 43, 51, 53.

187 Mary Lloyd, *Sunny Memories*, privately printed, 1880, pp. 31–8. Republished as 'A Memoir of J. M. W. Turner RA by "M. L."', *Turner Studies*, vol. 4, no. 1, pp. 22–3. Quoted in Hamilton, *Turner*, p. 299.

188 Medical recipes: Hamilton, *Turner*, Appendix 2; Joyce H. Townsend, 'Turner's Writings on Chemistry and Artists' Materials', *Turner Society News*, no. 62 (Dec 1992), pp. 6–10. Banks and Reynolds: quoted Gage, *George Field and his Circle*, 1989, p. 8. I have been unable to establish a source for this quotation.

190 *The Diary of Albert Goodwin RWS, 1883–1927*, privately printed, 1934, pp. 389, 477.

190 Leslie Carlyle and Anna Southall, '"No short mechanic route to fame": The implications of certain artists' materials for the durability of British painting, 1770–1840', in Robin Hamlyn, *Robert Vernon's Gift: British art for the nation, 1847*, 1993.

190 George Field, *Chromatography; or, A Treatise on Colours and Pigments and their Powers in Painting, &c*, 1835, pp. 51, 77–128, 161.

191 William Muckley, *A Handbook for Painters and Art Students*, 2nd edn, 1882, p. 47.

191 William Holman Hunt, 'The Present System of Obtaining Materials in Use by Artist Painters, as Compared with that of the Old Masters', *Journal of the Society of Arts*, vol. 28, April 1880, pp. 485–99.

193 'Our Articles are all Town Made': John Sell Cotman to John Hornby Maw, Maw Papers, f. 5.

194 Palmer's and Blake's methods: Samuel Palmer to Henry Acland, 8 Aug 1855, 29 Oct 1866; Bodleian, MS Acland, d.71, 49, 51–4.

194 Winsor and Newton catalogue, 1863, p. 14; http://viewer.zmags.com/showmag. php?mid=wtfrgd&preview=1&_x=1#/page0/.

195 'Your business, Mr Winsor': Reminiscence of W. E. Killick, quoted in Peter Bower, *Turner's Later Papers . . . 1820–1851*, 1999, pp. 12–13.

197 Sally Woodcock with Judith Churchman, *Index of Account Holders in the Roberson Archive, 1820–1939*, Hamilton Kerr Institute, 1997.

197 Among them are the Dollar Institution, Alloa; the School of Practical Art, Wolverhampton, 1828–70; Agnew and Zanetti, art dealers of Manchester; the Royal Italian Opera and Theatre Royal, Covent Garden; the Proprietors of the Diorama in Regent's Park; Sir Jamsetjee Jeejeeboy's School of Art, Bombay, 1863–74; the Great Western Railway, managed from Isambard Kingdom Brunel's office address, 18 Duke St, 1836–9, the period of the construction of the railway line from London to Twyford.

197 'In the evening [John] Opie dropt in': Sir Augustus Wall Callcott's journal for part of July 1805; Bodleian, MS Eng. d. 2263.

197 'What a fine broad fleshy colour': Haydon Diary, vol. 1, p. 45.

198 George Field to Thomas Lawrence, 19 June 1820; RA Archive, Lawrence Letters, LAW/3/159.

198 Hunt on Field's secret: Holman Hunt, *op. cit.*, p. 491.

198 Hamerton on Palmer: Quoted in Gage, *op. cit.*, p. 70.

198 Learned societies: Hamilton, *London Lights*, ch. 2. The Society of Antiquaries left Somerset House for Burlington House in 1874. The Geological Society resided in Somerset House 1828–74, and the Royal Astronomical Society 1834–74, when both moved to Burlington House.

199 George Adams, *Micrographia illustrata; or the Microscope Explained* : . . [4th edn, 1771], title page.

8 Engraver: 'Brother scrapers'

201 'Bending double': C. W. Radclyffe, *Catalogue of the Exhibition . . . of Engravings by Birmingham Engravers*, 1877, pp. 5–6. Quoted in Eric Shanes, *Turner's England*, 1990, p. 15.

201 Quoted in Elizabeth Harvey-Lee, *Etchings by Raymond T. Cowern*, n.d. [2000s].

202 On Woollett: M. T. S. Raimbach (ed.), *Memoirs and Recollections of the Late Abraham Raimbach, Esq., Engraver*, 1843, p. 15, footnote.

202 'They were all bent low': William Heath Robinson, *My Line of Life*, 1938, p. 92.

202 'brother scrapers': John Pye (J. L. Roget, ed.), *Notes and Memoranda Respecting the* Liber Studiorum *of J. M. W. Turner . . .*, 1879, pp. 64–5.

203 On engravers: James Ward to George Ward, 4 Feb 1850; Nygren, p. 22, no. 228.

204 Buckler's prices: John Pretyman to John Buckler, 'Letters and papers which were much prized by John Buckler FSA', Bodleian, MS Eng. Lett a 1, 28; Lord Clarendon to John Buckler, 13 May 1815, *ibid.*, 65.

204 Godard's remarks: Alençon Library, France, Godard Collection, 11469, trans. James Hamilton; quoted in James Hamilton, *Wood Engraving and the Woodcut in Britain, c.1880–1980*, 1994, p. 28.

205 Buckler and Cobbett: Thomas Powys to John Buckler, 9 Nov 1804, 'Letters and papers which were much prized by John Buckler FSA', Bodleian, MS Eng. Lett a 1, f. 150; William Cobbett to Thomas Robinson, n.d. [early 1830s], Robinson Papers, University of Reading Library. Quoted in Hamilton, *op. cit.*, p. 29.

206 Faraday on Hullmandel: Michael Faraday to Charles Hullmandel, 12 April 1827; Frank A. J. L. James (ed.), *The Correspondence of Michael Faraday, 1811–1831*, vol. 1, 1991, no. 321.

206 Britton's costs: *ODNB*.

206 Britton engraves Flaxman: Ann Flaxman to Rev. William Gunn, 15 March 1810; Flaxman Papers, vol. 11, BL Add MSS 39790, ff. 50v–51.

207 Bank-note quantities: *Times*, 8 Feb 1819.

207 Forgeries: 1812 – 17,885 forged notes; 1817 – 31,180. *Times*, 23 May 1818; FD, 29 Jan 1819, vol. 15, p. 5328.

208 Diamond type: *Times*, 8 Feb 1819.

208 Perkins's method: Hamilton, *London Lights*, pp. 184–5. Catherine Eagleton and Artemis Manolopoulou (eds), British Museum Paper money research catalogue,

www.britishmuseum.org/research/publications/online_research_catalogues/
paper_money/paper_money_of_england__wales.aspx.

208 On electrotypes: Raimbach, *op. cit.*, p. 143.

209 Pye engraves Turner: Hamilton, *London Lights*, p. 360, note. J. M. W. Turner to
 John Pye, in John Gage, 'Further Correspondence of J. M. W. Turner', *Turner
 Studies*, vol. 6, no. 1 (1986), p. 6 (no. 248a); John Pye to J. M. W. Turner, 19 Aug
 1835, Turner Correspondence, 194; Elhanan Bicknell to John Pye, 23 June 1845,
 NAL, V&A, Pye MSS.

210 'By the graver's art': Pye, *Patronage*, pp. 211, 244.

211 Orders of the Delegates of Oxford University Press, 1795–1810. Press accounts at
 end of volume, unpaginated. Oxford University Press Archive.

211 22 April 1806, *ibid.*, p. 203. See also Helen Mary Petter, *The Oxford Almanacks*,
 1974, pp. 15–17, 81–6.

211 The price rose to 3 shillings in 1805, and 3s.6d in 1807. Almanack folio,
 Ashmolean Museum, and Delegates' minutes, *op. cit.*, p. 239.

211 Turner's *Liber*: Of these seventy-one plates were published; a further nineteen
 were not. Gillian Forrester, *Turner's 'Drawing Book', The Liber Studiorum*, 1996.

212 'Respecting advertising': Proof in Royal Academy, Allen Collection 15c, quoted
 in Forrester, *op. cit.*, pp. 13, 175.

212 John Pye (J. L. Roget, ed.), *op. cit.*, p. 65.

212 Lewis's fee: J. M. W. Turner to F. C. Lewis, 14 Dec 1807, Turner Correspondence,
 21.

213 'I believe that it is only to be gotten': Maria Graham to John Murray, n.d.
 [1818/19: Graham mentions Turner's *Coast Scenery* as having just been published
 by John Murray]. John Murray Archive, National Library of Scotland.

213 'neatly packed': Quoted in Forrester, *op. cit.*, p. 22.

213 'A pack of geese!': W. G. Rawlinson, *Turner's Liber Studiorum*, 1878, quoted in
 Forrester, *op. cit.*, p. 27.

214 On Turner and Miller: Turner to William Miller, 21 Oct 1836, Turner
 Correspondence, 203; Turner to William Miller, 22 Oct 1841, Turner
 Correspondence, 246; Graves Papers, BL Add MS 46140, 31 March 1836, f. 54.

215 Insurance: Turner to Edward Swinburne, 2 Jan 1837; quoted in Luke Herrmann,
 Turner Prints: The engraved work of J. M. W. Turner, 1990, p. 226.

215 John Landseer, *Lectures on the Art of Engraving*, 1807, 3rd Lecture.

215 Herrmann, *op. cit.*, Appendices I and II. Herrmann's totals are 862, with a
 further ninety-one *Liber Studiorum* plates. Jan Piggott, *Turner's Vignettes*, 1993.

215 Landseer's prints: Lennie, p. 162.

216 Dealings with Gambart: Charles G. Lewis to Jacob Bell, 17 Aug 1848, MS RI,
 3/8; Charles G. Lewis to Ernest Gambart, 27 Sept 1848, MS RI, 3/9; Ernest
 Gambart to Jacob Bell, 27 Sept 1848, MS RI, 7/4; Charles G. Lewis to Jacob
 Bell, 13 Oct 1848, MS RI, 3/10; Edwin Landseer to Jacob Bell, 6 Nov 1849, MS
 RI, 2/4.

217 Landseer's prints: *Times*, 16 Oct 1850. The subjects are: *Pointer*, *Retriever and
 Woodcock* and *Spaniel and Pheasant*. Proofs are in the BM, 1853,0709.497–9.

217 Dealings with Blackmore: Charles G. Lewis to Jacob Bell, 12 Aug 1854, MS RI,
 3/34; Charles G. Lewis to Edwin Landseer, 31 Aug 1854, MS RI, 3/37; Charles G.

Lewis to Jacob Bell, 28 Sept 1854, MS RI, 3/39; Charles G. Lewis to Jacob Bell, 4 Oct 1854, MS RI, 3/40.

219 'Mr Cooper is too tame': Robert Cooper [?] to Abraham Cooper (no relation), 24 Dec 1828, Letters and Papers connected with Sir Walter Scott; letters to Abraham Cooper RA, BL, Egerton 2075, f. 45.

219 Contracts with Graves: Graves Papers, f. 56; 12 May 1830, f. 25.

220 Sales volumes: Pye, *Patronage*, p. 210, footnote.

220 Payments from Watt to Landseer: 100 gns, 30 April 1836; 100 gns, 24 June 1837; Graves Papers, BL Add 46140, ff. 55 and 74.

220 *The Drover's Departure*: 1 Feb 1838, Graves Papers, f. 89.

221 On copyright charges: Raimbach, *op. cit.*, p. 139.

221 Watts's dealings: James H. Watt to Hodgson and Graves, 4 Oct 1839 and 7 April 1840, Graves Papers, ff. 133, 145.

222 Dealings with Heath: John Murray to Charles Heath, 24 Dec 1818; John Murray Archive, NLS, MS 41908.

222 S. W. Reynolds to John Constable, early 1826. Constable's Correspondence, vol. 4, p. 267.

222 'truly . . . a gigantic man': Hamilton, *London Lights*, p. 189.

223 Bromley's contract: 30 March 1837, Graves Papers, f. 63.

223 Printing plate destruction: 27 Oct 1855. Ian Smith (ed.), *The Apprenticeship of a Mountaineer: Edward Whymper's London diary, 1855–1859*, London Record Society, vol. 43, 2008, p. 32; 'Destruction of Works of Art', *Times*, 29 Oct 1855; *Times*, 22 Nov 1855;

224 On John Martin: Hamilton, *London Lights*, ch. 14; Martin Myrone (ed.), *John Martin Apocalypse*, 2011; John Martin to James Northcote, 2 May 1817, Northcote Papers, 79, V&A, NAL; Thomas Balston, *John Martin, 1789–1854: His life and works*, 1947; Martin's printshop: Balston, *op. cit.*, p. 104; original source: Leopold Martin, 'Reminiscences', *Newcastle Weekly Chronicle, Supplement*, 9 March 1889, p. 1; quoted in Michael J. Campbell, 'John Martin as a Commercial Printmaker', in Myrone, *op. cit.*, pp. 23–33; John Martin's account book, Lilly Library, University of Indiana.

227 Martin's sales: 1826 – 213 prints sold; 1827 – 196; 1829 – 39.

228 Exhibition report: Hamilton, *London Lights*, pp. 308–9; Nancy B. Keeler, 'Illustrating the "Reports of the Grand Juries of the Great Exhibition of 1851": Talbot, Henneman, and their failed commission', *History of Photography*, vol. 6, no. 3 (1982), pp. 257–70.

229 Elizabeth A. Pergam, *The Manchester Art Treasures Exhibition of 1857: Entrepreneurs, connoisseurs and the public*, 2011, pp. 119–25, and *passim*. This gives a full and clear discussion of the successes and failures of the photographic project. See also Appendix V, 'Return Showing Catalogues, Handbooks &c . . .', pp. 251–2; Jeremy Howard (ed.), *Colnaghi: The history*, 2010, p. 11.

229 Photographic Society exhibition: peib.dmu.ac.uk/itemexhibition.php?exbtnid =1035&orderBy=exhibid&exhibitionTitle=1858%2C+London%2C+Photograph ic+Society.

229 *Athenaeum*, 20 Feb 1858.

229 Francis H. Fawkes to Thomas Griffith, 23 Nov 1864, Griffith Papers, 26.

9 Publisher: 'Six hundred and eighty-five ways to dress eggs'

231 On Murray: Humphrey Carpenter, *The Seven Lives of John Murray*, 2008, chapters 5, 6 and 7.

231 Walter Scott, *Marmion*, Canto V, ii, 359–60.

232 Scott on Murray: Scott Letters, vol. 2, 103; quoted in Carpenter, *op. cit.*, p. 55.

232 Gifford proof-reading: William Gifford to John Murray, 26 Feb and May 1809. John Murray Archive, NLS, MS 42244 (420A)/9.

233 'Your Good Will': John Murray to William Miller, 12 Aug 1813. John Murray Archive, NLS, MS 41908, Letter book, March 1803–11 Sept 1823.

233 Murray's problems: John Murray & Co. to Dr Strachan, 2 Aug 1811; *ibid.*

233 *Childe Harold*: Carpenter, *op. cit.*, p. 76.

234 Byron on machine-wrecking: House of Lords, 27 Feb 1812; Hansard, http://hansard.millbanksystems.com/lords/1812/feb/27/frame-work-bill#S1V0021P0_18120227_HOL_13.

234 John Murray to Bishop of Llandaff, 31 Dec 1839. John Murray Archive, NLS, MS 41911, Letter book, March 1839–March 1846.

236 '"Come, come", said Tom's father': 'A Joke Versified', *The Poetical Works of Thomas Moore*, 1860, p. 110.

236 Byron on Moore: Carpenter, *op. cit.*, p. 111. See also Andrew Nicholson (ed.), *The Letters of John Murray to Lord Byron*, 2007, p. 240, note 2.

236 Moore on Brummel: 6 Dec 1818; Wilfred S. Dowden (ed.), *The Journal of Thomas Moore*, 1983, vol. 1, p. 98.

236 Moore on his fans: 19 Aug 1818; *ibid.*, p. 27.

237 Thomas Moore [named as Thomas Brown the Younger] (ed.), *The Fudge Family in Paris*, 1818, Letter VIII, Mr Bob Fudge to Richard — Esq., pp. 82–4.

237 'Received a letter': 13 Dec 1818; Dowden, *op. cit.*, p. 101.

238 Ballooning: See Hamilton, *London Lights*, ch. 11; and Richard Holmes, *Age of Wonder*, 2008, ch. 3.

239 Maria Graham, *Journal of a Residence in India*, 1813, Preface, pp. v, xi–xii.

239 Maria Graham in London: Lady Callcott's Journal, p. 8, 6 Feb 1813; 14 Feb 1813. Extracts made by William Hutchins Callcott, n.d. [watermark 1846], Bodleian, MS Eng. d.2274.

243 On 'Conversation' Sharp: William and Robert Chambers, *Memoirs of Francis Horner*, 1849, p. 136; Charles Dickens, *Bleak House*, 1853, ch. 3.

243 Maria Graham, *Three Months Passed in the Mountains East of Rome during the Year 1819*, Longman and Constable, 2nd edn, 1821; Maria Graham, *Memoirs of the Life of Poussin*, 1820, Longman (London) and Constable (Edinburgh); Maria Graham, 'An Account of some Effects of the Late Earthquake in Chili [*sic*] . . .', *Transactions of the Geological Society*, 2nd series, vol. 1 (1824), pp. 413–15.

244 'Yes I have been ill': Maria Graham to John Murray, 6 March 1821; John Murray Archive, NLS, Acc. 12604/1186.

246 On London booksellers: Quoted in James Laver, *Hatchards of Piccadilly, 1797–1947*, 1947, p. 11; William Beloe, *The Sexagenarian; or the Recollections of Literary Life*, 1817, quoted in Laver, *op. cit.*, p. 12.

246 James Lackington, *Memoirs of the Forty-Five First Years of the Life of James Lackington*, 2nd edn, 1793, pp. viii, xxiii–xxiv.

248 Murray and Hakewill: John Murray Archive, NLS, MS 42576; 21 July 1818, John Murray Archive, Letter book, March 1803–11 Sept 1823, MS 41908. See also Cecilia Powell, 'Topography, Imagination and Travel: Turner's relationship with James Hakewill', *Art History*, vol. 5, no. 4 (Dec 1982), pp. 408–25; and Luke Herrmann, *Turner Prints: The engraved work of J. M. W. Turner*, 1990, pp. 95–6.

249 Murray's troubles with Heath: John Murray to Charles Heath, 24 Dec 1818, *ibid.*

251 On Tilt and Turner: *Times*, 6 Dec 1831; 12 Dec 1831; 16 Oct 1833; Herrmann, *op. cit.*, pp. 201–2, 269; *Atlas*, 10 Nov 1833. Nick Powell, 'Knight for a Day', *Turner Society News*, vol. 111 (March 2009), pp. 10–14.

253 On Tilt and Lamb: *Times*, 12 and 13 Aug 1836.

253 Tilt the millionaire: *Notes and Queries*, 3rd series, vol. 1, 18 Jan 1862, p. 53.

10 Curator: 'The awful care'

254 'the powerful sea-god Neptune': Waagen, 1853–7, vol. 1, p. 1 .

255 Emilia Venn, Diary of Tour to France and Belgium, 1815, University of Birmingham, Cadbury Research Library, CMS/ACC81 F7–F9.

255 On Waagen: *Dictionary of Art Historians* website: www.dictionaryofarthistorians.org/waageng.htm.

255 'Now, for the first time': Waagen, 1853–7, vol. 1, pp. 3–4.

256 'The celebrated . . . national dish': Waagen, 1853–7, vol. 2, p. 288.

256 'A succession of savoury . . . dishes': Waagen, 1853–7, vol. 2, p. 226.

257 'the hundred eyes of Argus': Waagen, 1853–7, vol. 1, p. 37.

257 Peel's 'engaging manners': Waagen, 1853–7, vol. 1, p. 397.

257 Rubens's *Chapeau de Paille*: J. M. W. Turner, 'Old London Bridge' sketchbook, TB CCV 44.

257 Introduction to *The Holford Collection, Dorchester House*, vol. 1, 1927, pp. xvi–xvii.

258 Waagen on Holford: Waagen, 1853–7, vol. 2, p. 194.

258 Waagen, 1853–7, vol. 1, p. 397.

258 Lady Eastlake, *Journals and Correspondence*, 1895, vol. 2, pp. 32–3. Quoted in Susannah Avery-Quash and Julie Sheldon, *Art for the Nation: The Eastlakes and the Victorian art world*, 2011, pp. 135 and 137.

258 For the birth and growth of the V&A, see Malcolm Baker and Brenda Richardson (eds), *A Grand Design: The art of the Victoria and Albert Museum*, 1997, and Elizabeth Bonython and Anthony Burton, *The Great Exhibitor: The life and work of Henry Cole*, 2003.

258 Anon. [Peter Patmore], 'The Late Fonthill Gallery', *New Monthly Magazine*; collected edn, Anon. [Peter Patmore], *British Galleries of Art*, 1824, pp. 119–41.

259 'unfit to be trusted': William Paulet Carey, *Some Memoirs of the Patronage and Progress of the Fine Arts in England and Ireland . . . with Anecdotes of Lord de Tabley, of Other Patrons, and of Eminent Artists, and Occasional Critical References to British Works of Art*, London, 1826, pp. 27, 30, 31.

259 On Carey: Also known as Junius Hibernicus, *ODNB*; Northcote Papers, 53; *Notes and Queries*, 4th series, vol. 5 (21 May 1870), pp. 481–4.

261 Carey on Turner: Carey, *op. cit.*, pp. 147–8.

262 London exhibitions: J. M. W. Turner to James Holworthy, 21 April 1827; Turner Correspondence, 122.

263 British Institution mission: British Institution minutes, V&A, NAL, RC.V.ii, MSL/1941/677.

263 'moneyed prosperity': Joseph Banks to William Smith MP, 14 May 1805. Neil Chambers (ed.), *The Letters of Sir Joseph Banks: A selection, 1768–1820*, 2001, letter 101, pp. 268–9.

264 On the British Institution: *Times*, 14 April 1806; Thomas Smith, *Recollections of the Rise and Progress of the British Institution, 1805–1859*, 1860, pp. 139 ff.

264 Porter's costume: British Institution minutes, 8 and 15 March 1806, V&A, NAL, *loc. cit.*

265 John Young, *A Catalogue of Pictures by British Artists in the Possession of Sir John Fleming Leicester, Bart*, 1825.

266 On the British Institution: *Times*, 19 July 1806; 4 March 1807; 27 May and 2 June 1817; 3 June 1824.

268 On Seguier: *ODNB*; John Burnet, *The Progress of a Painter in the Nineteenth Century*, 1854, pp. 72–3; *Times*, 10 April 1826.

269 On the Parmigianino: FD, 9 Dec 1795, vol. 2, p. 433. See also Cecil Gould, *The Sixteenth-Century Italian Schools*, National Gallery, 1975, pp. 194–5; *Times*, 25 April 1828.

269 On Holwell Carr: *ODNB*; Judy Egerton, *National Gallery Catalogues: The British paintings*, 1998, pp. 399–405; *Catalogue Raisonné of the Pictures now Exhibiting in Pall Mall*, 1816.

269 www.historyofparliamentonline.org/volume/1820-1832/member/watson-taylor-george-1771-1841.

270 *Imaginary Picture Gallery*: Richard Walker, *Regency Portraits*, 1985, vol. 1, pp. 615–18, and vol. 2, plates 1591–7. The finished painting is in a private collection; studies for the four main groups of figures are in the NPG.

270 Letters from 'Alfred': *Times*, 16 April, 12 June 1828.

271 On Lawrence: Alaric Watts, *A Narrative of his Life*, 1884, vol. 1, p. 222; *Times*, 1 Oct 1830.

271 On the British Institution: John Constable to C. R. Leslie, 31 Jan 1830, Constable's Correspondence, vol. 3, p. 25; *Times*, 15 June 1848.

272 'After the kindness': Draft letter John Northcote to Sir William Pole, Jan 1823. Northcote Papers, 31.

272 Cleaning Turners: John Constable to C. R. Leslie, 14 Jan 1832, Constable's Correspondence, vol. 3, p. 58.

273 Moving painting: B. R. Haydon, *Autobiography and Journal*, vol. 1, p. 289; Haydon Diary, vol. 2, p. 265.

273 *Waterloo Allegory*: James Ward's Journal, April 1820; Nygren, p. 65.

273 Rolling painting: William Etty to his brother, 1847. Letter quoted in Alexander Gilchrist, *Life of William Etty*, 1855, vol. 2, pp. 223–4.

273 Crowds at exhibition: *Literary Gazette*, 22 May 1819.

274 Carey on Turner: Carey, *op. cit.*, p. 147.

274 Prout's complaint: Samuel Prout to John Hornby Maw, n.d.; Maw Papers, ff. 40, 42, 44.

275 'That execrable Seguier': William Beckford, *Memoirs of William Beckford of Fonthill*, vol. 2, 1859, p. 293.

275 Prince Albert and Waagen: Avery-Quash and Sheldon, *op. cit.*, p. 135.

276 On Wornum: *ODNB*; Ralph Wornum's letters to his family, 29 April, 20 Sept 1834, National Gallery Archive 2/1/9, pp. 5–6, 39, 43–4.

278 Ralph Wornum's diary: 1855–77; 8 Sept and 12 Nov 1855; 1 Feb, 1 March, 25 Sept, Oct, 12 Dec 1856, National Gallery Archive, NGA 2/3/2/13.

279 On dismantling Turner's studio: Thomas Griffith to Francis Hawkesworth Fawkes, 19 Dec 1854; Griffith Papers, 18.

279 'The first Turners... to be seen': These were preceded by *Sun Rising through Vapour* (1807) and *Dido Building Carthage* (1815), hung at Trafalgar Square between two Claudes in accordance with Turner's will in December 1852. For picture cleaning practices at Trafalgar Square see *Report from the Select Committee on the National Gallery*, 1853, pp. iii–xiv, and paras 168, 172.

280 Wornum Diary, 8 Dec 1854, 3 Nov 1859.

280 William Holman Hunt, 'The Present System of Obtaining Materials in Use by Artist Painters, as Compared with that of the Old Masters', *Journal of the Society of Arts*, April 1880, pp. 485–99.

281 Wornum Diary, 22 Jan 1858, 21 Oct 1859 and 21 Jan 1860; Charles Eastlake to Michael Faraday, 17 June 1859, Frank A. J. L. James (ed.), *The Correspondence of Michael Faraday, 1811–1831*, vol. 5, no. 3602. For Faraday's report, see *Parliamentary Papers*, 1859, 2nd Session (106), XV.

281 Francis Fowke, *A Description of the Buildings at South Kensington, Erected to Receive the Sheepshanks Collection of Pictures*, 1866, pp. 16–17, 20.

281 On Goldsworthy Gurney: Hamilton, *London Lights*, p. 266.

282 Giles Waterfield, *Palaces of Art: Art galleries in Britain, 1790–1990*, 1991, pp. 49–65.

282 Wornum Diary, 1 Feb 1860.

282 'The Callcott Pisa': *The Entrance to Pisa from Leghorn*, 1833, Vernon Bequest, Tate Britain.

282 Queen's visit: Wornum Diary, 17 Feb 1860.

283 Turners return to Trafalgar Square: see also Alan Crookham, 'The Turner Bequest at the National Gallery', in Ian Warrell (ed.), *Turner Inspired: In the Light of Claude*, 2012, pp. 52–56.

283 Care of pictures: Wornum Diary, 12 May 1860; 22 Nov 1862. Three Ward cattle subjects were shown at the 1857 Manchester exhibition, including *St Donat's Castle* (now V&A). 'Turner getting loose': 15 Dec 1865; pictures at Kensington cracking: 19 Aug 1863.

283 Picture-cleaning schemes: Wornum Diary, 5 April, 3 Oct 1864; Turners cleaned by pea-meal: *Apollo and Daphne, Italy – Childe Harold's Pilgrimage, Bay of Baiae, Caligula's Bridge*, 5 July 1867; Pettenkofer's method: 7 Oct 1864; Hahn's method: 1 and 3 Aug 1866; praise from *Punch*, 24 Nov 1866.

285 George J. Kirby to James Bourlet and Sons, 4 Aug 1936. Bourlet album of letters, Bourlet & Co., London.

11 Spectator: 'So useful it is to have money, heigh-ho'

286 Lorenz Eitner, *Géricault's Raft of the Medusa*, 1972, pp. 61 ff.; Géricault to Dedreux-Dorcy, 12 Feb 1821, quoted in Eitner, pp. 64–5.

287 C. R. Cockerell's diary, 11 Dec 1821. Cockerell family papers, Drawings and Archives Collection, British Architectural Library, RIBA, CoC/9.

287 Karl Friedrich Schinkel, *The English Journey: Journal of a visit to France and Britain in 1826* (ed. David Bindman and Gottfried Riemann), 1993, p. 67; diary entries, 1, 2, 6 June 1826, pp. 79, 85, 97; itinerary, p. 212.

288 Isaac Schofield to Messrs J. Schofield, 21 Aug 1840, BL Add MS 88892.

291 Francis Bacon, 'On Seditions and Troubles', *Essays*, XV, 1625.

292 Diary of Emilia Venn, 30 April 1822, University of Birmingham, Cadbury Research Library, CMS/ACC81 F9; Venn MSS, www.mundus.ac.uk/cats/44/1206.htm; portrait of Rev. John Venn, NPG, D7531. Engraving by Edward Scriven, 1813, after a drawing by Joseph Slater.

294 Tom Taylor (ed.), *The Life of Benjamin Robert Haydon . . . from his Autobiography and Journals*, 1853, vol. 1, p. 377.

295 Richard Brinsley Sheridan, *The School for Scandal*, Act IV, Scene i.

295 Faraday's portrait collection: Royal Institution Archive. See also: Gertrude Prescott, 'Gleams of Glory: Forging learned society portrait collections', in James Hamilton (ed.), *Fields of Influence: Conjunctions of artists and scientists, 1815–1860*, 2000, pp. 129–62. Letter refs: Faraday to Edward Magrath, *c*.March 1830, Frank A. J. L. James (ed.), *The Correspondence of Michael Faraday 1811– 1831*, vol. 1, 1991, no. 437; Thomas Phillips to Faraday, 23 June 1841, James, vol. 3, no. 1353; Faraday to Angela Burdett Coutts, 29 Dec 1846, James, vol. 3, no. 1942; Jane Davy to Faraday, 23 Aug 1847, James, vol. 3, no. 2014; Faraday to L.-A.-J. Quetelet, 19 April 1851, James, vol. 4, no. 2412.

296 On Brockedon: Hamilton, *Faraday*, pp. 210–12; H. H. White to William Brockedon, 25 Jan 1832, NPG Archive. Of the British nationals included in the collection, only seven were not subsequently included in the 1903 *Oxford Dictionary of National Biography*; this falls to three in the 2004 *ODNB*. Charles Dickens to W. Wills, assistant editor of *Household Words*, 17 July 1851.

298 W. P. [? William Papworth or William H. Pyne] to Caleb Whitefoord, n.d. Whitefoord Papers, vol. 4, ff. 199–200, BL Add MS 36595.

299 Cyrus Redding, 'The Late J. M. W. Turner', *Fraser's Magazine*, Feb 1852, pp. 150–6.

299 Story of Gyges: Herodotus, *The Histories*, book 1; Penguin edn, trans. Aubrey de Selincourt, 1966, pp. 16–17.

299 Elizabeth Etty to Joseph Gillott, 20 March 1846, University of Birmingham Cadbury Research Library, XMS 94/1/1/3. 'Mr Bullock' is Edwin Bullock, Birmingham industrialist and collector.

300 *Times*, 23 May 1835.

300 William Etty's autobiography, in *Art-Journal*, 1849. Quoted in William Gaunt and F. Gordon Roe, *Etty and the Nude*, 1943, p. 22. See also *ODNB*, William Etty. Letter: William Etty to Joseph Gillott, 22 April 1847, Etty-Gillott Correspondence, XMS 94/1/1/11.

300 Lynda Nead, *Victorian Babylon*, 2000, p. 193; Hansard, 3rd series, vol. 146 (25 June 1857), col. 331.

301 Wornum Diary, 18 August 1858; National Gallery Archive.

301 Ian Warrell, 'Exploring the "dark side": Ruskin and the problem of Turner's erotica', with checklist of erotic sketches in the Turner Bequest, *British Art Journal*, vol. 4, no. 1 (spring 2003), pp. 5–46; Ian Warrell, *Turner's Secret Sketches*, 2012.

301 London brothels: Renton Nicholson (ed.), *The Town: A journal of original essays, characteristic of the manners, social, domestic, and superficial, of London and the Londoners*, 10 June 1837, no. 2, p. 13; 'Sketches of Courtezans', *ibid.*, 10 June 1837, no. 2, p. 13; Pisanus Fraxi, *Index Librorum Prohibitorum: being Notes Bio-Biblio- Icono-graphical and Critical on Curious and Uncommon Books*, London, privately printed, 1877, pp. xl, xlii.

304 Thornbury, vol. 2, p. 168.

305 Benjamin Disraeli, *Lothair*, 1870. Quoted in Ronald Pearsall, *Worm in the Bud*, 1969, p. 109.

305 On panoramas: *Times*, 12 April 1797, 24 Feb 1808, 31 March 1814, 2 Dec 1823, 23 May 1859, 13 Aug 1860, 2 March 1863, 23 June 1897. T. L. Donaldson to Robert Finch, 12 April 1824; Finch Papers, vol. 5, ff. 148–9, Bodleian. Henry Mayhew and George Cruikshank, *1851: or, the Adventures of Mr and Mrs Sandboys and Family, who Came up to London to 'Enjoy Themselves', and to See the Great Exhibition*, 1851, pp. 131–3. John Ruskin, *Praeterita*, 1859, para. 137, p. 168.

306 Greg Smith, 'The Eidometropolis: Girtin's Panorama of London', *Thomas Girtin: The art of watercolour*, 2002, ch. 9, pp. 188–205. Girtin's drawings for the Eidometropolis are in the British Museum and the Guildhall Library, London.

309 On public lectures: Michael Faraday, first lecture to the City Philosophical Society, 17 Jan 1816. Chemistry Lectures 1816–19, Institution of Engineering and Technology (IET) Archive, SCMS 2/1/3; Friedrich von Raumer, *England in 1835*, 1836, p. 60; Friedrich von Raumer, 30 April 1836, 'Extracts from letters written in 1836', *England in 1841 . . .*, 1842, p. 126; J. M. Thomas, *Michael Faraday and the Royal Institution*, 1991, p. 217; *Literary Gazette*, 13 June 1829. See also Hamilton, *Faraday*, ch. 14; *Times*, 5 Feb 1816, 1 Feb 1822; Iwan Rhys Morus, *Frankenstein's Children: Exhibition, electricity and experiment in early-nineteenth-century London*, 1998, p. 80.

311 On Exeter 'Change: *Times*, 1 May 1818 (advertisement), 2 March 1826; Leslie A. Marchand (ed.), *Byron's Letters and Journals*, 1973–4, vol. 3, p. 204, 14 Nov 1813.

313 On Bullock: William Bullock, *A Companion to Mr Bullock's London Museum and Pantherion . . . now open for Public Inspection in the Egyptian Temple just erected for the reception, in Piccadilly London*, 1812, pp. iii–vi; 'Bullock's MS Methods of preserving objects of natural history', Wellcome Institute, MS 1417; Hamilton, *London Lights*, pp. 170–3; *Times*, 10 June 1817; see also Susan Jenkins, 'Arthur Wellesley, First Duke of Wellington, Apsley House, and Canova's Napoleon as Mars the Peacemaker', *Sculpture Journal*, 2010, vol. 19.1, p. 115; *Times*, 20 May 1837.

315 On the Royal Panopticon: *ODNB*, Edward Marmaduke Clarke; *Illustrated*

Handbook of the Royal Panopticon of Science and Art, 1854, pp. 6, 9–10. Quoted in *Survey of London*, vols 33 and 34, 1966, pp. 488–503, Leicester Square: East Side.

316 On the end of the British Institution: *Art-Journal*, 187, vol. 5, p. 264.

317 'There are at least six of our students': Evidences, 1882: King's College, London; *City of London Livery Companies Commission Report*, vol. 1 (1884), pp. 203–10, para. 1781.

317 R. H. Parsons, *The Early Days of the Power Station Industry*, 1939, p. 21. Quoted 'Bourdon Street and Grosvenor Hill Area', *Survey of London*, vol. 40, The Grosvenor Estate in Mayfair, part 2, 1980, pp. 57–63.

12 A Gigantic Birdcage

318 On the Crystal Palace: Charles Richard Sanders (general editor), *The Collected Letters of Thomas and Jane Welsh Carlyle*, 1998, vol. 26, Thomas Carlyle to John A. Carlyle, 12 Jan 1851, p. 131; Thomas Carlyle to Arthur Helps, 26 March 1851, p. 50; Thomas Carlyle to Jean Carlyle Aitken, 3 April 1851, p. 54; *Builder*, 22 June 1850, p. 296; Henry Mayhew and George Cruikshank, *1851: or, the Adventures of Mr and Mrs Sandboys and Family, who Came up to London to 'Enjoy Themselves', and to See the Great Exhibition*, 1851, pp. 131–3 and 137; John Tallis & Co., *The Great Exhibition of the World's Industry, Held in London in 1851: Described and illustrated by beautiful steel engravings, from daguerreotypes by Beard, Mayall, Etc., etc., etc.*, London, 1852; Elizabeth Bonython and Anthony Burton, *The Great Exhibitor: The life and work of Henry Cole*, 2003, p. 133; Louise Purbrick (ed.), *The Great Exhibition of 1851: New interdisciplinary essays*, 2001; Hamilton, *London Lights*, pp. 143–6.

322 Tensions before the exhibition's opening: *Times*, 9 and 30 April 1851.

323 Diary of Isabella Mary Hervey, 5 May 1851, pp. 160–2; Sat 17 May, p. 167, Thurs 16 June, pp. 176 ff. Cadbury Research Library, University of Birmingham, MSS 7/iii/6 Ms 557/vol 1.

323 Jacob van Lennep, 'Gedachten bij de tentoonstelling te Londen', *Mengelpoezy, Poetische Werken*, II, 1872, p. 473. Dutch commission for the exhibition: 'Tentoonstelling te Londen', *Nederlandse Staatscourant*, 24 July 1850. H. W. Lintsen (ed.), 'Geschiedenis van de techniek in Nederland. De wording van een moderne samenleving 1800–1890'. Deel VI, *Techniek en samenleving*, 1995. I am most grateful to Froukje Pitstra for these references and for the translation from the Dutch.

324 'Light and its applications', *Illustrated London News*, 17 May 1851, p. 424.

325 Closure of the Great Exhibition: Hermione Hobhouse, *The Crystal Palace and the Great Exhibition – Art, Science and Productive Industry: A history of the Royal Commission for the Exhibition of 1851*, 2002, p. 71; *The Crystal Palace and its Contents; being an Illustrated Cyclopedia . . .*, W. M. Clark, 1852, p. 62. Total number of visitors to the Great Exhibition: 6,201,856; total receipts at door: £469,115.13s.

325 On the Manchester exhibition: Elizabeth A. Pergam, *The Manchester Art Treasures Exhibition of 1857: Entrepreneurs, connoisseurs and the public*, 2011 (see

Appendix 7); Tristram Hunt and Victoria Whitfield, *Art Treasures in Manchester: 150 years on*, 2007.

325 Other brewers who presented art galleries to their home cities include John Newton Mappin (Sheffield, 1887), Alexander Laing (Newcastle, 1900) and Cecil Higgins (Bedford, 1949).

INDEX